DESIGNING 3D
GAMES THAT SELL!

DESIGNING 3D GAMES THAT SELL!

Luke Ahearn

CHARLES RIVER MEDIA, INC.
Hingham, Massachusetts

Production: Publishers' Design and Production Services, Inc.
Cover Design: The Printed Image
Cover Image: Luke Ahearn
Printer: InterCity Press, Rockland, MA.

CHARLES RIVER MEDIA, INC.
20 Downer Avenue
Suite 3
Hingham, MA 02043
781-740-0400
781-740-8816 (FAX)
www.charlesriver.com

This book is printed on acid-free paper.

Designing 3D Games That Sell!
Luke Ahearn
ISBN: 1-58450-043-3
Printed in the U.S.A.

Printed in the United States of America
01 7 6 5 4 3 2 First Edition

CHARLES RIVER MEDIA titles are available for site license or bulk purchase by
institutions, user groups, corporations, etc. For additional information,
please contact the Special Sales Department at 781-740-0400.

Contents

CHAPTER 11

CHAPTER 12

Introduction

If I have seen farther than others, it is because I was standing on the shoulders of giants.

— Albert Einstein (1879–1955)

Peple love to use the term *black arts*. It sounds so cool. But the fact is, making a computer game is no longer a "black art"; it is something anyone with the right tools, talent, skill, and (most important) drive can do. However, there is a distinction between *making* a game and *designing* a game. Designing a game that will be seriously considered by publishers, nets you a development deal, and then goes on to perform in the marketplace, takes knowledge beyond the ability to merely physically construct a game. It takes an understanding of the business of the game audience, publishers, and marketplace.

Let me clarify that statement. Game development is no longer a "black art" (read: mystery), the way movie making is no longer a black art. The tools and knowledge to make a movie are out there and ready for the taking. For example, just look at the average hand held video camera. These cameras are like miniature television studios in your hand. They have the ability to hook into a computer or even a broadcast-quality setup. The tools of the game developer are also this advanced and accessible. Game development is even starting to be taught in many accredited colleges, as film classes have been for decades.

There are few people in the world like Steven Spielberg or John Carmack who have the talent and the drive to perform magic with their tools. Furthermore, it is usually larger companies (with unlimited resources) that can afford to hire the talented individuals who can make magic; cream does rise to the top, and we will always see the small independent make the next blockbuster movie or hit game. Remember, both Spielberg and Carmack started with not much more than a dream and a lot of passion for what they do—much as you are doing right now.

This book provides the up-and-coming developer with the tools, guidance, and encouragement they need to make their game development dreams come true. Most of all, in reading this book, you will gain the ability to understand the way games are chosen for publication, and why they often are not.

GOALS OF THIS BOOK

The goals of this book are as five-fold—to help you gain perspective, follow a course of action, understand the business of game development, polish your business skills, and gather the best information and tools to use in developing a game.

GAINING PERSPECTIVE

Our first goal is to teach you to consider your game—not as a programmer, artist, or gamer, but as a product designer, publisher, and, above all, a business person. Looking at your project from the same business perspective as the publisher, even as you are conceiving the game, is the only way to ensure that the publisher will view it favorably when you submit it.

Your ultimate goal should be to design a game that is appealing to the consumer, and though you might already understand what is "appealing," you need to be able to take a step back, be certain that you are right about your assessments, and then have the ability to explain your game title to the publishers in a language they understand. We will talk more about the importance of your initial instincts, and discuss how most new developers follow an erroneous course with their opinions about advertising and product design, only to find out that it is, in fact, the publisher's job to communicate with the end users.

FOLLOWING A COURSE OF ACTION

Follow a course of action in which you explore and document your instincts and present them to publishers in the language that will help them understand the validity of your ideas. (In addition, you *should* communicate with your consumers on a regular basis—but as a developer—and never in conflict with the publisher.)

This course of action will give you a head start over other talented artists, programmers, and individuals making their way into game development. Many of these individuals are closer than they think to becoming commercially successful; what they lack is direction—not "direction" in terms of the actual creation or production of the game itself, but direction in getting the game published. The challenge is not *how to make a game*, but how to make a game *that will sell*, and then *selling* it.

Selling a game doesn't only involve selling it to the consumer. First you have to sell it—to your team, the publisher, the reviewers, the retail buyers and managers, the end users—and always to yourself. You need to be the *champion* for your idea and never lose the love you feel at the initial stages of design, all the way through development—even when you are bored to death with your own creation.

So take heart, because it's not the tools or the knowledge of game development that people lack; it's an understanding of how the game publishing business works and what makes a game sell, and it is just that information that this book will give you.

UNDERSTANDING THAT GAME DEVELOPMENT IS A "FOR PROFIT" BUSINESS

This point might seem extremely obvious, but it is often forgotten during development, when things get overwhelming and sometimes personal—but the fact re-

mains that you are in business. This fact needs to be applied to every aspect of your game proposal, submission, and development.

I do not suggest that you become so greedy that the quality of the game suffers just to turn a profit. Rather, to become commercially successful, you must be aware of the legitimate economic needs of the publisher. If you understand the core business principles of intended audience, project management, scheduling, budgeting, and, most important, publicity and marketing, you'll be better prepared to deal successfully with game publishers.

If you decide to try your hand at being a commercial game developer, you will frequently hear about the economic perspective. You can attempt to avoid this reality, but it will be there waiting for you when you try to publish a game. You will need to understand and speak intelligently about the business aspects of your title if you are to *build confidence with a prospective publisher*. If you understand what a particular publisher is looking for, you will be able to deal with that publisher more effectively; if you are familiar with standard business practices, you can apply them to your own game development. If you make a high-quality, well-informed presentation to your publisher, the publisher will have confidence in you. Then when you say you can complete your title within a two-year-in-terms-of-development-cycle, your publisher will have reason to believe you.

POLISHING YOUR BUSINESS SKILLS: PRESENTATION AND PROPOSAL

Developing your business skills is vital, and this book is about just that: designing your game to sell to all the groups you need to sell it to. It's about selling your game *and* yourself to the publishers and the marketplace. Game development (in other words, successful commercial development) is not only about high-quality art, the most concise programming, or even the best game for that matter; it's often about the best presentation to the right people—to *all* the right people.

A polished presentation is similar to meeting a person for the first time. Appearance (the presentation itself) is very important, but eventually the product must be found to have substance. Although it might be easy to get attention with a gimmick, it is imperative that you have a worthwhile product to back up your claims, or you won't get a second glance. On the other hand, without the proper presentation to the appropriate group, your game will go unpublished—regardless of the product's quality.

The good news? There's no "magic" about it. Submitting to a publisher involves routine processes that most developers have not been exposed to, because we've spent our time programming or creating graphics. These processes are similar to those with which a writer is intimately familiar (cover letters, a synopsis, and knowledge of the intended audience); these are all things a writer must submit to the book publisher to get published. It's similar with game development.

PROVIDING INFORMATION AND TOOLS TO DEVELOP A GAME

Another important benefit of this book is that it provides useful information and the proper tools for developing a game. All the tools you need to create a game are here: the software applications, code, art, models, and so on. A major obstacle new development teams face is acquiring the tools to make a commercially successful game. These tools are from many different sources; they are all *fully-functional* and *free*.

Although successful commercial game development concerns making a product that will sell, it doesn't necessarily require the latest technology or the hottest licensed property. However, on the CD-ROM that accompanies this book, you will find some of the latest technology. In Part II of the book, we go step-by-step through the basics of game development using those tools, from model creation to the actual process of building a level. Finally, there is even a program that allows you to package your game demo into a "professional install routine." The majority of these tools are free or remarkably reasonable in their terms and pricing.

THIS BOOK IS ALL YOU NEED, BUT . . .

Obviously no *one* book or single information source will answer all your questions on design and development or presentations and budgets or provide everything you need in any single subject area.

If you are unfamiliar with the actual technology and construction of a computer game, you should read some of the many other books on the market that will give you the fundamentals before proceeding to try being a game developer. If you are relatively familiar with the language of computer games or if you are a fledgling artist or programmer who wants to bring a team together to do a modification (MOD) or game demo, all you need is a nudge and the tools in this book.

In your quest for the best source of computer game development information, start with these books:

The Game Developer's Marketplace, Ben Sawyer, Alex Dunne, and Tor Berg; Coriolis Group Books, 1998.

This book provides a wonderful overview of the entire game development landscape.

Game Design, Secrets of the Sages, Marc Saltzman; Brady Games, 1999.

Great insight from industry professionals and the questions you would want to ask them if you could.

Game Architecture and Design, Rollings and Morris: Coriolis Group Books, 2000.

A *very* in-depth look at the minutia of game design. This book is really geared toward advanced users who have a large team development effort to manage, but it is well worth owning.

You'll find other books and sources of information, such as the Internet and magazines, that are specific to your area of expertise—programming, art, animation, sound, business, or the like. You need to actively seek those out as well. Check the list of resources in Appendix D of this book to get you started.

If you don't know what a 3D game is you really should go play several before you read on. This book assumes you know the difference between *real-time 3D* and *pre-rendered 3D*, as well as *first person* and *third* person (and even *overhead third-person orthographic*). Even if you don't know all these terms, you will find a lot of useful information here, but you might have to come up to speed on the technical information covered in Part II.

INTENDED AUDIENCE FOR THIS BOOK

NOVICES

Given all the people who have e-mailed me with questions about game development (getting started, getting a job, getting an advance), I imagine that there are a lot more of you who want to make games and have the ability to do so, so you just need some answers. There are many talented people who could be developing games; I hope this book helps them.

STARTUP DEVELOPERS

This group consists of people who started as gamers, landed jobs developing games, and now want to break out and start their own companies. It would help their cause to know what to expect on the new path—making a good game is not the same as getting one published. This book will help these folks.

OVERVIEW OF PART I

Part I looks primarily at the business of game development. How do you design a game that will sell in the marketplace? What are the common business practices you should be aware of to avoid misunderstanding and disappointment? What obstacles might have prevented other developers from succeeding—and how do you avoid those obstacles? What are the odds of success in this competitive industry? How can you distinguish your game from the others in the eyes of the publisher?

Finally, most new developers have many questions about how to go about preparing documents for submission to a game publisher—how to handle the treatment, design document, team introduction, budget, schedules, and so on. This book looks at how to submit materials in the proper fashion on the first attempt in order to have publishers consider your work seriously. We look at how to deal with rejection and how you can prevent abuse by aggressive publishers. We also examine

alternatives to publisher funding, such as using the Game Agent. Finally, we look at finding a job in the game development industry.

OVERVIEW OF PART II

In Part II, we look at the basics of game-level creation as opposed to level design. We get very familiar with the Genesis 3D Level Editor and tools. We build a small level to gain an understanding and the vocabulary and the technology of game creation.

Then we move up to the Reality Factory, a greatly enhanced version of Genesis 3D, and explore the creation of special effects and other entities that have been added to Genesis 3D. With Reality Factory we will be able to create an application closer to a complete game.

PLEASE KEEP IN TOUCH

Please e-mail me at *designing@goldtree.com* with your feedback concerning this book. I am especially interested in the stories you gather on your game development journey.

PART

I

CHAPTER 1

The Game Developer

A lot more effort is focused on protecting brilliant game ideas than on stealing them.

—Mike Wilson, *Gathering of Developers*

In this chapter, we will clear up a few distinctions and misconceptions. It's important to note that this book looks at game development from a point of view most developers usually don't consider or even understand: the marketing and business perspective.

Many misunderstandings occur within the game industry among the various groups that must coordinate their efforts in order to design, develop, and publish a computer game. The fact that many developers are not concerned enough with the business aspects of game development, and never thought they would need to be, cause them to often lack the terminology and mindset that the publisher is looking for in a game developer as a partner and as an investment risk. Quite often, publishers are searching for more than just a viable game; they are looking for a game made by a team that understands *business goals*—profit and loss, the marketplace and the audience being designed for, why deadlines are important, and, in short, what the publisher is doing and why it is doing it. A complete development team capable of implementing the *entire* process of game development, which includes contracts, project management, paperwork, and all traditional office functions in addition to making the game, stands a greater chance of success when hunting for a development deal.

What position does the game developer hold in the game industry? Generally, the Golden Rule applies here as in most cases in life, "He who has the gold rules." The one with the gold is usually the publisher. As a developer, you are relegated to being a very small cog in a complex machine—and there are a lot of cogs in a complex machine. Even developers with a title or two under their belts face competition from talented upstarts and more successful developers as well as the whims of a fickle marketplace. (We look at these forces and the elements of the game industry in Chapter 4.)

As this book was being completed, Tim Morten wrote Ten Independent Development Myths Debunked, *an article that can be found on the Gamasutra site at www. gamasutra.com/features/20000918/morton_01.htm. It is a must-read article for aspiring game developers. Keep in mind that it is only one person's experience in the industry, but the struggles Tim Morten endured hold true for many other developers as well.*

A simple representation of the game industry can be seen in Figure 1.1. The number of viable developers is large and the competition is fierce. Placing yourself

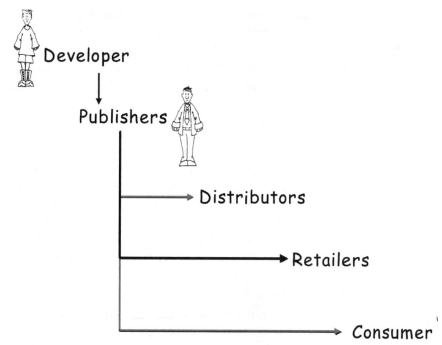

FIGURE *A simple version of the game development industry.*
1.1

ahead of the thousands of other developers for publisher consideration is important and fortunately not too difficult once you know how to do it.

Later we will look at alternatives to going with a publisher. You'll make many trade-offs by going the self-publishing route, but it is a viable option.

DEVELOPERS: NOT JUST PROGRAMMERS ANYMORE

Traditionally, game development was governed solely by the developer. All aspects of the process were seen as a plethora of technical issues. As a result, all aspects of a particular game were understood in the context of game *development*. "Design" meant designing the *code;* "features" meant the features *coded* into the game; and a comparison to other games was done almost strictly on a *technological* basis. Although we are still programmer-centric in this industry, and technology is an important factor during development, we have swiftly become a "real" industry; developers need to start looking at their development efforts with marketplace concerns, not just technical issues, in mind. We must do this because it is required by commercial game publishers when they review demos and proposals. They consider new projects based on traditional business practices and market potential.

Although the business of game development has many new and unique aspects, it is still a commercial enterprise and is run like most other industries. These traditional business concepts might be new and alien to many of you who have spent your time *playing* games or learning to create them. To succeed in the design game, though, you must consider these business practices.

THE GAME INDUSTRY IS STILL AN INDUSTRY

The truth is, the game industry really is like most other industries. That means that what you are seeking to accomplish is no mystery, whether your desire is getting a job, developing a game, or simply being a beta tester. If you want in, the doors are wide open. Furthermore, as in other industries, you often have to start at the bottom and pay your dues in the game industry, be in the right place at the right time, and learn about the industry from the ground up.

From outside the industry, game developer seems like the perfect job, and it can actually be close to perfect at times; when you are at a convention, holding your first boxed game, getting demos of hardware before it is released so that you can develop for it in your next title. If your job is going to require long hours, low pay, and all the hassles of "real work"—in short, if your job is going to be a real job—it might as well be the kind of job people think is cool, right? The title of game developer is enough reward for many, but the myth of the game developer existence and the promise of fame and fortune pull many into game development, and they are the ones who are eventually most disappointed.

The misconceptions and false hopes about the game industry are as bad as those in the film industry. For every actor who achieves the status of a Harrison Ford, thousands of would-be actors are working as waiters and attending rehearsal after rehearsal with no success. Likewise, for every top-rung game developer, hundreds of development teams wash out everyday. Many of these washouts can be prevented.

A GAME DEVELOPER CAN PLAY GAMES ALL DAY

If only this statement were true. When something becomes a job, it often becomes no fun. Yes, you can get sick of playing games, and often when you make games, you don't have as much time to play them. Believe it or not, it is possible that you could end up hating your own game by the time your proposal is ready to go—before you have even really started developing it. This is one of the biggest things you having going against you: You can't escape reality. You can play a game only so long until you are thoroughly sick of it. Try playing the same game for two years straight!

Your game might no longer be fun after you have to make it, have to make it on time, and have to make it within budget. So you might want try your hand as a freelance artist, a beta tester, or a game reviewer first and get to know the industry and those who work in it. Knowing what you want and knowing what you are trying to get is key.

THE CHALLENGE OF GETTING A DEVELOPMENT DEAL

Before a demo is sent to a publisher, a developer has at least six months of work ahead of him or her involving the research, design, and creation of the demo and accompanying materials. Once the demo is sent off, the developer can then expect several more months to pass before a deal is closed—at least three to five months, by industry estimates. To dedicate a year to getting a game deal can tax anyone's resources and willpower. If the developer—whether a first-time developer working a day job or a developer with a game or two on the shelf—is attempting to get a game deal in his or her spare time, this phase can cause many with completed demos to drop from the race. Among the many discouraging things that can happen in this one-year period is simply technological advancement.

THE CHALLENGE OF TECHNOLOGICAL ADVANCEMENT

Technologies such as Direct X and Open GL have helped make the job of making games easier than ever; licensing technology from a company whose job it is to stay current is another great option. You can even use one of the many 3D engines on the Internet, such as Genesis (*www.genesis3d.com*). The technology and tools of game development are so readily available now that often the best option, even a preferred option by many publishers, is to use licensed technology.

Our industry changes very fast. In fact, this year alone game developers will spend a total of $3.5 billion on hardware, software, and services, according to a *Game Developer Magazine* 2000 Subscriber Survey. These technologies evolve so rapidly that we are forced to not only keep up with the product releases and updates, we must purchase much of the technology ourselves. The rate at which everything in this industry changes is astounding. Look at the recent changes in peripherals, Internet connections, hardware, and drivers. As soon as you think you have a commercially competitive game, another title is released that raises the bar technically or moves the bar totally. When your hot new demo suddenly seems outdated in light of games just released and you are faced with having to go back and possibly redevelop the demo; that is a serious blow to any team's resolve to continue on with the project. But technology is not the end-all of game development, so if you are not able to produce the "technology of tomorrow," you should focus on your other strengths.

Many games and interactive products do not demand or even desire cutting-edge technology. Later in this book, we discuss the difference between making a game that will beat a technology-driven hit like Quake 3 in the retail channel as opposed to making a game that is fun and requires less technology. Titles like *You Don't Know Jack* focused less on technology than on the research and production values that gave this title such great content and game play. *You Don't Know Jack* was a hit

when it was released in 1995 and is now a major franchise. The developers, coincidentally, are also the same people who developed *Who Wants to Be a Millionaire,* a recent chart topper.

THE BUSINESS WHIRLWIND

The game industry is a billion-dollar-a-year business. Knowing how to make a game—in effect, an interactive environment—empowers you in the marketplace to get a job or to possibly start a company. If you are good, you are a rarity. Simply being able to create a running demo will get you looked at in many cases, but it will not get you *considered* in most.

Being considered is an important distinction from merely being looked at. *Being considered* means that your product was not simply looked at and returned to you, but it was actually sent from the recipient to the person in charge of product acquisitions and was considered as a possible title to be published. You might get a great number of people looking at your title, but you might never realize that none of them actually considered it for publication. This is one of the drawbacks to being in such a lucrative industry. This industry seems such fun to be a part of, and the tools to make a game demo are so readily available, that many individuals send in submissions simply because they can.

Hundreds of other submissions might accompany yours in the door and get on the mail cart, but if you follow a few simple guidelines, yours can be one of the few left on the publisher's desk at the end of the day. The good news is that most of the other submissions probably miss the mark in one or many ways. Sometimes the dilemma is simply finding the right person at the right publisher to send your package to. Publishers might be inundated with submissions, but they are also dying for that next great game submission from a team that can implement it. If you simply put the right name on the package, you are a step ahead already.

The business whirlwind comes not from the numbers of individuals in the industry but the numbers of individuals rushing in and out of the industry. Just as there are many developers sending in submissions, many companies come in and out of the industry in the capacity of publisher as well. For example: if you were to take a list of publishers from any source and try to contact someone at those companies, you would find the list grossly out of date, even if that list is only a few months old. Game publishers often shut down, move, are bought and sold, merge with others, or are even renamed. Huge successes and failures can cause companies to change dramatically as they grapple with closure or growth. Even the simple act of moving offices or the fluidity of careers in the game industry sometimes makes it hard to find the right phone number for the company or individual you want to contact. Quite a few large publishers make it simply impossible to establish human contact with.

The last time I submitted a game title, it took days to simply compile and update a list of publishers that would potentially be interested in it. Even after all that work, a few submissions were returned because the person I sent them to didn't work at

the publisher anymore—only days after I had confirmed their position on the phone! In one case, the individual who originally helped me on the phone had not been notified that the publisher he worked for no longer published PC titles. During this time I also spoke to several published developers whose stories ranged from "getting a million dollar deal in one meeting" to "it took us years and a few 'throw-away titles' to get here."

So don't get caught in the storm of the game development industry, jumping in unprepared only to be tossed right back out. Go steady and build a solid game proposal or résumé.

ENTERING THE BUSINESS ARENA UNARMED

A certain celebrity and mysticism surround the computer game developer, and those qualities alone are enough to encourage many individuals to become game developers, but there is also a certain amount of cynicism saying that we are the ones that get the short end of the stick in the industry. Our disadvantage is due mainly to developers' inexperience in business. Entering any substantial business deal ignorant of business terms and tactics will likely be a disaster for all involved. The fact that many developers don't understand the difference between gross and net profits is a cause of many of the horror stories of the industry. If a developer expects a check for 10 percent of the retail price of his game because the contract said he is due a 10 percent royalty, that developer is in for a big disappointment when he finally understands the concept of net profits:

Gross profits = Everything the title made
Net profits = Everything the title made, minus everything it cost to make the title

Net profits can include the developer's advance, the game's packaging (and package design), advertising (and ad design), channel buy-ins, convention costs, and many more items. Depending on what the publisher spent to publish your title, the actual worth of your percentage will vary. We look at some of these items in the coming chapters and examine more of what the publisher must do to compete in the retail channel.

So, it feels like a no-win battle: On one hand, you want your publisher to spend a million dollars to market your game, but you are afraid that that million spent also decreases your chances of getting any royalties. In fact, based on their market knowledge, most publishers have a pretty good idea of how much they should spend on publishing a title to ensure a return on their investment.

If you as a first-time developer enter the arena of game development and publishing unarmed with the knowledge of how that arena works, you will most likely have one of the following experiences:

- **Meet up with one of the many small publishers that pop up and fail at regular intervals.** As we will see in Chapter 3, nine out of ten products fail to

meet their financial goals, according to the American Marketing Association. These small publishers, which may have virtually no titles on the shelf and have all their resources tied to one title, stand a 90 percent chance of failure in the marketplace. Working with these small publishers can have many benefits, but it would not be wise to invest your own funds to pay for the development or advertising costs of the title to get a deal.

- **Get a legitimate deal and not know what to expect, then become very frustrated and overwhelmed a great deal of the time.** This is where you need a good attorney to explain to you what you are signing, a good accountant to explain to you basic accounting and what to possibly expect in the way of royalties, and even a basic education in your industry and the process of publishing a game.

- **Obliterate your chances at getting a good deal by not understanding what a good deal is.** If you handle the proposal or negotiations wrongly, asking for way too much or even for not enough resources, the publisher might drop you. Even if you signed a contract and are bungling the development because you weren't prepared, the publisher might drop you.

BREAKING INTO THE GAME INDUSTRY

It has never been easier to get your hands on the tools and information you need to make a game. Many colleges are teaching game programming and 3D art, even offering classes on game design. Game companies are giving away to their audiences the tools and knowledge they have used to make their games. Furthermore, the Internet is the most awesome tool you can use for learning about game development. With the Internet, you can learn the trade, put together a portfolio, and even get a job in the industry—all without leaving home.

A fact about the game industry: It is actually pretty easy to get into the business and really hard to make it once you are in. Sure, the game business is a billion-dollar industry (bigger than the film industry), but the competition is fierce. A little later, you will read more about the danger of stumbling blindly into the game industry.

Getting into the industry is easy—meaning that you can easily drop a lot of time and money developing a game that will not sell. It happens, even now, that developers spend lots of their own time and money developing games and show up at the Electronic Entertainment Expo (E3) with tens of thousands of dollars already invested and start asking, "Wanna publish my game?" The sad truth is, as you will see later, all that investment might actually cripple their chances for a *good* deal.

In addition, the fact that it is so easy to obtain game development tools is the same reason we have so much competition. It is easy now for a "wannabe" game developer to drop in the mail a level they made—or, more accurately, attach a

7-megabyte file to an e-mail and send it to *anybody@anypublisher.com* at a hundred publishers with one click of a mouse button.

The good news is that even with all this so-called competition, it is really quite simple to make yourself stand out from the crowd. There might be a lot of fierce competition, but you are competing with relatively few people when you get your demo to the level inside the publisher at which it can be taken seriously. Most of the thousands of game submissions sent to publishers really miss the mark and are not considered for very long, if at all. These hundreds of other submissions are not really your competition; rather, they are lemmings rushing off the cliff while you calmly plot your course to publication.

C
A
S
E

S
T
U
D
Y

CASE STUDY: BARBIE® GENERATION GIRL™ GOTTA GROOVE™ CD-ROM!

Barbie Generation Girl Gotta Groove CD-ROM! is a CD-ROM game that gives the player the ability to mix and match dance moves to create the "perfect performance."

Many developers turn up their noses at the thought of developing a Barbie game, but—as we see in Chapter 2—often the greatest opportunity to make money in the game industry lies in audiences and genres other than the hard-core, "first-person shooter" market. *Barbie Generation Girl Gotta Groove CD-ROM!* was the number-seven best-selling game for Christmas 1999. This title was created using the Genesis3D 1.1 engine (a free and open source game engine in this book) by Neurobatics Corporation, a team of three people. At last count, the title had sold over 450,000 copies! This is a *tremendous* success story for small development project.

Before working on the *Gotta Groove* project, Tim Brengle of Neurobatics Corporation was actually unemployed after having been involved in a startup company that failed. Since Tim had worked at various game companies, mostly game publishers, since 1990 and knew one of Stunt Puppy's founders, he was able to consult with them on various projects. Stunt Puppy, a small game design company that was working with Mattel on various Barbie projects, had Tim make a few presentations to Mattel, and eventually the Barbie project was offered to Tim, who formed Neurobatics with his partner, Ian MacKenzie, to be Stunt Puppy's programming resource. They made their own good luck in this instance by partnering with Stunt Puppy, which already had a positive relationship with the producers at Mattel Interactive, to get in the door at Mattel. All that was left to do was to convince Mattel that they needed to

use advanced 3D technology to create their next game and that Neuro-batics was the group that should do it.

At the time, Stunt Puppy had lots of game design talent and art resources but no technical development capability. In the past, Stunt Puppy had completed several smaller, yet successful, products for Mattel Interactive and wanted to step up to developing more ambitious projects and needed the programming resource to do so. Tim and Neurobatics were in the right place at the right time.

The idea for "Barbie and her friends dancing" in a game came during a brainstorming session involving a Mattel Interactive producer and Stunt Puppy. After the initial idea was conceived, Neurobatics was deeply involved in the refinement and final game design. The idea evolved continuously from then until the day the game shipped, 14 months later.

THEY USED GENESIS 3D—NOT FOR LACK OF FUNDS

Genesis can be used for free (it costs $50,000 only if the developer wants to take the logo out of the startup of the engine), but money was not a major issue in the decision, according to Tim. Had they needed it, Mattel could have provided the funding for the rights to any 3D game system available. To give you an idea of the purchasing power of Mattel, the company bought The Learning Company for $3.8 *billion* at the time. Although $250,000 or more to license a commercial engine might sound like a lot to a small developer, it is not beyond the reach of a company such as Mattel.

Of course, Mattel was happy that Neurobatics saved them so much money in the end by using Genesis, but the decision to use Genesis was made for several other reasons. Tim had known the principal architects and authors of Genesis for a number of years and very much respected their abilities to create commercial-grade, reliable, high-performance software. Tim knew that he would get the high level of support he would need during development due to those friendships. In the end, Tim actually received a degree of support that exceeded even the high level he expected from Eclipse and from Mike Sandige in particular.

One of the key features of Genesis, on which the whole game idea depended, was motion superposition and smooth blending. This feature was not easily available in the other 3D engines Tim had researched. Since artists were expected to create the individual pieces of the dances by hand, the software had to do the blending. This blending of each dancer's body segment had to be of a high level of quality to be approved by Mattel, and the motion needed to blend together extremely

smoothly in order to make the assembled dancing Barbie look graceful and flowing, not blocky and jumpy.

SEVEN THINGS THAT WENT RIGHT (IN NO PARTICULAR ORDER)

The following seven things went right during the game's development:

- Planning, designing, and implementing a flexible, changeable system that was easy to modify as the design evolved.
- Choosing Genesis. The outstanding support from Eclipse made a huge difference in terms of the success of the development.
- An excellent and fun game design produced a successful hit game.
- A highly motivated team worked well together, even under pressure.
- Incredible motion capture production and talent.
- Blending Genesis seamlessly with DirectShow, DirectDraw, and DirectSound 3D.
- Royalties on anything relating to Barbie!

SEVEN THINGS THAT WENT WRONG (IN NO PARTICULAR ORDER)

The following seven things could have gone better during the game's development:

- Forcing an 18-month project into less than 14 months
- Trying to force a high-end 3D system to run on very slow user systems
- A game design that was finalized six months after it was expected and needed
- Having to change the lighting model at the last minute to get acceptable results
- Bringing traditional 2D artists up to speed on 3D techniques and processes
- Five weeks working on-site at Mattel Interactive at the end of the project, 18 to 20 hours each day
- Adding staff at the very end of the project

THE TEAM

The development team consisted of the following people:

- One game designer/part-time producer
- One part-time project manager
- Two programmers, with some occasional help from a third on time-critical components
- Three artists and some additional art help
- One art technician who handled much of the art creation process

THE DEVELOPMENT BUDGET

Stunt Puppy received between $850,000 and $950,000 for the game, and Neurobatics was paid about $200,000. This case study can not begin to delve into what Mattel Interactive actually paid for the entire project.

EQUIPMENT

Many different PCs were used during the development of the Barbie project, since compatibility was a paramount issue.

Neurobatics was active in a great deal more than programming. They created the 3D art path, did much of the art conversion work, helped supervise the motion-capture shoots, instructed the artists in 3D Studio Max techniques, made textures, built rooms, and basically had their hands in every part of the project, from conceptual design through debugging, and mastering. They even had input into the creation of the TV ads.

Finally, one of Tim Brengle's finest moments in life was the Saturday morning that his kids rushed in excitedly to wake him up so he could see the commercial on national TV for the game he developed. That was when he knew that all the effort and late nights had been worth it.

STANDING OUT IN A CROWDED FIELD

Standing out is not about being obnoxious or unprofessional, but making too many followup calls, sending odd-sized and weird packages, and spending money on gifts is. All these things will make you stand out, but it will be in an undesirable or ineffective way. People often confuse the advice to "get noticed" with standing out in any and every way possible. All that actually matters is making your *submission* stand out. That means putting together and submitting a well-developed demo and proposal.

As you will see, standing out is more important than ever in this competitive market. Once you understand what games are on the market, how they performed, and what the publisher is looking for, then put all that information to work for you, you will stand out in the most desirable way.

A MOMENT OF REFLECTION ON YOU

Many people out there can make a game or make the portion of a game they are interested in (art, programming, and so on). By sheer force of will, you can learn any

application and work through any tutorial. By studying games and reading the Web sites dedicated to gaming, you can learn what people like and don't like in games.

Believe it or not, most people are not very good at what they do, because they don't take the time to figure out how to do things right—they don't take the time to push their abilities further. That is primarily due to negative self-talk. Get someone talking about their dream, and nine times out of 10, if you listen, you will hear them gradually talk themselves *out* of pursuing their dream, even on the level of a hobby. They will often make comments like, "Well, I could never do that. I could never beat so-and-so (naming a huge developer)." Of course, if your goal is to beat a huge established developer at its own game, it is no wonder that you are overwhelmed and defeated before you start.

Often the biggest thing you have going against you before you even start the process of becoming a game developer is yourself. Your limits in terms of time, endurance, and belief in yourself determine whether or not you do what it takes to make a game proposal, get a deal, and stick around long enough for it all to pay off.

WHERE DOES GAME DEVELOPMENT BEGIN?

Do you think that the game, MOD, or game demo that has been burned on to a gold disk, sitting in the nice folder on your desk, is ready to go out to publishers? Or, worse yet, do you think you are ready to run ads in your favorite gaming magazine, because you are going to sell the game yourself? (Please say you haven't written the check for your magazine advertising yet!) Well, don't mail that check, because we are going to take a step backward and look at a few crucial basic things.

Before you begin to submit proposals or even to develop your game, you should do several things. The very first thing is, familiarize yourself with the products, the people, and the industry. The "big picture" is bigger than just the game you want to create.

Creating a game can be done by a few people working over the Internet—but making a level and some textures is only a small part of the equation if you want to land a real game development deal. If you are serious about getting your game sold, financed, or published, you have to know a few things before you start development. These next few chapters cover game development from a business perspective and help you lay the foundation to convince someone to take a chance on you and your game.

It will be important to know the industry, the intended audience for your game, and what your financial backer or publisher is thinking. A publisher's point of view is often different from yours. You need to generate honest and objective feedback on your game idea.

THE BASICS OF SUCCESSFUL GAME DEVELOPMENT

The following is a list of a few basic and important prerequisites for a game to be successful in almost any sense of the word.

YOUR GAME MUST BE SALABLE

People (*many* people) must want to play your game, and play it more than once before tossing it aside. You need to get feedback by exposing your game to your audience as well as people with industry experience. A publisher or agent knows what to look for in a potentially successful game and (usually) will not be timid about telling you what needs to be changed, upgraded, or fixed in terms of game play, graphics, and content.

In this book, we look at the audience, game industry, and how to dissect other games on the market to determine what makes them failures or successes.

YOUR GAME MUST BE "IN THE CHANNEL"

When we say your game must be "in the channel," we mean that your game has to be available in the retail stores, such as Comp USA, Babbages, and Electronics Boutique. These retailers generally buy from distributors such as TechData and Ingram-Micro. People also buy games through online stores, but even these entities benefit greatly from (and rely on) the traditional aspects of marketing, such as word of mouth, print ads, and hands-on demos. In short, the game has to be available to consumers on a global scale, and this takes a team of people with great resources and experience to sell your game to the buyers at large retail chains, making deals to bundle your game and otherwise get it out there. Your game needs to be packaged and stored, shipped, and constantly cared for. Once you start doing this, you are no longer a developer, you are a publisher.

In this book, we look at the importance of the channel and the publishers and distributors that get you there.

YOUR GAME MUST BE PROMOTED

Promotion takes a lot of money and personnel (marketing managers, copywriters, ad designers, mailing lists, and the list goes on). Placing the right amount of advertising is expensive. An average one-page ad in a top game magazine costs about $15,000; you pay extra for premium placement in the magazine, such as inside the covers or on the back cover. Marketing and advertising costs extend beyond this fee. There are trade shows to attend, design firms for the ads and packaging, and simply getting onto the retail channel—a task that you might not know is quite involved.

In this book, we look at the basics of knowing your market and understanding marketing.

YOU PROBABLY NEED A PUBLISHER

Of course, the game itself has to be good, and that is the developer's job, but people still buy books based on their covers, and the book has to be where people can buy it, that is the publisher's job. All these things take a *great* deal of time, money, and talent. Although the view of this book is skewed toward what developers need to do (since it was written for developers), the publisher is a necessity, and you must understand its role in order to be successful. The key is to find the *best* publisher and the *best* deal for you and your game. Some publishers take advantage of inexperienced developers; others are simply not the right match for your game. You also need to learn to look at yourself objectively to be sure that you have accurate and realistic expectations of yourself, the publisher, and your game.

The fact is that each person has an important job to do and at least a basic understanding of the other person's job will make things smoother and more productive for all. That is what you, the developer, will be able to do with the knowledge in this book: identify and understand your role in the process and then present your title to the publisher so that you can sign a contract and get your game out to the market.

WHAT IS DESIGN?

The distinction between design and development is very important. The term *design* covers the research, writing, and general "gathering of resources" period before significant development is done (development being one portion of the process). Figure 1.2 shows an illustration of the game life cycle.

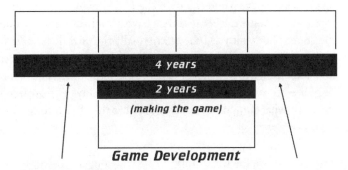

FIGURE **1.2** *The game life cycle. Actually making the game falls in the middle of the cycle, not at the beginning.*

Many people use the term *design* to mean the design of the game's menu interface or the design of the code base, but designing these elements is actually part of the development of the game, and they are done after the actual game as a whole is designed.

Before you start designing interfaces, you need to know what kind of game you are developing, for what audience, for what publisher, and other important aspects of your title. Game design in its proper definition is to approach designing the game, as other industries approach the design of their products, to be used and sold on the market. Design is the initial guiding force and final goal of development and, finally, the reason the sales and marketing of the title might be successful.

ACCEPTED DESIGN PRACTICES

Although the "If it's cool, we'll use it" methodology works for industry leaders, few have the luxury to be in that position or the talent needed to design games in such a way. In fact, most people who try to design a game that way end up frustrated with a barely started game. Furthermore, the "We'll ship it when it's ready" methodology is reserved for the very elite of the industry. No publisher will sign a deal with you because you say the game will be cool and will probably be ready in a year or two. You will simply have to prove up front to the publisher that you can make the game and propose to make it within certain financial and time restraints.

So be aware: "Develop a game" is still used as a catch-all phrase that lumps together (or leaves out!) distinct and important portions of the actual design process. The danger to you is that this approach puts undue pressure on the development team and sets you up for major stress and disappointment in the end.

All too often, an inexperienced development team starts developing a game (literally making the game right off the bat), leaving out the many steps that should precede development because they have no way of knowing that these steps need to be done. They wait until they have finally finished their game or the demo of it before going to the publisher. It seems easy at first. You start working, and if you don't like something, you change it. This works only for a while before it gets overwhelming and impossible to keep up. When they finally get the game to the publisher and find out what should have been done that they failed to do, it is very discouraging, to say the least.

TRY ON THE PUBLISHER'S SHOES

Imagine telling a few people that you are interested in building a new house next year because you just love the house you are in now, but it will be old by then, so you want to start planning ahead because it will take the new construction crew a

year to build your new dream house. Of course, you were thinking about employing a crew that has actually built a dream house before looking at sketches, plans, and proposals first for the job. Of course, word gets out that you are looking to spend a lot of money on your house, so anyone who has ever nailed two boards together wants to get the job.

You wake up one morning and there is a big truck in your driveway. A crew starts unloading a huge pile of supplies and a few half-finished walls that have been pre-assembled. By the time you are on the lawn in your robe, they are half done with the front of the house. This scenario sounds silly, but that is, in effect, what we do as developers when we (along with hundreds of other developers) approach a publisher with packages that contain half-finished games that don't address the publisher's needs.

When developers take this approach, they might produce a stunning demo, but they will hit a point at which they are asked a lot of hard questions they cannot answer because the publisher requires more details. Since many developers don't even call the publisher first to inquire about what the publisher would like to see, they have a slim chance of sending the publisher what they want. Usually, the developer simply doesn't know the steps that should have been taken first in the way of research, fact finding, and formatting.

Therefore, the developer either realizes too late that he or she didn't know what the publisher wanted or the developer never realizes it at all. Several developers might get a follow-up call from a publisher and have to answer questions, either face to face or in the form of a long and detailed product submission form and, if they are not prepared, will be unable to defend the project; this results in the publisher moving down its prospect list and calling the next developer.

The product submission form is a lengthy form that asks you some of the questions you should have asked yourself *before* you started developing your demo. To complete these forms requires an education in marketing and a knowledge beyond art and code. You will see where a simple design document is not enough to get a deal. A great deal of research goes on before significant amounts of development are performed.

There is nothing more discouraging than to pour your heart, your soul, and all your limited resources into a game demo that takes months to complete—only to have it ignored by the publishers you send it to. In another discouraging scenario, you might get feedback as to why the publisher won't publish it; only at that point you might not have the heart or resources to do any further development on the title.

YOU MIGHT NOT WANT TO BE A GAME DEVELOPER

Once you learn more about it, game development might not be what you think it is or what you really want to do. Slowing down long enough to look at the industry

and what is required to be a commercial developer might prevent you from hitting a few roadblocks that could ultimately be more discouraging to you than some basic facts to begin with.

One fact is that you might not want to be a game developer, meaning that you might not want to run the business that develops games. If what you like is actually working on games, being the project manager or even lead designer might be very difficult, if not intolerable, for you. An education in your industry can only help you make that decision.

As in any career, with game development you have to enjoy the work in order to do what it takes to be successful at it. And that means that—aside from the desire to have a game on the shelf or the entertainment of playing them—you must love the *process* of developing a game and the seemingly endless stream of tedious tasks that go along with the job.

There are also ways to make a living in the interactive and game industries without creating a game. In fact, there has never been a better time to be a programmer, a 3D artist, or a Webmaster—or any profession relating to computers and content creation. The key is making educated decisions.

Let's look at how we can stack our advantages *before* going to the publisher, before we even start making a game. In the next chapter, we look at how we can better plan our development so that we are designing a game that publishers might want to fund. You will learn some concepts that will guide you in your development effort and in your presentation to publishers.

CHAPTER

2

Designing for the Intended Audience

A child of five would understand this. Send someone to fetch a child of five.

—Groucho Marx (1895–1977)

In this chapter, we look at the roots of design, the market (audience), what the term *marketing* really means, and the most important words in a designer's vocabulary: *innovation*, *invention*, and *imitation*.

You are a serious game player; game boxes and manuals litter your desk. Magazine CDs, stuffed with demos, are piled high, and you played through them all. You spend hours each day reading the latest game news (blissfully unaware of world events). You are a walking encyclopedia of game knowledge. If you are like average gamers, you spend more money on your games and computer gear than on clothes, food, and education. So, do you think you are capable of designing a best-selling game? In reality, even though you probably have what it takes to design a best-selling game, you are also probably not quite ready—at least, not yet.

Although you undoubtedly have much to offer—you are primed with the raw material of great game design—a head full of good ideas does not make a great game. As a matter of fact, ideas are a dime a dozen, and often, the mark of an inexperienced developer is his or her maniacal and paranoid desire to protect those ideas. To quote Mike Wilson of G.O.D Games, "A lot more effort is focused on protecting brilliant game ideas than on stealing them."

It is a common misconception among gamers that because they have played every game ever made and can point out every flaw in those games, they can create a better game. This is like someone watching *Star Wars* a hundred times who notices that the Tie Fighters have flaws in their Chroma-Key, then declaring the movie a piece of garbage, and subsequently thinking that they can make a better movie. That is very flawed logic. However, with your knowledge, you do have the raw material needed to start designing and developing games. You are, in fact, very close to being a productive member of the game development world. The point is, *criticizing* and *creating* are two different things.

So let's take a big step back to Step One in creating a product: defining the audience of people who are buying games.

THE BASICS OF PRODUCT DESIGN: HOW TO READ A MARKET

You may be a hard-core, first-person-shooter fan intent on making a first-person shooter game, no matter what, but looking at the market is still a necessity. Among the reasons for examining the market are the following:

- When you study the market, you will see what genres are topping the charts. Switching genres might not be so bad if that can actually improve your chances of getting published.
- Knowing what games in your genre have sold well, failed, or were even "no shows" on the retail shelf could give you perspective on how to design, develop, and present your game to a publisher. Walking into the publisher and comparing your game to last year's failure can be damaging if you are not prepared to illustrate how you fixed what caused the other game to fail.
- You will sound a lot more credible to the publisher if you are able to talk about the market in an educated manner.

Publishers are always asking, "Who buys computer games? What type of games sell the best?" and many other questions about their audience. Publishers also spend a good deal of time and money finding the answers. The best source for answers is PC Data (*www.pcdata.com*). You might be surprised to find out that it is not the first-person shooter you spent 10 hours playing last night that is the top seller on the charts; in fact, most hard-core gamers consider the types of computer games that most people buy to barely fit the definition of a game. The facts of the marketplace are that *Who Wants to Be a Millionaire* is still topping the charts. See the chart in Figure 2.1.

Top Sellers

July 2000

Sony Playstation Games

1. Legend of Dragoon
 Sony
2. Driver
 Infogrames
3. Spec Ops
 Take 2/Rockstar
4. X-Men Mutant Academy
 Activision
5. Tony Hawk's Pro Skater
 Activision
6. Digimon World
 Bandai Digital Entertainment
7. Who Wants To Be A Millionaire 2nd Ed.
 Sony
8. Tekken 3
 Namco
9. Syphon Filter
 989 Studios
10. NCAA Football 2001
 Electronic Arts

Weekly **More Lists**

FIGURE *The PC Data Hits List of top-selling games for July 2000.*
2.1

Of course, the importance of defining and reaching the market is obvious: That's how you make money. Just as other products on the market have categories and genres, so do games. In book publishing, there are romances, comedies, thrillers, medical thrillers, psychological thrillers—a seemingly endless number of categories. In software, the market is broken down into categories by PC Data. Generally, the categories are:

Software. PC based (Windows or Mac) in the genres of business, home educa-tion, personal productivity, reference, tax software, and games.

Games. This category is divided further still by genre and platform (Windows, Mac, console based, Nintendo 64, Sony Playstation, Game Boy, and so on).

U.S. retail sales of interactive console and PC games reached $7.4 billion in 1999, according to PC Data—that's a 20.7 percent increase over 1998, with most of the growth coming in the videogame market. Of the three segments that make up the industry, sales of console videogame software were $3.75 billion and accounted for 50.5 percent of the industry's total revenues. Console videogame hardware and PC game software split the remaining 30.9 percent and 18.6 percent, respectively. The top company in the PC game arena is Havas Interactive with *Half-Life* (num-ber six) and *Starcraft* (number five). The second most popular PC game publisher is Electronic Arts with *Sim City 3000*, the second best-selling PC game title of the year.

A new study projects next-generation console sales will top 50 million units by 2004. The 700-page DFC Intelligence report, *The U.S. Market for Videogames and Interactive Entertainment,* forecasts that U.S. revenues for interactive entertainment will exceed $11 billion by 2002. "We believe that over the next few years, consumers will be spending a great deal of money on video and computer games. However, there is still a great deal of uncertainty about exactly which game systems will do well," said DFC President David Cole.

But console development is still largely out of reach for the small or startup de-veloper due to the cost of development kits and the fact that most console games are produced by large companies and based on major licenses such as Pokemon or Mario Brothers. Console publishers seldom even consider submissions by unknown developers.

Developing for operating systems other than Windows is also less profitable at present. We do see many games on the Mac and Linux OSs, but they still represent a very small fraction of the market and are usually ports of games that were origi-nally Windows based. But there is also a large movement to port many hit games to Linux and to develop new games for the Linux OS. Loki Games (*www. lokigames.com*) has ported many top-selling PC games over to Linux and is busy porting more and more. Many developers and early adapters like the idea of using the open source Linux OS. However, although Linux is open source, the games are almost always not at first. Linux might also offer developers easier access into the

console arena. Recently, Indrema, a San Francisco-based company, announced that next spring it will release the Indrema Entertainment System (IES), which uses the Linux OS.

At present, the small developer has the greatest chance of success by developing a PC-based game on the Windows OS. The availability and cost of the development tools alone make this option more feasible, and the willingness of PC-based publishers to look at new teams and their projects make success a possibility. Although the category represents less than 20 percent of sales in the retail game market, making money on a PC game can still be done. PC titles are also regularly ported (or converted) to other platforms and operating systems.

OTHER PROFITABLE MARKETS

Many developers would cringe at the thought of developing a Barbie game, but as we saw in Chapter 1, *Barbie Generation Girl Gotta Groove CD-ROM!* was the number-seven best-selling game for Christmas 1999. This title was created using the Genesis3D 1.1 engine (a free and open source game engine in this book) by Neurobatics Corporation, a team of three people. At last count, the title had sold over 450,000 copies! This is a *tremendous* success story for small development.

Although you are most likely reading this book because you want to be a computer game developer—you are also most likely a first-person or strategy-based hard-core PC gamer—there are other markets for game development skills and interactive content creation. Of course, the Internet is a booming market for these skills. Companies like Metastream and Wild Tangent are developing new technologies that demand this type of content. But who composes the online audience? The answer might surprise you.

On August 31, 2000, NetValue (*www.netvalue.com*) released a report on Internet use, and its conclusions are in line with other reports on the Internet. Internet users still consist of about 49 percent women, but women are more exploratory than men when going online. The report claims that women see 30 percent more unique pages than do men. Women clicked through almost twice as many banner ads than men. The top five Web fascinations for women are:

1. Astrology/horoscope
2. Arts and culture
3. Women
4. Fashion/beauty
5. Food

Furthermore, a survey by Peter D. Hart Research Associates earlier this year showed that 32 percent of Americans who play computer and videogames are age 35 or older, and 13 percent are age 50 or over. The study also showed that 43 percent of

game players are women, and the average age of these women is 29 years old. Sixty percent of all Americans—about 145 million people—claim to play interactive games.

This information could alter the focus of your game's design. The opportunity for new developers is actually very great. The problem seems to be that currently, capable startup developers are stacking their proposals on the doorsteps of a few large game publishers while there are many smaller companies with big demands for their skills. With the push for high-speed connections and more interactivity, several shopping sites are already putting 3D models of their products up for examination in the virtual world. See *www.metastream.com* for examples. There is an increased need for individuals who can create the content these sites need for their presentations.

THE FOUR PS: PRICE, PRODUCT, PLACE, AND PROMOTION

Although many publishers might not call these items the Four Ps, they are all well aware of them. These four items are the four controllable elements a publisher deals with in a product's development in order to make the most of the product's launch. The elements are product mix, price, place (distribution), and promotion. These are the elements a good publisher can control to make a profit—hopefully, a huge profit.

PRODUCT MIX

The first controllable element the publisher considers when designing a game launch is all physical aspects of the *product*, such as the quality, assortment, scope of the product line, packaging, and any guarantees or service policies. A $50 game will be packaged differently than a title intended to sell for $14.

For example, if you are developing a hot strategy game, you will probably expect your publisher to package it in a fashion similar to the other titles on the retail shelf. If you go to a value-ware publisher, its model of packaging and distribution might be to package your game in a jewel case only and place it in racks for $20.

PRICE

Price is usually the most influential element from a consumer viewpoint. It is the first thing the consumer sees and the first criterion by which the consumer judges the product. The issues related to pricing are cost, competition, and the consumer.

You can find out the prices of other computer games from online ordering sites, Babbage's and Electronic Boutique, the publisher's own Web site, and the large computer retailers such as Comp USA, and of course, PC Data lists the average price of the computer software it rates.

One example of pricing strategy was the initial low cost of *Deer Hunter*. Most PC games were selling for $40 or $50 in specialty retailers, but *Deer Hunter* was launched for about $20 and was available at K-Mart.

Most recently, Sega has dropped its price on the Dreamcast games *Sega All Stars,* a lineup of the year's most popular Dreamcast games. They are now available at a manufacturer's suggested retail price (MSRP) of $19.99. The price drop might be intended to increase interest in the Dreamcast, which has the outlook of a continuing smaller market share than the Playstation. According to a PC Data survey of 1,500 home Internet users between May 15 and 18, 2000, over 63 percent said they planned to buy a Playstation 2. Meanwhile, other platforms fared as follows: Sega Dreamcast (22.4 percent); Nintendo Dolphin (17.2 percent); and Microsoft X-Box (11.9 percent).

PLACE

A publisher can control *place*—where its product is distributed. It can have an online-only ordering outlet or penetrate the global retail market. To compete in the retail computer game market, a publisher has to get its game on the shelves of the major retailers and then drive the buyers and end users to purchase the game. We look more closely at what is involved in the process of getting a game in the retail channel in Chapter 4.

An example of place is Comp USA. Of course, this place is harder to get into and requires a product expected to sell more units, but other outlets are opening up for other types of niche software.

PROMOTION

Promotion includes mainly publicity and advertising. This is one of the four Ps most familiar to the general public, yet it is very misunderstood. Promotion is more than just buying ad space in game magazines, as we will see in the next chapter.

Publicity consists of an image projected from the media to the consumer (indirectly). Publicity is nonpaid advertising such as reviews in game magazines, articles, and so on. Publicity is usually short lived and can turn out positively or negatively. This is the most volatile of the controllable elements.

For example, many game reviewers are very well versed in gaming, and if your game is reviewed and reminds the reviewer of another game he hated, he might draw the negative comparisons out and downplay what you think is good about the title.

Advertising consists of messages to the media for the consumer (directly). Advertising, such as ads in magazines (see the *Game Developer* rate card), is paid for. Advertising creates brand identity and interest.

There are many examples of brand identity in the game industry: *Tomb Raider's* Lara Croft, *The Ultima Series* of games, and *The John Madden Sports Series.*

Among the ways that companies establish brand identity are with the use of the following:

- Color
- A logo

- A mascot or icon
- A slogan
- Name recognition
- A spokesperson
- Quality

Mascots such as Duke Nukem and Lara Croft are among the most recognizable in the game industry. When you think cutting-edge technology, you generally think of id and their line of first-person shooters. In the gaming world, names like Sid Meier, John Carmack, and Lord British sell games. Genre alone—role playing, for example—causes a role-playing fan to stop and read a preview in a magazine or the back of a box in a store.

DEVELOPING SKILLS FOR TARGETING THE INTENDED AUDIENCE

It is imperative that you have more than ideas to present. You need to start developing hard assets, whether for a portfolio, a résumé, or a game proposal. Here are some steps to take.

STEP 1: TAKE ACTION

Spend a few hours of your spare time doing game development. If you aspire to be an artist, do some art such as model making, texture creation, or tutorials to learn other people's tricks and techniques. If you want to be a game developer and you are a 2D or 3D artist, learning to use a few of the most prevalent level editors will take a few nights to do, but that knowledge will knock you several notches higher in the eyes of a hiring developer. If you are an aspiring programmer, learn the required tools, such as programming languages, mathematics, or the ever-important art of code optimization. Surprisingly enough, it is pretty common to hear from individuals who have never tried to make a game—who don't even play games—yet want to be game designers or developers. At first you might struggle with simply learning your way around before you are able to master a level editor, art program, or any aspect of game development, but persistence does pay off, since sending out a substandard demo or résumé will only be a waste of time.

STEP 2: STUDY ALL THE DEMOS AND GAMES YOU HAVE PLAYED

If what you do is look for the flaws in a game, start studying games from a different perspective. Look at the similarities and differences between games. Look at how each game was made—the engine that was used, the level editor, the focus of development, the 2D textures, 3D models and animation, game levels, game play—or

maybe it was simply reliant on licensing. What made the game a success? With most newer games, you have a great degree of access to the textures and files that compose the game—even the code and other information, too. There is nothing to stop you from thoroughly examining the top games out there, because they almost all come with the tools that made the game: the level editor, textures, and sound effects. The developers of the game are almost always online talking about the game, how it was made, and writing articles about it. As more and more games are being made with the same engines and level editors, learning how they were put together becomes easier and easier.

You can also try to determine the source of each game and what you think will be (or should be) done next. Get used to analyzing games to determine what made them winners or losers. Most of the good game news sites have reviews that do this.

The key to successful innovation is knowing what to change and improve and how to present that information to the publisher. You don't have to reinvent the wheel or copy someone else's wheel, just take the next step.

STEP 3: GET FEEDBACK—CREATE A WEB SITE

Post your first creations and get feedback—and improve. You will find some really nice and helpful people on the Web. You could even hook up with some other "doers" and make a game together. If you have done anything in the way of developing a game, you are using tools that are no doubt supported on the Internet by user group message forums, mailing lists, and more. If you have something you feel is worth looking at, post to these forums and you will get a lot of feedback. The Internet also has game development Web sites, newsgroups, and message boards. Appendix D of this book lists many of them.

Creating a Web site can be done for free on most major servers or search engines—Infoseek, America Online (AOL), and XOOM, to name a few. A Web site, even a free one, that is well done will make your development look more substantial. It gives you a place to showcase the game and all aspects of your development. It gives interested parties a place to go see a well-organized presentation at their convenience.

When you have a site up and something substantial to look at, invite publishers, game agents, gamers, writers, and even other developers to look at it. You do need to protect your ideas and assets to some degree, but the input from these sources will be very valuable, so it is worth exposing your idea to the minuscule chance it will be stolen. You will get more valuable information and ideas from these individuals than they could ever steal from you.

If you have a running demo, get it to the above-mentioned groups (if they agree to review it) and catalog the input. Host a gathering to let individuals test-play your game. You can often learn more by watching a person use your game than by asking the person to tell you what he or she thinks.

You can even attract people to test your game; these people are called *beta testers*. If you trawl for beta testers over the Internet, you should exercise a greater degree of caution.

You can submit the link of your new game site to www.gamedev.net, www.gamasutra. com (become a member—it's free to create your member page with a link), or other applicable sites that are right for your game.

When you create a game site, you should include screen shots, a team section, and a short description of the game. Ask for beta testers and screen them if possible. It is probably not a good idea to put every detail of your game and development up on the Web, but give enough information to give users a feel for the game.

When selecting beta testers, don't forget to learn about them as well from a marketing point of view; their age, education level, other games played, and so on.

Announce—do not spam—the appropriate newsgroups and bulletin boards with an invitation to check out your site and your game. You might also pick up some team members this way. The following sample message is based on the standard press release format. (We look closer at an actual press release later, in Chapter 3.) Notice that this basic announcement message includes the name of the developer, the title, its genre, its features, and contact information.

```
Subject: Beta Testers Needed for 3D Action Game Now in Development

ABC Developers has just started development on our first 3D action
title, Lords of the Dance. LOTD combines the fast-paced shooter with
the art of modern jazz.

We have the game technology in place and a basic running game demo.
We are looking for beta testers and welcome volunteers to help with
3D modeling and map design. We are hoping to go to publishers with
our proposal in eight months.

Check out our Web site for more information on the game, and e-mail
us if you are interested in joining our team.

ABC Developers

On the Web: www.members.freepage.abc~eee.html

E-mail: abcdevelopers@freemail.com
```

When you approach your design by realizing that the marketing of your title starts with you—your attitude, your level of professionalism—you will see how these attributes will help you successfully convince a publisher that your game will sell in the marketplace. You will have a much stronger start on getting your game published when you realize that you are designing for a market, an audience.

STEP 4: STUDY POPULAR GAMES, THEIR DESIGN AND DEVELOPMENT

You can save yourself a lot of wasted effort by preplanning your game from the marketing perspective. Look at this endeavor from a broad perspective, larger than only the technical or game-play aspects. Take lessons from the other industries. Other industries that have been around longer than the gaming business have had more time to develop procedures for tasks similar to those that a game developer faces. Project management, budgeting, and marketing are all major areas that offer useful information.

Be careful not to rely solely on hype, statistics, and buzzwords. This practice is what blinds people to the truths of the marketplace and whether they are working with a flawed development or not. Your game still has to be really fun to play—pure and simple.

STEP 5: KNOW WHAT THE PUBLISHER WANTS

And know what publisher wants your game. If, in fact, you have designed a sure-fire hit game and developed a proposal for it, you still have to find the right publisher for it. Finding the right publisher can take quite a bit of effort, especially in this industry. This can also be the most important part of selling your game: selling *you and your company* to a publisher. Knowing what the publisher wants includes looking on the shelves and the PC Data Web site and noting what publisher is publishing what titles. Go to each publisher's site and read the entire site if possible. On their Web sites many publishers state what they are looking for in the future and what they are moving away from, in the form of press releases, frequently asked question (FAQ) pages, contact pages, and in virtually all sections of the site.

INNOVATION, INVENTION, AND IMITATION

Among the many reasons that many games don't get picked up, or don't sell well if they are picked up, are these three words: innovation, invention, and imitation. These three words are often not understood by developers, or even by publishers. Actually many developers have an innate feel for these terms, but they fail to translate their feelings and instincts into the marketing jargon that a publisher needs to hear.

The way these terms apply to your title, whether in a good or bad way, defines your game and its potential to sell. You must first understand these terms as they apply to your title and then be able to communicate them in terms of your title to the publisher. See Figure 2.2.

INNOVATION

Your game is an *innovation* if you take a basic genre, format, or platform and develop it further. Most successful games on the market represent varying degrees of

Invention = The Wheel

First of it's kind!

Imitation = "The WHEAL"

A copy of the original

Innovation = Modern Tire

An improvement of the original.
Cheaper, quicker to make, faster, safer, lighter, stronger, more comfortable, etc.

FIGURE *The concept of invention, imitation, and innovation.*
2.2

innovation. For example, *Half-Life* was a successful innovation of the first-person shooter (FPS) genre.

Valve Software made a major innovation to the genre but didn't stray too far from the FPS formula. By definition, one of the major goals of a first-person shooter is to let the gamer look through the eyes of the protagonist, and *Half-Life never* takes you out of first person. All events occur in the game, from the opening to the closing. Almost all FPS games still do it the "*Doom* way": text-based level briefings, level transitions, and floating weapons and powerups that are scattered around randomly. Most important, there are no levels in *Half-Life*. You can walk from the beginning to the end of the game.

Not all innovations are successful. *Blake Stone* was an improvement to *Wolfenstein* but did not offer enough in the way of new technology, art, or game play to satisfy gamers. *Doom*, id's innovation on its own product, was far more successful because it did offer better art, game play, and technology.

INVENTION

Your game is an *invention* if it is the first of its kind.

The term *invention* can be applied to *Wolfenstein 3D*. At the time, this concept was new. The key to successful invention is to carefully examine and exploit the invention's potential to sell on the market.

Invention is unsuccessful if you invented a game that can't sell the number of units it was projected to sell. It's not necessarily a bad game, but it's a game that the publisher might not be able to sell for any number of reasons. A publisher will seldom pick up a game that can't sell a certain number of units. Maybe a game that can sell 10,000 units online will be worth your investment, but 10,000 units won't be worth the time for a large publisher who needs to meet a certain sales goal of units to make a profit.

IMITATION

Your game is an *imitation* if it is a lot like another game. This can be good if you are parodying a title, but it is bad if you are simply copying another title. *PYST* was a parody inspired by the best-selling PC adventure game *MYST*. *PYST* was an imitation of *MYST*, in a good way; it was intended to be a parody of the original, and thus an imitation. Many games are simply imitations, or uninspired copies, of other games.

You can see many examples of imitation games in the wake of any successful game. For example, in the wake of *Quake,* we saw literally hundreds of first-person shooters that were almost indistinguishable from *Quake*: space marine, space station, big guns—the same gaming experience. This was true for *MYST* as well and, most recently, *Deer Hunter* has spawned many games in which the player hunts does, bucks, and stags.

You don't have to be a competitor to be an imitator. Many games imitate themselves in their own sequels. When you buy the sequel to your favorite game and find it has the same technology driving it, the same types of levels, weapons, and features, you feel shortchanged because the sequel wasn't a sequel taking you further than the first game—it was an *imitation* of the first game.

In summary, you don't want to create a title that is merely a copy of an existing title or something that cannot sell because there is no audience for it. The fact is, if you don't bother figuring out what the publisher wants or figuring out what the market wants (the market being gamers) and then convincing the publisher that your findings are sound, you will most likely fail in your attempts to sell your project.

ARE YOU DESIGNING A GAME THAT WILL SELL?

This is a very important question you should always be asking yourself as you design and develop your project, and you should try to answer it as honestly as possible.

This question will be answered in greater detail when you develop a *competitive analysis* later in the book. However, you should also do your own analysis of your idea before you do any significant development and especially before you submit your game to publishers. Follow these steps.

STEP 1: RESEARCH YOUR GAME IDEA

Has this idea been done before? Are you making an innovation or an imitation?

Has your game been overdone or not done at all? What is the reason no one has done the idea? Are you too ambitious with your design, technology, or market analysis?

What can you offer that is an innovation to the titles that are out there in way of technology, artistry, or design?

Look on PC Data's Web site (*www.pcdata.com*) and try and determine who plays what type of games. In other words, know your audience.

We will explore this topic in more depth in the coming chapters when we work up a competitive analysis.

STEP 2: GATHERING YOUR MATERIALS TO PRESENT TO A PUBLISHER

If you can avoid the dreadful experience of having your demo turned away by a publisher—a demo you might have worked months on only to learn that it is not a marketable game—you will be glad you spent the extra time to determine the feasibility of your title. This work will also strengthen your presentation tremendously when you do approach the publisher.

The rest of Part I is about gathering the things that should be collected during your prepublisher research for your proposal. These things include documented testimonials from beta testers, comparison of similar games, comments from industry professionals, and a lot more.

In the next chapter, we look at how games are marketed and how you can promote your own game.

CHAPTER

3 Marketing the Game

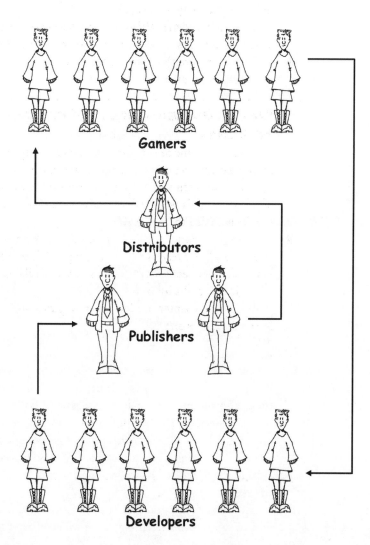

Gamers

Distributors

Publishers

Developers

Marketing is the process of planning and executing the conception, pricing, promotion, and distribution of ideas, goods, and services to create exchanges that satisfy individual and organizational goals.

—*Dictionary of Marketing Terms,* second edition
(edited by Peter D. Bennett; American Marketing Association, c1995)

There is a difference between the terms *market* and *marketing.* The *market* is your audience (consumers, end users, or gamers), and *marketing* is the publisher's plan for letting the audience know that the product exists and then enticing them to buy it. When the publisher starts marketing a product, it must create a marketing plan that is designed to reach *two separate* audiences: those who will *sell* the game, such as Comp USA, Babbage's, and other retail outlets, and those who will *buy* the game—the end user or gamer. It is important that the publisher have a two-pronged approach and direct the *promotion* of the game to both store buyers and end users, for two reasons:

- It doesn't help your game succeed if the end user knows about the game but can't find it anywhere for purchase.
- It doesn't help your game succeed if the game is available in the store and no one comes in to buy it.

PROMOTING TO STORE BUYERS

One of the largest jobs a publisher has to do is promoting its product to store buyers. A publisher must send out announcements of a new game before its launch to entice the buyers—three to six months before the game's release! Publishers are responsible for getting product demos in the hands of buyers. Sometimes the publisher even has to demonstrate the game in person to major clients. The publisher must meet and keep in contact with the buyer; in short, the publisher must court the buyer.

And who is the buyer? The buyer buys the product that will be shelved and sold in a retail store. Sometimes this person is buying for hundreds of stores. The publisher also promotes to major wholesalers. For example, Tech Data (*www.tech-data.com*) services 100,000 technology resellers in the United States, Canada, the Caribbean, Latin America, Europe, and the Middle East. These resellers in turn sell to major chains and smaller retailers. The publisher also conducts promotions directed at smaller retail stores via faxes, press releases, e-mails, product updates, and the like.

The publisher's sales representatives visit these major resellers; they also purchase what is called *coop advertising* in the wholesalers catalogs that are sent to thousands

of retailers. Coop advertising is very costly. The publisher pays for the ad; the wholesaler prints and distributes the catalog.

Publishers must also attend trade shows like Retail Vision, where, according to the Retail Vision Web site, "retail decision makers representing more than $60 *billion* in buying power are all in attendance." Publishers have to do even more—much more. It is no wonder they get offended at the attitude that all they do is stick a game in a box and run an ad.

PROMOTING TO END USERS: THE GAMERS

Of course, the publisher has to promote to the end user, or *gamer,* as we call the customer in this industry. We are all more familiar with this type of promotion, since we are usually the targets of it. This type of promotion includes space ads in magazines, the demo on the disk, and more recently, TV ads and other cross-over promotions.

Buying space ads alone can be quite involved and costly. Simply defining your key sales channels can involve a great deal of work and require the help of many people. The key sales channels for a computer game can be the specialty retail stores such as Babbage's or Electronic Boutique, large retailers such as K-Mart or Comp USA, online and Internet sales, international sales, and, possibly, direct mail and other sales channels.

Usually a company follows some form of what is called the *space ad algorithm.* The space ad algorithm consists of the following steps:

1. Reviewing the plan and goals for running the ads
2. Checking the publication dates of all the titles
3. Reviewing the demographics and determining the *primary* audience for the titles due to be advertised
4. Selecting the magazines based on their audience, editorial calendars, costs, and the publication dates of the titles
5. Making a primary and secondary (or optional) list of magazines to advertise in
6. Check the budget and determine the number of ads and the size of each ad, based on costs of magazines and closing schedules or deadlines
7. Create the appropriate ad for the target audience, considering language, style, colors, ad copy, font, size, and graphics; a typical space ad for a computer game and the typical banner ad based on a space ad are shown in Figures 3.1 and 3.2.

NEW WAYS TO PROMOTE TO THE END USER

Adaboy (*www.adaboy.com*) is trying a new type of advertising, called *in-game advertising,* which is aimed at online gaming. Adaboy is teaming up with gaming Web sites to create a new revenue stream for game developers and publishers. The

FIGURE *A typical space ad for a computer game, including screen shots appealing to intended*
3.1 *audience.*

Adaboy technology works within the gaming environment, using patented Targeted
Message Technology (TMT) to put ads into the actual game as it is being played.

Adaboy is relatively new to the Internet and still in the early stages of growth.
The company has so far brought advertisers to only a handful of games, but it is ac-
tively working on agreements with developers and entertainment destinations, such
as online malls and gaming sites.

"Traditionally, smaller and independent game developers have had a hard time
making a living as the game goes to the shelf and then is sold for a limited period of

FIGURE *A typical banner ad based on the space ad.*
3.2

time," says Barbara Pearson, director of marketing at Adaboy, Inc. "Adaboy gives the online game developer a revenue stream that goes beyond play-value, providing ongoing revenue for the creator."

INTERNET-RELATED PROMOTIONS

And last but not least, the Internet is a huge factor in the marketing of a game title, especially among the hard-core audience who will follow the development of the title and download the demo as soon as it is available. But the Internet is also important for reaching more and more people as the Internet grows in use and demographics. More women play games online than men (according to data on *www.yahoo.com*), and more online-only games are meeting success, such as *EverQuest* and *Quake 3 Arena*.

Internet promotions consist of the familiar banner ad, user groups, gaming news sites, and demo downloads. Many retail stores are selling games online as well. For example, Babbage's runs *www.gamestop.com*. See Figure 3.3.

BEGINNING TO UNDERSTAND MARKETING

Marketing is a catch-all term—a buzzword. The term *marketing* doesn't explain itself and in fact is so misused that people are now confused as to what marketing really is. Most people think marketing is like a switch you turn on when the product is done. "Gee, the game is done. Let's market it." In truth, marketing concerns start the minute you consider doing a game.

At its core, the best marketing is creating a product that sells on its own merits.

The term *marketing*, especially as used by many companies, is foisted onto a few individuals in a specific department, when the job of publicity, promotion, advertising, selling, and even ad design should be the collective job of all involved in a game title with a visionary head in place to coordinate the campaign. Today the problem is that the individuals responsible for marketing (and yes, many actually have

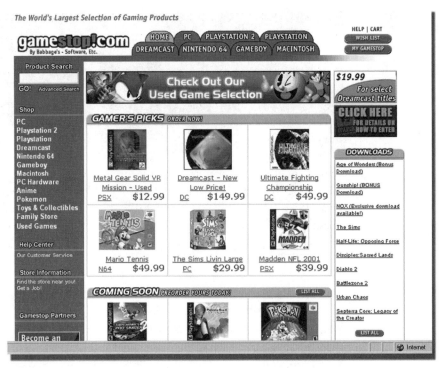

FIGURE
3.3
Game Stop, Babbage's online game store.

degrees in marketing) usually know little about true marketing; they only know how to place ads. From the outside, ad placement appears easy—simply write the magazine a check—but in reality, *effective* advertising requires many steps to be performed properly, as we saw previously in our space ad algorithm checklist.

Sadly, placing a space ad is often the beginning and the end of the scope of the marketing campaign and is done with precious little input from individuals making or buying the product. Although this trend is being recognized and dealt with by many companies, too many still do things the "old" way.

Most big, successful publishers have great marketing departments in place and know how to do true marketing, but just as often, there are publishers that know little about the markets they are in, the products they are marketing, or the technology that the product is based on. The way they were taught to market is to mass mail demos, run multiple ads, and look for the "gimmick" behind the product. What they might not realize is that to build a relationship with the group of editors that might *actually* review the product favorably would be easier and more effective. So today we see wasted money in marketing and precious little effectiveness.

MARKETING STARTS WITH YOU, THE DEVELOPER

As we read in the last chapter, the initial marketing work is done by you, designing for the intended audience, and is done simply to get the publisher to consider your title and be convinced it will be profitable to develop. The important point is that marketing starts with you, the developer, and is not something the publisher decides to do at the last minute. The marketing lives and dies with you; if you don't formulate a proposal that touches on at least the basics of audience and market, the publisher will most likely not entertain your idea, and the reviewers and audience will never see it.

In addition, even after the publisher takes over the marketing as you start the development of the title, you need to have formed a vision that will help sell your game on its own merits when the demo is played and the reviews are written. This doesn't mean being contrary or a difficult *prima donna* in any sense of the word. It also doesn't mean selling the game the way the publisher will: getting retail space, running ads, and packaging and shipping. What it means is developing a game that, when played, will inspire the gamer to tell everyone else about it. Sometimes, it is only the developer of the game that is in tune with the subtle distinctions of game play, art, physics, and artificial intelligence (AI) that other gamers will be aware of. In fact, whether the publisher ends up doing a great job or a poor job on the marketing of your title, you can't do much but gently offer your input (unless, of course, there is a contractual reason, and that is a different matter altogether). Getting angry won't help, but having a great game could help sell units and garner good reviews, and it definitely will help you get your next development deal or job.

This is not to say that print advertising, demo mailings, press releases, trade shows, original equipment manufacturer (OEM) deals, and all the other capital- and labor-intensive forms of traditional advertising are not needed; they certainly are. The point is that when your title leaves your hands, it might actually get as far as the retail shelf, whether it is really that good or not. All along the way, the title will be selling itself to the people who see, hear, read, or come into contact with it in any way. You see, if the publisher does a great job marketing an inferior title, everyone might hear about the title, but it will not make money. However, if your publisher fails to market a great game sufficiently, you and your game do not need to go unnoticed by the gaming community. A good team with a good title can get the recognition they deserve, if not the royalties, if you simply understand the *true* essence of marketing.

MARKETING, NOT JUST BUYING AD SPACE

Let's look at the concept of marketing. Marketing is defined in the dictionary as the act or process of selling or purchasing in a market, the process or technique of promoting, selling, and distributing a product or service, or a set of functions involved in moving goods from producer to consumer. Let's look at how this process pertains to the game industry.

The game industry, in particular, is so inundated with advertising and product that we are not being sold anymore, we are *choosing to buy*. The distinction is that fewer and fewer of us buy games based on advertising as much as we buy based on word of mouth or brand loyalty; advertising simply reminds us that our favorite game developer or publisher has a new product out.

Nowhere is this consumer behavior more prominent than on the Internet. The Internet is a weird sort of collective consciousness. Where it used to takes weeks or months for news of a product to spread by word of mouth (you *had* to advertise to get any attention), now we have almost instant awareness for a certain segment of the game industry. Print advertising is too slow. By the time a computer game comes out, we all know about it, what it is like, and where to get it; we've even played it, in most cases. Telling us to buy something in an ad doesn't work anymore if the product is flawed, and we have seen the product itself before the ad telling us to buy it even hits the newsstand.

Starbucks coffee is a prime example. Starbucks didn't spend more than $10 million on marketing in the first 10 years of its existence. Yet the company delivers annual sales approaching $1 billion. Ten million dollars might sound like a lot, but it's nothing for a company that size. Consider that in 1996, Proctor & Gamble spent more than $2.5 *billion* to advertise its products.

NOTE

The most effective place to be when you have to market a product is to merely have to announce that desirable product, not to try to make that product desirable. It is easier to promote a product where a need already exists, compared with "selling" the consumer on the need and then the product.

In his awesome book *The 22 Immutable Laws of Branding*, Al Ries points out that "Marketing has become too complicated, too confusing, and too full of jargon." He explains that marketing in most companies, even small ones, is spread thin over many entities, and coordination among those players is difficult. Many companies lack true vision and direction because they have not assessed the market correctly, penetrated the proper channels, or advertised correctly, or they have simply produced poor packaging that confused the consumer.

WHY PRODUCTS FAIL

According to the American Marketing Association, 9 out of 10 products fail to meet their financial goals for several reasons.

REASON 1: THE MARKET WAS INADEQUATELY ANALYZED

The "me too" attitude sometimes has developers and publishers alike producing games that have no market—or, in most cases, an oversaturated market. When the

first few first-person shooters did well, for example, developers and publishers responded with a huge wave of shooters—too many for the market. The same holds true for all types and genres of games. Several years ago, the young female market was ignored, and occasionally, when a game or application was made for this audience, it failed. Usually such product attempts merely had some flowers stuck in the graphics to appeal to young girls—talk about inadequately analyzing a market! In the past few years, the Barbie license accomplished what no other product has been able to: It put a title designed only for girls at the top of the charts.

REASON 2: QUALITY OF PRODUCTION WAS POOR

Flimsy boxes relay a message as to the quality of the game inside; a flimsy box will not get $50 out of a customer's hands very often. Just as bad graphic design or graphics that miss the intended audience hurt sales, so does packaging a product that requires a box in a jewel case and putting it on a rack.

REASON 3: PRODUCT WAS DELIVERED IN AN UNTIMELY FASHION

Store buyers usually buy seasonally, meaning that they know that sales will peak during the holiday buying season. They often do their buying three to six months in advance, which means that in many cases, they are buying product in July to go on store shelves in November or December. If you build a huge buyer and consumer interest in your game but the product is delivered months late, you will suffer in terms of lost sales and bad press. This is one of the reasons a publisher seems to fanatically adhere to a deadline, even when a game or product could be made better, given more time. This is also the reason that the "We will ship it when it's done" methodology won't work for virtually all developers—especially new ones.

REASON 4: FAILURE TO DISTRIBUTE EFFECTIVELY

If a game title is available only in limited stores, that will hurt sales. If you sell your own title on the Internet but can't take VISA and Master Card orders, your sales will be greatly diminished. Even the best, most desirable game in the world will not sell well if it is not easily available and cannot be bought through traditional outlets. If a title is too hard to obtain, the customer will move on to another title.

REASON 5: INADEQUATE PROMOTION

Even if you've created the best game in the world, if no one knows about it, no one buys it. If the publisher fails to get reviews, send demos to the audience, place ads, and create a huge demand for the game, it will not sell. Promotion includes many selling activities that all need to be developed, designed, and scheduled. These activities include the prerelease, post-release, demo previews, Internet advertising

and publicity, space ads, meetings with buyers, convention attendance, and much more.

PROMOTING YOURSELF WITHOUT STEPPING ON TOES

Once you have a publisher for your title, your job will be to develop the title. You will most likely be doing *none* of the traditional marketing functions we discussed. Other than the initial defining of the intended audience and keeping an eye to the market as development progresses, you will not be concerned with placing space ads for your game, getting reviews, or any of the selling activities. However, you should be promoting yourself during this time.

Getting a publishing deal is probably the best reason in the world for a developer to do some promotion, but be very clear that self-promotion as a developer does not mean doing anything in conflict with the publisher. Self-promotion as a developer simply means promoting your development team and the *development* of the title. Having an active Web site, writing a few articles for industry magazines and Web sites, attending the GDC, and making sure that the (publisher-approved) demo is out on the Net is enough. Your great title should promote you as a great developer. Doing none of these things will cause you to pass up many opportunities and a lot of recognition as a developer.

Even a simple plan to write an article or two, post a few announcements on the appropriate newsgroups, and making your own developer-related press releases to the game community through magazines and major Web sites will gain you the recognition you deserve. We tried self-publishing one of our early titles; however, having been spoiled by the success of even earlier titles, we didn't know the odds against us at the time. Even as the title's sales were sagging and the money was not coming in, there were still many opportunities to capitalize on the fact that we had a great game that was fun to play and it was complete and in a box. We wrote articles, received some great reviews, and gained a publishing deal for our next title based on a game that we self-published.

WHEN AND HOW TO START PROMOTING YOUR GAME

Start promoting your game the minute you start developing it. This is not to say that you must have a full-time staff member promoting your game; that would actually be overkill. All you need to do is a few simple things every so often to let the world know that you are toiling away in the glow of your monitor and creating a work of genius.

PRESS RELEASES

At every significant stage, the development team should write and release an announcement. Primarily, the signing of a publishing deal should be announced on the team's Web site and then sent to the games press. (Again, the publisher should be consulted on much of this activity.) You should include the game title, genre, and the information that will help your audience understand what the game is like and why it will be so interesting to them. One of the main reasons for doing this is to build momentum.

When dealing with the press, whether a teenage Web site reviewer or a full-time reporter for a major publication, you must treat them all the same: professionally! You might be surprised to know that it is possible that more people (your audience) will read the teenager's words than the reporters; and the Web preview of your game will be around a lot longer. Make sure that members of the press have all the information they need immediately so that they can write you up. If you wait too long or whine to them about how busy you are, they will drop you and review something else! See next page for a sample press release.

MAINTAIN COPIES OF YOUR PRESS DOCUMENTS

Make a folder on your hard drive for your press documents, and keep it updated with press releases, the best artwork and screen shots you have, and anything else that might help when publishers or audience members ask you to send materials on your game. Include small versions or thumbnails of the art and logos, bios, and other information. Once you have done your other work in preparation to go to the publisher (such as the competitive analysis discussed in Chapter 7), this portion of your job will be easy.

EVENTS YOU CAN ANNOUNCE

Take advantage of your upcoming game-related events by announcing them to suitable interested parties:

- **The primary announcement of the new title.** Once you feel comfortable that you will in fact try to develop a game, send out a press release to game sites and other developer-oriented sites. You could get volunteer help and some initial input.
- **The announcement of a publishing deal (after it has been inked and *only* if the publisher approves).** Nothing generates more excitement than a deal that is real. Let's face it, many hundreds of developers start a project, but only a few get a publisher deal. At this point, people will bombard you with requests to do beta testing, write previews, and work for you.
- **The launch of the site for the game.** This step includes both your developer site and the official game site (usually handled by the publisher). People will

123 Publishers and ABC Developers Announce Multiplayer Game, *Big Hit Game*

Big City, CA, August 8th, 2000—Computer and video game publisher 123 Publishers is proud to announce that it will publish *Big Hit Game*, developed by ABC Developers. The game will be a massive multiplayer game similar to *EverQuest*, but ABC Developers takes the multiplayer technology way beyond today's technology by allowing millions of gamers to play online simultaneously. *Big Hit Game's* world combines first-person action and the complex moves of a fighting game. *Big Hit Game* will be released in the fall of 2001.

In *Big Hit Game*, players are challenged to run wildly through dark and dreary landscapes, killing each player they meet. Their only weapons are their hands and any objects found littering the game world. All the while, real weather conditions, disease, and an endless war of chaos tear up the virtual world.

Founded in early 1952, ABC Developers, Inc., is a development house dedicated to pushing the massive multiplayer online technology to its limits. For information on ABC Developers, please visit the company's World Wide Web site at *www.abcdevelopers.com*.

Founded in Big City, California, in March 1996, 123 Publishers is a cutting-edge computer game publishing company. For more information, visit the 123 Publishers Web site at *www.123games.com*.

###
Press contact :
Bob Namehere
VP of Sales and Marketing
123 Publishers, Inc.
555.333.7878 voice
555.333.7878 fax
information@123games.com

want to see the game as it develops and will usually sign up for a mailing list if it is available.

- **At least a monthly update of development progress.** Sending out a press release to the major online sites every month or so to show off new art and screen shots is a great way to generate and maintain interest.

- **Development milestones such as alpha, beta, and gold master.** These dates are great times to send out press releases, too.
- **Demo availability, upgrades, and patches.**
- **A *post mortem* of your game for magazines and the Internet.**

REQUEST BETA TESTERS

As mentioned in Chapter 2, it is also helpful to get the fans involved as beta testers and even add-on level makers, if that opportunity presents itself. Even after the launch of the title, you can release upgrades, patches, add-on weapons and levels, and the like. Keep the community involved!

CONCLUSION

Hopefully, you now have a clearer idea of the difference between *market* and *marketing*—audience (consumers, end users, or gamers) and the marketing plan. You also learned that when the publisher starts the marketing of a product, it must create a marketing plan for those who will *sell* the game as well as those who will *buy* the game.

Next, we look at the life of a computer game. From the time you think of being a developer to the time the game hits the retail shelf, a great deal has to happen, as you'll learn in the next chapter.

CHAPTER 4

The Publisher's Perilous Journey

Learn to see in another's calamity the ills which you should avoid.

—Publilius Syrus, Roman philosopher, first century B.C.

Before we get into the details of the actual game proposal, let's look at some of the potential hardships faced during the development and publishing of a game. We looked earlier at some of the stumbling blocks that the developer must avoid; now let's focus on the publisher.

As we have seen, the game as an entity has a perilous life. From the time it is conceived as a great idea in your mind to the point of its commercial success, the game faces many hurdles. Simply moving from the idea stage to becoming an actual, physical game proposal, is a huge effort, as you will see in the following chapters. Before you even go to the publisher, you must have defined your intended audience, gained an understanding of the game market, and marshaled significant resources—a development team, a well-developed game idea, and a plan for its implementation—and finally, you must have produced a functioning demo. Although the generation of all these elements for a game proposal, followed by the actual development of the game, is a huge undertaking, publishing a game is just as immense a task, if not more so.

THE PERILOUS JOURNEY

Although publishers that want to get into the game development industry are not as numerous as game developers that want in, there are quite a few. The reasons for the lesser number of publishers wanting in are that being a publisher requires a great deal more money and experience to be successful, and a great deal more risk is involved. Furthermore, just as the developer's journey is fraught with peril, so is the publisher's. In general, before the publisher sees any profit from a title, it will have invested quite a bit in that title. From the expenses of running a business office during that time, screening other potential developers, funding the development of the current title, marketing and promoting the unreleased title, getting the game into the channel, managing the channel, and a great deal more—all before any profit is realized.

To operate during this time, publishers often have investors, venture capitalists, or publicly traded stock to fund their operations. These types of arrangements step up the pressure and seriousness of doing business as a publisher. You could request $2 million to develop a game, but the cost to the publisher during the time you develop that game can easily be many times that amount, considering the cost of doing business.

So, even before your proposal is handed off to the acquisitions person at the publisher, the publisher is expending resources on the ongoing job of doing business.

After a developer is signed and the development commences, the publisher's job escalates and will continue long after the game has been completed by the developer. The publisher, which, during the development of the title, was busy promoting to the buyers and preparing for the game's launch, now turns its attention to the actual launch of the title as it hits the channel. This chapter discusses the challenges facing the publisher while publishing a game.

THE COST OF RUNNING A BUSINESS

Among one of the largest costs of running a business is salaries. Hiring positions such as office staff, product testers and reviewers, sales staff, marketing, officers, in-house legal counsel, and even on-site network administrators for the computer network all add up quickly. In addition, consider that along with salaries comes the cost of bookkeeping, paying taxes, insurance, other benefits, and overtime. In fact, there are costs associated with the hiring and releasing of employees, contracts, interviews, and the salary of the person whose job it is to screen, interview, and hire people.

Dealing with customer complaints and technical support are more of the publisher's expenses. The publisher must provide assistance to the consumer in many ways (phone, Web site, e-mail) and release patches and fixes if necessary. The process of customer service for computer games—especially in the case of the PC game, in which the hardware, drivers, and computer used all factor into how well the game runs—is a complex undertaking.

Consultants and freelancers are often used by publishers for anything from copywriting to game testing, accounting, and sales support. In short, all functions can be hired from out of the company, just as a developer can hire a freelance programmer to optimize code or a musician to write musical scoring for games.

If the publisher must deal with stockholders or investors, there can be a great deal more expense for attorneys, brokerage, auditing, and accounting firms.

THE COST OF DEVELOPMENT

The development budget for an A-list game at this point in time can range from $1 to $2 million. The publisher traditionally pays these costs. Although the publisher could pay the game developer $2 million over the course of development, the cost of development is actually more. The publisher usually employs game testers to find bugs and potential problems as well as having market testing done by contract groups to determine if the game is really the best playable game. The publisher must also pay a producer, a development liaison, a project manager, or a person in a similar position in-house that will work with the developer and track progress during development.

If the deal is a licensed one, the publisher must pay the licensing fee and the associated attorney fees and possibly even have to hire additional staff, that represent the licensed property, to perform certain tasks. If the licensed property that is being made into a game has a specific artist, voice talents, or other assets that must be produced for the title, this talent must be paid for.

THE COST OF MARKETING

Even while the game is being developed, the publisher begins to market it. Remember that the publisher must promote the game to two separate audiences: the buyers and the end user. In Chapter 3, we looked at all that is involved in these steps. Although it used to be that with three of the top game magazines, you could get minimum market awareness with a modest marketing budget, it now takes a great deal more money and effort to entice the game-buying audience.

Remember that marketing the title goes beyond running the ads; it also includes marketing to the buyers and retailers.

THE COST OF MANUFACTURING

Although the cost of getting an entire game package produced—the *exact* same quality of computer game packages you see on the shelves of computer retail stores—can be inexpensive in small lots, the costs adds up quickly. The actual costs of production increase substantially when you factor in the larger quantity and then the storage, shipping, and handling of that much inventory.

Keep in mind also that having the package manufactured does not include the copywriting, logo design, design and layout, and even the costs involved in getting barcodes put on the package. Barcodes involve a registration process and some additional expense. The design fees for a quality retail box can range in price from a few thousand dollars up to tens of thousands of dollars, depending on the layout firm, the complexity of the layout, and other factors. We are talking strictly manufacturing here, but you should realize that this process involves more than just printing a box.

Let's look at the cost of getting a basic computer box, slated for competition on the retail shelf, manufactured in a quantity of 25,000 units. The box must have a book-fold front (the flap on the box you can open to see more about the game), screens shots, features, and quotes. We will have foil embossing on the front only. Foil is just what it sounds like—that shiny metallic surface you see used on logos—and embossing requires a special die to stamp the cardboard so that the surface is raised. This sort of box costs about $2.00 per unit. There is also a one-time cost of about $800.00 to get the embossing die made.

There are also other one-time costs associated with getting a box manufactured, including printed proofs of the box and materials, the initial film for printing, and even mock-ups of the box. This initial cost can run about $1,000 (not including the stamping die), and if you don't like the box after you see the proofs, you must have new film shot and new proofs made and go through all the initial steps again (and of course pay for it all again).

Every detail must be considered, planned, tested, and then manufactured. Even the black-and-white registration card, which might seem insignificant, compared with the box itself, must be considered in the manufacturing of the package. The card must be laid out, the film shot, and then inserted into the box—all at a cost to the publisher. You can see a sample of a manufacturer's quote in Figure 4.1.

Quantity:	25,000
Software Box w/bookfold cover, 6 color w/silver foil, embossed 10-1/4 x 8-3/4 x 2, 18 pt, UV coated, with box insert	$2.06
Registration Card 3-1/2x5, 7 pt card stock, 2SDD, 1color black	$.04
1-3 Color CD ROM	$.41
Jewel Case	$.21
4/0 Tray Card	$.04
24 Page Manual approx, 4 color cover w/1 color print, 5x8 w/ saddle stitch	$.24
*Assembly	$.36
Total	$3.36 Each

Embossing die estimate $810.00
Cutting die estimate $550.00
CD Film $25.00 per color
Laser Proof $25.00
CD Evaluation $25.00
Box Film and proof estimated $1050.00
Tray card & Manual film estimated $628.00

FIGURE 4.1 *This is a portion of the manufacturer's quote. You can see the items that must be made broken out here by cost.*

The plastic cases that games and music CDs come in are called *jewel cases* and usually have a four-color insert on the back of the case and the users' manual inserted into the front. These manuals involve the usual layout, film, and proofs and then must be printed and stapled, cut, folded, inserted into the case, and shrink-wrapped and inserted into the box. A cardboard insert is usually required to keep the box from being crushed and to hold the contents in place. In addition, the insert makes the box feel more substantial, which is important because it relays a message to the consumer as to the quality of your game.

In short, all these elements have to be designed, laid out, manufactured, assembled, and then handled. A basic breakdown of the box manufacturing we have discussed is shown in Table 4.1.

The costs in Table 4.1 add up to $3.25 per box. Multiplying this figure by 25,000 (the number of boxes you'll need for your game's first release) gives us a total of $81,250. Now we add the $1,000 in one-time fees and the $800 die-stamp fee, and we have a total of $83,050. This fairly substantial amount of money does not include the shipping and handling of the boxes.

Not only do these individual game boxes have to be put in a larger box for shipping purposes, (foil-embossed computer game boxes are not the most durable containers on the face of the planet); these boxes must all be put into master cartons, or cardboard boxes that are made to hold the smaller game boxes in a certain quantity—and hold them safely to prevent wear and tear as they are moved about. These master carton boxes must be paid for, assembled, and then filled with the completed game boxes. These master cartons are usually put on *palettes*, large wooden platforms that hold many master cartons. Of course, these large wooden platforms, stacked about eight feet high with master cartons, must have a warehouse in which to be kept. And it does not stop there. The inventory must be stored in a facility that is reputable, insured, has an inventory tracking system, and a lot more so your games are not lost or destroyed and can be shipped quickly to the vendor that orders them.

You can see how manufacturing costs can add up. Simply manufacturing and managing 25,000 units of a game is a costly and sizable job.

Table 4.1 Manufacturing Estimate for One Computer Game Box

Item	Cost
Four-color box with front flap (book fold); embossing, foil on front	$2.00
Registration card, printed on two sides	$0.05
CD replication with one to three colors	$0.40
Jewel case	$0.25
Manual (four color and stapled)	$0.55

THE COST OF BEING IN THE CHANNEL

Once the game is actually in the retail store, publishers still have to do marketing and promotions to raise consumer awareness of the new game—such things as pre-sale promotions, in-store displays, and mail-in cash rebates, as well as securing space within retailers' print advertisements, which is often required by a retailer for a publisher to secure an order and shelf space.

Publishers have to use the various distributors, for the most part. Only the largest publishers can handle distribution on their own, selling directly to the retailers. Distributors also must make a profit for the handling, shipping, and inventory management of the product. Publishers have to promote their games with giveaways, promotions, and reduced prices.

THE $30,000 CARDBOARD DISPLAY

You might be surprised to know that the cardboard pedestal on the retail floor cost the publisher $30,000. Just getting into the retail channel is not enough, though. Often, the publisher must spend money on premium shelf space and positioning on end caps. It can also spend money on window displays, cardboard standees, banners, and even a professional firm to go to the retailers to check and make sure that all the publisher's money is actually being used. There are companies that can be hired to go and make sure that the sales people are knowledgeable, the ads are run in the retail circulars, standees and banners and in-store promotions take place, and even that the game is actually on the shelf and in the right place.

In defense of the distributors and retailers, they can't afford to buy all the product they want to stock, especially a product like a computer game that has a short life span on the retail self. Their reluctance to buy every game they want to stock is founded in the fact that with close to 5,000 games coming out each year (and that number rising higher each year) coupled with the fact that only about 2,000 will have a chance at even seeing the inside of a retail store, there is a high failure rate, and they could easily get stuck with an enormous amount of games that can't be sold.

THE TRADE SHOW

Here is another expensive proposition that any serious publisher has to entertain: trade show attendance. This proposition involves more than just airfare and a hotel room. Booth spaces must be rented, and the exhibit halls are run by companies separate from the show that charge fees for everything from extension cords and tape to electrical and phone access. Furthermore, the design, construction, setup, and storage of the booth itself is expensive. As with advertising, when faced with what the

competition is doing, the publisher must try to keep up. The booths of the larger companies at E3 are amazing. They are huge and have laser lights, fog machines, and even second-floor meeting rooms and buffets. The trade show can be extremely expensive, even on a small scale.

The two big ones from the game publishing perspective are the Game Developer's Conference and E3. Minimal exposure at the Game Developer's Conference starts at about $4,000 for a 10- × 10-foot booth. With food and lodging, a rock-bottom estimate states that attendees pay roughly $12,000—just for a few people to walk in the door and sit at a table. Add travel, airfare, taxis, and other expenses, and you go well beyond the estimate. Not only are hotel rooms expensive around the time of a show, they are also hard to get. Many companies book a year or more in advance.

CONCLUSION

As we've seen, the publishing of a game title is no small undertaking. Knowing what steps the publisher must take in order to publish a game properly will help you plan your game submission more effectively. At the very least, it might make you grateful you are not in the publisher's shoes.

Finally, no matter what the perils of the game industry, if you in fact have a great game proposal, the top agents and publishers will pick you up. But if you insist on going to the wrong publisher with a poorly thought out game, you will enter with many strikes against you, and you will not get a good deal—if you get a deal at all.

In the coming chapter, we begin to look at the game proposal—which can be more involved than you previously thought.

CHAPTER 5

Game Proposal Basics

If a million people say a foolish thing, it is still a foolish thing.

—Anatole France [Jacques Anatole Thibault] (1844–1924)

N ow we start looking at the process of putting together a game proposal. We spend the next several chapters doing this because the process is fairly involved. In essence, when you are assembling your proposal you are putting together a business plan.

Now we are not just going to talk about the design document. People often confuse the design document and the game proposal. They are two *very* different things. The game proposal is the package you go to the publisher with, proposing that the publisher give you a lot of money to develop the game and spend even more money to market and promote your game when it is finished. The design document is simply a document that is part of the game proposal—a document that details your game.

By going through the steps of the proposal, you will clarify your game idea and the goals and expectations you should have for your proposed game title. You will, in the course of generating these documents, know what it will take in terms of time, talent, and resources to make your game and whether or not your game idea is feasible (in other words, whether it will sell in the marketplace).

Ultimately, your goal with a game proposal is to communicate to the publisher that you have a great game idea, you are able to actualize the game you propose, and your idea is worth a publishing deal.

These documents are geared toward the procurement of a publishing deal. They do not replace the other business documentation generated in the day-to-day functioning of a business: detailed budgets, schedules, and other business documents.

In these early days of brainstorming and note jotting, a great deal of your effort should revolve around the goal of creating an effective proposal; it is what you should be aiming to create first and foremost. The proposal will fall to one side once you've got a deal, but the budgets, schedules, and game design specs should be refined until you start development, then you should consult and update them at regular intervals. It is normal (and desired) to deviate from these documents during a two-year game development cycle, but the design document needs to be updated regularly. You need to see the effects that these deviations will have in other areas of game development. Simply adding a menu could create work for the artists, the programmer, and other team members. The tremors even a small change could send down the schedule could snowball, so do everything you can to plan ahead and visualize the work a change will involve.

Before we talk about the specific parts of a game proposal, you must know something:

No one can tell you *exactly* what should be in your game proposal, and those who think they can are wrong!

The Internet is a vast repository of tools and resources, but it is also filled with bad advice. Armchair game developers that have never developed a game tend to really hammer their views on people. All the newbies who comb the net looking for answers usually end up with an ear full of this bad advice. They are often referred to documents that are not very useful. These documents could contain out-of-date information or information that is not applicable to what they are trying to accomplish. You can't just fill in the blanks for a design document, a business plan, or a document that defines anything as fluid as a game development effort; these documents must evolve from your game.

FORM FOLLOWS FUNCTION

Form follows function is the fundamental principle of professional design in any field, whether you are putting together a proposal for a computer game, the design document for the game, or any other thing meant to perform a certain and unique function. You first have to project and examine what the end result will be: What type of game will it be, or what is your goal? Then determine the market strengths of your idea: Are the key strengths your reputation or name, a licensed property, a unique design, the artwork, or the technology?

Only when you have formulated a clear idea of your game, development team, and other factors can you go about assembling and ordering your proposal. You should then use the form you have decided on consistently throughout your proposal. The choice of structure, fonts, language, marketing focus—everything will be in the decided form. In other words, if you decide that your strength is your design, artwork, and marketing research, that should be the focus of everything you say or do pertaining to the title, and it should be put first in the proposal.

Letting form follow function and then staying focused will help sell your vision that you can make the game and the game is worth making. The form that your game proposal will take will be a product of you, your game, and your situation.

That being said, it is a safe bet that most of you will not ink a deal based solely on a good game proposal; you will also have to have a running demo. However, it is a certain bet that you will never ink a deal based on a bad proposal, even with a great demo, because publishers are not looking for awesome talent and great game ideas alone—they are also looking for ability: the ability to complete a marketable game.

BASIC ELEMENTS OF A GAME PROPOSAL

At its most basic, the elements of a game proposal are as follows:

- Your game idea
- The plan for its implementation
- Most important, the reason to develop the game

This concept goes back to designing for the intended audience. You must know who will most likely buy your game and include the reasons they might buy your game over the competition. Remember: will it sell, to whom, and why are among the questions the publisher will ask you.

The most important fact to realize about your game proposal—and the most overlooked or unknown fact—is that the publisher wants to know how it can make money selling your game, not how cool it is. It is *your* job to make the publisher desire your game. This does not mean *telling* the publisher how great your game is or how well it will sell; it means *showing* that's true, with a demo, marketing research, and other materials and information.

Yes, you do need the best possible, most refined, functioning demo—that is paramount! But the written portion of the proposal is what will convince the publisher that you can make the game and that it will sell.

For every 1,000 game submissions, publishers might see a handful of technical achievements, artistic masterpieces, even design accomplishments, but seldom do they see a proposal that makes them feel like they are holding the next million-unit seller in their hands.

In order to achieve a proposal of this quality, you must do the following:

1. Define the market for the game and the reason and proof that the market will buy it. This section of your proposal cannot be based on your opinion or personal opinions such as, "Well, they bought *Quake 2* in numbers." This section has to be a well thought out and researched marketing piece.
2. The proposal must describe the game both in general and detail. In the treatment or cover letter that accompanies your proposal, you will describe the game in selling language (general language); and in the design document, you will detail the game. You want the game to sound exciting, but your focus will be on the details of the game.
3. The proposal must show that you are qualified and capable of developing the game.

TIPS ON CREATING A GOOD PROPOSAL

When submitting a proposal, the cover letter is the critical component. The following tips outline characteristics of a good cover letter, including some "Do's and Don'ts."

PUT YOUR BEST FOOT FORWARD

Your cover letter will be the first document to orient the reader (in other words, the publisher) to you and the game. What comes next depends on your strengths and weaknesses. If you or your team is something special (hit game producers, celebrities, or have demonstrable and superior skills), lead with that piece of outstanding information. If your title is really on the brink of opening up an untapped and huge market and your marketing report is top notch, that should be the primary focus of your proposal.

Even if your game idea itself is truly something great, you still have to convince the publisher it will sell to an audience. Leading with the game design document itself is almost never done. It is always the market that is primarily of importance to the publisher. If there is no market, why publish the title?

BREVITY

Despite popular opinion, the "longer the better" game proposal is not the best. In fact, a bloated, wordy proposal will do more harm than good. There is a time for detail and a time for concise selling language, but there's never a time for pompous word spewing.

The *sizzle language* is contained in your cover letters, presentation (phone and face-to-face interviews), the Web site, game proposal, and press materials. These documents are not full of exaggerations or grand promises, but sales language. These documents can contain facts and proof, but they are concise and designed to grab attention and generate demand to see more.

The detailed documents are informational—design of the game, schedules, budgets, and negotiation terms. The detailed documents are usually looked at more in depth, after the selling documents. If a game design document takes 10 pages, do it in 10; if it needs 500, use 500.

WRITING

As you might have guessed by now, a game proposal contains an awful lot of writing—and even more rewriting. If you are not a writer or don't like the process of writing, this can be a difficult part of the proposal process, and you might need help. You could be tempted to gloss over these portions or try to hand them off to other individuals, but you cannot do that. Writing might be a chore for you, but you and the other individuals who are intimate with the game market and the proposed title

must be the ones to detail the proposal before letting a writer or consultant try to edit or rewrite for you. Usually only you and the team can explain the game before significant materials have been developed to present it adequately. Perhaps the greatest benefit of this process is that it will help you clarify the game in your mind and improve on your concept and presentation.

ON TECHNIQUE: OPENING LINES

Proposing a game is not a personality contest—it is a business proposition. Your game proposal will be judged primarily on content (audience, the demo) and not writing style. Of course, you should have your materials proofread, and they should read well and be grammatically sound, but you cannot sell a game on writing style alone.

When trying to sell your game idea, it is often tempting to let your enthusiasm shine through, to feel desperate enough or beg, or to try and get attention in the wrong way. For example, here are some good and bad opening lines and attitudes that you might want to be aware of.

GOOD OPENING LINES

"From the team that brought you (*insert hit game title here*) . . ."

Of course, if you use this line, you should really be "the team that developed the hit game X," or at least the key members of that team, not just an intern or low-level member of the team. It would be a good idea to clarify your position up front and make sure any claim you make is *absolutely* true and does not lead to disappointment in the publisher's eyes, or worse, give the publisher the feeling that you are not an honest person.

"Everyone says that (*insert hot movie title here*) would make a great game. We got the license and the team to do it."

If you use this line, you should, of course, truly have the license to the movie. It would also help a great deal in this situation—finding yourself the holder of the rights to a hot movie—to understand exactly what those rights entitle you to do (the realm of a lawyer specialized in this area). It would also be of benefit to you to realize two things: not all hit movies translate easily into computer games, and having the license to a hit movie will not guarantee a hit game.

Again—the market. How do you know if the audience that made a certain movie a smash hit even plays computer games? If they own computers, you still need to know who they are and what type of game they would most likely play. You cannot

expect a hit movie license to automatically generate a hit game. The license is mostly an awesome tool for the marketing of the eventual title; it can create interest in the title. Secondarily, it can be the source of things such as good content, story lines, and characters. However, a terrible game based on a hit license usually results in low sales, high returns, and an all-around, well-known flop.

> "Finally—a 3D game that appeals to the masses! (*insert very detailed and credible marketing report here.*)"

Of course, if you use this line, you should truly have the awesome marketing report. Many so-called marketing reports are simply exaggerated opinion, and it is apparently hard to understand that making the marketing report more credible doesn't mean making it more emphatic. *More credible* means that the report is backed up with material from sources such as PC Data, polls, and even interviews with industry leaders.

> "5,000 polygon limit? We can render 50,000 on the same machine. See if you can tell how we do it."

Of course, your demo should really deliver the promised technology. Remember, technology alone will not get you a game development deal, but a significant technological breakthrough will get you noticed. If the technology is significant enough, your game proposal might actually lead you into a job, a pairing with another developer whose art and design shines but technology lacks, or other possibilities.

BAD OPENING LINES

Yes, there a lot more bad lines than good ones. The following are all real lines that appear over and over in proposals.

> "This is your next big hit!"

Making this claim makes the writer look amateurish. This line, like many of the others, is used a lot and says nothing to the reader. If what you are trying to say here is based on marketing research, use a line or fact from the research itself, not this bit of hyperbole.

For example, "Joe Publisher, president of *Big Hit Game Publishers,* said in a recent interview that anyone who could design a game that would run on *all* Windows systems would have a hit on their hands. We feel we have designed that game and have enclosed a demo in this package."

> "This is a guaranteed hit!"

That is a foolish claim. Remember, *show,* don't tell. You should lead with the *implied* hit status of your title based on your research, innovative design, or talent—whatever skills or idea you possess that is most credible.

"I don't expect you to understand or be able to play my game at first."

This line tells the publisher that the writer thinks he is stupid or that the game is not playable—or both. If you don't think the publisher will be able to understand or play your game, you have to address that problem *before* you send it for perusal.

Is the game not playable, or are you assuming that publishers don't know their own industry? Maybe this line is used out of fear—the fear that the person getting the package might not be a hard-core gamer and the game demo was designed for hard-core gamers. If this is your fear, realize that game publishers can either play the games they publish or hire people to do it for them in the form of outside contractors, freelancers, or an internal review department.

"To whom it may concern . . . "

You will be surprised at how many people are *not* concerned when a letter starts this way. It tells the publisher that the writer is too lazy and unprofessional to bother getting the right name on the package. Researching and using the name of the person who should receive your proposal helps the recipient feel as though the package is for him or her, whereas "To whom it may concern" is a label for junk mail—and your package will be treated accordingly.

"I am familiar with the titles you publish and can see where you are going wrong."

This line is the most unbelievable of them all; surprisingly, opening lines and language like this is used quite frequently. Even if the writer has a great title and marketing to back it up, he or she might just bury them with this opening line.

If what the writer is attempting to do with this line is to explain an untapped market to the publisher, that is what should be said, in tactful and professional terms.

"I have played games for (*X* number) of years."

This is like a form letter, it is so common an opening. It might seem that the writer is building credibility, using this reasoning for being able to develop a game, but this line is so overused that it is a detriment as an opening line. However, the sentiment behind this line can actually be of great help later (*much* later, in your biography), but not as an opening line on your cover letter.

As we discussed, playing games is not the same as making them. In your biography, you should go into a fair amount of detail, especially if you have no industry experience, about the games you played and give a quick summary of the good and bad of those games, to demonstrate your knowledge of the technology and the industry.

"Please sign the enclosed NDA."

or worse:

"Only after you have signed the enclosed NDA will I show you my game proposal."

We discussed the fact that publishers and developers have more ideas than you can imagine. If the writer really possesses some world-shattering design, he or she needs to send a query letter first that explains the idea and request a nondisclosure agreement (NDA) politely.

Setting up a demo with publishers under NDA conditions is difficult, and you will need to show something initially that really entices the publisher to want to do your game. Publishers see so many game ideas, and so few are actually unique, that they would run the risk of getting sued by everyone they ever signed an NDA with every time they published a title.

If you really possess a license, artwork, or technology that you believe is world-shatteringly original, you can get legal protection before going in and not worry about an NDA. Simply make sure that you document your presentation and mail a copy to your attorney by certified mail and ask him or her not to open it. Of course, consult an attorney first if you find yourself in this situation.

"I have never played a computer game, but . . . "

How can someone expect a *game* publisher to read this and take the writer seriously? Certainly many game developers don't play many games. Some admit to not playing games at all. But playing games is usually a prerequisite to knowing how to develop them, and it is *certainly* a prerequisite for designing them. Yes, it has been said that playing games is not making them, so don't overplay the fact that you play games, but to declare that you have never played a computer game tells the reader that you don't understand them.

An opening line is a first impression, and this line is a *bad* first impression.

"I play games so much I can't hold a real job."

Getting $2 million of the publisher's money for a two-year development cycle is as real as it gets. Game development *is* a real job. This line only serves to put in the

mind of the publisher the image of the developer they just funded picking up and leaving after a few weeks when they realize that they have yet another pesky *real* job. Maybe the writer was trying to be witty or illustrate how saturated he or she is in games, but again, this is not a personality contest.

"I know that if you give me a chance . . . "

The writer is too personal. Remember, it is not about *you,* but about making money—for both yourself and the publisher. The publisher, by definition, is already giving the writer a chance by reading the proposal. What the publisher gets out of this statement is, "Please make an insane gamble of $2 million on me, even though I can't prove to you that it will be worth your while."

"Dear (*wrong name here*) . . . "

This is a no-no, but is sometimes overlooked. Just make sure that in your packaging frenzy, you are careful to put the right letter in the right envelope. At the worst, this makes the recipient feel as though he or she were sent a piece of bulk mail.

"I have a game that I believe . . . "

The writer risks possibly losing the attention of the publisher with this opener, even if the writer follows up with a great letter, because deep down, the publisher might be thinking, "I don't care what you believe and I am tired of hearing personal opinion. Prove it! What's the market? Have you researched it? Can this title sell?"

"This is the third time I have sent this proposal."

This line sounds confrontational and accusatory. There is a reason the first and second proposals were not acknowledged. Did the writer determine that reason or just keep mailing the proposals, thinking the publisher is acting wrongly and *must* respond?

Remember, it is *your* job to figure out why your proposal, calls, or e-mails are not responded to and fix the problem. This opening line also reminds the publisher that someone in the organization already rejected your proposal sometime in the past, so there's no use looking at it again.

The list of bad opening lines is long. Most of the errors stem from the simple fact that the writer took the focus off the publisher and placed it on him or herself. What will make the publisher want to see more? Showing the publisher how your proposed title can sell, that's what. Do not focus on what you want personally; focus on giving the publisher reason to develop the game.

REMEMBER: SHOW, DON'T TELL

In a proposal, the visual words *see* or *show* are used, even though we are dealing with written documents. The difference is illustrated here. For example, you can *tell* the publisher:

"I am the most qualified level designer for the proposed game expansion."

or you can *show* the publisher:

"I ranked number one in the level design contests on (*game site*), and my levels have been featured at (*source*). I also maintain the largest fan site for this game on the Net and have written several tutorials. Please see my site description under my biography for links and industry quotes."

CONCLUSION

This chapter gave you a basic orientation of what the game proposal is meant to accomplish. We next look at the actual parts of a game proposal.

CHAPTER

6 The Parts of the Game Proposal

The Game Proposal

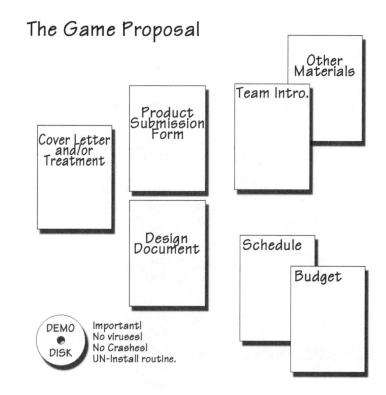

Other Materials

Team Intro.

Product Submission Form

Cover Letter and/or Treatment

Design Document

Schedule

Budget

DEMO
DISK

Important!
No viruses!
No Crashes!
UN-Install routine.

Form follows function—that has been misunderstood. Form and function should be one, joined in a spiritual union.

—Frank Lloyd Wright (1868–1959)

In the last chapter, we said that form follows function, and that is a truism of design. However, a good bit of form must be followed, regardless of the particulars of your game. You must have certain basic elements in your game proposal that are fill-in-the-blank information the publisher will be looking for. These particular bits of information should be made obvious with document organization and formatting.

In addition to creating your own proposal from the ground up, using this book and other sources of information, many publishers have fill-in-the-blank submission forms that ask for much of the same information. Determine if the publishers you're submitting to use these forms before you submit; that way, you'll be able to find out what the publisher is looking for before you work all those months on a game submission that might miss the mark. In addition, many publishers have their own product submission forms that they require you to fill out before submitting to them. These forms help you determine whether you designed a game that will sell to the publisher in question.

Publisher and agent submission forms are very much the same thing, and the information they ask for will be extracted from your game proposal. Many publishers have these forms, which help their internal flow of incoming submissions. These forms are invaluable to you because they will help you answer many of the most important questions about your game.

In this chapter, we look at the basic facts about your game that will be contained in your proposal as well as in these forms. The basic parts of the proposal are illustrated in Figure 6.1.

GAME PROPOSAL COMPONENTS

A proposal generally contains the following elements:

- The game treatment
- The competitive analysis
- The design document
- The team introduction
- The budget
- The schedule

The Game Proposal

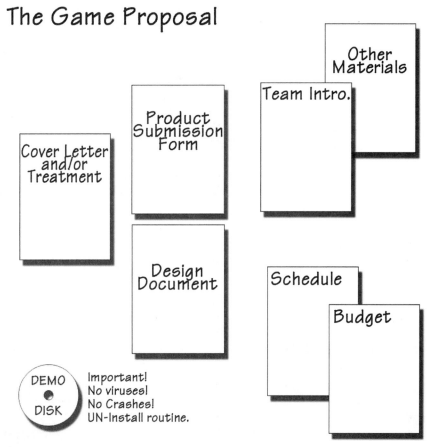

FIGURE
6.1 *The basic parts of the game proposal.*

THE GAME TREATMENT

The *game treatment* is a short and concise overview of your game and proposal. Be warned: Although this one- or two-page document is the first to be seen by the publisher, it is the last document you generate before going to the publisher.

THE COMPETITIVE ANALYSIS

The *competitive analysis* (discussed in more detail in Chapter 7) tells the publisher how your game relates to the competition. You must research the market and be able to tell the publisher why your title is different enough to outdo the competition but similar enough to be sold right next to them on the retail shelf—in other words, how your title is a successful innovation compared with current titles.

The Design Document

The *design document* (discussed in more detail in Chapter 8) is the document that shows the publisher your game in detail.

The Team Introduction

The *team introduction* contains the résumés, portfolios, and whatever other details are needed to convince the publisher that your team can complete the proposed title.

The Budget

The *budget* (described in more detail in Chapter 9) is the amount of money it will take to make the game.

The Schedule

The *schedule* (described in more detail in Chapter 9) is the amount of time it will take to make the game.

Let's take a more detailed look at each of these components of the proposal.

The Game Treatment

> *I didn't have time to write a short letter, so I wrote a long one instead.*
>
> —Mark Twain (1835–1910)

This Twain quote sums up a very important aspect of the game treatment: Although it is easy to write a 10-page document describing your game, it is much harder to write (and rewrite) a one-page document that sings—that concisely says everything efficiently and effectively. You will need to get this document proofread, edited, and read by as many "qualified people" as possible. Work a great deal on your game treatment; it will be your *primary* selling tool.

The game treatment is where you get to prove to yourself and the publisher that your idea is as complete and crystal clear as you think it is. If you can't explain your game idea in a few sentences, it might be one of the following:

- Too big and complex; your idea might be too ambitious.
- Your idea might not be as good as you think it is.
- You might need help writing it down. In this case, get help from an objective source who knows a bit about games. This source can be simply a friend to whom you try to explain your idea out loud.

Many people erroneously believe the treatment is the first thing you write, because in sample game proposals, it is the first thing they see. However, this document must be written *last*, right before you go to the publisher, so that you are sure you know everything you can possibly know about your game.

This document should quickly orient the publisher to your game, mentioning genre, platform, story and other elements. Most important, you want to quickly grab the publisher's attention and keep it with potential market and sales information, intriguing the publisher into reading more and then contacting you. If it is truly a good idea, the publisher might even consider reading your design document all the way through.

BASIC SUBMISSION INFORMATION

Proposals and forms are generally used by publishers and agents to weed out developers and game ideas—not necessarily bad developers or bad game ideas. It's just as likely that they are weeding out inappropriate or unwanted ideas and developers.

Any forms, letters, or paperwork should be filled out on a typewriter or printed on a letter-quality printer.

THE GAME TITLE

You should indicate that the title you are using is a *working title*. This means that you are aware of the fact that the title might be changed. Coveting the name you gave your game is a sign of inexperience. Publishers change game titles for many reasons. Often, title changes need to take place due to copyright issues, marketing information, and—believe it or not—because your title idea might not be the best one.

Does this mean you should give no thought to your title? No. You should have a title that speaks to the publishers and connotes the essence of your game, if possible. This is another place to demonstrate your talents and understanding of your game and its genre.

CATEGORY OR GENRE

Usually the publisher wants the innovation and not the invention, meaning that they want the improved version of the latest hit, not the new, cool, untried idea no one can define in traditional market terms. Publishers want innovation because it is usually based on a proven genre (action games or RPGs, for example) and is therefore easier to market, get accepted into the channel, and sell.

Game Categories

In the book *Game Architecture and Design,* genres are defined in their truest sense and can be broken down into about seven types:

- **Action.** Lots of frantic button pushing.
- **Adventure.** The story matters.
- **Strategy.** Nontrivial choices.
- **Simulation.** Optimization exercises.
- **Puzzle.** Hard analytical thinking.
- **Toys.** Software you simply have fun with.
- **Educational.** Learning by doing.

Things can get a bit more complex when you combine genres—for example, action/adventure titles or action/strategy games and many other combinations.

Now add technology, marketing, and the many other factors a computer game has to offer, and the traditional genre labels become less effective. You are faced with having to convey details about technology, interface game play, and more in only a few words.

For example, much confusion surrounds the simple term *3D*. If a box says *3D Action* in big letters on the cover, what does that tell you? Are you getting a prerendered movie, a *Doom* clone (older technology), or a game using a cutting-edge game engine? Will it be played from a first- or third-person perspective? Will there be multiplayer abilities as well as single play? Obviously, the term *3D Action* doesn't answer all the questions a consumer will have about a game.

So, we are left with a lengthy list of genres that you will need to understand in context. When labeling your own game, make sure you include some text describing the game and don't put only *3D Shooter*. If the publisher has a particular bias, it might make negative assumptions about your title: "It's been done to death," "Not another 3D shooter," and so on.

Game Genres

Here we look at the many genres, subgenres, and hybrids of computer games. You need to know the genre of your game before you design it, but chances are, if you have an idea for a game, it already fits into one of these categories. Genre is important at this point; it will help determine the amount of art, technology, time, and money you will need for your game. If you plan to get your game published, you need to be able to quickly and clearly position your title in the publisher's mind by comparing it with other games and discussing your game in terms of its genre.

Maze Games

Maze games have been around almost longer than any other genre. These are the very familiar games like *Pac Man* and *Ms. Pac Man*. Maze games are simply that: The player runs around a maze and usually eats or gathers something while being chased by some form of enemy. Maze games started in 2D with an overhead view of the maze.

Board Games

When a traditional *board game* like Monopoly, Clue, or Sorry is recreated on the computer, it retains its original genre classification of board game. This recreation is usually done with a very close adherence to the original game and no innovation in game play, no original use of the technology of the computer other than to make the game function as it did in real life, and no artistic improvements on the original game board and pieces. Initially, the challenge of getting the AI to play the game was enough to keep the developers busy, so new innovations in art and game play had to wait.

Card Games

Card games like solitaire, poker, hearts, and strip poker are on the computer and are a huge-selling genre. And, like board games, these titles have so far seen little innovation in most ways. *Hardwood Hearts* by Silver Creek Entertainment is a card game (see Figure 6.2) that shows some really cool innovations such as multiplayer modes and custom decks.

Battle Card Games

Battle card games came about with the *Magic: The Gathering* craze, which spawned such card games as *Spellfire, Legends of the Five Rings,* and *Pokemon.* Battle card

FIGURE *A screen shot of the innovative* Hardwood Hearts. *A demo can be downloaded at*
6.2 *www.silvercrk.com.*

games play very much like traditional card games, only with pretty pictures and an emphasis on being collectible. Naturally, the decks are open ended, and if you buy more cards, you will be more powerful. These games' move to the computer has been much like the traditional card games' move to the computer.

Quiz Games

Quiz games are big; games like *You Don't Know Jack, Jeopardy,* and *Trivia Wars* are some of the biggest in this genre. The logic behind these so-called "multiple choice games" is rather easy, since all you do is display a question and then three or four answers, but the research and organization of all the content—the questions and answers— are the hard part. Figure 6.3 shows the typical quiz game interface.

Puzzle Games

Tetris, Dr. Mario, and others fall into the *puzzle games* category. Usually in these games, the player has to line up pieces falling from above before they hit bottom and fit them all together in the most efficient manner. The player's goal is to have no open spaces between the pieces. The pieces become more complex and fall faster as the game progresses.

Shoot-'em-Up Games

Space Invaders, Asteroids, Sinistar, and *Space Battle* are examples of 2D *shoot-'em-up games* in which the player is in a ship in space and shoots oncoming things—aliens, missiles, and the like— before they hit him or her.

FIGURE *A trivia quiz game.*
6.3

Side Scrollers

Side scrollers are what made id a success. Remember Commander Keen's *Invasion of the Vorticons*? This category also includes the original *Duke Nukem* and *Prince of Persia 1*. Side scrollers usually have the hero running along platforms and jumping from one to the next while trying not to fall into lava or get hit by projectiles. A typical side scroller interface is shown in Figure 6.4.

Fighting Games

There are many *fighting games*: *Street Fighter 2, Samurai Showdown, Martial Champion, Virtual Fighter, Killer Instinct, Battle Arena Toshinden, Smash Brothers,* and *Kung Fu.* Fighting games started as a flat 2D interface and now feature full 3D arenas and animated characters. The focus in a fighting game is the almost endless fighting moves and special moves you can use against your opponent.

Racing Games

Racing games center around the concept of driving really fast around different tracks. *Wipeout, Destruction Derby, Mario Kart,* and *South Park Derby* are all racing games. At one time, 2D racing games were made with a scrolling road and the "sprite" of the car moving over the surface. With the explosion of the color Game Boy on the scene, these games are making a comeback.

FIGURE *A side scroller.*
6.4

Flight Simulation Games

A *flight simulator* (or *sim*) attempts to simulate real flying conditions by giving you control over such things as fuel, wind speed, and other instruments—even control over the flaps and wings of your craft. A sim responds with the same limits as a real vehicle, as opposed to a more simple flying game, in which the player simply flies and doesn't have as much to think about. *Wing Commander, X-Wing,* and the *Microsoft Flight Simulator* are all flight sims.

Turn-Based Strategy Games

In *turn-based strategy games* such as *Breach, Paladin, Empire, Civilization, Stellar Conflict,* and *Master of Orion,* players each make their decisions and the game progresses after each person has taken a turn. When playing these games, a player uses much more strategic thought and planning, much as in chess.

Real-Time Strategy Games

Populous, Command and Conquer, Warcraft, and *Syndicate* are a few popular *real-time strategy games.* In these games, you don't have forever to take your turn before the next person takes one. The faster player can make many moves in a short period of time. These games are also a bit like sims because the player is usually overseeing a large battle or war and the building of towns and outposts. Resource management is important—for example, the amount of gold you can get in *Warcraft* before you run out and can build no more.

Simulations

Sim City, Sim Earth, Sim Ant—Sim Everything! In these games, the player runs a simulation of a town, world, or ant colony, making decisions and managing resources. Simulations are often called *God games* because the player takes the part of God in the game world.

The terms first- *and* third-person *refer to the point of view of the player. Just as in literature, where we have first-person novels ("I shot the rocket") or third-person voice ("She shot the rocket"), in gaming we have points of view as well.*

First-Person 3D (FPS) Games

In games such as *Castle Wolfenstein 3D, Doom, Duke Nukem, Quake, Dark Forces,* and *Sorcerer,* the focus is on technology and atmosphere. These games attempt to put the player into the action; the player "looks out" of the eyes of the character, seeing and hearing what they see or hear. As you can see in Figure 6.5, the point of view is from a person on the street.

FIGURE *A screen shot from* Sorcerer, *a first-person 3D game.*
6.5

First-Person 3D Vehicle-Based Games

These games are much like the FPS except the *first-person vehicle-based shooter* has the player in a vehicle that could be a tank, a ship, or a giant robot. This genre is more similar to an FPS shooter than a racing game because the player is not simply driving as fast as he or she can to cross a finish line. The goal is more similar to that of the FPS: kill or be killed. Examples of vehicle-based shooters are *Descent, Dead Reckoning,* and *Cylindrix.* You can see a screen shot of a vehicle-based shooter in Figure 6.6.

Third-Person 3D Games

Tomb Raider, Dark Vengeance, Deathtrap Dungeon, and *Fighting Force* are all *third-person 3D games.* Although in some games, you can switch from first- to third-person perspective, most games are designed primarily to be one or the other. *Tomb Raider* in first person is not as much fun because the game is primarily designed around seeing Lara Croft jump, roll, and tumble, and playing in first person, you would not see these acrobatics.

In Figure 6.7, you can see an image from a third-person game. Notice the spell effects you cast (the protection circle) when in third-person mode. Likewise, when

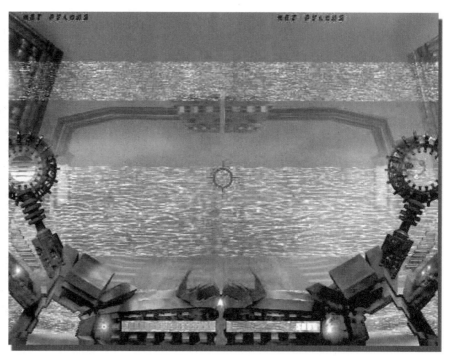

FIGURE *A screen shot from* Dead Reckoning, *a first-person 3D vehicle-based game.*
6.6

playing a first-person shooter like *Quake 3 Arena,* you depend on speed and accuracy in battle to win; that is the point of the game. If you were able to play *Quake 3* in third-person mode, you would die an awful lot, since you would not be able to run, aim, shoot, and run some more as quickly.

Role-Playing Games
Wizardry, Ultima, NetHack, Dungeon Hack, Might and Magic, and *Daggerfall* are all *role-playing games,* or *RPGs.* These games are focused on the emulation of traditional pen-and-paper games in which the player plays characters that have particular data related to them, such as health, intelligence, strength, and areas of knowledge and skill. RPGs are like a simulation of an adventure.

Adventure Games
Zork, Hitchhiker's Guide to the Galaxy, and *King's Quest* are all *adventure games.* In an adventure game, the player tries to fulfill a quest or unravel a mystery. The player typically collects information and items; battle is light and not the focus of this game type.

FIGURE *A screen shot from* Sorcerer *in third-person mode.*
6.7

Interactive Movies

Full-motion video (FMV) games like *MYST* and *Riven* require a good deal of art and animation or video production and precious little of anything else; there is simply no room for anything else, because FMV is a limiting genre at present. In FMV, the player mostly watches a movie and then selects another portion of the movie to watch next—kind of like a computerized version of the "choose your own adventure" books.

Educational and Edutainment

Some games or interactive products fall under the genre head of *education and edutainment,* which seems to be more determined by the intention of the product than the content or technology. A first-person game would be an edutainment title if its intention was to educate and entertain, as would a quiz game. These genres are instructional and informative; the edutainment variety attempts to make learning fun, while the educational genre involves straightforward learning.

Sports Games

The *sports games* category is a huge-selling genre all by itself. In fact, PC Data places various sports into their own categories. But this is another genre label that doesn't

convey the technology, game play, interface, or other aspects of the game—"It's just about sports." In other words, in fiction, a thriller that takes place at a football game might be called a "sports thriller," or an inspirational nonfiction book with a sports theme may be called a "self-help/sports" book, but in games, we don't use labels like "quiz game/sports" or "quiz game/football" or "third-person football simulation"; it's all lumped under "sports."

Screen Savers and Desktop Toys

Although *screen savers* and *desktop toys* are not games—and many are not even very interactive, for that matter—these products are generally entertaining and lumped in with games and interactive products. Screen savers and desktop toys are fairly lucrative products that are rather easy to develop.

Genre Combinations

Even with all these genre breakouts, we still have many games that cross over and combine genres. Generally, a good game has elements of many other genres, such as puzzle solving in a 3D game. We also see genre breakouts where technology permits; for example, many fighting games started out as side scrollers for the 2D platform and evolved into 3D shooters or 3D games. *Duke Nukem* is a good example. Duke's progress is shown in Figures 6.8–6.10.

FIGURE *The original 2D side scroller,* Duke Nukem.
6.8

FIGURE *The first 3D* Duke Nukem.
6.9

FIGURE *The latest* Duke Nukem, *which uses the Unreal Engine.*
6.10

When discussing your title, keep genre in mind; it is the first step in communicating your vision clearly to all involved. Once you have a clear idea of your game—for example, "It is a first-person adventure game with shades of military simulation"—you can proceed to describe it in visual terms on paper, eventually breaking it down into the elements that will make up the design document.

TECHNICAL SPECIFICATIONS

The *technical specification* explains how the game will technically be made by the programmers and forces the programmers to think of the game, and all of the tasks that need to be completed, in order to finish it. Even using a licensed technology requires time to learn and master that technology, so you need to plan for that.

The technical specification is *extremely* important for the proposal as well as the development schedule, but it is beyond the scope of this book due to its highly technical nature. There are many great books on game programming and programming in general. The best source article on the Internet that discusses technical specifications is *The Anatomy of a Design Document, Part 2: Documentation Guidelines for the Functional and Technical Specifications,* by Tim Ryan; you can find it on the Gamasutra site (*www.gamasutra.com/features/19991217/ryan_01.htm*).

A passage from the article pertaining to the technical specification is particularly important to note here: "The target audience is the lead programmer on the project and the technical director of the company. Therefore, it will generally be written from the system perspective as opposed to the user perspective. It will be boring and Greek to the producer and any other nontechnical readers."

MINIMUM SYSTEM REQUIREMENTS

List the platform, hardware, software, special peripherals, RAM, and so on in a section on minimum system requirements. This is where you name the version of Direct X or Open GL the player will need as well as required processor speed and RAM. If you list every platform known to man, back up your claims that your game will run on these systems and how you plan to get your game on those systems.

In addition, you might want to demonstrate your understanding by explaining the current installed base of a certain configuration. This information will both make the publisher feel better about you and maybe even make the publisher desirous of your title, if it in fact will be supported on a large user base. For example, a game that requires very high system requirements might be limited in appeal due to the small audience it can attract. All its pretty pictures won't mean much if no one can run the game. But if you point out that the same high-end title has the menu

options to allow for the use of a wide range of systems, you just upped your publishing chances a notch.

MEDIA

What media will your game ship on? Usually, PC games are shipped on a CD-ROM. If you need four CDs or a DVD disk to hold your game, discuss that fact in this section—and justify the added expense the publisher will see in terms of replication, packaging, and even design fees. Explain why that media is justified and why the game will still make the publisher money. Keep in mind that publishers generally want a game that will be economical to make, easy to market, and fit current standards in terms of shelf space and box design.

INTERNET AND MULTIPLAYER CAPABILITIES

Oddly, a game must have multiplayer capabilities to get published, and the catch is that (at least right now), your game can't be multiplayer only as a general rule. So, as a designer, you are stuck having to design and develop essentially two games, or a great single-player game with poor multiplayer functionality, or the other way around. Of course many games do both well and badly in the multiplayer arena. Maybe the success of online-only games such as *Quake 3* and *EverQuest* will allow developers to focus on multiplayer-only games.

DEFINITIONS OF DEVELOPMENT STAGES

Each publisher has its own definitions of these development stages. You should understand each publisher's definitions when you work with them. The development stages generally follow the descriptions here.

WORK IN PROGRESS

The work-in-progress stage is pretty self-explanatory. At this stage, you have something done, maybe art and a little code. Nothing is expected at this stage but a firm understanding of where you are headed and the demonstration that you can probably get there. You should at least have a great paper presentation (design documentation and so on).

ALPHA

Usually, the product is running to some degree at the alpha stage. The user interface is defined, you have the general layout of the program, its graphical look and feel is achieved, and the programmer is just starting to get the cold sweats as he or she realizes how much there is left to do.

At alpha, you should be able to demonstrate the game play and its look and feel.

INTERIM BETA OR SECOND ALPHA

This stage comes just before the final beta stage. Some bugs and errors are found and fixed at this stage. Your game is essentially running and mostly done. Some tweaking is taking place, as is initial beta testing. Your artists are having gag reflexes at the sight of the game and will often break down in tears. This is the stage at which publishers most want your title to be when they look at it in a proposal.

FINAL BETA

All features are functional and complete at the beta stage. Components such as the install routine, help files, and splash screens are complete. All text files have been checked for spelling and grammar errors. The game has been tested by the development team, and all the problems or bugs found during that testing have been corrected.

GOLD MASTER

This is the final version of the game burned on a CD-ROM (which is usually gold colored) and is used as a master for duplication and mass production.

COMPETITIVE ANALYSIS

Often publishers will ask you to fill out a competitive analysis on your game. In filling out this form, it might seem at first that you are doing the marketing person's job—and you are, since you are the initial person responsible for marketing your game. If the developer does not prove that the title has an audience, the publisher will not be likely to look at it. However, done correctly, your competitive analysis can be a major tool to place you ahead of other developers. The well-done competitive analysis demonstrates that you understand the publisher's goals as well as the market in which your game will compete. This exercise will give you the information you will need when discussing your title with publishers. You will be able to rattle off your competitive analysis findings and conclusions and impress and convince everyone that your title will sell.

So, exactly what is a competitive analysis? It is basically how your game relates to the competition. It contains your conscious and researched thoughts on why your title is different enough to outdo the competition but similar enough to be sold right next to the competition on the retail shelf. We look more closely at the competitive analysis in Chapter 7.

THE DESIGN DOCUMENT

The design document is the document that shows the publisher your game in detail. We discuss the design document in more depth in Chapter 8.

THE TEAM INTRODUCTION

As you know by now, you need to convince the publisher that you are a good risk and build your credibility. The team introduction is one way to do that. You want to include any information pertaining to you and your team—résumés, portfolios, and press clippings—that will help convince the publisher to go with your game (and your team).

Once again, it is assumed that most of you have never developed a game or had a million-unit best seller. Most submitting developers have no real industry experience or published game titles. This is the reason that a substantial demo, a near-complete game, is required. Such a demo is the only way to prove to the publisher that you have the team skills, technical skills, and personal ability to produce the title you propose—even if the publisher thinks the proposed title is a good idea.

A publisher will look favorably on any serious, related work experience—after all, you will not be just another gamer wanting to make a game. If you can demonstrate real-world experience that somewhat relates to your job description in the proposal and a good employment history, you will achieve some credibility. Proving you can hold a job, deal with people and deadlines, and communicate well are all pluses.

CONCLUSION

Working through all the aspects of your proposed title will take time and might feel like a waste of time to a developer who wants to code or create, but a well-formed proposal is the best tool to convince a publisher that you can make a game that will sell. Next, we look at the competitive analysis and the design document more closely.

CHAPTER

7

The Competitive Analysis

The illiterate of the 21st century will not be those who cannot read and write, but those who cannot learn, unlearn, and relearn.

—Alvin Toffler, futurist (1928–)

The competitive analysis is one of the most important aspects of planning your trip to the publisher. It is often ignored, misunderstood, or otherwise simply not done right by the developer—if the developer is even aware of the existence of such a document. This document can play a big part in the success of your proposal because it demonstrates to the publisher that your game can successfully compete in the marketplace in terms of genre, technology, features, and other important aspects.

The common assumption, if a developer is even asked for a competitive analysis, is that it is simply an exercise in listing game play and technological features. But once again, the competitive analysis is a chance to prove to the publisher that your game will perform strongly in the marketplace. Even if the publisher never sees your competitive analysis, this document will help you design a game and game proposal that will make a publisher's ears perk up as you compare and contrast your game's unique features and selling points and the fertile market you are designing for. If you can produce sales figures, industry quotes, and supplemental materials, you will go a long way toward getting publisher consideration. In this chapter, we look closer at how you can effectively compare your game to the competition.

WHAT IS A COMPETITIVE ANALYSIS?

A competitive analysis is basically a document that discusses how your game relates to the competition. It contains your conscious and researched thoughts on why your game is different enough to outdo the competition but similar enough to be sold right next to the competition on the retail shelf. You'll want to include the ways in which your title is a salable innovation of current titles. During the process of writing your competitive analysis, you will justify your title's design by backing up your decisions with quotes from magazines, reviews, or even the publisher's own materials. Many publishers might state that they are looking for a certain type of game, so you can build your competitive analysis around that point. A publisher might have a strong position in the market with a certain type of game but might want to add to its line-up or move into other genres. It would be beneficial to you to be aware of these types of facts before you write your competitive analysis.

GENERATING THE COMPETITIVE ANALYSIS

The first step in your competitive analysis is to identify the games that are your competition. Your first reaction might be that there is *no* competition for your game because it is so great or so different. If this is really true, you have to ask yourself whether or not your title can be sold. You have to be honest and really look at your game objectively. If your game has a weakness, the time to be aware of it is *before* you go into the publisher's office. At this point, you can fix the problem or at least honestly address it and explain how you plan to approach it in development. For example, maybe your artwork is lacking, but you have a top-notch artist ready to join the team, pending the receipt of funding. You can bring the artist's portfolio and demo to the publisher and address this weakness up front. Trying to justify a problem to a publisher—or worse, getting caught lying about a problem—will severely hurt you in the publisher's eyes, if not kill your chances altogether.

IDENTIFYING COMPETITORS

You are probably well aware of most of your competitors, but you still must thoroughly research them. Searching game sites on the Web, reading back issues of game magazines, talking to fellow gamers, and walking through the local computer software retail store will probably turn up many games that you didn't know existed. This new information can be invaluable to you; you need to examine games like yours that have not done well. If the reason for another game's failure is that the game idea was a bad one, you might have just saved yourself some time and trouble, but if the game has failed or performed poorly due to poor packaging, promotion, or one of the four reasons listed in Chapter 3, that's even better. Being able to tell a publisher that such-and-such a game would have been a hit if not for the following reasons, and then backing up your findings and showing that you will overcome those shortcomings will be a strong argument for developing your game—the right way.

Write down all your findings! Create a computerized spreadsheet to which you can add fields, tally numbers, and keep filling them in. Keep files with reviews, previews, ads, and press clippings on your top competitors. If you do not organize your findings, they will become useless. Among the data you should keep up to date are the titles produced by the publishers to which you are submitting. Are they failing, thriving? What comments or press releases are being sent out by the publisher? If possible, you want accurate sales figures as well. You might notice that some games are promoted heavily, but you might also be surprised to find out that they often fail despite the heavy promotion. If you compare your game to a game that, although heavily promoted, failed in the marketplace, you might make your title simply look like the next big market failure waiting to happen, if you aren't careful to outline

how you will overcome the failings of the other game. It might also happen that people working at the publisher you are submitting to formerly worked for the company that experienced the failing title. Their in-depth knowledge and personal experience with the failed title will only make their view that your title will be a failure all the more adamant.

Once you have a list of games that are similar to yours, you can start to break out their features and make a spreadsheet. But this spreadsheet is only the beginning of creating your competitive analysis.

If you can't find any game that is like yours, or you find that your game is very similar to many other games, you might want to reconsider the design of your game. What is it that makes all the games so similar, and what can you change, enhance, or remove to make your game stand out? If you find that only a few games were ever made like yours, you have to ask yourself why that's the case. When a hit game like *MYST* or *Doom* comes out, everyone rushes to capitalize on the new craze, and a million imitations are spawned. If no one is doing what you propose, though, there might be a very good reason for that.

If that reason is that your idea is so new that it cannot be compared to other games, you have to look hard at your title. What makes it so new? Is its technology so advanced that a publisher would not be interested? Is it that your title lacks comparison because the characters or subject matter is obscene, offensive, or objectionable and cannot be sold in the mainstream distribution channel? If so, you are most likely wasting your time going to see the publisher. Even if your title is so new and unique that it defies description, you will have a hard sell because publishers tend toward innovative titles that they can position easily and sell in the market. A better role-playing game has an audience ready to buy it, whereas a concept that is so new that no one has a basis for understanding what it is will be an uphill battle to sell to the publisher, buyers, and end users.

COMPETITIVE ANALYSIS CHECKLIST

When you do your competitive analysis, you should have at least 10 titles that are similar to yours and have been released in the past two years. You have to be able to list both their bad *and* good points. Ask yourself the following questions:

- Did you pick at least three or four titles that you feel are representative of competitive products and compare them to yours in terms of features, number of levels, hours of play, benefits, price, and value?
- Did you list any special strengths and weaknesses, such as reputation of title or developer, technology, tools included, and licensed property?
- What problems does your title clear up that gamers have complained about, or what problems have been left untouched? Does the title create new problems to be solved?

- Did the developers mention a list of things they were going to include in the title that time, but other restraints prevented them from getting to? Can you include those things in your game?
- What market is the title serving? Can you create a game that will expand the user base—maybe even expand it by being more hard core or specialized?
- What really happened to the titles that were promoted as the "next greatest gaming experience"? Did they really sell well, or was it hype? What are the gamers saying on the Net, in the newsgroups, on the Web sites? Can you get real numbers from PC Data or other sources on the performance of these titles?
- Have you seen all that the publishers have done for competing titles? Were ads run, and if so, how many, for how long, and where? Were box designs always the same, or did they suddenly change after a few weeks on the shelf? Were contests run, articles written by developers, press releases, trade shows attended—what sort of retail promotions and saturation were achieved?
- Have you played your competing games to the point of intimacy, built levels with them, played them till you are an expert, talked to the fan base?
- Have you tried to talk to reviewers, editors, publishers, and anyone you can about what they would do with a particular game if they had the chance?

In the course of this exercise, you might find that certain titles that seemed so ever-present in the marketplace didn't do well, whereas some sleepers needed only the right innovation to be a hit. There are titles that were adored by those few who actually played them but failed due to one of the reasons given in Chapter 3: the market was inadequately analyzed, production quality was poor, the product was delivered late, the title was distributed poorly or promoted poorly. You could come across several titles that many people made comments about, such as:

- "If only game X didn't crash all the time." You can fix the crashes.
- "If only game X allowed you to customize maps." Allow the user to customize maps.
- Adding other features "would be so awesome!" Add them if you can.

Finally, successful publishers are in command of their marketing plans; your competitive analysis is something they will no doubt want to see and will be a tool they will use to determine if your game idea is worth considering. Although putting together the competitive analysis takes effort, a good game designer should be aware of the basics and benefits of the exercise. Comparing features, playability, and other design details that will make a game better are what designers do best, and that should translate into a creative, convincing competitive analysis.

CONCLUSION

As we've seen, a competitive analysis is not just a list of items on a spreadsheet; it is a chance to effectively analyze the competition and refine your own design and development strategy. When you present a truly impressive proposal to a publisher, one that answers the question, "Why is your game so special?," you will earn serious consideration in return.

CHAPTER 8
The Design Document

Literature is strewn with the wreckage of those who have minded beyond reason the opinion of others.

—Virginia Woolf, author (1882–1941)

With your design document, you will make your game idea a concrete and detailed reality, on paper. Hopefully, at this stage you have done at least some basic market studies and researched a competitive analysis of your idea compared with others on the market; you should be aware of the parts of the proposal you will have to develop. After all this, your work on the design document will be more evolutionary than simply a fill-in-the-blank exercise. This evolutionary approach will help you build a comprehensive design for your game that will help you answer questions that you might otherwise be inclined to gloss over, define portions of your plan that are vague, and clearly communicate to anyone involved what the game really is in terms of genre, game play, complexity, and other characteristics.

The two basic purposes of the design document are to describe the game in detail, allowing the document's intended audience (the development team and the publisher) to visualize what playing the game will be like, and, for resource management purposes, to break out every aspect of the game that has to be developed in order to create the game. In the process of defining, researching, and detailing your design document, you will develop the game's strengths, uncover weaknesses, make it easier to budget and schedule the resources it will take to develop your game, and even bolster your confidence in the game as the design document becomes a substantial reality.

More recently, first-time developers have pushed to know more about design documents; it *is* an important document, but don't be misled. The design document is only worthwhile if it details a good game idea. The quality of the design document alone seldom lands a game deal. Although you can use a bad design document to make a great development deal look bad, you can't use a good design document to make a bad deal look good.

AGAIN, FORM FOLLOWS FUNCTION

Obviously the type of game you're developing will determine the contents of your design document. A first-person shooter might have very little in the way of story line or character description, but it will have detailed descriptions of levels, powerups, and weaponry. A role-playing game will feature more complex character descriptions—even massive scripting, if the characters must attempt even the most rudimentary conversation with the player—and usually quite a large back story.

However, even the amount of dialogue in *Draconus*, an action title, surprised the developers, who ended up with a great many pages of script.

The actual contents of a design document will seem like common sense after you see them. In fact, if you were to try and reverse-engineer a published game on paper, you would probably end up with a fairly good version of a simple design document for that game. A good exercise for writing your design document is to sit down with several of your favorite games and try to create design documents for them, using as a guide the sample design document by Gathering of Developers that appears at the end of this chapter. As you examine your favorite games, take note of how the developers addressed all the topics of the sample design document.

This exercise works for poorly developed games as well. When a game reviews poorly, the reviewer often uses language that points to flaws that possibly were evident in the design document. Criticisms such as poor game play, bad graphics, poorly planned levels—all are parts of the design document that, if developed properly, should not be the reason for a game's failure in the marketplace. If you were to read all the computer game *post mortems* on the Gamasutra site, you would see that the way initial planning and design were handled is almost always listed among the reasons for failure or success of a game.

As you can see in the sample design document by the Gathering of Developers that I include at the end of this chapter, the parts of the design document are typical, to some degree, but can vary depending on the game. The same is true in determining what it takes to write a good story. Although the basic parts of a story are beginning, middle, and end, some stories have quick and short beginnings that cut right to the middle in a few pages, while others have long and well-developed beginnings. Which is the "right" way to do it? Should you use a long or short beginning? That, of course, depends on whether the story requires a well-developed beginning or not. It is possible that a long beginning is not necessarily well developed; rather, it might simply be too long, losing the reader because he or she feels nothing is happening in the story.

DESIGN DOCUMENT BASICS

The basic focus of your design document should be to define the game's ambiance, style, and setting. The sample document at the end of this chapter asks first for a game overview in one or two pages. This is to help the reviewer determine whether or not your game idea has any redeemable qualities. Even before the technology is demonstrated, the art reviewed, the design document read, or the team members considered, the game overview, introduction, or treatment is read.

What Gathering of Developers calls an *overview*, this book calls the *game treatment.* From earlier discussions, you will remember that the game treatment is a document that should quickly orient the publisher to your game (genre, platform, story, and other important elements). You want to quickly grab the publisher's attention

and keep it, hopefully intriguing the reviewer into reading more. If it is truly a good idea, the publisher might consider reading your design document all the way through. If you can't write your game idea in a page or two, you are not ready to submit your idea to a publisher.

The design document should be as long, or as short, as you need it to be. Being wordy and verbose will not help the process; remember, this is *not* a selling document. Many first-time design document creators tend to keep up the sales pitch throughout the proposal, but such an approach is not needed and is, in fact, a distraction to the reader.

Doing the design document properly—forming it from your market research, competitive analysis, prototype work, and other materials collected to this point—will help prevent the publisher's acquisitions department from simply returning your proposal. By being objective and thorough, you can save yourself a great deal of wasted effort.

WHO WRITES THE DESIGN DOCUMENT?

The person best suited for the job should write the design document, and no *one* person is usually perfect at it. The design document requires the input of the designers, producers, programmers, and even lawyers and other executives, if the game is a licensed property. The person writing the document could simply function as an editor, providing consistency for the document, or that person could be the best game designer alive and have complete control over what goes into the document. In either case, good communication skills are extremely important in this process.

As hard as it might be to write a design document, keeping to the terms of the document after it is created is far more difficult. In many cases, the design document that was used to sell a game sits untouched throughout the development cycle, and that can spell disaster. Frequently during development, changes and modifications must be made to keep up with the industry; if those changes are not documented and dealt with and planned for, and your design document updated accordingly, they could snowball.

Although the design document needs to be as concrete and detailed as possible before development begins, someone needs to be assigned to maintain, update, and, in short, be intimately familiar with the design document throughout development of your game.

It is true that most games undergo changes during development because developers need to improve the game, keep up with technology and the marketplace, fix previously uncovered errors, and address other aspects of the game, but the design document must be updated to reflect these changes. Changes must be reflected in the other documentation as well (schedule, budget, back story, dialogues, and so on) and consideration made in other areas.

You must be careful that important elements of the game design are not changed. For example, the seemingly minor act of an artist veering from an initial design of a character to create a tougher-looking foe might be in conflict with the voice samples, text descriptions, and other assets that are still based on the initial design, in which the character was intended to be something of a weakling. This rule applies to all aspects of development. Problems often arise due to the simplest good intentions. If each programmer, artist, and other team member tried to improve a title with small "contributions," the overall design could suffer inconsistencies and incompatibilities, and the schedule could even suffer a setback when these things need to be corrected or retrofitted into the old version of the design.

If you increase the time or financial budget for the project, change the intended audience of the game, or change any other element of the initial design and proposal, the tentacle effects of that decision need to be considered across the board. Carefully considering any changes made and then updating the appropriate documentation bring far more benefit than detriment to the development effort.

Although we said that the design document is not a sales document, and neither is it a technical document, it is still intended to introduce the reader to the game in terms that conjure up the game in an exciting context in the reader's mind. You should use language such as this:

> "The player must navigate the dangerous sewers of Townsville to the enormous underground vault, where the alien outhouse is located. In order to complete the level, the player must then fight the King Alien using the Death Ray that has only three shots. It takes exactly three shots to kill the King Alien."

as opposed to:

> "When the player presses Enter, the sewer level will load (sewer.wad) where the player must kill all the enemies in order to proceed to the end of the level, where the player must find the special weapon and kill the more powerful alien."

GENERAL AREAS OF THE DESIGN DOCUMENT

The most general and important design document areas common to virtually all games are the story, the game play, and the notion of levels or missions. The design document should develop these areas as appropriate.

STORY

Game fiction can be important, even if that fiction consists of but a few pages. Part of successful game play is the concept of being *immersed* in the game. A great deal of

successfully pulling off this effect lies in the graphics, physics, and how the game responds to the player, but another part of the equation is how consistent and logical your game world is, and that stems from the background of the world, the characters, and the events that cause the game situation to come about. Even a magical fantasy or a science fiction game needs the core elements of a good story: motivation, conflict, and a satisfying conclusion. Note that all these elements do not take a full-length novel to accomplish.

Your game fiction should be as long or as short as the game requires. A shooter could require a page of back story, whereas a complex RPG might have many pages of fiction, detailed characters, long and complex scripting, and histories of certain geographic areas. For example, the users' manual for *EverQuest* contains detailed histories of the game world and regions that you can visit as a character in the game. Each religion, character race and class, skill, combat, magic, and other aspects of the game are detailed in writing. *EverQuest* is also a massive online world, so there is more fiction when you actually play the game; hundreds of computer-controlled characters speak to you, there are many quests in which items and directions are detailed, and some of the monsters say phrases when they attack based on special aspects of your character. All of this richness requires appropriate fiction writing on the part of the developer.

Furthermore, game stories might not all be fiction. Some games, such as strategy games, games with a real military background as the setting, or historically based games, could require a great deal of research. You should realize that if you are proposing a game in which one of the selling points you list is factual information, you need accurate research on the topic. If, for example, the history of a certain era such as the U.S. Civil War is involved in your game, and you have hand grenade launchers on the battlefield, that lacks credibility. This is, of course, not to say that you can't mix these elements, but if it appears that you have done so out of ignorance, that is a strike against you in a publisher's eyes.

GAME PLAY

For the most part, game play will be the focus of your writing in the design document because game play includes all aspects of the game, from AI and physics to issues concerning the intended audience and resources needed to complete the project's development. Your initial description of the game presents the game in terms of how it is played and then breaks down the parts of the game. You could end up referring to other documents, such as your art bible (described in a moment), as certain aspects of the game become unwieldy within the context of the design document.

Be mindful when writing the design document; everything you put in the document must actually be created for the game or developed in the design document itself. Here are a few examples:

- Imagine you are writing the design document for an RPG and you state, "The player will have to try to converse with several characters on the road between each town, and the computer-controlled characters might talk to the player, giving clues pertaining to the next quest—or even attacking if the player killed too many innocents." This feature indicates that the game has many computer-controlled characters with such diverse likes and dislikes (they might or might not talk to certain other characters, even attacking them on sight) that a large matrix or database might need to be developed to track them all. You must ask yourself, Will these characters speak (in which case, you need voice recordings) or will there be a text window (a menu must be designed)? Will the characters move realistically as they speak (animation work)? In addition, each such item will require some amount of additional programming.

- If you are designing a fast-paced first-person shooter, you might want to maintain notes on how the levels played in testing, where people seem to be dying too quickly or where an unfair advantage could diminish the level's playability. If there is a spot in which one player can sit and kill everything without being in any danger of dying him or herself, this point needs to be addressed. Maybe this situation doesn't require a major redesign; it might simply be a matter of moving powerups for health or ammunition to make the safe spot a place of peril.

- A quiz game that might seem simple from a technological point of view could require extensive research, editing, and cataloging of the data. Things that need to be tracked could include questions that have been used, the level of difficulty of each question, topics to which each question belongs, and so on. You might even need to consider foreign translations of the game; certain topics could offend in translation or some words could be confusing or impossible to translate.

- If you describe in detail a game that emulates real-life situations, forces of nature, or behaviors of things such as bouncing balls or any interaction in the game between objects, you could be describing physics that will take the programmer months to write. Again, in getting this information down on paper, it is important to include everyone involved.

- Most games have some form of artificial intelligence. If you describe complex behaviors in great detail and reactions among computer-controlled characters, you are most likely describing advanced AI. If you are not a computer programmer or are not very familiar with development, learning what you can safely describe in terms of behavior could take some getting used to and assistance from those who *do* know.

- If you are a hard-core gamer trying to design for a broader audience, remember *Deer Hunter*. Its game play and interface was simple by design (or on purpose). A more complex interface or game play would most likely have frustrated the nonhard-core gamer, which was the intended audience.

- If your game involves any multiplayer capabilities, this must be considered from all points and detailed in terms of game play and programming. You must also consider any special needs apart from the game. If your design document describes a massive multiplayer world in which a server is required for every 2,000 people who play, and you are assuming that the publisher will simply pick up this expense, you are mistaken.

Detailing great game play could be fun and you could be detailing the most innovative game ever, but when the programmer, publisher, and others involved read the design document, they will be thinking of what it will take in terms of time, money, and other resources to create and market the proposed game. You must try and learn their points of view, define a thought-out scope of the game based on your research, and stay focused.

LEVEL DESCRIPTION

The level description portion of the design document contains at least a basic sketch of the various levels, such as a floor plan with key areas marked on it, and detailed information to build the level. Level descriptions can also be as complex as a huge outdoor terrain on which zones cross, script points are defined, triggers (both visible and invisible) are placed, and more.

The term level is still used to define the portions into which a game is broken up—various zones, tracks, fields, arenas, or other terms that connote the genre, type, or setting of the game.

Level breakdowns should also list repeated elements, such as all the interactive elements—weapons, powerups, switches, traps, items, and trigger points. The sample document at the end of the chapter does a very thorough job of breaking out all these elements, with suggestions on how to think of the level and game as a whole.

CHARACTERS

You must thoroughly describe the characters in your game. Each should have a background, even being developed to the point (from the fiction) at which each fits into the world logically, is driven by a motivation, and has an overall reason for walking down the hall of an abandoned warehouse, attacking you on sight, giving you aid, or whatever function the character will end up playing in the game. Any special abilities must also be defined, consistent with the world and within the parameters of the game. All aspects of the player's role and characters must be broken out as well—textures (for the model and any effects textures for any special abilities), models, animation needed, and sounds (voice and effects).

Most developers start with rough sketches, build up to refined sketches and mockup models, and go through many iterations of character refinement.

THE ART BIBLE

Your *art bible* lists all the artwork needed in the game and includes a bit of writing, since a great deal of notes should be taken on the overall look and feel of the game. Some of this material could be redundant of the design document, but it will help the artists stay consistent with the mood, ambiance, and atmosphere of the game. Here is where color schemes can be recorded and explained, rules for what colors mean in the game, and other elements that are *visually* important to the game. This document helps producers, designers, and individual artists communicate and create textures and assets that will fit into your game world.

The art bible should also contain lists of things that need to be done, such as the following:

2D Art

Menus

- Buttons and interfaces
- Background art
- Logo must be included in main screen
- Character icons, small
- Navigational compass
- Cursors—all should be 16 frames of movement
- Cursor, general
- Cursor, battle
- Cursor, menu mode

Credit Screen

- Font: Arial bold
- Screen shots 32a–36a must be included
- Get text file credits.txt from art folder for names and titles
- One button to quit

The art bible is sometimes useful as a version of the game development as it pertains to the artist. Everyone needs to be up to speed on the entire project and understand how his or her work affects everyone else on the team. Having a schedule focused on one aspect for the artist can help.

The art bible should also take into consideration the publisher and its needs. It is not the developer's responsibility to do package or ad design, but you will be asked for screen shots, high-resolution models, and other assets for Web page art, sell sheet design, demo splash screens, magazine ads, press art, packaging, the user manual, and more. Be prepared and make time for these deliverables in the schedule before

going to the publisher. Sometimes a publisher will ask you to take screen shots, since you may have the most recent version of the game with a new feature enacted. Taking good screen shots can take time.

TEXTURE SETS

Of course, ample room in the art bible will be dedicated to your *texture sets*—texture libraries of bases such as the stone, wood, cloth, or other materials from which your levels are made. You will also develop textures for each level, character, and item and all game objects. You will need sky textures, and if you have weather events in your game, maybe you'll need an entire section on skies, rain bitmaps, and other environmental effects.

A major division of your art bible might be devoted to the characters and monsters in the game. Each character could have multiple skins (the art covering the character model) and multiple animations. One character alone might require so much information that separate bibles are broken out for animation as well as art in general.

For example, the typical character in *Quake 3 Arena* has the following animations associated with it:

Full-Body Animations

When the character in *Quake 3* dies, one of the three following animations will play.

- death1
- death2
- death3

Upper-Body Animations

- Taunt
- Weapon attack
- Change weapon
- Weapon idle
- Melee idle

Lower-Body Animations

- Walk
- Crouched walk
- Run
- Run backward
- Swim
- Jump forward
- Jump forward—land

- Jump backward
- Jump backward—land
- Standing idle
- Crouched idle
- Turn in place

The upper and lower parts of the character in *Quake 3* are combined by the engine so that the movement of the lower body is independent of the movement of the upper body. For instance, you can combine the weapon-attack animation from the upper body with the run-backward animation from the lower body, and the character animation will look as though the player is running backward as he or she is attacking. This would be something the programmer might decide to do for efficiency's sake, and the artist and animator would need to understand it so that it can be rendered properly. Any movement a character makes in the game must be broken out, included in the schedule, and then created by a team member.

When a weapon is fired, the type of weapon could determine what type of blast comes from the muzzle. Smoke could puff from the barrel, a mark could be left on a wall, and other events could occur that need a special texture created for them. RPG games or games with a lot of magic spells being cast could require hundreds of spell effects. Look into some games and you will see other special effects textures such as blood smears, footprints, explosions, smoke, steam, and more.

The art bible includes cut scenes and movies. If you will be producing high-resolution 3D rendered movies, video movies, or a composite of the two for cut scenes, these can get as complex as small film productions and could need to broken out and handled as separate documents. Even if you are producing in-game cut scenes with game assets and scripting that use the game engine, they should be scripted separately.

THE SOUND BIBLE

Sound effects are often listed with the levels and characters with which they are associated, and then a master list is created, but often a game contains so many voice recordings, sound effects, musical scorings, and the like that a separate *sound bible* is required to track them all. Like the art bible, a sound bible could be the place where the technical aspects and creative goals for the sound and music are stated (even if this is redundant from the design document).

Sound is often done later in the development and is often done poorly. Since several types of sounds—effects, events, voice, and music—need to be done for a game, the task is often turned over to one person or firm to accomplish. Of course, many developers are limited in terms of budget and must do it that way. But even with a limited budget, quality music can be created. Some musicians specialize in game

music; they have the equipment and the musical talent (not just the technical ability to press the Record button) and can provide the unique soundtracks that stand out from the norm and compete with even big-budget film scores. Recently, Jesper Kyd (*www.jesperkyd.com*) completed the scoring of the game *Hitman* and produced tracks that change in sync with the story, elevating the player's immersion in the experience. Think about the effect that sound has on you as you watch a movie. Similarly, adding the power of on-the-fly scoring to an action game will deepen the player's experience.

The sound bible should, of course, describe the technical specifications, sampling rates, file sizes, and formats as well as the overall ambiance of the game and each level. It should break out the sound needs to each event, voice, and effect. When breaking out the sounds for a game and listing them, keep in mind that game sounds are more than just weapons fire and screams. Sounds can include the Menu—rollover sounds, selection sounds, error sounds, and atmospheric sounds such as animals calling, wolves howling, floor creaks, and footsteps on stone or metal.

A FUNCTIONING DEMO BEFORE THE DESIGN DOCUMENT IS CREATED?!

For the most part, the game design should be done on paper first, but there are many benefits to doing functional prototypes first, and doing one might not be as involved as you expect. With so many game engines available and the similarities among many technologies, obtaining and using the technology to create a functioning demo is a very doable goal. If it is possible, the level designers and artists can benefit from experience with the level editors and tools used. The team will get a feel for what the game engine can and can't do as well as the time involved in making a level, and you can simultaneously produce screen shots for the team Web site and game proposal.

SAMPLE DESIGN DOCUMENT BY GATHERING OF DEVELOPERS

This sample design document can be found online at *www.godgames.com* in The Oracle. According to God Games, "The Oracle could be described as a moderated public forum geared toward striving game developers. Basically, The Oracle provides answers to your questions about game development and publication." Readers are able to submit questions about game development and publishing, and if a question is selected, the moderators locate an industry expert to answer it.

Read the already answered questions and you will find that most topics have been covered, and covered very well. The Oracle is definitely an invaluable resource for developers of any level.

PROPOSED GATHERING OF DEVELOPERS STANDARD DESIGN DOCUMENT FORM, VERSION 1

Design document by Drew Haworth, Terminal Reality Inc.

This sample design document is split into two sections. The first section, "Treatment/Introduction," is intended to standardize and streamline the Development Board's approval process. It serves as the initial submission of a proposed game to the Development Board. The second section, "Design Document," has a twofold function. It represents the game's milestone schedule, from which Gathering-appointed overseers (Board members or otherwise) may judge sufficient development progress. It may also aid the individual developer as a template for the construction of a living document that will provide internal organization, visualization, and presentation throughout the development cycle of a game title.

I. TREATMENT/INTRODUCTION

This section's purpose is to introduce the overall game concept to the Gathering's Development Board. The suggested guidelines for completing this section are as follows:

A) One to two pages of *overall* game idea
B) Use broad strokes; specifics will be addressed later
C) Stay concise and focused
D) Include these elements:
 1) Game title
 2) Game genre
 3) Brief story description
 4) If applicable, main character or units description (including general actions)
 5) Brief description of settings and scenarios
 6) Overall look of the game
 7) General computer AI description
 8) Minimum/recommended hardware specs
 9) List of necessary development tools
 10) List of team members and skills required to produce game
 11) Estimated completion/release date
 12) Similarities to other genre games
 13) Standout features—"competition killers"

II. DESIGN DOCUMENT

The completion of this section will be required as an early milestone subsequent to the Development Board's approval of the submitted title. It will also be used by the Gathering Review Team as a measure of progress throughout the title's development cycle.

A) Overview/Story

 1) Define the game's key ambiance/attitude

 2) Describe the game's overall style

 3) Describe the general world(s) and the state of the world in which the game takes place

 4) Team members who will be working in this area and their specific duties

 5) Production art

B) Characters/Units

 1) Thoroughly describe player characters/units

 a) Current status/situation/ambition

 b) Personality traits, history/relevant relationships

 c) Abilities, special abilities (powers and/or techniques), and their accompanying animation (and effects)

 d) Weapons or utility items

 2) Describe persistent nonplayer characters/units (see previous list: C/1/a-d)

 3) Describe persistent arch-enemies (see previous list: C/1/a-d)

 4) Team members who will be working in this area and their specific duties; include necessary technological implementation

 5) Production art

C) Level Description

 1) Break the game into manageable sections according to its genre

 a) Levels (action/platform)

 b) Chapters (RPG/adventure)

 c) Geographical areas (RPG/adventure/action/strategy/sim)

 d) Mission (sim/strategy/action)

 e) Races/tournaments (driving/sports)

 f) …ad infinitum

 2) Description of each level

 a) Level name

 1) Describe the level in referential terms that everyone can understand: "Blade Runner Metropolis," "Spider King's Lair," "Atlantis, Third Stage (Waterfall)"

 b) Environment

 1) Appearance

 2) Geographical features (main and subareas)

 3) Inactive (background)

 4) Active (foreground)

 5) Puzzles/traps/environmental challenges

 6) Key area for artwork

 7) Maps may be helpful

 8) Team members who will be working in this area and their specific duties; include necessary technological implementation

 9) Production art

 c) Main goal of level

 1) Explains the purpose of the level

 2) E.g., "Pascal needs to navigate through the Hellhole to rescue Auntie Garfungiloop so she can give him the Jeweled Monkey's Head."

 d) Level's relevance to story

 1) How the results of the player's success or choices in this level affect the overall story (particularly in a game with a branching storyline)

 2) How the level, and the events portrayed within, fit into or advance the overall story (contextual placement)

 3) How these story elements are related to the player (through dialogue, in-game events, or framing cinematics)

 4) Keep track of subplots

 e) Characters/enemies encountered

 1) Conversation/dialogue

 2) Nonplayer character actions

 3) Attack moves

 4) Physical appearance

 5) Brief character sketch

 6) Relevance to story

 7) Technical description

 8) Key area for artwork

 9) Team members working in this area and their specific duties; include necessary technological implementation

 10) Production art

 f) Actions/animations specific to level

 1) Explicit actions performed by main character to accomplish level goal(s): defeating a boss, discovering or recovering an artifact, special abilities granted by powerups, etc.

 2) Explicit actions performed by other characters in the level

 3) Terms like "run" and "jump" are insufficient; it is important here to describe how a character jumps and what he looks like while doing so

 4) Team members working in this area and their specific duties; include necessary technological implementation

 5) Production art

 g) Music for level

 1) Technical aspects (event-triggered, Redbook Audio, etc.)

 2) Desired effect on players

 3) Purpose of music (e.g., background ambiance, tension building, or clue supplying?)

 4) Team members working in this area and their specific duties; include necessary technological implementation

 5) Production art

 h) Sound effects for level

 1) Level of realism

 2) 3D aspects of sound

 3) Hints provided by cues (e.g., T-Rex Shockwave thuds getting louder as something approaches) or sounds that result from certain actions (e.g., hollow sound resulting from shooting a false wall)

 4) Scripted dialogue

 5) Background ambiance

 6) Team members working in this area and their specific duties; include necessary technological implementation

 i) Items per level

 1) Powerups

 2) Weapons

 3) Any other items with which the player can interact—pushed, climbed, thrown, switched, clung to, hung from, triggered, blown up, ridden on, eaten, examined, etc.

 4) Key area for artwork

 5) Team members working in this area and their specific duties; include necessary technological implementation

 6) Production artwork

III. SCHEDULE

Since every development cycle varies greatly, the following are to be viewed more as guidelines than hard requirements.

 1) Technological development milestones

 a) First year: Engine/tools development should be broken into quarterly milestones

 b) Following 12 months of engine/tool work: Technological additions should be scheduled with 8 to 10 monthly milestones

 c) For titles using licensed engines and tools: Adjust the previous schedules accordingly; budget three months for midproduction engine upgrade

 2) Art and nontechnological content development milestones

 a) Preproduction art: Character sketches and model sheets, architectural rendering, color studies, etc. should coincide with the engine/tools schedule (see above); should be complete at the end of the first 12 months

b) Crucial story elements, plot devices, level and character concepts, etc. should coincide with the engine/tools schedule (see above); should be complete at the end of the first 12 months

On completion of concept stage, art production should begin concurrent with monthly milestones of technological progress.

CONCLUSION

Now that you know a lot more about your game, what it will be, and how you plan to make it, you can start thinking about how much and how long it will take to do so. In the next chapter, we look at budgets and schedules.

CHAPTER

9

The Budget and Schedule

Failing to plan is a plan to fail.

—Effie Jones, educator

As part of a complete game proposal, you must create a detailed budget and schedule. Be aware that this schedule is not simply for you to look at when you develop the game. A well-done schedule will help the publisher see the scope of your project; more important, it will be the biggest illustration of whether you can actually produce the proposed game. A well-developed schedule is yet another factor a publisher will look at when determining whether you can do the game you propose and if you understand what you are trying to get into.

An all too common misconception of scheduling is that writing a schedule is filling in the blanks on the fly. Trying to write a schedule without proper planning and research is a waste of time at best and potentially a great danger to your business. Schedules, like budgets, come from careful research and planning. If you write a business plan or proposal and gloss over, or make up, the content, you doom yourself and your proposal. When publishers look at your schedules and budgets, they will spot inconsistencies and errors right away.

SCHEDULING

You must take several steps to gather the information to properly schedule your game. This information includes, but is definitely not limited to, the following:

- Interviewing, separately and in groups, your team members to assess their needs and opinions on the schedule
- Interviewing those who have done what you are about to do and comparing notes
- Reading up on the latest in the technology methods, and equipment you will be using
- Being intimately familiar with each task and goal that has to be accomplished in your project

To generate budgets and schedules properly, you must understand the art of project management, to some degree. Project management involves planning the game project, extracting the schedule and the budget from those plans, and finally controlling the generated budgets, schedules, activities, and overall objectives throughout the life of the project. A good project manager also does a thorough *post mortem* of the project for future reference.

START BY PLANNING YOUR DREAM SCENARIO

You should start by planning your game, assuming that you have the best possible resources at your disposal, whether resources will actually be available or not. The time for compromise is later. Start by assuming that you have the money to buy the necessary equipment, rent the best office space, and pay the best people to do the work. The initial game design should be done this way as well, designing the best possible game you are able to design. We will juggle numbers and make compromises later; right now, define the best possible solutions, with no limits, so that you work toward the highest ideal possible.

Initially working toward the highest ideal possible is good project management. This approach opens up opportunities to achieve goals previously assumed impossible or improbable. By aiming high, you could make it half the way to your goal, but by aiming low, you will never get above the low standard set from the beginning of the project. If an ideal goal is never examined, it does not have a chance of being reached.

PUTTING THE SCHEDULE ON PAPER

You should already have at least a rough version of your design document done at this point, consisting of the basics of what makes up your game. At this point, the seemingly simple notes you are jotting about the title, genre, technology, and scope of the game are almost encoded versions of your schedule and budget. After you've written the actual treatment, a publisher can read it and have a very good idea what it will take to develop the title you propose. They can then check your supporting documentation to see if it is in line with what they think is true.

Once you start putting the schedule on paper, you will begin to notice relationships you could not have seen otherwise, and a million questions will pop up. Not until you actually list everything that has to be done and everything that you want to do on paper in an organized fashion will you start to see what you really have ahead of you. Once you start assigning responsibilities to the tasks, you'll start to see overlap in schedules and work flow.

Don't forget holidays, conventions, and other milestones and dates when drawing up your schedule. These days, even one-day events are critical to plan for if they fall on a milestone day. If you set a milestone on a religious or national holiday when a key worker is needed, there could be conflict if that person expects that day off. Holidays and days off are part of employee hiring and management as well.

MISTAKES OFTEN MADE IN SCHEDULING

Beginners often make the following mistakes:

- Defining the scope of the project (time and monetary budget to reach the desired outcome) by what they *think* the publisher wants to hear, or using so-called conventional wisdom to give pat answers, such as "A game takes two years and $2 million to develop." That time-and-dollar figure will not always fit any given project.
- Defining the scope of the project using personal desires or agendas; inflated budgets, huge salaries, and even the opposite—tiny salaries and not enough resources—to do a project, hoping to woo a deal out of the publisher.
- Defining the talent needed by who you have on hand or personal loyalty. This is not to say that loyalty should not be rewarded, but if any member of the team cannot produce the needed assets for the game, that person must be released or demoted. This is where the reality of business can be harsh, and it is hard to be the boss in the case of having to let someone go. But people management is another topic and very different from planning a project. It is okay to schedule and budget supplemental employees or contractors to complete your game.

CAUTION

Unless you have done it before, people management is very difficult—especially so when friends and family are involved.

- Not understanding each and every decision in the plan and being able to justify those decisions. Salaries are often one of the biggest areas in which developer and publisher disagree. A developer might see certain top developers sporting the rich lifestyle, but that developer might not be aware of the typical pay rates in the game industry.

STARTING THE PROCESS

You start your schedule by breaking out the tasks to be done. If your programmers will be using an existing engine and set of editing tools, that will decrease your development time and could even decrease your cost of development. Keep in mind that no matter what the tool set, there will still be a significant amount of programming to do if you are to develop a game that stands out. (Remember how important standing out is?) A game that is simply another game with assets swapped will have much against it in the publisher's "potential title" arena.

If your team does not have enough experience in developing projects, you might have to complete a running demo just so you and your team will be intimately familiar with the tools and code base used. Only this way can you know if you'll need any supplemental tools and what is involved in writing the additional code your game will require. In addition, you need to be well aware of the previous uses of the technology you licensed, its amount of support, upgrades forthcoming, and its strengths and weaknesses.

STEPS IN SCHEDULING YOUR GAME'S DEVELOPMENT

There are four basic steps to scheduling your game's development. You must ask yourself:

1. What must be done?
2. Who will do it?
3. What resources are needed to do the job?
4. When must it be done?

What Must Be Done?

Having your game defined and experience with the technology to be used are imperative. You simply need to know how many levels, what sound effects, menu screens, code libraries your game will have—every aspect of your game. The tasks that must be done include equipment purchases, office rental, phone lines hooked up, and so on.

Who Will Do It?

Extracting from what needs to be done, you can decide who will do it. For example, if your game is art heavy, you need to have the right number of artists on hand.

What Resources Are Needed to Do the Job?

With every person you add to the team, you must add office space and furniture, computers and equipment, software, and salaries. This could also include added legal expense for each contract that must be negotiated. Of course, these costs also include game development software each team member will need, such as programming technology and the 3D/2D tools for your artists.

When Must It Be Done?

Each person needs detailed schedules for his or her work and an understanding of how that work affects the whole of the project. When deadlines are set, they must be met. The effects of one team member missing a deadline can have drastic effects teamwide.

BREAKING THE WORK DOWN INTO A SCHEDULE

To put these tasks into a schedule, you use a *work breakdown structure,* or *WBS.* With the WBS, you break a complex task down into smaller tasks. You keep breaking the tasks down until you can estimate, with accuracy, what each of the individual tasks will take in terms of time, talent, and money.

You should break each of the tasks down into units, using days as the smallest unit of time. A task should not exceed a week or two in length. If building eight character models is a task that the artist estimates will take eight weeks, that task is not broken down far enough. That task should be broken down into eight tasks (each model being a task) that each take one week to complete. This task schedule will be easier to track and control during development. If the task was left as one

eight-week task, it would potentially be two months before anyone knew that the artist had fallen behind schedule. At a weekly status meeting, a one-week task can be checked and verified; it's either done or not done.

For example, if you were to break down the simple task of creating a menu screen, you would have something like this:

 Menu screen
 Background image
 Collect screen shots, photographs, digital images, scans
 Layout initial background
 Option buttons
 Choose or create font
 Color scheme

The artist working on these tasks will suddenly have a long list of questions for several people—for instance:

How many options will there be in this game? The more options you have, the smaller my font will be or the more menus I will have to design. Will I be using a prepackaged font or creating a custom font for the game (which will take a lot more time)? Speaking of fonts, will I have to create each menu option, or will the programmer *blit* fonts over the menu? What resolution will this menu be displayed at, and will I have to create versions of the font in different resolutions, or will the programmer resize the images on the fly?

You get the idea. Things like resolution, number of colors, and file sizes will come out of this process. Furthermore, note that this example, a menu screen, could be quite simple to create for a 3D shooter but could be highly complex and involve many artists for a game like an RPG that might have a great number of menus and options. In addition, note that a task as simple as a menu screen suddenly becomes a task that can take a week or more, seeing that the artist must get input from other people and consider a great many options.

This example also illustrates the importance of having the people who are going to do the work participate in these planning exercises. It is really easy to underestimate the amount of time any given task will take when the whole of the project and the interdependencies of other members' tasks are not taken into consideration. Needs and tasks will evolve from the breakdown of each task. The preceding artist breakdown of one simple task illustrates how the artist will need input from the designer, the programmer, and maybe even the accountant, who will want to know, "What's cheaper—buying a font package or spending days creating a font?"

It is critical that everyone sees and signs off on the WBS. It is impossible to schedule something as complex as a game without the input of all involved. This is also the process in which potential problems are uncovered and ingenious solutions are devised.

For example, let's say that an artist requests an application to simulate the menu so he can run his art through it and see how it looks in operation. The programmer dreads adding this application to his workload and immediately resists the idea. Another team member suggests using a drag-and-drop Web layout program to load the screens and see aspects of the menu in operation, such as the menu roll over buttons and screen changes. Here we can see that the input from another team member can avoid problems and delays.

ESTIMATING

It is important to be sure that you know you are operating on schedules and budgets that are *estimates*. No one can predict a budget or schedule with 100 percent accuracy. When the project manager's priority becomes the 100 percent accuracy of her budget or schedule, you are in danger of making bad decisions (or having them made for you). Staying on budget or schedule is of course not bad, but making decisions solely for the purpose of "hitting the mark" can be a bad thing. This is also not to say that you don't have to have a great degree of accuracy in your estimations—you do.

The purpose of estimating is not to protect you from huge mistakes or your own incompetence; rather, the estimate is intended to show a realistic amount of variation in a schedule. This is usually expressed in a fluctuating percentage of some resources: time, money, or other. Explain how your estimates were made based on experience or research and give a "freshness date" for the estimate. Some of your estimates could be based on factors in which time will affect the accuracy of the budget or schedule.

WITH A WBS, YOU CAN START TO SCHEDULE YOUR GAME

For the purposes of this book, we look at the basic *Gantt chart* as a scheduling tool. Figure 9.1 shows a simple bar chart that will effectively let you plan and document your proposed development and communicate to your team. Professional project managers use the critical path method (CRM) or the performance evaluation and review technique (PERT). These methods are more complex and thorough, and you will eventually need to use them for the actual development of the game.

If a team member fails to complete a task or is late in completing it, the project will hit a standstill if no one can move on toward a goal or milestone because of the slip. A noncritical slip, such as the failure to implement a new font in the menu, would not slow down the project. A critical task is one that prevents meeting of a major milestone.

The danger of slippage during development must be watched carefully, which can be a hard task. Every day that a milestone slips is another day that has to be made up or a day that the completion date must be pushed back. All too often, it is easy to think you will burn the midnight oil or somehow make it up at the end, but

Gantt Charts

FIGURE *Basic Gantt charts.*
9.1

this usually never works, and slippage begins to snowball. The effects are both real and psychological.

It is extremely important for the team members to always assess and update their project schedules. It is hard to be honest with yourself and especially with the publisher, but it is better to admit you are a week or two behind early on than wait until the end of development and announce that you will have a three-month delay. The mental effects on the team and the project leader will be enormous if you let this happen.

Almost everyone knows the feeling of being overwhelmed by a task that feels impossible or out of control, and no one likes it. Few can function at their best under such circumstances. When the publishing staff finally do find out about the delay,

they will not be happy about it, to say the least. Since, at that point, there will most likely be no option to complete the game on time, the publisher could simply drop you and sue you for the advance and lost revenue as well. If the publisher projected that it would make $1 million off the title, there is a chance it could sue you for that amount if you are the cause of the loss of that projected revenue.

To prevent this situation, it is a good idea to have weekly status meetings—quick meetings that bring everyone up to speed on the status of the other team members' work. Grievances can be aired, suggestions made, and any slippage corrected. It is often the case that no matter how hard you work at communicating among a team, things are not understood and wires get crossed; having a weekly touchpoint can help avoid these errors.

An example is the discrepancy in communication that exists between individuals with different areas of expertise. When a programmer says "a small file," he might mean, for example, a 256×256 Indexed color image, about 66kb in size. When an artist hears "a small file," she might come back with a 6MB file, which is small compared to the 60MB files she might have dealt with in the past.

THE MOST EFFECTIVE SOLUTION

The primary concern of the project manager should not be solely focused on the scheduling; instead, picking the right solution to the completion of the project is the goal. As was said, scheduling is a byproduct of project management. Getting the right person and the right tools for the job—in short, the most effective approach— is your main goal in project management.

A great real-world example of good project management is Third Law Interactive's use of the LithTech engine for *KISS Psycho Circus*. Even though the developers had access to any game engine or technology they could want (UNREAL, Quake, etc.), they chose a platform that would work on a wide range of computers. They realized that the best thing to do would be to create a game that would please both hard-core and not-so-hard-core gamers. The band KISS has a huge following, not all of whom are hard-core computer gamers with the fastest computer driven by the latest technology. Not many developers would walk away from using UNREAL or an id technology for the right reason, and it might also have been hard for the publisher to pass up an opportunity to use one of those big-name technologies in the marketing of the game. But they did it, and they made the most effective choice for their situation.

THE BUDGET

Now that we've defined our project and scheduled it, budgeting should be an easy task, right? Well, actually, you still have several decisions to make regarding a few factors, and you still have a good deal of research to do.

Let's look at the factors that are involved in the budgeting of a game development project:

$$Performance + Time + Scope = Cost$$

- *Performance* is the quality of the job to be done.
- *Time* is the amount of time needed to do the job.
- *Scope* is the extent of the work to be done or the size of the project.
- *Cost* is not a final dollar figure. Cost is the overall resource that is needed to do the job.

If, for example, you plan a triple-A game (performance and scope) that you plan on taking two years to develop (time), the cost will fall into a certain range. Changing any of these factors will affect at least one of the others and will almost always affect the cost.

For instance, say you decide to use fewer people and take four years to develop your game, assuming that you will save money, then look at the big picture. Your cost actually goes up because you have to pay for two more years of development overhead and expenses. This also applies to morale, cash flow, and other areas of the project. Think of the effect a four-year development cycle could have on an individual. Four years is generally too long to work on a game from all points of view: marketing, technology, and morale. You will lose people due to boredom, and your technology and the market will change, so you will be faced with more delays and costs in trying to "develop on the fly."

Likewise, if you try to do the title in half the time, costs will go up. In order to meet a deadline in half the time, you need to pay personnel extra money to work overtime and do the game that much faster, or you'll need to pay premiums for more qualified individuals to do the work on an accelerated schedule. Think of the effect an intense, nonstop, one-year development schedule could have on a team. The stress of trying to do a two-year job in one year could kill the project altogether.

Obviously, this is not to say that every project should take two years; these are illustrations. An add-on pack could take six months to a year. A creative development team could, in fact, come up with a way to cut a two-year development cycle. Using a licensed engine is an option that could cut six months or more off your schedule.

When scheduling, you will start to see *sweet spots* in the process where you get the most optimal effect. A sweet spot is the peak of a bell curve of effectiveness. Looking at other factors, we can see the same sweet-spot pattern showing the peaks of maximum effectiveness—that is, the points at which you begin to lose effectiveness if you go too far in either direction.

For example, if you hire an inexperienced programmer for a job, he or she could take longer to learn the tools and not work as fast. Or if you hire an overpowered, high-priced, or even celebrity-status programmer when he is not needed, you might be wasting money. See Figure 9.2.

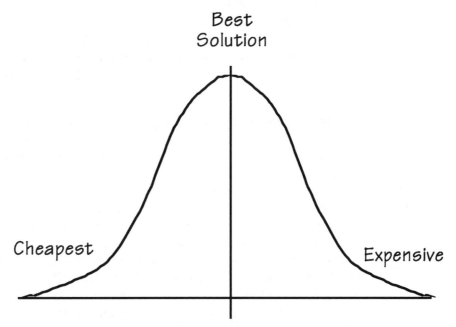

Effectiveness Curve

Best
Solution

Cheapest

Expensive

FIGURE *The theoretical bell curve of programmer effectiveness.*
9.2

Another example is buying the cheapest computer equipment to save money. If a game developer's computers all have small monitors, slower chips, and overall terrible performance and usability, you will lose effectiveness in many ways and negate any savings made in the budget. Top-performing computer equipment is one area that is a bit hard to overdo—in this industry, at least. The better the equipment a game developer uses, the faster and better that developer can work. Systems that take a long time to render, crash a lot, or cause eyestrain cut down on production. You will end up wasting more time and money on repairs, lost data, upgrades, and employee breakdowns. It is still advisable to make sure the equipment or software you plan to purchase is actually needed and will be used, but if it is, buying the best is often the most economical decision.

STATEMENTS OF PERFORMANCE

The statement of performance aspect of the proposal goes back to the importance of proper design, research, and product development. If you state in your proposal, "We will make the best 3D shooter ever!" that's a *statement of performance*. If this

phrase is your goal and guides the expectations of the team that has adopted it as the vision for the title, and you then move unconsciously into development without the tools, talent, knowledge, and know-how to make that statement of performance a reality, you are doomed to face frustration and failure.

Making unattainable statements of performance unconsciously is what often happens to a great many startups and new developers. They fail before they even get started, because they are unaware of the fact that the equation *(Performance + Time + Scope = Cost)* is in effect. As this equation makes itself apparent after the fact, these developers quickly become frustrated and stall in their efforts.

BUDGET RESEARCH

Researching a budget does not involve simply finding the cheapest possible solution. Once again, we return to the bell curve of effectiveness. The goal here is to weigh the choices and brainstorm new ones to get to the best solution for the problem. Let's examine a few examples.

Say that you have several long cut-scene movies in your game that are being produced by a 3D animator. The movies must be rendered on a computer frame by frame, which takes computer time to do. You are faced with a few decisions: Do you buy the extra, high-end computer system that can handle the rendering, budget time to render on all the computers overnight or on weekends, or maybe send your files to a company with a render farm (a large computer network specifically designed to render 3D animation) and pay the fee for no-hassle rendering? Other options might also arise: Should you redesign the game to have reduced or no cut scenes? Should you outsource the 3D animation completely?

Another example: If you are developing a title that is not a cutting-edge shooter but requires a simple 3D walkthrough of an environment by the end user, do you write the code from the ground up or license an engine? This, like all budgetary questions, goes back to your game design and earlier research and is affected by other factors. To make this decision, you need to know your intended audience and the technology base they are using, and you need to look into the technology you are considering licensing (can it do the job? is it well supported by the vendor? Is it stable?). Finally, whether you choose to write the code from the ground up or license the technology dramatically affects the programmer hiring decision. Does the programmer you hire need to code an entire engine with complex AI and physics, or is the walkthrough a simple development task that requires only a low-level programmer?

One of the largest wastes of time and money is to mindlessly go for the cheapest solution. When looking at two choices:

A) getting inexperienced individuals to do a job because they will work for less money

or

B) getting the experienced, reputable, and more expensive person

it is usually a safe bet that choice B will be the best choice. The more inexperienced individual will most likely take longer to do the job, might not do it as well, and could possibly ask for tools and money during the task that, due to lack of experience, he or she did not foresee needing.

WRITING DOWN THE NUMBERS

A game budget usually breaks down into two parts: one-time costs and recurring costs. *One-time costs* are for equipment, software, certain contractors, and down payments. *Recurring costs* are salaries, taxes, insurance, and rents.

Once you have defined:

- The level of *performance* you want to achieve (level of technology, art, licensed property)
- The amount of *time* you need based on market movement and other factors
- The *scope* of the project (addon pack, demo, cutting-edge game)
- The *cost* (artists, programmers, designers, computers, software, offices, etc.)

you can start the spreadsheet. Table 9.1 shows a sample budget spreadsheet based on a 24-month development cycle. The sample is not meant to represent any real game or development situation.

Table 9.1 Sample Game Development Spreadsheet

Item	Cost x No. Payments ($)	Total ($)
Programming		0
Lead programmer	7,000 × 24	168,000
Assistant programmer	3,000 × 24	72,000
Program testing	12,000	12,000
Art and Game Design		0
Producer	10,000 × 24	240,000
Designer	3,000 × 24	72,000
3D artist	3,500 × 24	84,000
Level designer	3,500 × 24	84,000
Animator	1,500 × 24	36,000
2D artist	1,500 × 24	36,000
Management		0
Business manager	5,000 × 24	120,000
Accounting		6,000
Legal		5,000

(Continues)

Table 9.1 *(Continued)*

Item	Cost x No. Payments ($)	Total ($)
3D Engine License		50,000
Sound FX	10,000	10,000
Music	5,000	5,000
Six PC workstations	4,000 × 6	24,000
Software		0
3D Studio Max	3,000 × 3	9,000
Photoshop	1,500	1,500
Office equipment		24,000
Rent	1,300 × 24	31,200
Total		$1,089,700.00

You need to know whether your team members will be full time, part time, or freelance, their salary and benefits, and other expenses not covered here. This is where you should have a good accountant help you determine the actual cost of employees. In the United States, after you pay your employees X dollars, there are still many other expenses involved: taxes, Social Security, insurance, benefits, and other items. Having one or more employees could become the largest portion of your budget.

CONCLUSION

And without further fanfare, you are ready to go to the publisher with your game. In the next chapter, we take the big step.

10 Going to the Publisher

Publisher Bait

Manuscript: Something submitted in haste and returned at leisure.

—Oliver Herford (1863–1935)

So, you did it! You assembled a team of talented individuals, wrote the documentation, even got a working demo of your game ready to go. You are now ready to try to get your game published. So wash your hair and brush your teeth—you have to be sociably acceptable.

As you have seen, submitting a title to publishers goes far beyond just shipping them copies of your demo. The amount of work and expertise it takes to land a game deal is enormous and can take longer to accomplish than developing the proposal. It can cost more money in some cases as well, once you factor in CD replication, shipping, airfare, legal fees, and so on. Once again, realize that the publisher is basically giving you a business loan of $2 million. You have to show more than just a great game—you have to show that the game is a good investment and that you can actually develop it.

As touched on in our discussion of the proposal, you have to be in one of the following situations to get a game deal:

- You are John Carmack, Peter Molyneux, or have a big name in the industry.
- You have a hit game on the shelf and a good idea for the next game you want to develop.
- You have little to no game development experience, but you have a killer demo of an awesome game idea, a well-detailed design document, and a team of individuals capable of developing such a game.

It is assumed that most of you will be in the last category, relying almost solely on the strength of your game proposal and demo. The good news is, you and your proposal will be judged by your game. Publishers will judge your proposal harshly and quickly because almost everything they see is not up to their standards, and they will assume that your game will not be, either. They also know that they have a stack of potential game deals on the floor by their desks.

But there are several things you can do to make sure your game gets through the initial tests and is seen by the right person. Mailing to the right person is a start, by the way; find the name and title (and correct spelling) of the right person and you'll be ahead of the pack.

You should be well aware of the titles that are on the retail shelves and even what titles are to be published soon. A trip to the publisher's Web site will tell you what's coming. From there you can find the developer sites and get the scoop from another angle. You can even talk to these people, but keep in mind they are all most likely busy, so don't expect a response and don't badger for one if you don't get it.

THINGS YOU MUST GET RIGHT THE FIRST TIME

The game developer must consider a number of details prior to contacting the publisher or submitting a game proposal. The following items should be considered before moving forward.

YOUR GAME HAS TO BE GOOD—NO, GREAT!

As important as are all the details—the right name on the package, the right company for your title, and all the presentational details, as well as market knowledge—pure and simple, your game has to be a great game that is fun to play. It must be innovative in some significant way. There must be a reason for the publisher to invest a huge sum of money to have you develop the title and then more money for the title to be published. You cannot excuse away or be blind to any defect in your game. Old technology, poor design, bad art—no detail in your game proposal can stand out and say, "I am not good enough for the retail channel!"

Ernest Adams, a producer at Bullfrog Productions, said it best: "As a game developer, it's your job to make a good game, and for that you have to have a certain amount of objectivity and detachment. You need a sharp, self-critical eye and to be constantly asking yourself, is this good enough? What would make it better? What deficiencies am I tolerating or overlooking? You must become your own toughest reviewer."

Talent and hype do not make a successful game. There is a difference between demonstrating superior programming skills with a fast rendering engine or superior art skills with an awesome portfolio and demonstrating how those superior skills (given the time and resources) will turn into a great game. The great game idea and the marketability of that idea must be implicit in the design document. You can't expect the publisher to trust you, read your mind, or give you a break.

You can't have unrealistic expectations of yourself, your game, or the publisher. You must understand who the publisher is: its publishing model, how it will publish your game, the number of units that are realistically sold via that model, the price at which the game will retail, and more.

And maybe your game *is* great—a great shooter, for instance. But the publisher you approach publishes children's titles, so it's most likely that a submission sent to this publisher will not be a gem in its representatives' eyes. That is not to say that you shouldn't have your pitch ready and call the publisher anyway, saying something like this:

"Hello, I am aware that Fuzzy Bunny Publishing currently publishes only children's titles, but I thought I would give you a call and see if you are considering going into the action market any time soon. We have a proposal ready to go if you are interested."

Such a call could open up an opportunity for you with a publisher that could possibly be talking internally about expanding its market. Being in the right place at

the right time and being somewhat aggressive is often the way people are able to land good deals. The key is to know what the publisher wants and to deliver it. If you deviate from that rule, you have to give a good reason. Often, a good reason will entice and interest a publisher if it is presented properly.

Before going to a publisher, ask yourself:

- Did my game crash all my friends' computers?
- Did everyone who saw my game act unimpressed or make derogatory comments about it?
- When talking about my game, did everyone compare it to other titles?

If your friends are all game players, maybe they are too jaded or subjective, but don't discount their input. You should also seek out a number of gamers who are not your friends and show your game to them—and then listen to what they say! The best way to do this is through beta testing. We talked about that in previous chapters.

YOUR PROPOSAL HAS TO COVER ALL THE PUBLISHER'S CONCERNS

You can't expect the publisher to wrestle with your proposal. Your publisher should have hard copies of your documents, the demo should install easily and not crash, and the folder it is contained in should be a quality standard folder. You do not want to skimp here and expect the publisher to print every document or type in batch commands from DOS; that is not acceptable anymore.

If you are invited to demo the game for a publisher, don't expect to use the publisher's system. In fact, many publishers (and most magazine editors) have a policy against letting developers install demos on their systems, and they have good reason. You may ask, "Don't they want to see the game that could make them a million dollars?" And the answer is a resounding no—at least, not at the expense of destroying their office equipment. These individuals have all had their systems crash, be infected by viruses, and even whole networks go down from bad demos.

The more you can demonstrate your understanding of the publisher and its needs and goals, the more interested the publisher will be in working with you.

YOU MUST CONVEY AN IMAGE OF PROFESSIONALISM AND COMPETENCE

If you deliver a quality proposal and get the interest of a publisher, you will be taking many calls and (gulp) flying out and meeting face to face with the publisher's representatives. As in so many things in life, first impressions are important in this situation. At some point, you have to step up and meet the publisher, even if you are working through an agent. The publisher's staff will want to meet the people they are funding and see you in action. You will no doubt be asked to demonstrate your game demo; this is your chance to show yourself and your game at its best.

And while you are sitting in the chair to run your demo, the publishing staff will crowd around you. This is when little things like oily hair, bad breath, and body odor become factors. So I was serious about that—brush your teeth and wash your hair!—and by all means practice your presentation of the demo.

This point is most important: You should not engage in bragging, lying, or exaggerating. These behaviors can be tempting when you're faced with the pressure to please a publisher so you can get a deal. If you do any of these things, you will kill your chances for a deal and will most likely create a label that will stick to you in the industry. As soon as the publisher thinks you cannot be trusted, you are sunk.

Obviously, most successful publishers are good business people, and many of them came up in the ranks of game development or have simply dealt with so many titles and development teams that they will sense if you are lying or exaggerating, or if you are simply misinformed.

ETIQUETTE

So, how do you act when you're around a publisher's representatives? A serious demeanor is probably best. Not that a bit of legitimate enthusiasm isn't a good thing when talking about your game, but being silly or nervous to the point of losing focus is a bad thing.

LET THE PUBLISHER TALK

By letting the publisher's representatives talk (and really listening to them), you will also pick up on valuable things that might be said. For example, if one game editor, eager to get the meeting rolling and over with in a timely manner, could start by introducing the new product lineup and, in the process, explain what he doesn't like anymore, you can hopefully tailor your proposal on the fly to avoid falling into the areas he's said are no longer of interest. Of course, you won't lie or exaggerate, but if the publisher explains why it will no longer publish FMV games, you can downplay the FMV portions of your game and focus on the game play or other features.

The "on-the-spot" pressure of the face-to-face proposal and meetings are another great reason you want to have your game well defined in your proposal. Chances are, if you've got the publisher this interested in your game, you have the details well organized in your mind and ready to present to the publishing staff.

THIS IS NOT THE END

Hopefully, even after your first call and your second, after your meeting and presentation, you and the publisher's representatives will keep talking. At the end of each conversation with the publisher, settle on a day that you can call them back or that they are supposed to call you back. This will help stave off the impatience of waiting for a call and not knowing if it will come. If you know you have to wait a week or

two for a call, you can write it down and worry less about it. After you call many people over a period of months, it's often hard to keep track of who you spoke to and when. Keep notes; write everything down. These notes will help you appear even more organized when publishers do call you back.

Be aware that trade shows, product launches, and holidays will usually keep people out of the office.

REMOVE STRESSFUL AND ON-THE-SPOT SITUATIONS

Most of us do not perform well when put on the spot; none of us really likes the prospect of having to be on the spot at all, if we can help it. One of the most stressful situations you can find yourself in is to attend a convention with the hope of meeting with a publisher's reps. Not only are you tired and facing a time deadline, but so is the publisher, and after the entire proposal, they will refuse to take your package. They will not want to carry it on the plane. A simple handshake and a nice business card will suffice; what you really want is the right name and address to send your package to in the mail.

Tailor your submission package and pitch as much as possible for each audience you're going after, focusing on each particular publisher. There might not be that many publishers on your submission list. Once you build up your list and seek out applicable publishers, don't be surprised if you have only 10 or 20.

Be ready to answer questions about everything—technology, game play, the market for your game, and the deal you are looking for. If, for example, you don't have an answer to the question, "So how much is it going to cost to complete your game?" you are not ready to talk to publishers yet. Your answer could be contingent on what features the publisher wants, but you should have a range in mind, and you should have an opinion regarding the features you feel the product needs to have.

Spend some time preparing. Pretend you are a publisher, and think up questions a publisher might ask. Then spend some time with other developers and ask them what questions they have been asked when they've met with publishers. With a good list of potential questions, you can develop quality answers ahead of time—but again, if you have a well-developed proposal, you should be able to answer all the questions put to you.

REALIZE THAT THIS IS NOT GOING TO HAPPEN OVERNIGHT

The biggest mistake that most businesses make is underestimating what it will take to be successful. Doing a demo and proposal might be a lot of work, but hunting for a publisher will take more time, more work, and more patience. You will end up doing a lot of stuff you probably don't like—stuff that seems so off the point and just plain no fun when what you *really* want to do is develop games. Let's face it: If you are an artist or programmer and got into all this for the joy of gaming, the sub-

mission process is everything but that. Still, it is a necessary evil, and you will help your own cause greatly by putting the same strong effort into the tasks you *don't* love as the effort you put into the ones you do.

WHY DOES IT TAKE SO LONG?

Once you send your package to the publisher, it has to be reviewed by one or more people, and that takes time. This is one reason you have to stay in touch with the publisher's reps to keep track of your submission. Even after the entire review process, there might be reason to wait longer—maybe months, until after a holiday season, a product launch, or a major trade show has passed.

By then, your demo might start to feel stale. Other games will have come out, and you might have thought of ways to improve your project. If your team is a group of full-time employees waiting for funding, you might be waiting quite a while. You will be faced with a team that doesn't want to do any more spec work on the title and wonders what's taking you so long to get the money. Once a publisher does mention a deal, you might be facing a few more months of talking and negotiations before you see any of the publisher's investment.

This is where a good attorney or an agent can help. A good representative is detached and impersonal. He or she knows how to negotiate and will add credibility to you and your cause. An agent or attorney will help you avoid the pitfalls of a bad deal.

USING THE GAME AGENT

Designing and developing a game is enough work in its own right. Submitting the proposal, following up, and getting a deal is even more work and, quite frankly, the worst kind of work for a developer type. So, giving an agent a percentage of the take on the back end might turn out to be a good deal.

Once again, you have to assess your own situation. Maybe you can handle the entire submission and negotiation processes on your own. If you represent an established team, you might have the contacts and experience to handle these jobs on your own. But even if your game gets you a great deal immediately, it still takes a great amount of time, knowledge, and effort to successfully negotiate and maintain that deal. You will need a person who functions as a business person. No matter what happens, someone has to be on duty to handle the business, and if that person is a member of the development team, those tasks will cut into the time that person can spend modeling, texturing, or developing the game.

A good agent can extend the power of your title with financing, publishing, licensing, and distribution agreements. Agents meet with and develop relationships with game publishers and, as the number of want-to-be developers grows along with

the fierceness of the marketplace, more and more publishers are turning to agents to get them their games. Maybe the game industry will eventually function like the book publishing industry, where agents provide the best possible clients, since their reputation depends on doing so, and the publisher will often take a book on the word from a long-trusted agent.

Another benefit in working with a good agent is that he or she will generally know the publishers. One publisher might offer a deal that's slightly inferior in objective terms, but that publisher would do a much better job marketing and building the developer's brand in the long term and would therefore be the better deal—and a good agent will know that. Good agents also know which publishers are in financial straits, and that can be extremely important in determining who will pay and who won't, and even who will be around in a year to publish your title. Of course, you must check the references of your agent.

CAUTION

Be cautious of some individuals calling themselves "game agents" that often deceive inexperienced developers into signing the rights to their games over to them. These "agents" claim they need those rights to effectively negotiate the deal. In my opinion, what they are doing is simply going out with your submission package and trying to get your game published for themselves. You should sign over the rights to your game only to the publisher publishing it.

Legitimate agents will usually work on a revenue base, which means they get paid only if you do. Don't work with agents who ask for up-front payment for *any* reason. They might claim that you need to pay fees for advice, product reviews, or the like, but this is not true.

Finally, realize that most publishers will still deal with a team if a team is good enough and has an established track record. However, you still have the deal to work through, and that could go better with an experienced individual in your corner.

REJECTION

Part of going to the publisher is dealing with so-called rejection. It is no wonder the word *rejection* is used so prevalently when it comes to the submission of creative works such as art, writing, and game proposals. We personally feel rejected because, after working months, sometimes years, on our game proposals and then submitting them, they are thrown back in our faces with no ceremony—or at least we take it that way. It only makes sense that we use the term *rejection* to describe this process when we view it from a highly personal perspective. However, what is actually happening is not a *rejection* of you or your game; rather, it is a sign that something was not right about your demo—maybe something you can fix!

LOOK AT THE SITUATION FROM A LARGER PERSPECTIVE

The process of repeated failure exists in other industries, but it is not as often called rejection or failure. What we term *rejection* may in the business world be called a lost sale, a soured deal, or another term that expresses the perfectly normal fact that you, your product, or your service will not always be wanted by the people you are trying to sell them to. Businesspeople learn from these "failures" and move on. The facts of doing business are that a certain number of deals need to be entertained, hands shook, and doors knocked on, and the businessperson will find it acceptable to try and try again.

Salespeople know that they have to knock on a hundred doors to make one sale, but many creative types think that their masterpiece will be snapped up instantly on its merits alone. We are not prepared to hear "no thanks." However, the fact is that if you are striving for a game deal, you are entering the business arena. Having poured your heart and soul into a proposal might make it feel very personal, but still, *you* are not being rejected. Instead of hanging our heads in sorrow, we should really be planning to move on, assessing our situation, and knocking on the next door. Maybe you were not rejected at the very first door because no one was home or you simply went to the wrong house. But at some point, you will face rejection, and you must deal with it.

So when the proposals come back, realize that it is not the publishers that have to change—they wouldn't anyway—it is *you* who must change. You have to change your approach if you are to get a deal. Primarily, you have to change your notion of rejection. It is that simple. If you refuse to change, there are hundreds of other developers ready to do back flips if necessary to get a deal.

WHAT IF YOU GET A "NO THANK YOU" NOTE?

```
Dear Developer:

We are rejecting you and your title!
Please never send us anything ever
again. We are sure other publishers
will feel the same way.

                    Cordially

                    The Publisher

P.S. Your dog is ugly, too!
```

Now *that* could be called a rejection letter, but that is not even close to what you will get from a publisher that is not interested in your title. In fact, the so-called

rejection letters are usually, at worst, very nice form letters. They are not personal in any way, so don't let yourself shut down and give in to negative thinking. This is a critical time to keep moving forward with your plan to get your game developed. Realize that the concept of rejection is not valid, for two reasons:

- What people usually call *rejection* is really a choice. Do you "reject" the pickles at Subway, or do you simply choose not to eat them? That is how the publisher looks at your title—just another choice at the game developer buffet. Your job is not to get offended but to figure out why your title wasn't accepted for development.
- If someone actually attacks you on a personal level or attacks your team or your game, that person has a personal problem. Maybe the individual is having a crisis; maybe you did something to upset him or her. If someone at a publishing company does act this way, you have to ask yourself three important questions:

 1. Am I taking this person too seriously? Did he or she really mean to be so abrupt, or was I just being too sensitive?
 2. Should I talk to someone else at the company? Does this person have the authority to dismiss my game? Am I talking to the acquisitions person?
 3. Finally, do you want to work with a company that has a person like this working for it?

In all likelihood, you will never be treated this way. Some people might be too busy to talk to you and get you off the phone rather quickly; others will answer all your questions; still others might keep on talking for a bit longer than you would like, but in general you will never be rejected in a highly personal fashion.

So, if the top game publisher in the world is not interested in your first-person shooter, it is not a rejection of you or your game. It might be that the publisher already has many of the top games in its lineup. The reasons a publisher might not want your game are many and varied. You simply need to ascertain why you were rejected and decide whether you can fix that problem or not. Doing this is extremely important and cannot be stressed enough.

YOU MUST SEIZE THIS GREAT OPPORTUNITY

The point of sending out demos is to get what you and your team have worked so hard for: a publishing deal. To let a rejection pass without significant investigation is like climbing Mount Everest and not bothering to stick the flag in the snow. It is amazing that many developers will work for a year or more on a game proposal, mail out the packages, and never make followup calls when they get a letter from a publisher that says "no thank you." They call it a rejection letter and feel as though they have failed.

When you start getting form letters that say "thanks, but no thanks" or no response at all, ask yourself the following questions:

Did I Talk to the Right People at the Publishing Houses?

Did you get in touch with the person who makes the decisions and ask them why your title was not accepted? Keep in mind when asking a publisher this question not to sound accusatory. Make sure that you make it clear to them that you are calling to learn and improve, not to hard-sell them on your title.

Did I Talk to the Right Publishing Houses?

Did you do your homework? Or did you send a bloody first-person shooter to a company that publishes only children's titles—maybe even a company that has pioneered the fight against violence in games? Are you sending proposals to publishers that are out of business or that state in their PR materials that they do not accept independent developers or don't publish on the platform you develop on? In short, did you know who the publisher is and what it wants, and does not want, in a game?

Was There Any Interest at All?

What made the publisher perk up and request a proposal in the first place? Were you simply talking to the assistant to the assistant to the secretary of the VP of new product development and submitting your title into the slush pile? If you in fact talked to the decision maker at a publisher and that person was initially interested in your title, find out why and what turned him or her away from your title in the end. Once again, it will probably boil down to the fact that the publisher had other titles ahead of you, more experienced teams ahead of you, or any number of reasons that have nothing to do with you personally or your game specifically. But you need to know why in order to fix whatever aspect of your game might have led to the rejection.

Did You Present a Game That Was Marketable and Technically Feasible?

Was your idea any good? Did you do the proper research into the marketability of your title? Did you define a feasible development schedule and budget?

Did You Do Your Completely Awesome Game Proposal on a Hard-to-Obtain License?

Did you make your game based on the movie *The Matrix* and have no idea what a license is, how to get one, or who has it? The fact is, a publisher will not want to deal with a situation like that, no matter how great the game proposal and idea, because the rights for a hot property like *The Matrix* are usually tied up and/or handed off to

more established teams. If you develop a proposal on a license like this, you are taking a huge gamble. Don't be surprised if you find no takers.

Did You Present Yourself as Someone Who Could Do the Game?

Did you give an ineffective presentation or otherwise cause the publisher to question your ability to develop the proposed game? Is your team's track record convincing?

Conclusion

This is arguably the most critical time in the proposal and submission process. While most developers can develop a demo and then develop the game, the actual submission process between the development portions can be the hardest and the area in which most development efforts fail. How you handle this portion of the process can possibly make or break your deal, and you must be prepared for hard work, both mentally and physically.

In the coming chapter, we look at negotiations. Negotiating starts when interest is shown in you as a developer and your game as a viable project.

11 Negotiating Your Deal

For business reasons, I must preserve the outward sign of sanity.

—Mark Twain (1835–1910)

I f you have ever tried to buy a car and sat through the typical car dealer treatment at a dealership, you have gotten a small taste of negotiation. Even the best negotiation can be a very tense experience, but negotiation need not be confrontational. In fact, real negotiation happens when the parties involved work together to fill each other's needs and find the best possible solutions—where each side wins, so to speak. If one party is not happy with the final deal, before long, *both* parties will be unhappy.

CAUTION

If you find yourself in a confrontational negotiation, you are doing something wrong, the other party is doing something wrong, or the situation is not right for the two of you. In any case, it would be wise to back off and examine the situation before proceeding.

Do not view negotiation as an all-out contest in which one party must win and the other must be defeated. Here is a classic story about successful negotiation: Two chefs were fighting over an orange. Each needed the orange for a dish she was cooking. The typical "cut it in half" solution would have left each chef with only half of what she wanted and needed. A wiser party stepped in and asked the first chef, "What do you want to do with the orange?" The chef replied, "I want to use the pulp for my dish." The other chef suddenly lit up in awareness, "Well, all I wanted was the rind for my dish." Of course, in the end, both chefs got *everything* that they wanted and needed. This might not always be the case in your negotiations, but you will be surprised how often things can work out to the benefit of all parties.

In addition to adopting the "right" view of negotiation going into it, there are other key factors to successful negotiations. Not being afraid, not taking the process personally, and being prepared are all important.

ABOVE ALL: BE PREPARED

The basic key to successful negotiation is being prepared by knowing what you and your idea are worth. You need the most accurate possible assessment of what you will need to develop the game. If you don't know what the costs will be or you don't have good research and reason to back up those costs, you will be either dismissed or pushed all over the table during the negotiation process. The worst thing that could happen is that you get yourself into a bad deal.

Never make decisions under stress. If you are sick, fatigued, emotionally drained, or dealing with personal problems, the negotiation will have a big chance of failing

for both parties. If the negotiation turns into a situation in which you feel cornered or can't think straight, temporarily stop the negotiation. A good deal will wait until the time is right. Never make decisions under stress. This is one reason to have at least one other person—an attorney, agent, partner, or experienced negotiator—with you to help take all the focus and pressure off you.

While you may think that the deal should be clear-cut—you need X amount of resources to make the game, and if the publisher wants the game, the publisher will simply give you the money—it almost never is. The negotiation process will squeeze your preconceived notion of your game development, and all the work you did, right out of shape—but that is to be expected. This can sometimes be the effect of your lack of preparation or often is simply due to an experienced game editor (who will have seen hundreds of development efforts take place) asking you pointed questions you might have not anticipated. You will be made to think of options and circumstances you haven't considered. The publisher sometimes knows more than you do about game development and, if he or she is really interested in your title, might actually help you reassess your development plan to make it more effective. Don't expect or request this help, though—ever! You have to go in fully ready to tackle the job on your own.

Keep in mind that you are negotiating for more than just money. Ask yourself questions such as, How secure is this company? How long term are they talking? Do I like these people? How did everyone else in the company act as I walked through the office? Did I look at other products this company produced and talk to its other developers? Read the reviews of the company's products? Compare the deal I was offered to others on the market?

YOUR NEGOTIATION POWER

You might have determined what your game *might* be worth in the marketplace and what your unique skills or job description are worth on the job market (which, for the purposes of creating a budget, you should have done by this point), but what are you worth to the publisher? This is a good question that few developers ask themselves. To determine the answer will also help determine your degree of negotiating power. That's right, you *do* have negotiating power—maybe only a little, but you wouldn't be there if the publisher wasn't interested in you.

Look at the publisher you are approaching. Does it have other developers lined up in the hall? Have the publisher's reps made comments about you and your game as though it is already theirs? Are they that excited about it? Who did they send to negotiate with you, and what is that person's position in the company? How much authority does that person have? Can you talk to other developers about their negotiations with this and other publishers?

WHAT DOES THE *PUBLISHER* WANT?

Negotiation of your deal is not only about what you want and how to get it from the other party. If you stop and look at it, the publisher might not simply want a great game to publish. Put yourself into the mind of the people at the publishing house—that specific publisher. You need to ask yourself questions about their point of view: What represents a successful development for them? What will this publisher consider a "win" in a negotiation? How can you make them look better, feel better, and walk away happy?

HAVE NO FEAR

Fear leads to Anger. Anger leads to Hate. Hate leads to Suffering.

—Yoda

The temptation is to be nervous when you walk into a negotiation. It could feel as though you are about to choose a door—on the left: your old life, and on the right: your dream life as game developer. Don't let those apocalyptic visions enter your head. They'll only make you more nervous.

Remember that walking away is always an option. *Never* take a bad deal. If you are being pressured, something is not right; even more than ever, you need to cool down about the deal and assess it. There are other publishers out there. Hard as it is to believe, no deal at all is better than a bad deal.

NEVER LET IT GET PERSONAL

Negotiations can get emotional, especially your first one or two (or 10, for that matter). However, you absolutely *must* remain calm and collected. Most publishers are used to dealing with novice negotiators and will try to make it easier, but some will use the heat to roast you. Either way, it is important that you are prepared to stay calm and pay attention.

One of the things that could throw you off is the publisher's approach to your game. Although the publishing staff might praise your game proposal, they are often not interested in talking about the game so much from your perspective (how cool it is and enjoyable to play) and will instead want to talk about everything else: intended audience, budgets, schedules, and all the business aspects of developing the game.

In almost all negotiations, the same thing happens: when it comes time to talk money, all your research and numbers will be scrutinized, and the publisher will feel

very differently than you do—sometimes drastically so. The publisher's staff might suggest changes that will diminish the game in your eyes. For example, they might insist you use other development tools that are cheaper but (in your opinion) not necessarily better, simply because they have those tools in house. Just as likely, they could suggest better routes for development, better vendors, and even some design changes that might open up the market for the title.

Keep in mind that your deal is not all about money, and the work you did was not wasted; this is where it actually pays off. This is where communication is important and where creative solutions come from. A publisher could look at your salary demands and wonder why you want so much. You need to be able to justify your salary in terms of the market, your employment history, and the work you will be doing on your game.

YOU HAVE TO MAKE A LIVING

Remember from the Introduction of this book: Game development is a for-profit business. You are in *business,* and you need to act as a businessperson does. Businesspeople tend to want to make money. In the thick of negotiations, you can get worn out, emotionally or physically, and start thinking things like, "This is my dream life, I would do this for free if they let me." Or "Maybe if I come way down in my salary, they will be happy and we can finish this torture." But that won't happen, for reasons we will look at later.

You have to get paid, and you should get paid what you're worth. Letting yourself get too enthusiastic falls into the category of getting personal and unprofessional and undermines your negotiation power. Remember that game development is work, and you will sorely regret making a deal based on doing what you love for free or less than what it's worth, because you will quickly fall out of love when reality sets in. The accurate and only thinking is, "What is the *true market value* of what I am proposing?" Remember, though, that although you have to go for a fair deal and get paid, you can't go for an outrageous amount, either.

ASK FOR WHAT YOU NEED, NOT WHAT IS FAIR

There are many ways to negotiate, and most people start out thinking that between two fair-minded parties, negotiations will go smoothly and quickly. The theory is that asking for money or terms very close to what you actually need is fair. The problem with that thinking is that what is fair and what you need might be far apart, and this inaccuracy will mark you as unprofessional and make you miserable if you take less than what you really need.

For example, let's say that you determine that the costs of your salary and office space amount to almost $20,000 a month (just to pick a round number). In an attempt to make your deal more attractive to the publisher, you knock that way down,

thinking you could simply live in a cheap apartment and have the office in your home. You might get the cost way below $10,000 a month, but doing so will come across as unprofessional, and the experienced person will know that after too long, you will not be very happy with low wages and no personal space. Professionals ask for what they will need to do a job. "You get what you pay for" also rings true in a publisher's mind.

PSYCHOLOGICAL SATISFACTION

You should start your proposal from a reasonable point but have some room for sliding down toward your bottom-line number. There are many good reasons for this technique, and one of them is psychological. Most people will simply not believe that you gave them the cheapest and best deal, with terms in their favor, immediately in the negotiations and will proceed to negotiate anyway. This feeling is due to the expectations we have of what a negotiation is supposed to be.

Imagine going to buy a car from a dealer you have dealt with before. You have also dealt with the dealer's salespeople and know that this dealer does not charge a fair price for all the cars on the lot. In fact, you expect the sales staff to sit you down and make you wait a bit to wear you down. Having done your homework, you are prepared with data on the actual worth of the cars. Now, if you offered a price below the list price and the salesman quickly responds, "Okay, sign this," your first thought would be, "Whoa! What's wrong with the car?"

It's a fact: People don't feel satisfied until they have gone through the process of exploring a deal, negotiating, and determining that they have gotten a good deal. If this is not done, you will walk away feeling that you could have possibly asked for more (money, resources, whatever), and you will also be tortured by the question, "Why did they roll over so easily?"

This does not mean that you should double all your budget numbers or ask for an unreasonable amount, but asking for your dream deal might get you one that is more than acceptable. Some of the negotiating points that you should be flexible on are advance amounts, royalties, and time to complete.

ROADBLOCKS

There will usually come a time in a negotiation when things seem to hit an impasse. This impasse *might* have been created by a shrewd negotiator. After some debate over a point not really important to the negotiator, he or she might back off, but only after bringing up another item that was not initially important to them. The negotiator might have dismissed an earlier point by saying, "Let's get back to that." The negotiator didn't get emotional or tell you the point was important to him or her; the negotiator simply attacked it from a different angle, with you none the wiser.

Not all negotiators do this, and most impasses are real. The way to handle any impasse is to not be pressured or backed against a wall. Don't get frustrated; simply step back for a few minutes, an hour, a couple of days. If you return to the table and it seems nothing (moods, points of contention, and other aspects) has changed, you might have an aggressive negotiator bent on having his or her way, and you might want to question the wisdom of dealing with this company. Normally a good negotiation, after a break, will resume with a pleasant attitude and several creative proposals for solutions or changes in the deal. Both parties will usually have a long list of questions for each other. Furthermore, both of you will also have had a chance to reexamine the deal and the points that were being discussed. Often, the original point of contention will dissipate because it was a product of stress, fatigue, or miscommunication.

NEGOTIATION IS NOT A DEATH MATCH

This negotiation will not be the last time you see or deal with the publisher. If either of you is unhappy—or becomes unhappy at a later date—chances are strong that both of you will end up unhappy. Keep this in mind as you negotiate, and don't settle for less than you need.

HAVE YOUR LAWYER CHECK EVERY DRAFT OF YOUR CONTRACT—EVERY TIME!

As part of the negotiation process, you will most likely receive many drafts of the contract. With so many terms and areas for movement, negotiating a game development deal often creates more copies of the contract than you can imagine, and you *must* read them all. Most people tend to read only those terms or sections marked as changed, but it is important that you and your attorney read *every* line of *every* new version of the contract. This practice helps you know *exactly* what you are getting into.

Don't be afraid to look up words in the dictionary and ask your attorney to explain legal concepts and phrases; that is what attorneys are paid for. In a contract, every line and every word means something important, or it wouldn't be in the contract. It could take several read-throughs for you to entertain all the "what ifs?" that you can come up with and play out how that situation will transpire under the current draft of the contract—but you must spend the time doing that.

Remember, once you sign the contract, you are bound to its terms.

CLOSING THE DEAL

At the conclusion of the negotiation, you should feel more that you are in a partnership than in a negotiation. If you don't feel that way, reassess the deal. If both sides have not dropped their defenses by now, there is something wrong.

During a negotiation, "Never let them see you sweat" is an important guideline. After the deal is signed, "Never let them see you dance in the parking lot" is the important rule. Don't let down your professionalism at the end, as though it is not needed anymore. There will still be times you have to negotiate, renegotiate, and deal with the publisher professionally—there will be a *lot* of these times. So go to dinner, celebrate, be relaxed and joyful, but stay professional.

GOD's TEN COMMANDMENTS

The Gathering of Developers (GOD) offers 10 commandments on its Web site (*www.godgames.com/?section=corporate&page=10commandments*) that together constitute a useful guide for aspiring game developers. Although the areas covered by these 10 Commandments are important to understand, keep in mind that the terms presented will most likely not apply to first-time developers. In fact, the terms presented pertain only to well-established, major-hit-producing developers. The Gathering's Stance items in the 10 Commandments are not terms you should present to every game publisher.

The areas covered by GOD's 10 Commandments follow. They are defined here for your reference, but you should always work in conjunction with a qualified attorney.

INTELLECTUAL PROPERTY RIGHTS

Intellectual property rights include your game's name, characters, story, trademarks, logos, copyrights, source code, and any art, illustrations, music, or other content that you create for your game.

ROYALTIES

Royalties are the percentage of sales that comes to you as payment. Typical royalties are of the publisher's net.

MERCHANDISING AND NONINTERACTIVE MEDIA EXPLOITATION RIGHTS

These are the rights for the creation of tee shirts, toys, and other products that could make further profit for the publisher.

PORTS AND CONSOLE VERSIONS

These are the rights to port your game over to other game systems, operating systems, and platforms.

MARKETING BUDGET

The marketing budget is the amount of money the publisher spends to promote your title to buyers and end users.

YOUR COMPANY'S REPRESENTATION

Where will you get credit as the developer of the title? Where will your logo be displayed, and how prominently? Will there be a credits page in the manual, in the game, and on the publisher's Web site? Some games give barely a clue as to who developed them, whereas others are marketed on the developer's name. Generally, the developer gets adequate representation or financial recompense.

PUBLISHER'S FAILURE TO PUBLISH YOUR GAME

What happens if the publisher does not publish your game? Of course, what happens will depend on *why* the publisher did not publish it. If you did not develop it according to your agreement, you have no recourse, but if the publisher failed in its duties, you might have recourse. These details should be spelled out in the contract.

GAME TESTING

It is a good idea for a game slated for commercial publication to be thoroughly tested by a professional firm. These companies specialize in game testing and not only test your game on a large variety of hardware, but they offer consumer testing as well. The publisher generally pays for game testing.

INDEMNIFICATION CLAUSES

You should be held liable only for actual content you create.

YOUR EMPLOYEES

Your contract should include a clause that does not allow the publisher to hire your employees for up to two years beyond the date on which your game was released. This is known as a *nonsolicitation clause*. Your publisher will rightfully want the same protection.

CONCLUSION

In conclusion, negotiations can be the hardest part of making your game deal. Experiences can range from very smooth, with everything clicking into place, to months of fruitless discussions and debates that finally end with no deal. Although it might seem terrible to invest a lot of effort in a deal and then have it cut off, in hindsight, the many developers who had a rough negotiation period also had a rough development (as far as relations with the publisher) and their titles were also

more likely to be scrapped. If you find yourself in a "rough" negotiation, you might want to question the wisdom of pursuing a long-term development deal when the negotiations are going so poorly.

Finally, being a game developer might be your dream—to the point where you think you would endure anything to do it—but you are in fact better off never being a game developer than signing off on a bad deal. A bad deal will most likely leave you with no game or one that puts such undue stress on you and your team that it can potentially ruin the chances of your team moving on intact to your next development deal.

Next: What if, after all this, you do not get (or decide you do not want) a development deal? All is far from lost. Read on!

CHAPTER

12 Finally, After All This

Anyone who has never made a mistake has never tried anything new.

—Albert Einstein (1879–1955)

When all has failed in your efforts to get published, do not despair. You will have many options after having produced a well-done game proposal. You can consider funding your own development, getting venture capital funding, or trying your hand at Internet publishing. You have several options, as you'll see in this chapter.

ALTERNATIVES TO PUBLISHER FUNDING

We discussed what the publisher goes through when it agrees to publish a title—taking on virtually all the financial risk; packaging, replication, marketing, technical support, the retail channel, and more—so this seems to be the best way to get your game published, if you can. If you can't get a publisher's interest or if you haven't tried to, and you are planning to get financing for your title from some other source, think very seriously about it first and thoroughly explore what you are getting into. It is not suggested that you try to fund your own development unless you know what you are letting yourself in for, have a background in the business or finance, and have a feasible plan that will make it a successful investment.

BANK LOANS

When trying to fund their own development, many developers first go to a bank for a loan. First, you should know that you will almost assuredly not be able to get a $2 million loan from a bank, especially if you have no collateral. Since most of your money would go into salaries and equipment (computers) that depreciates rather quickly, the bank would not have much to seize and sell to recoup its loss if you should fail.

Even if you *were* able to get a loan for such a highly speculative venture as a computer game, your loan would be for a five-year period, and you would have to start repaying it six months after you took it. Your payments would be about $44,000 a month! Part of the expense of paying back the loan would include interest—an additional $640,000 above the original $2 million. You could not make these payments, because you can expect no incoming cash flow throughout the development cycle of your game, and royalties will not come in for months after the game's launch. During the writing of this book, a top-selling developer that had produced many hit titles closed down due its poor cash flow.

You will most likely be in the company of the thousands of other developers who don't sell a million units (prerelease) and who have to deal with the tough finances

of trying to be a commercial developer, even if you get a publisher and produce a hit game.

WHY IS FUNDING YOUR OWN DEVELOPMENT VERY RISKY?

Funding the expensive process of game development and not getting a publisher's interest will likely find you with a game that no one will publish. A completed game with no publisher input could miss the mark in the marketplace. Publishers are necessary and good at their functions. Because publishers normally fund development, they spend a great deal of time assessing that huge risk and trying to minimize it. The earlier chapters of this book touched on the marketing and other areas publishers strive to master in order to know what games will sell and to whom.

Most publishers will not feel "close" to a title they didn't have a hand in developing. It will be harder for them to market and rally behind such a game. Most games need to be marketed and publicized months before launch (six months or more), so even a complete game will still be at least six months from launch when the publisher accepts it.

Of course, if you find yourself in this situation, you hold some attractions for a publisher. Publishers didn't pay you a huge advance, so one could take on your title and publish it, but if that publisher determines that the game you developed (without its input) should be in the bargain bin for $14, that might be right where it belongs, and you'll have to live with that. Remember, this is business, and a publisher will sell your game where it is most likely to make a profit. A well-placed bargain might make money—maybe even be an astounding success, as *Deer Hunter* turned out to be. If a publisher tries to pass off the same title on the retail shelf for $40 by putting it in a fancy box, consumers who buy it will be disappointed and the publisher could easily lose money.

Let's look at *Deer Hunter*. Initially, many developers were critical of this title because it was not as "full blown" as *Quake 2* or other games. But what they did not realize was that *Deer Hunter* was *designed* for the bargain bin; the publisher had a different *intended audience* than it had for previous titles. The publisher was very successful doing what it set out to do. *Deer Hunter* hit the number-one PC game spot in 1998 and hovered in the top 10 list for months. It has produced many sequels, spinoff products, and, of course, many imitations. *Deer Hunter* opened up new markets and distribution outlets and created new opportunities for developers.

In fact, as developers, we need a proper perspective on what the *Deer Hunter* development team accomplished. *Deer Hunter* is often compared with games costing two to three times as much in the retail outlet, with budgets 10 times or higher than what the *Deer Hunter* team had to work with. It has been said that *Deer Hunter's* total development cost was around $75,000! *Deer Hunter* was targeted specifically at nonenthusiast game players. Toward that end, both controls and game play were kept as simple as possible—on purpose. *Deer Hunter* was also developed from the

ground up by three programmers (one was a college intern) and a part-time artist in less than three months.

So, the publisher may well determine that what is right for your game is not what you want, but it might be for the best. The publisher will not gear its marketing and sales to what *you* think should be done. Sadly for you, the publisher can also not gear the game's expected return to your development costs; it must place the title where it believes the game belongs in the market. Think about how *Deer Hunter* would have performed had the publishers put the title on the shelves next to *Quake 2* where hard-core gamers would find it and charged $40 for it. Not only would the hard-core gamer probably not touch it, the *intended audience* would have never found it and bought it in droves—so the game would probably have been a loss all around.

So, although you might have spent $50,000 of your own money developing your title, you could find that the only interested publishers are willing to give you about $10,000 as an advance. Are you being short changed? Are you being treated fairly by an honest publisher? Most likely, if this was your first title and you received no feedback during development, you spent $40,000 learning how to develop a $10,000 game.

If you do find yourself in this situation, you *might* have a chance to convince the publisher to invest more resources in the marketing and promotion of your title while you use that time (about six months) to improve and make changes to the game.

FUNDING THE PUBLISHING AND THE DEVELOPMENT YOURSELF IS EXTREMELY RISKY

Unless you are a professional with some background in both developing and publishing, you can't fund both the publishing *and* the development of your own game—especially your first time out. This general rule applies because, although there are examples of developer/publishers and startups that make it, it is assumed that most readers of this book are interested in game development, not publishing, and have enough to deal with just trying to get a first game idea developed and looked at by a publisher.

Developing and publishing games are two different businesses. They both take money, time, and talent that is hard to successfully bring under one roof, even for established professionals. Although some have succeeded at doing it all, most must choose one course of action, as id software did. It tried publishing, was successful, but did not like the distraction it posed to its main talent (developing) and stopped.

GETTING A PUBLISHER AND THEN FUNDING THE DEVELOPMENT YOURSELF

Getting a publisher and then handling funding yourself might signal no real interest in your game on the part of the publisher if all that transpires is a conversation in

which the publisher says, "Yeah, you develop the title and we will publish it." If, in fact, you get a publisher to work with you because you are going to fund the development yourself, you need an attorney and an experienced game industry professional to help form the deal. Everything must be in writing, and you should expect the development and the terms of the contract to be very different from a traditional deal. You should probably expect a higher royalty rate and more access to information but you'll still get the publisher's input on the title.

This discussion centers on developing and publishing for the retail channel. It is quite feasible to make a game and sell it on the Net. Later we look more closely at that option.

In the opinion of most developers and industry experts, you really shouldn't fund your own development. Developer funding is one of the most common mistakes made by first-time developers—investing your own money, using your house and savings as collateral, with the hope that the "big payoff" will make it all up in the end. It almost never does, and gambling with your life is the quickest way out of the game development industry.

THE GOOD NEWS IS . . .

You can explore many other options besides bank loans and funding your own game yourself—options that require less time, money, and commitment and that could make you happier in the long run:

- Develop levels and addon packs for existing games for fun, profit, or learning.
- Develop 3D applications and content for companies that only want walk-through demonstrations and not full fledged games.
- Do your first game for the experience and/or to eventually get a job in the game industry.
- Self-publish your game on the Internet.
- Publish for another market. This is often easier to do, and a larger demand for easier games is opening up—card and tic-tac-toe games as well as games that are not of the 200 frames per second, 4 million polygons a frame, and "you better have a 45-inch monitor and a T3 line or you can't play" variety. Look at *Deer Hunter, Barbie,* and other titles that had audiences different from the intended ones and made their developers successful.
- Focus on an aspect of game development you shine at, and contract out your skills. Some individuals and production houses optimize code, do game testing, and create art and music and even storyboards for the game industry.

ALTERNATIVES TO THE PUBLISHER ITSELF

Most alternatives to the publisher involve some form of self-publishing. There are a few options, but you should thoroughly explore each option before you commit to one.

VENTURE CAPITALISTS

A great deal of venture capital is on the market these days (in 1999, 4,006 companies received $35.6 billion in venture capital funding, according to the PricewaterhouseCoopers *Money Tree Survey*); there are also loads of hungry startups and emerging companies competing for those funds. Although it seems as though there is a lot of money for the taking, getting your hands on that money is a different story and could be difficult with such a speculative deal as a game. Keep in mind that a venture capital firm may see 3,000 or more business plans a year, yet give funding to only 10 or 15 of them.

When you work with a venture capitalist you are basically selling your game, your company, and yourself (for a period of a few years) to that entity. If the venture capitalist is to fund the entire enterprise, it only makes sense that it reap the benefit of the gamble it is taking. If you go this route, you are, in effect, buying yourself a job as a game developer (the VC will then become your employer). This is a hard sell to a serious VC, since you will have to sell the nontraditional nature of your business. You will have to explain why your business plan has no cash flow for at least three years, no marketing section, or other traditional areas, since you will most likely be dependent on getting a publisher to do these things. And you will still have to get a publisher.

It will be difficult to provide any hard data to show that the VC will ever make a profit or even simply get its money back, since most games do not make the developers a huge profit, if any profit at all. If you are going to get a publisher to do the expensive dirty work after you develop the game, you should have the publisher finance the development as well. In addition, as previously mentioned, if you get all the money and develop the title with no professional game industry input, you might develop a game that a publisher will not want, pointing out its flaws after you have spent all the VC's money. It would seem that doing all the work it takes to get a VC, and then doing the work you will have to do to get a publisher, you are doubling your workload. Why not simply get the publisher?

INTERNET PUBLISHING

There is great potential in Internet publishing—so much so that many companies are heading in that direction already. For instance, Wild Tangent is producing an Internet-based game development tool, and Web Corp. is beginning to publish online games. Both companies have recently teamed up. You can even make a down-

loadable, small-scale game and sell it on the Net yourself. Setting up an order system can be done for about $1,000 of initial investment. On the Internet, you can sell fewer games for less money and still make a profit.

You can also develop niche products—games that a smaller audience will appreciate—on the Internet. Since most publishers will not publish a game if they can't sell a minimum number of units, you can develop a game that might be profitable selling only a few thousand units on the Internet, as opposed to tens or hundreds of thousands of units on the standard market.

Here are the basic steps in self-publishing on the Internet:

1. Get an account at one of the many online stores, such as the Yahoo! Store (*http://store.yahoo.com*). There are others, but be careful to look into their policies on pricing, security, reputation, and the like. The ability to take orders and payments online is a very powerful tool.
2. Create your game-specific Web site and make the demo available for download from your site as well as *www.download.com* and other sites your intended audience might frequent. Your Web site should have screen shots and other areas to build interest in your game. Have a contest to give away a copy of your game; include the customers in other promotions.
3. Inform the game-oriented Web sites so they can announce, preview, or review your game. In general, the game magazines won't review a game that is for sale online only, but you might not need them, since the audience you will reach could be much larger on the Internet.
4. Announce your game in newsgroups and other appropriate forums, and gauge your responses.
5. The beauty of this approach is that you can change on the fly and learn directly from your customers, and you don't have to have millions of dollars invested. But if done correctly, this approach will take you back to understanding product design and marketing.

ONLINE PUBLISHERS

Earlier, I mentioned World Entertainment Broadcasting Corp., or WEB Corp. WEB Corp. is a company founded by Jim Perkins, the former senior VP of GT Interactive and founder of FormGen, which distributes games online and plans to make games episodic in nature. Gamers will be able to download one episode of a game, play it through, and then wait for the next installment to be released. It's a novel idea that shortens the development process and allows gamers to have direct feedback into the direction of future installments. Recently, Wild Tangent Inc. and WEB Corp. teamed up on a technology called WebWorks Web Driver.

According to Jim Perkins, "Using an 'entertainment series' concept, we look forward to cliffhangers or ironic plot twists never before seen in this industry. As we give developers the freedom to spell out organic story lines, we revolutionize the

consumer experience. It was the episodic series phenomenon that drove television to the mass market—we see our model doing the same for Internet entertainment."

This could be an opportunity for the small developer who can download the Wild Tangent SDK (*www.wildtangent.com*) and start developing a game with it.

GETTING A JOB IN THE GAME INDUSTRY

By this point, you might not be so excited about trying to publish a game yourself. Maybe you just want to make games and would rather get a job where you can make games in peace and let others deal with the marketing, contracts, negotiations, and other business issues. Having a well-developed game proposal is an excellent tool in helping you get that job.

> *A lot of people think that it's difficult to get into the games industry. The truth is, there aren't enough good people to fill all the available jobs. Getting a job in the game industry is the same as in any other industry, and it all comes down to one question: "What kind of experience do you have?" I know a lot of people in the industry at many different companies who started off in places like quality assurance testing games. They showed competence in those roles and had the opportunity to fill other roles in the company and are now producers, designers, lead programmers [. . . } Just working for a good game company in any capacity is an excellent step in the right direction.*

> —Mike Dashow, blizzard north

If you have spent many months, or a year or more, of your life developing a game proposal and don't get a game deal, don't despair. You now have a great experience for getting into the game industry as well as a great deal of knowledge and experience you would not have gotten otherwise. You must capitalize on this experience. At the very least, you will most likely think of a million things you would do differently the next time you develop a game. You will be better and faster at what you do. In fact, everything you have read or studied previously will take on newer and deeper meanings and become more useful to you.

First, decide what it is you really want to do. What did you enjoy the most about the process of developing the submission? Was it the organization, the team, the solo work, the art, textures, modeling, freedom, or security? Keep in mind that what you *like* to do might be different from what you are actually *qualified* to do. What work did you do that got the most comments (good and bad)? What job description do you fit the best on *www.gamasutra.com* and other game sites with job listings?

Research the companies you like. Send your résumé and demo to those developers or content houses you want to work for. Be clear as to what you did on the demo. You will be in a much stronger position to get a job with the skills and the

demo you have built and the understanding of the industry and its processes that you will subsequently acquire.

After going through the game submission process, getting a job might feel easy by comparison.

YOUR JOB SEARCH: SOME POINTERS

What composes the best résumé? The best content, plain and simple. In this industry, literally thousands of individuals are sending in ROMs, videotapes, Web links, slide shows, images, and AVIs—all looking for a job in game development. With such overwhelming competition, you need to stand out. With a great game demo under your belt, this will be easier to accomplish. You will not only have good content in your résumé—you'll have a much deeper understanding of what the companies are looking for in employees and how to approach those companies.

The competition is overwhelming, but it is mostly overwhelming in terms of quantity, not quality. Most submitted résumés and portfolios (a full 95 percent) have no redeeming value. In most cases, it's the submitted material, not the individual's skill, that's of little value. If you work at it, you can make yourself and your work stand out.

This section lists items that, if addressed, will greatly increase your chances of being considered for a job. These items are not hard-and-fast rules; rather, they are guidelines you should be aware of when conducting your job search. There are many books and articles on the subject of résumé writing, submission strategies, and all the common aspects of job hunting. You must tend to these aspects of your job search. This section focuses more specifically on the content and presentation of your game-related work.

Show, Don't Tell

Once upon a time, a developer received a five-page snail-mail letter from a 2D artist raving about his artwork, but the letter contained absolutely *no* images. The artist did not even sign his name! The letter was printed on a dot-matrix printer. There was no e-mail address, phone number, or URL. How was the developer supposed to write the artist back? The developer didn't waste his time even trying.

On the other hand, it is common to receive envelopes from artists with fancy hand-lettering, several sheets of really high-quality artwork, and a note that simply says, "I am sorry I have no e-mail address. My phone number is 555-5555. Please call collect if you want to speak with me." These individuals usually get a second glance. They demonstrate, in the simplest fashion, the fact that they are good artists and they know who they are sending the art to. If you are a 2D artist, and a good one, you don't need much more than this in a résumé.

Let your work speak for itself. Don't describe it in words. Listing the applications you use is great, but don't hard-sell yourself. Let your work speak for you.

Larger Companies Usually Like Focus

Since larger companies hire larger teams and more people with specialized jobs, focusing on a strength could help you get a job. Even a small developer will see your best work when it is focused and will be more impressed by it. Don't try to be a jack of all trades. Define your strength and briefly discuss it. Are you an animator, an artist, a programmer (if so, what is your specialty?), a model builder (low resolution, high resolution, organic, mechanical?), a texture artist, good at lighting, color composition? Discussing your specialization will especially be helpful in targeting a job in a larger company.

Focus is especially important if this is your first game development job. It deflates your credibility to claim that you can model anything, program anything, or do any job given you if you are only 18 and have no previous job experience or a portfolio. If you really *can* do all these things, you still need to focus, because employers tend to fill open job slots with a specialist for each job. They feel that the specialist in the slot will be better than the genius who is generally good at everything but not great at any one thing—jack of all trades and master of none.

Part of the focus is being able to self-edit. Don't drown your good work with inferior work. Quality, not quantity, is important. Bad texture and bad lighting might distract from a great model. If you are a programmer and want to demonstrate your graphics engine, get an artist to loan you some assets to render; don't just use a cube.

When you send a demo tape, portfolio, or Web link to a potential employer, don't overload your presentation. All that work you did in the beginning of your career or studies might have been the hardest to complete, but is it the best? If it's not, leave it out of your presentation.

Your presentation should be short and contain only your best work. Resist the temptation to put everything you have ever done into your résumé.

The Specific Job

When applying for a job, apply for a specific position—a focused position that your work and experience tell the hiring company you can do. For example, rather than apply as an artist, apply as a 2D texture artist, a 3D modeler, a level designer, a conceptual artist, a storyboard artist, or the like. Hopefully, you are applying for an open job position and can tailor your résumé to it.

Best Foot Forward

Again, as in the game proposal, show your material first. Don't show your work chronologically, oldest to newest, because your oldest work is probably not as good as the most recent. Your résumé and presentation must capture interest *immediately* and dazzle the viewer.

Show your absolute best work first, and consider ending it there.

Don't Mistake Your Tool's Ability for Your Own

Don't showcase the bells and whistles of an application or technology that you are using and thereby fail to demonstrate your ability to control that technology. If you are applying for a job as a programmer, showing an engine you didn't write but simply recompiled is not demonstrating programming ability. Likewise, showing off text that you ran through a few filters in Photoshop is not demonstrating artistic ability. Using the default settings in any applications is almost always obvious to the person reviewing your work.

Don't Resubmit Material Without Good Reason

You are wasting your time and money when you resubmit material. If your presentation was good, it's on file. If it was thrown away the first time, it will be thrown away the second and third times as well. If you are sending updated material, indicate that on your submission, and explain what you changed if it's not very obvious.

Credit Correctly

Any samples of your work, when mixed with others' work, must be clearly broken out. For instance, as a programmer, you might have coded some really good artificial intelligence but used an open source engine and stock game assets (that every developer will recognize) to demonstrate them in your demo. Make sure that the reviewers know this and that they know they are supposed to be focusing on the artificial intelligence of the demo, not the game assets. As an artist, if you use a free model in your résumé to showcase your textures or animation work, make sure you mention where the model came from. If you don't credit properly, you run the risk of confusing reviewers as to what aspect of the portfolio they should be considering, or worse, it might look as though you are trying to take credit for something you didn't do.

When using free models, free textures, application standard materials, tutorials, other code sources—anything not created by you—you should question what the impression will be from the reviewer's perspective. Will it look like you're trying to take credit for someone else's work? Will it look like you didn't tweak the scene enough? Will it look like you copied someone else's design? Even if you are modeling an asset based on a movie prop, go ahead and mention it. It is better to look like a model maker who can build from a design than to raise any doubt that you might be trying to pass off that prop as your own.

Beware of School Projects

When 50 students at the Acme College of Design do the same project and then all get the same handout with the same companies listed on it for their job search, guess what happens. The game companies on the list all get 50 packages with 50 copies of the same school project. If possible, try to develop a totally unique idea to submit to

a potential employer, or ask your teacher if you can change the assignment in some meaningful way.

Don't let yourself be one of 50 lemmings. This is a chance to stand out.

Beware of Tutorials

You cannot simply do a tutorial from a book and put it in your résumé as your own. Make sure you learn the lesson the tutorial is teaching and make the knowledge your own. Take what you learned to a new (or at least different) level by experimenting with the concepts and applying them to your original creation.

A Pressing Question: Are You Experienced?

What is considered valid experience in your job hunt? It's not necessarily having had a job directly related to what you want to do. Rather, it is the ability to produce samples of good work and demonstrate that you are a good employee. It is better to have done a few minor projects that look great than to have had a paying job in which all you did was the same boilerplate work for years.

Experience helps, but it is still your work that is judged, for the most part. It is usually not a hard choice for an employer to choose between an experienced individual with bad work or an inexperienced person with great work. Experience often doesn't mean that much. So, most of you who don't have experience should be heartened to know that you don't really need it to get a job. You just need to demonstrate talent through a good body of work.

How Do You Create a Good Body of Work?

You are the one responsible for creating that body of work. Building up that portfolio should be your priority and hopefully a joy. If you are not enjoying doing the work it takes to build that portfolio, you might not enjoy doing that activity as a job. For the most part, companies don't like having to train people they hire, unless they advertise up-front that that is their intention. But if you show signs of talent, you will be a safe bet. Most aspiring game developers start at the bottom of a company and work their way up. Some, on their own, make a demo reel that is something special. Some get involved with a project and volunteer their time in order to learn.

Know the Company

Never send a résumé through an automated mailer, especially the ones that include the 200 other addresses your résumé went to. At a minimum, you should have the company name and contact name in your cover letter or e-mail. It is impressive to an individual when you know even the smallest bit of information about his or her company or refer to anything that indicates you thought before you sent your résumé off.

You also need to determine who at the company you should send your work to, in what format, what they are looking for, and other important details. Some companies prefer Web site links; some don't. Sometimes a simple e-mail saying, "Dear Sir, LOOK!" and then a link to a Web site is enough. Most every person in charge of hiring dislikes getting huge downloads and e-mail attachments. With the recent e-mail viruses, attachments are now mostly deleted without a thought.

Most companies tell job applicants what to send them and where; if you come across such potential employers, follow their directions! If you won't, or can't, follow those simple directions, what message does that send as to how you will function on the job? One of the most adamantly requested rules, and the most often broken, is "No file attachments, please." Almost every person in charge of hiring dislikes getting downloads at all because they eat up server space and could contain viruses. Most attachments are deleted without a thought, because it is not worth the risk to open them, and many are filtered out before they reach anyone at the company.

You should determine what companies want before sending them anything.

Never Name Your Salary

Do not name your salary. Period. Unless you have serious and applicable related work experience, in which case you could mention what you made at your last job. If, however, you're coming out of the Acme School for 3D Design and your previous employment was as manager at a fast food restaurant, don't name your salary range.

Be Courteous

Finally, persistence does pay off, but don't badger! A followup call or a simple e-mail will suffice.

The Power of the Internet

One of our greatest assets can be the Internet. Be active on it. Join forums, participate in discussions, post your work in online galleries. You have no idea when a prospective employer will be out scouting talent, and the feedback you get can be useful.

Give some thought to protecting your work and ideas, though. Think about what you are posting for the world to see.

Home Sweet Home Page

A home page on the Internet with a gallery of your work is almost a must. When you update the gallery, post it in newsgroups so that people know it exists and is current. If you wait for a search engine to magically take someone to your site, you will be waiting for a very long time.

When you design your site, make sure to put smaller thumbnails of bigger images and state the sizes of files for download. Above all, make the navigation of your site

easy. If someone is having a hard time getting around a page, that person will usually drop it and move to the next link in his or her e-mail in-box. Don't overload your site with graphics other than your best work. Take your time designing the site, and make it as nice as possible. Remember that more people are likely to see your Web site than any printed materials you send out.

And now, the most difficult thing you must do:

Be Honest with Yourself

Is your work really any good? This is a hard one, and you have to be able to answer it accurately in order to be successful in the marketplace. Can you make a great texture or model? Can you really write good, solid code? When you look at your work next to other people's (professional) work, how does it compare? When you find work similar to yours, ask yourself where those people are in the game industry. Realize that this is probably your level as well.

Back up and look at what you are doing. Are you simply taking someone else's models and sticking them in a scene with standard MAX textures? Are you just copying code from a book? If you answer "Yes" to those questions, you might want to rethink the direction you're taking.

CONCLUSION

Now on to the fun part: Part II, "Making a 3D Game"!

P A R T

II

Making a
3D Game

CHAPTER

13 Introduction to Part II

One focus of this book is the business end of game development; the other is to provide the basic tools and information you will need to develop a basic game proposal. In this portion of the book, we look at the basics of game creation. In addition to the materials detailed in Part I, it is advisable that any new developer approach the publisher with a running demo. Hopefully, this section will give you the head start you need in assembling that running demo. All the tools and assets you need to create a 3D game have been rounded up and are on the CD-ROM that accompanies this book.

We use *Genesis 3D* and its associated tools and look at *Reality Factory*, a greatly enhanced version of Genesis, so that we can create a first-person shooter that has many of the effects seen in commercial games, such as particle effects, smoke, and fires. The source code and necessary agreements are included on the CD-ROM, so you can make a commercially publishable game.

Once you have mastered the basics of this book, you will be ready to attract the talent you will need to complete a game demo. Armed with the knowledge of game creation on a fundamental level, you will be better equipped to hire the supporting talent you need, whether programmers, artists, or designers.

In this part, we will learn some of the tools and techniques of game creation: special effects, tricks, and "tweaks" that make a level or game world look much better. We will also look at important things such as lighting, texturing, and composition. You will see how huge a difference lights and composition will make to even the simplest game levels or rooms.

In a real-world development scenario, you would have to go through the process of proper design and research first, and then you would be jumping back and forth from pencil and paper, your level editor, 3D application, paint program, and even sources of inspiration. You would be scanning images, surfing the Net, and taking digital photos; you would even spend time playing other games. However, for the purposes of this book, we will work in a linear fashion. We will make an isolated set of game rooms or chambers simply to utilize the tools, techniques, and features of good game development. Armed with this technical knowledge, you can then apply to the game design the lessons of Part I of this book.

CRITERIA FOR CHOOSING THE CONTENTS OF THE CD-ROM

The tools that accompany this book were chosen for two simple criteria: the tool had to do the job, and the tool had to be free.

THE TOOL HAD TO DO THE JOB

The tool, asset, or resource had to be able to be used commercially.

THE TOOL HAD TO BE FREE

The tool had to be free or free to use for a significant amount of time, with no limits, and the subsequent purchase price (if any) had to be reasonable.

In the process of searching for the right tools for this book, it was surprising to find that they were as good, or better, to use for game creation than some professional tools.

For example, given the current limits in a game environment for what we can create (number of polygons and texture size), it is far easier to boot up *Milkshape3D* to make a simple textured 3D game model than to boot up *3D Studio MAX*. There is also the factor of price. *Milkshape3D* can be used for 30 days, then it costs only $20 (US).

Many 3D engines and development suites are for sale or lease; most of them pale by comparison to *Genesis 3D* and the *Reality Factory* enhancements. Of course, the *Quake* and *Unreal* type tools are better, but they are a lot more expensive and more complex. In addition, many, many companies are licensing technology for tens of thousands of dollars that has not the polish, community support, or completion that *Genesis* does.

As many of these development products were reviewed, we had to ask the question, "What good is a rendering engine that needs a level editor, numerous converters, AI, physics, network code, and all the other portions of a basic game to be written by a programmer?" It seems some of these products were offering only textured triangles and lights.

Ultimately, the tools chosen for this book are fairly simple to work with—but of professional quality. Since it is a complete environment, you can dive right in and create assets, adjust parameters, and, most of all, learn. You don't need to touch the code or hit road blocks due to lack of tools.

OTHER GAME CREATION ENVIRONMENTS

Of course, many other game development environments are on the market; depending on your specific needs and goals, you should review the major ones and know which one to choose in any given situation. Being at least familiar with all the aspects of game creation, no matter what your job description on the team, will only help you function better on the team. By taking the time to familiarize yourself with your tools, you will be able to make more sound decisions in development and increase your chances of getting a game deal, getting a job, or simply being more effective at what you do.

Several top engines are available for use; they range in price and support options. Some of the other environments include *LithTech*, *Quake 2* and *3*, and *Half-Life*, and *UNREAL*. Monolith's *LithTech Engine* (*www.lith.com*) is coming out with Version 2, which looks impressive. In addition, more and more developers are using

LithTech for many reasons. One of its strong suits is that it was developed from the ground up to be licensed, and that has made it easier for developers to pick it up and adapt it to their needs. The other professional game engines—*Quake, Unreal,* and so on—range in price and have various levels of support and tools available.

If you plan on doing game work for fun, a job or résumé piece, or to develop addon packs, move up to a professional tool being used on the top-selling games. The major drawback for these tools is that the cost to license them is very high.

These game engines may be found on the web.

- **The Wild Tangent Game Driver (*www.wildtangent.com*).** Version 2 of the *Genesis* SDK; for use on the Web.
- **Jet3D (*www.jet3d.com*).** The continuation of *Genesis 1;* not for use on the Web.

You should also note that you can build a game proposal using the commercial engines without buying a license, but if you do that, you must be very clear with the publisher on what your goal is. If you are building a level as a demonstration of your talent for a job position, you need no special permissions, but if you are using the engine to get a game deal and plan on getting the engine license *after* the publisher accepts your deal, make sure that your plan is known and accounted for to all involved; make it clear that you do not yet have the license to use the engine. In addition, the fact that prior to licensing you might not have access to some or all of the code could hinder your ability to innovate your game, to a great degree.

KNOW YOUR TOOLS

When going to a publisher, you should not only know the engine you are using inside and out technically, you should also know the terms of the license, any special considerations you might get from the company licensing the engine that could be an incentive for the publisher to use you, upcoming improvements on the engine, other titles that use the same engine (maybe there is some marketing value here or a technical comparison for the publisher to look at), and your own reasons for choosing the engine.

CONCLUSION

In the coming chapter, we look at level construction as opposed to level design.

CHAPTER

14 Level Design vs. Level Construction

There is a difference between level design and level construction. The area of *level design* covers actual game-play issues: mission design, story line, and other aspects of designing a level for a certain game. Other than to comment on those areas as they pertain to level construction, we will not discuss level design. Level design requires an in-depth knowledge of the specific game, genre, audience, and other detailed facts on almost a per-project basis. In this chapter, we focus on *level construction*—or building a level that looks good and runs efficiently.

Typically, when you are designing a level, it is a good idea to first sketch out the layout of the level for game-play and aesthetic reasons. We start by sketching the levels we have planned for this part of the book.

You will also take into consideration the technology used and your "budget" for objects, textures, special effects, and any other aspect of the game level that will affect the performance of the game. Later, you will learn some of the optimization tricks and techniques for larger and more complex levels. When designing a level for a full-fledged game, you also have to work with the design documents, fiction, and specific characters that may inhabit a given area or room.

In level design, you primarily want to know the purpose of the level—whether the level is a death match, a single player, capture the flag, or even the tutorial level. At their outset, many games must teach you their game play and functionality. For this book, we designed a small level to showcase the tools and techniques of a 3D game and level construction.

We will build an abandoned subway station for this part of the book. Building the subway introduces us to the basics of Genesis and dwells on some of the finer points of level construction such as texture planing, placement, basic lighting, and simply getting your first level to run.

LOCATION, TIME PERIOD, AND ATMOSPHERE

When designing your level, you need to think about the artistic details of the level: the architecture of the world, its details, and ornamentation. Will the level be indoors or out? A modern city or a fantasy creation? What will the color scheme, mood, even the weather be like here?

When designing the abandoned subway, for example, you streak the tile walls with dirt, make the lights flicker (if they work at all), and there is even a hole in the roof. The corners fall away in darkness, and old faded posters grace the walls. Even the poster has an art style from decades ago to help set the age of the station. You will see that a good texture base and some simple composition will make a huge difference in how good a level looks.

THE IMPORTANCE OF SKETCHING AND PLANNING

We start by making a few rough sketches of the subway, the floor plan, and a couple of detail views. Although you can see that the sketches made for this small project are quick and not very detailed, they help nonetheless in laying out a set of rooms.

This planning phase is important. When working in the level editor, most people are operating in a different mental arena—needing to be so much more patient, precise, and tedious than on paper. Your best ideas for the level might not even surface if you don't get them on paper. Even the roughest of sketches will improve on what you build in the editor because you can explore and sketch ideas unfettered by the tedium of the editor. Experimenting while sketching an idea on paper is easier because we are not investing as much time and effort as we would if we were building it directly in the editor.

Every minute you spend planning, sketching, and giving thought to your level or room is reflected in how much better your level will look in the game. As you will see, the difference between making an amateur-looking level and making a good level in terms of actual level editing time is sometimes only a few minutes.

When you are working from a sketch, you can sometimes put together a level extremely quickly because you are not thinking of so many things at once. You are literally able to think in a one-track fashion because the ideas have already been detailed; you are focused only on implementing them.

DEVELOPING A LEVEL

Typically, a level is developed in the following fashion. Remember that level construction is only part of the overall level development. Even before the stage of test level, which we discuss shortly, the level designers, programmers, and artist could each have a level he or she calls a test level, which is used for benchmarking and testing various aspects of the tools and technologies they are using.

TEST LEVEL

Often a *beta* or *test level* is built from an idea that has been laid out on paper, based on the documentation previously generated. This layout might be solely the creation of the level designer based on notes and the design documentation, or the level designer might be given sketches, floor plans, and a mountain of information, both textual and visual, that he or she must assemble into a game-world level. This process could require several stages of beta leveling, depending on the size of the level, the size of the development company, and the degree of structure the company uses. Some development teams have one person doing all the "level" work; others have level designers, level editors, and even specialists in lighting and game

play. Regardless of how level design and construction are done, it is an evolutionary process, either up front or during the actual construction.

It is almost impossible for even the most experienced level designer to think everything through up front. Often, until the game is running and playable, mistakes cannot be found, dead spots cannot be discovered in levels, and other areas that must be addressed.

PROTOTYPE LEVEL

After most of the paper design has been tested and discussed, bugs fixed, and other major obstacles addressed that could cause redevelopment later, a *prototype level* is built that closely emulates the final game. After the paper has been updated, the levels are laid out in detail, and construction begins. At this point, there should be no more questions about the game and its design; atmosphere, setting, mood, or the like.

Also at this point, the process of building and testing levels should be approved. How assets are created, named, and stored should be standardized and written down. A workflow should be defined, as follows:

- Level mocked up from documentation
- Texture set created
- Level tested and approved (repeat this process until moving on)
- Finalize level: lighting, entities, optimizations, continuity check
- Final compile and testing

The level should always be subject to a process so that it is consistent and running at its best, and the workflow should be paced to keep the team from being bored or overworked.

Consistency can involve items from the fiction. For example, "Legend has it that the castle with the green stone walls contains powerful magic." Someone has to make sure that the walls of this magic castle are in fact green. A programmer testing the level will undoubtedly uncover areas where the engine is choking (running slow) or running fast, and artists can add more detail to the level.

DEMO LEVEL

The *demo level* is often the pre-beta level that testing firms, reviewers, and sometimes the public get to see. The demo level should have no bugs or problem areas, and it should represent the game well.

FLOOR PLAN OF THE SUBWAY

Here is the floor plan of the subway based on some rough sketches. As you can see in Figure 14.1, the floor plan is rather simple: stairs going down to a room, an access

SUBWAY

FIGURE *The floor plan of the subway station.*
14.1

door overlooking the tracks. However, this simple layout will require many of the Genesis tools to create it.

MAPPING MISTAKES

Many beginner-made levels suffer from some common ailments—things that a few minutes of tweaking would fix. The most common include the ones discussed in this section.

BAD TEXTURES

Bad textures are textures that are not created or placed properly. Textures are very important and second to lighting only because with lighting you can control so much of the color and atmosphere of your level. It is possible to make a well-lit series of rooms with *no* textures look, or rather feel, better than a room with the best textures that is poorly lit. With poor lighting, your level will look like a bunch of painted cardboard boxes, as shown in Figure 14.2.

FIGURE *Here is a level with bad textures and the same level with good textures.*
14.2

Textures are abundant on the Net as are the tutorials and tools to make them. Taking the time to place them properly in the game world pays off big, as you will soon see.

BLOCKY CONSTRUCTION

Levels of *blocky construction* feel as if the world was built rapidly, with no attention to detail. The fact that Genesis has no *vertex manipulation*, or the ability to drag out individual points on an object, makes blocky construction an obstacle. You can taper a cube, for example, and make a cool base for a column by typing in different parameters when creating the cube, but that is not vertex manipulation. There are ways around this limit, and using light and composition are some of them. See Figure 14.3 for an example of a level with the same objects arranged and lit differently.

BAD LIGHTING

You will see that the default light level in Genesis is harsh and flattens the colors and depth of the scene. The only benefit to this default setting is that level designers won't find themselves in the dark if they forget to place lights in the world.

One of the most powerful aspects of Genesis is the ability to control the lighting and its many parameters. Lighting in Genesis is a huge bag of tricks that should be explored. Unfortunately, many beginners leave the default setting of light in the world. See Figure 14.4 for the difference lighting can make.

PLANNING THE GAME TEXTURES

All assets for the tutorials are on the CD-ROM in the Tutorials folder.

The key to many great 2D textures is the fact that are based on images that are scanned or imported in from a digital camera or they are rendered in a 3D program. There are many ways to make great textures in a 2D application, but many find this difficult to grasp at first.

Going back to our initial level design, we have to create a few types of textures for the subway station: the walls for the station and tunnel, which will cover 99 percent of the level, as well as the detail and specialty textures.

Since our subway station is abandoned, the wall was made from a digital image of a tiled wall that was cleaned up and modified in Photoshop. It was made to look messed up and dirty. But it was also cleaned up so it would tile well, and imperfections were removed that would stand out and make the pattern of our tiling texture visible. Making the texture not look tiled, yet not look too plain is part texture work, part lighting, and part how the texture is used in construction. See Figure 14.5 for an example of a texture that is obviously a tile, too plain, and finally just right.

FIGURE *An example of a room with the same objects arranged differently. Composition is an*
14.3 *important aspect in making levels look good.*

FIGURE *The default lighting, and then the hand-placed lights in a scene.*
14.4

FIGURE *A texture that is obviously tiled, too plain, and finally just right.*
14.5

FIGURE *Using transparency on a plain cube with a good texture can help break the solid, blocky look*
14.6 *in a game level.*

A sign and a poster were a few textures made for the subway to add detail. These are the ornamental textures that we will use to break up the open areas and add realism.

Finally, we will deal with transparency to help break the blocky look of the level. A poster, wire fencing, and some metal beams will add some "delicacy" to the objects in our game world. See Figure 14.6.

If you make your own images, save all of them in a folder where you can find them again. Remember to back up all your work, and save the larger, high-color version of these images. Create copies that are 256 x 256 and 256 adaptive color.

If you don't follow these instructions, though, don't worry. All the images are included on the CD-ROM as well as in the Texture Library format ready to use with Genesis 3D.

CONCLUSION

In the next chapter, we start looking at Genesis 3D.

15

Introduction to Genesis 3D

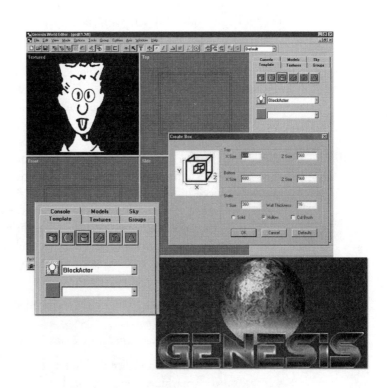

Genesis 3D is the best way for a beginner to start in 3D game development. It's also a top-notch engine easily usable by professionals. Nowhere else will you find such a large and helpful online community as in the Genesis online forums. The Genesis Web site also has many links to other Genesis 3D developers and resource sites.

The forums on the Genesis site can be searched. Chances are that any question you have, has been asked and answered, so search the forum first before posting.

If you start seriously getting active on the Genesis forum, you will be hit with some confusion about the companies and product versions involved with Genesis. This chapter gives you the rundown.

GENESIS 3D, JET 3D, AND REALITY FACTORY

Wild Tangent acquired the assets, technology, and most of the employees from Eclipse Entertainment, the developers of Genesis 3D. Eclipse is still its own company and retained the ability to license the existing Genesis source code for non-Internet applications. Wild Tangent has written a game driver that will specialize in Web play and is a superset of the Genesis and Wild Tangent technologies. A beta version of the game driver will be released at the Wild Tangent Developer Conference, to be held during the GDC Conference. Wild Tangent is developing Genesis 3D Version 2, but it will not be open source.

Eclipse is going forward with Jet 3D, its Version 2 of the technology it holds. As of this writing, there has not been a lot of significant progress on Jet 3D.

Rabid Games built Reality Factory on the latest version of Genesis 1.1 and is greatly enhanced in many ways. The best option right now is to learn the basics of Genesis and move to the Reality Factory once you've mastered them.

We will look at Reality Factory after we learn the basics of Genesis. Rabid Games has made significant improvements to the code and editor of the original Genesis.

For the latest and most accurate information on these technologies, visit the Web sites of these companies:

- Wild Tangent Game Driver and Genesis 3D: *www.wildtangent.com*
- Jet3D: *www.jet3d.com*
- Reality Factory: *www.rabidgames.com*

Genesis is an open source license. You agree to the license when you install the software on your machine. You are strongly encouraged to read the details of the license. A text copy of the license can be found in the Open Source directory in the installation. Essentially, you are allowed to do whatever you like with Genesis as long as you display the Genesis logo at game startup.

WHAT CAN GENESIS 3D DO?

Genesis is designed primarily for games such as *Quake,* with indoor scenes and moderate polygon count, and operates at a very high performance level. Genesis can also be used to build outdoor scenes, but you must be careful to plan and build outdoor scenes correctly. Of the advances Reality Factory has made to Genesis, the ability to use fog and a clipping plane allow much larger scenes, outdoor scenes, and better level optimization. We will look at these options later in the book.

QUICK FILE SPEC

The textures for your levels will have to be to the order of 2. This means that each texture must be square (in other words, the sides are all the exact same size). The accepted sizes are 64 x 64, 128 x 128, and 256 x 256.

Your texture has to be 256 colored bitmap (BMP), but if you handle your texture creation right, you can make them look great using the adaptive option when you convert them.

As always, work big, and then reduce your image. Keep backup copies of the large files and the nonflattened files from your paint program. This way, you can always go back and tweak them, and on occasion, you might want to create more textures with the original as the base texture, for continuity.

BEFORE WE START

It is very important to back up your default Genesis files!

Before we start, be sure to make a copy of the Genesis files we will use and place them in a separate folder, so you can start over if you need to. Primarily, we will be altering the following folders:

C:\Genesis3D11\BMP
C:\Genesis3D11\LEVELS

You can zip these files and save them in another folder. It is strongly suggested you unzip and restore (copy the originals back into their right directories) rather than reinstall Genesis. Simply reinstalling the program will wipe out any work you did, if you keep that work in the same folder as Genesis.

You don't need to make backups of the entire Genesis installation.

GETTING GENESIS READY

Genesis is a straightforward installation. Go to the Genesis folder on the CD-ROM and open it. Click Genesis3D120.EXE and follow the installation instructions. You

will be prompted with several standard screens, the most important being the Software License Agreement and the Destination Location screens, as shown in Figures 15.1 and 15.2.

It is important that you read the license agreement. It is also important that you either install Genesis to the default folder or, if you change the install location, take note of where it is installed. It is assumed that you are not changing the default installation parameters. If you do change the default installation from C:\Genesis3D11\ to another drive letter and folder, you must compensate for this.

POSSIBLE ERRORS STARTING GENESIS
Error in Ctl3d32.DLL

This file must be in your Windows system directory. You can copy this file from the Redist folder in the Genesis folder to the Windows system folder.

"Could Not Find glide2x.DLL in the Path"

If you get this error message, make sure that you have the latest Glide drivers.

FIGURE *The Software License Agreement screen.*
15.1

FIGURE *The Destination Location screen.*
15.2

"Failed to Decompress %s, Might Not Be Enough Free Disk Space in the TEMP Directory"

If you get this message during installation, do the following:

1. Check to see that you have enough hard drive space.
2. Check your AUTOEXEC.BAT file. Your temp directory should be SET TEMP=C:\TEMP, or it is also good to have SET TMP=C:\TEMP.
3. Make sure that the folder C:\TEMP actually exists.
4. Clean the C:\TEMP folder of all files.

Make sure none of the files is set to read-only by right-clicking on files, clicking Properties, and unchecking the read-only attribute check box.

Your video driver could be causing the installation program to go bad. Switch to VGA mode and try installing again.

You will need to restart your system after trying these changes in order for them to take effect.

REMOVING GENESIS LEVELS

If you modify, replace, or remove the levels shipped with Gtest, you will need to go into the Gtest directory and delete the DEMO.INI file.

Gtest in D3D Mode Does Not Work Properly

Make sure that you have DirectX 6 installed. Make sure your card supports D3D.

Viewing Your Own Compiled Level in Gtest

Copy the BSP file (my_level.BSP) in the levels directory of the Genesis folder and run Gtest from a command line. Type **gtest -map 'mylevel'.bsp**.

CONCLUSION

Now that you have Genesis installed and running on your system, let's look at the Genesis level editor.

CHAPTER 16

Introduction to the Genesis Editor

O nce you have Genesis installed, we can begin looking at the level editor.
Going back to our original plan for the subway level, we have determined
that we need a texture set or texture library for the level. There is already a
file called SUBWAY.TXL in the Tutorials folder on the CD-ROM. This file con-
tains all the textures needed to build the subway level.

Let's start by getting our texture library in place.

TPACK

TPACK is a utility that allows you to put all your created images into one file. Go to
the folder on your computer in which you have installed Genesis and find the file
TPACK.EXE. Click on the file icon. Once TPACK is opened, select File | Open.
This choice will default you into the GENESIS3D11 directory. Go to the Tutorials
folder on the CD-ROM and open SUBWAY.TXL. See Figure 16.1.

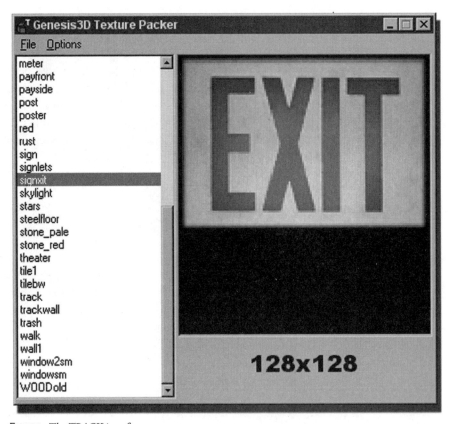

FIGURE *The TPACK interface.*
16.1

Now click File in the menu bar. Doing a Save As, save the file SUBWAY.TXL in the Levels folder of the Genesis installation folder on your computer. It will need to be there later.

When you copy or do a Save As of the file SUBWAY.TXL from the CD-ROM, it might be set as a read-only file. You will have to go to the file, right-click it, and uncheck this attribute in order to edit the SUBWAY.TXL file.

While in TPACK, you can click a filename and see the image in the window on the right-hand side. You will also see the image size: 128 x 128, 256 x 256, and so on.

If you add images to the library on your own, be careful. When you drag the image files to TPACK, they are added in a subtle way; your image will not appear in the window. You will have to scroll the list and look for the name of your image and click the name to see the image.

Make sure that your images are of the right size and color depth. TPACK will let you put the wrong-sized images into it, but Genesis won't let you use them.

You can also delete images from the library by pressing the Delete key.

You can also extract your library to the folder that TPACK is in. This extraction will unpack every image in the file, so be careful if you don't want image files mixed with every other file in the directory. Extracting images will not delete or alter the original texture file.

Now close TPACK and open GEDIT.

A QUICK OVERVIEW OF GEDIT

First a warning. Not only should you save your work often, but you should get into the habit of saving your work after every few actions in GEDIT. GEDIT will sometimes crash or shut down, more on some computers than others. So save, save, save! It is also a good idea to create a few copies of your level in case the level file becomes unstable or un-recoverable.

When you first open Gedit, you will see a standard Windows-type interface: a Menu bar across the top, the Toolbar just below with all its icons, the four View windows, and finally, the Command Panel with the Option tabs. We will go over the quick basics here and look at what each window does, then later we will look at the specific functions and options for each item in the tutorials.

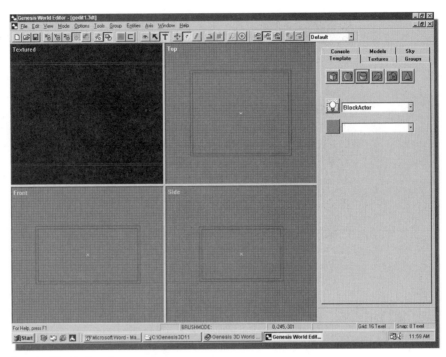

FIGURE *The Gedit main screen.*
16.2

The Menu bar contains all the options available in the level editor, as shown in Figure 16.3.

The Toolbar has icons that are shortcuts to the most commonly used functions in GEDIT, as shown in Figure 16.4.

The four View windows are where you lay out your level; adding geometry and entities, as shown in Figure 16.5.

The Control Panel and its tabs offer access to different modes and tools in the editor, as shown in Figure 16.6.

FIGURE *The GEDIT Menu bar.*
16.3

FIGURE *The GEDIT Toolbar.*
16.4

FIGURE *The four View windows in GEDIT.*
16.5

FIGURE *The Command Panel tabs.*
16.6

THE FOUR VIEW WINDOWS

There are four windows on the main screen of GEDIT that let you see your level from different views: camera, top, front, and side.

Camera View

With Camera view, you can look at the game level with textures on or off. The Camera view is also used for face editing, which we talk about soon. If you can't see

the textures or the changes you made in this view, you can click the Quick Compile button to refresh the view.

Although this view is close to what your level will look like in the game, it is not exactly what the level will look like in the game. There are many reasons for this, but primarily, at this point the game engine is not displaying the level—the level editor is. You will eventually get used to this and start to know what the level you are building will look like.

Top, Front, and Side Views

You will do all your geometry and entity placement in these three views.

THE COMMAND PANEL

The Command Panel is displayed to the right of the views in the Editor window. The tabs of the Command Panel are:

- Template
- Textures
- Groups
- Console
- Models
- Sky

The Template Tab

The Template tab has three areas. One allows you to place geometry; the next, entities; and the third is blank. The third tab is where your loaded prefabricated game objects are accessed.

BRUSHES

The basic geometric shapes are accessible from here, and you can assign certain properties to them and then place them in your level.

There are six different geometric shapes (or brushes): cube, spheroid, cylinder, staircase, arch, and cone. Each of these primitives has parameters and functions we will look at in the next chapter. See Figure 16.7 for the Template tab.

ENTITIES

Entities are things such as lights, models, and level starting points. We look at each entity in detail later.

The entity will be placed 16 texels from the surface on which you clicked.

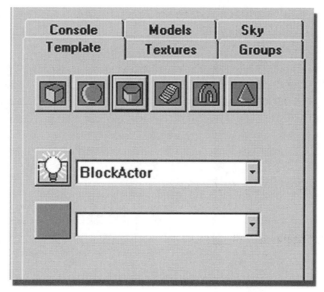

FIGURE *The Template tab.*
16.7

We will discuss the storing and use of pre-made (or prefab) objects later.

The Textures Tab

When you click the Texture tab, you can view all the textures in the assigned TXL file. In the case of this book, you will be viewing SUBWAY.TXL. This is where you place a texture on a piece of geometry—or a face, if you are in face-editing mode. In addition, the texture you have selected will be applied to any newly created geometry. See Figure 16.8.

The Groups Tab

You can group your level's geometry and entities and name them. This is helpful when a level gets large. You can hide and unhide groups for easier working. The editor will also run faster since it won't be displaying everything in the level. You can also assign colors to groups. This is another helpful tool because you are often zooming into a level to tweak brush placement, and all you will see are many lines on the screen. It helps distinguish the lines if they are different colors. See Figure 16.9.

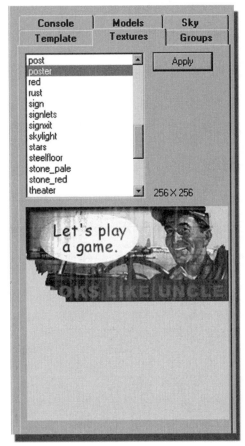

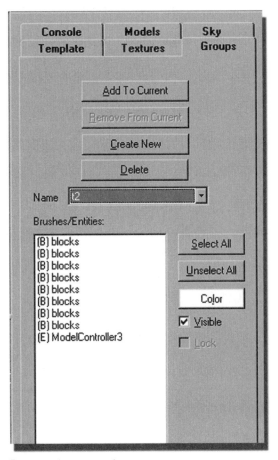

Anything hidden is not used when compiling the level. This means that the time required to compile the level can be greatly reduced by hiding large parts of the level, but it also means that the compile could fail if you hide a brush that subsequently creates a hole in your level and causes a leak. We will talk about the importance of sealing a level when we start building one.

The Console Tab

If you click the Console tab when you first start the editor, it will be blank. This area is where the editor spits out messages when it compiled your level for running in the

game engine. The console will be helpful for some errors such as lost textures, leaks, and missing assets. See Figure 16.10.

Most error messages are very familiar to the folks on the Genesis forum, so fret not. You can log on and send them the console errors.

The Models Tab

In Genesis, you can make models using one or more brushes, then you can animate them to make doors, elevators, and even atmospheric movement such as ceiling fans and water wheels. See Figure 16.11.

The Sky Tab

The Sky option lets you assign textures to the Sky box that surrounds your level and set the speed at which your sky moves. You can't see the Sky box in the editor, only in the game. See Figure 16.12.

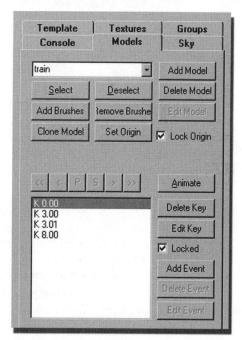

FIGURE *The Console tab.*
16.10

FIGURE *The Models tab.*
16.11

FIGURE *The Sky tab.*
16.12

CONCLUSION

Next we look more closely at the building blocks of your level. Many parameters and options allow a great deal of flexibility in what you can build with Genesis.

CHAPTER 17
The Building Blocks of Genesis

In this chapter, we look at creating the most basic geometric shapes in your map to create the walls and objects in your game. Then we look at the settings that allow you to make a wide variety of shapes to further customize your level. Finally, we look at the attributes that make your brushes function in many ways in the level.

BASIC BRUSH SHAPES

The most fundamental aspect of building a level is creating, placing, and manipulating brushes or geometry. A *brush* is a piece of geometry that has various properties assigned to it. The basic brushes you can create are:

- Cube
- Sphere
- Cylinder
- Stairs
- Arch
- Cone

When you are in template mode and select any of these shapes, a menu pops up, allowing you set several variables that allow the creation of a wide range of shapes. In general, when creating a brush, you can also select a few parameters such as the top and bottom size of the shape, the height, and the width.

We look at each brush and its options here.

CUBE

The cube (see Figure 17.1) allows for the creation of a solid or hollow cube. Other options include the ability to set the size of the top and bottom of the cube as well as its height. Using these options, you can create tapered columns and rooms that have slanted walls.

You can even create building roofs with a hollow cube. Set the Top X size very small and the Bottom X size wide, and make the Z size the same, and you get a prism shape. If you use a hollow brush, you can make a roof with an attic underneath.

SPHERE

Creating a sphere is pretty straightforward (see Figure 17.2). However, you can choose the number of vertical and horizontal stripes. This process is illustrated in Figure 17.3.

CAUTION

Do not try to make a smooth sphere with many sides. At best, it is horribly inefficient in the game, and it usually crashes the level editor.

FIGURE *The Create Box (cube) dialog box.*
17.1

FIGURE *The Create Sphere dialog box.*
17.2

FIGURE *The vertical and horizontal stripes in a spheroid.*
17.3

CYLINDER

With a cylinder, you have the option to set the size of the top and bottom of the cylinder and the offset (see Figure 17.4), but these variables are actually easier to change visually in the level editor using the Size and Skew options. You can set the number of stripes, as in the sphere, for a smoother-curving cylinder. You can also make a hollow cylinder or a ring. A ring has no end and is great for pipes, tubes, and tunnels.

STAIRS

You can set the height, width, and length of your staircase. Most important, you can set the number of stairs. You can also make a ramp (no stairs, of course). See Figure 17.5.

FIGURE
17.4 *The Create Cylinder dialog box.*

FIGURE
17.5 *The Create Stairs dialog box. Notice the Ramp option.*

ARCH

Creating an arch is easy, and there are many parameters. As with the other brushes, some of these parameters can more easily be changed in the editor, and others are "set in stone" the minute you press Enter. See Figure 17.6.

Here's a look at some of the parameters:

- **Start and end angle.** These are the places the arch begins and ends. The defaults are 0 and 180 to create the traditional arch. If you were to change the start angle to 90, the arch would start half way to the end angle.
- **Thickness.** This is the thickness of the cross-sections as viewed from the side.
- **Width.** This adjusts the thickness of the arch as viewed from the top.
- **Inner radius.** This affects the height of the inner arch and the overall size of the arch.
- **Hollow wall size.** This is the hull thickness of the walls in a hollow brush.
- **Number of cross-sections.** This is the number of sections composing your arch.

And, of course, you can make it a hollow brush or a ring. A ring allows you to use an arch as a tunnel. See Figure 17.7 for the various arch options.

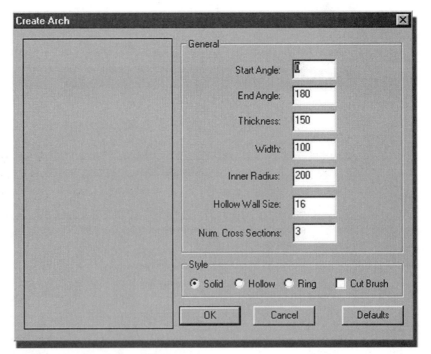

FIGURE *The Create Arch dialog box.*
17.6

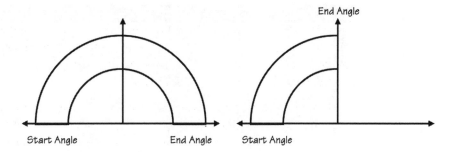

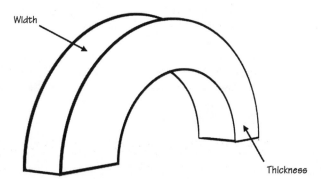

FIGURE *The various options of the Arch brush.*
17.7

CONE

The cone (see Figure 17.8) can have a vertical number of stripes assigned. Therefore, a cone with four stripes (or sides) is a pyramid. You can also make a cone a funnel. A funnel has an open bottom and, when inverted, makes a great brazier for hot coals and fire.

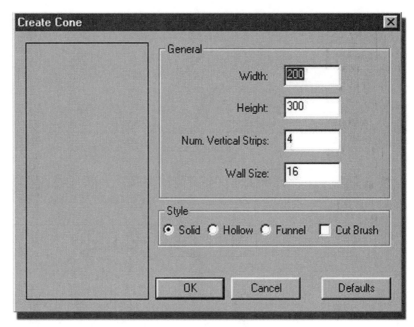

FIGURE *The Create Cone dialog box.*
17.8

BRUSH TYPES

After you create a brush, you can also change how it functions in the world.

Don't be afraid to experiment with brush creation. You can always click the Defaults key to restore all the original settings of the brush.

THE SOLID BRUSH

Solid brushes block passage and visibility—hence the term *solid*. They will compose the obstacles in your world, such as columns, doors, platforms, and anything else that you want to build. It can be difficult to get detailed in your construction, but you can build simple and convincing objects with brushes. See Figure 17.9.

THE HOLLOW BRUSH

Hollow brushes are the same shape as solid brushes, but they are hollow inside and are used to create the rooms and major areas of your level. You can change the wall thickness of the hollow brush (called the *hull size*). As you resize the brush, the hull size remains constant. Hull size consistency is important when you start using the

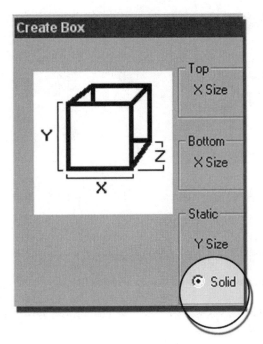

FIGURE *The Solid brush.*
17.9

hollow brushes to make levels and want to make a room bigger, without having the walls swell as you resize the room. See Figure 17.10.

THE CUT BRUSH

Cut brushes are brushes that carve or cut their shape out of other geometry in the shape of the solid brushes (Boolean operations). You can use cut brushes to hollow out solid objects, cut doors and windows in walls, or build fairly detailed forms of geometry. There are several ways to make a cut brush:

- Intentionally selecting the Cut Brush check box in the brush primitive's template
- Selecting an existing brush and clicking the Carve Toolbar button
- Selecting Cut from the Brushes property box.

See Figure 17.11 for an example of the cut brush.

In the future, you might create a cut brush that overlaps several objects, of which you only want a few to be affected by the cut brush. You can select the objects you want not to be affected and use the Make Newest command. This will make the brushes unaffected by the cut brush. Following the same logic, you can make a cut brush newest and have it affect every brush it contacts.

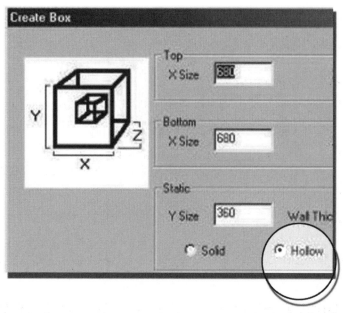

FIGURE *The Hollow brush.*
17.10

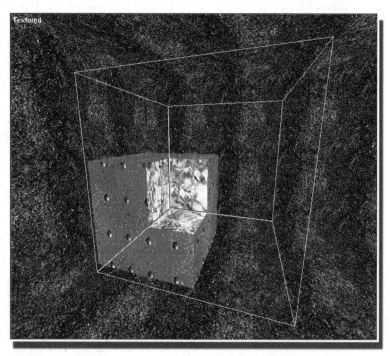

FIGURE *The Cut brush.*
17.11

Cut brushes are inefficient and should be used sparingly. For example, create rooms with hollow brushes, not solid brushes that are cut out with cut brushes.

THE SHEET BRUSH

A *sheet brush* is a one-faced brush, useful for placing decals and images against the walls for posters, gunshots, stains, and the like.

To be effective as a decal, you want to place a Sheet brush one texel from the surface. When you do this, however, the engine will have a hard time displaying the flat plane so close to another, so you should have the flocking option checked. We discuss this option later.

THE FACE

A *face* is a side of a brush. A solid cube, for example, has six faces: top, bottom, left, right, front, and back. A hollow cube has 12 faces: six outside and six inside. See Figure 17.12.

FIGURE *The face of a solid brush.*
17.12

BRUSH ATTRIBUTES

After you place a brush in the world, you click on the Brush Attribute icon or use the menu options (Tools | Brush | Attributes) and alter the brush in some interesting ways. Figure 17.13 shows the Brush Attributes dialog box.

SOLID

You can make a brush a solid brush by selecting this option.

Notice that your other options will change based on the type of brush you have selected.

CUT

You can also turn a brush into a cut brush from here if you didn't create it as one originally.

FIGURE *The Brush Attributes dialog box.*
17.13

EMPTY

These brushes are visible but can be passed through. This is useful for creating pools of water and lava. You will learn later in face editing how to make reflective and translucent liquids.

WINDOW

A window is a translucent piece of geometry; it allows visibility but blocks passage.

CLIP

A clip brush is an invisible piece of geometry that blocks passage but is entirely see-through. Clip brushes are useful for preventing access to parts of a level without having to build a solid wall. They are different from the window and other brushes because they cannot have textures assigned to them and other properties. In addition, they are more efficient to use if all you want to do is block passage with a perfectly clear field.

HINT

A hint brush is invisible and doesn't block passage; it is unseen during game play. Hint brushes instruct the level compiler to split along a particular plane. Their sole purpose is to help the level compiler generate a more efficient level.

OTHER BRUSH ATTRIBUTES

You can also assign other attributes to a brush based on the brush type.

HOLLOW

A hollow brush is a piece of geometry with a hole cut out of it. You aren't allowed to set this flag from the Brush Attributes dialog box (only from the Brush Template dialog boxes), but you are allowed to change the hull thickness for hollow brushes.

WAVY

If you enable the Wavy flag for an empty brush, the texture with which the brush is filled will "wave" or animate to simulate moving liquid.

DETAIL

The Detail flag helps the compiler run more efficiently by removing some pieces of geometry from visibility and lighting calculations. Detail brushes should be used for geometry that you know won't block visibility. A wall between rooms would be a poor choice for a detail brush, but a column or beams going across the room or any small fixture that doesn't block the visibility of the room would be an excellent choice.

AREA

The Area option is for brushes that seal off areas of your level (such as doors). This flag allows the game engine to completely ignore very large portions of the world if the area brush is visible, which makes rendering much faster.

FLOCKING

If you want to place decals on your walls, such as cracks, posters, signs, or other flat art that you want to look as though it is either part of the wall or flat against it, you need to make sure this option is checked. If not, the level editor, when compiling the level, might try to remove the flat plane. This option makes sure that the sheet brush you placed stays and that it is also displayed properly. The exception is, if you use transparency with your decal, check Detail and not Flocking. See Figure 17.14.

SHEET

This option turns the selected brush into a Sheet brush.

HULL THICKNESS

This allows you to change the hull thickness of a Hollow brush.

FIGURE *The same decal with the Flocking option on and off.*
17.14

WATER/LAVA OPTIONS

This option allows you to change an empty brush into water or lava. When players enter water, they can swim; lava, they take damage.

SETTING UP GEDIT

TEXTURES

Go to Options | Level Options and select the Browse button next to Texture Library from the popup window. Find the folder you installed Genesis into, and then open the Levels folder. Select the SUBWAY.TXL file that you copied in earlier. Go to the Texture tab in the Control Panel and you will see the textures used in the Subway level. See Figure 17.15.

THE GRID

Go to Options | Grid Settings and make the grid snap 32 texels. We do this so we can lay out the room quickly and precisely, but when we zoom in later we will still be able to align objects to the one texel level. Our goal is to not only tweak a level so it looks good, but so it runs efficiently. When you are precise and organized, your level will run better. See Figure 17.16.

Placing all geometry, when possible, one texel away from other geometry helps reduce the polygon count in the game world and helps efficiency.

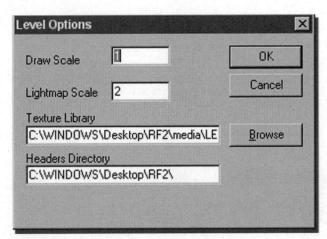

FIGURE *The Level options box.*
17.15

FIGURE *The Grid Settings box.*
17.16

CONCLUSION

In the coming chapter, we start building our first room in Genesis.

18 Your First Map

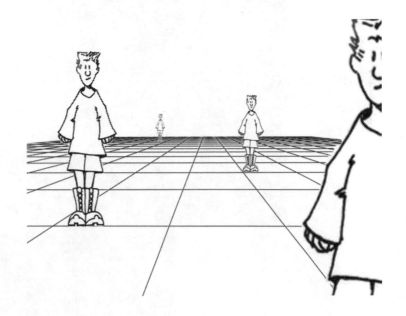

Now that you know your way around GEDIT, load it and let's make a map. When you start GEDIT, you are given a new and empty world with one *potential* hollow cube in it. This potential brush does not exist yet in the world; it is called a *template*. If you click one of the view ports to activate the editor and press Enter, you will hear a "Whoosh" if your sound is on, and the cube will be made real. See Figure 18.1.

Get used to the difference between the potential brush or template and the real thing. Frequently, the outlines of the template are positioned directly over a created brush and make it hard to see.

FIGURE *The start-up screen of Genesis, with the potential hollow cube and then the actual cube.*
18.1

It is easy (especially if your sound is turned off) to create multiple brushes, one on top of the other. This can lead to errors and, at the least, confusion when you edit. Be careful not to press Enter multiple times, because that creates multiple brushes.

THE THREE EDITING MODES

Once you have pressed Enter, you have created your first room. In order to change and add to it, you use the three modes of editing.

CAMERA MODE

Holding the Shift key and using the mouse, you can navigate in the Camera/Textured window with ease. The movements are:

Shift + Left mouse button = Look side to side and move backward and forward
Shift + Right mouse button = Look up and down and side to side; you stay in one place
Shift + Both buttons = You move side to side and up and down while looking straight ahead

In the other views (Top, Front, and Side), you can hold Shift + Left mouse button to move the view up, down, left, or right. Shift + Right mouse button allows you to zoom in and out.

SELECT MODE

In Select mode, you can select entities and brushes to move and edit them.

TEMPLATE MODE

Template mode allows you to add brushes and entitles.

ROOM ONE

First, we will create the basic room. Simply click the Template Mode button in the Toolbar or go to the Options panel and select the Template tab. You can also use the hot key T to activate Template mode.

If all the primitive icons are grayed out, that means you are not in Template mode.

By default, when you start the editor, you should have a blank new file with a Hollow Cube template waiting. If you press Enter, you should hear a "Whoosh" and see the textured view update with you inside a box. You might need to first click the textured view before pressing Enter to make sure the editor is active.

Learn to use hot keys, which are keyboard shortcuts. They speed up your work considerably. For example, pressing T for Template mode, M to move, L to resize, and Page Down to toggle between Face Editing and Brush Editing modes.

QUICK LEVEL SETUP

Before we do anything else, we need to save this file. Save it as SUBWAY when you are prompted.

Next go to Options | Level Options and click the Browse button next to the Texture Library window. See Figure 18.2. Find the folder you installed Genesis in and open the Levels subdirectory. You should see the SUBWAY.TXL file here. Click it. Select OK when you return to the Level Options box.

You might notice that the geometry in the level of your Texture view is now covered in solid colors. What happened was, we just switched texture libraries so the geometry lost its texture map. To fix this problem, do the following:

- Select the Hollow Brush that makes up your room.
- Go to the Texture tab and find the Wall1 texture in the library.

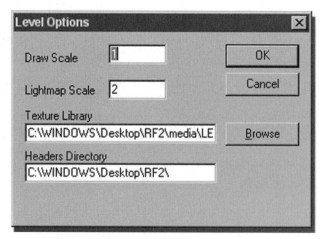

FIGURE *The Level Options dialog box.*
18.2

- Click Apply, and Wall1 will map on every face of our hollow cube room. See Figure 18.3.

At this point, it might be a good exercise to click the Textured window and practice using Shift plus the Mouse to move about the room.

Now you will see that the nice wall texture does not look so good on the walls *and* floors. To fix this, click the Texture View window of the editor and select the Hollow Brush. The outline of the brush will show bright green when it is selected. If at this point you were to go over to the Texture tab and scroll through the textures and start applying them, they would also be applied to *every* face in this mode. If you do this, make sure that you reapply Wall1 to the room before continuing.

Before moving on, make sure that the room is still selected from the Texture window.

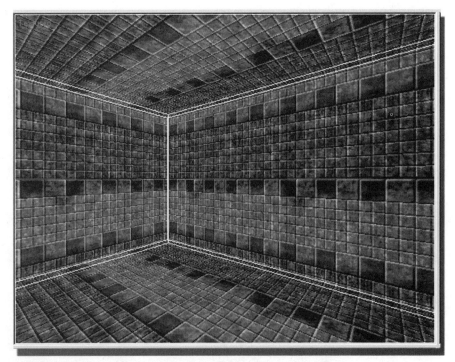

FIGURE *The room with the same texture on every face.*
18.3

WORKING WITH FACES

To apply a texture on only one face, go to Mode | Face Adjust (PgDn is the hot key). You will notice that the lines outlining our object turn purple. This indicates that you are in face-editing mode and that all the faces are selected. Click the floor and notice the lines once again shift to green, only now the floor is the only face highlighted in purple.

Often, the Level Editor allows you to select only one face, but not the face you want, because of your position in the world. You can use the Arrow keys to cycle through the faces until the one you want is highlighted.

Now, with the floor highlighted, go over to the Texture tab and find the Tile1 image, and click Apply. You now have a tile floor, as shown in Figure 18.4.

By clicking on the ceiling of the room, you can go over to the Texture tab, select the ceiling image, and apply it to the ceiling. See Figure 18.5.

FIGURE *The room with a tile floor and the outline of face mode.*
18.4

FIGURE *The room with walls, tile floor, and a ceiling.*
18.5

FACE ATTRIBUTES

As nice as this little room is starting to look, there is a lot more to face editing than just placing textures. When in Face Editing mode, you have access to the Face Attributes dialog box, which allows you to change the attributes of the selected face.

To view this dialog box, make sure you are still in Face Editing mode and click the Face/Brush Attributes Toolbar button to display the Face Attributes dialog box.

NOTE

The Face Attributes dialog box is a modeless dialog box. You can select different faces and edit their attributes without closing the dialog box. The changes that you make to each face are saved when you switch faces. This is a major convenience because it allows you to edit many faces without having to repeatedly open and close the dialog box.

CAUTION

While in Face Editing mode, you can still navigate the world using the Shift + mouse combination, but you must click the Texture window first before pressing Shift or you will simply toggle the Mirror Attribute to On, which will cause errors and inefficiencies that will be hard to weed out later in level construction.

Each face of each brush can have a different attribute. We assign these attributes using the Face Attribute dialog box, as shown in Figure 18.6.

You can select multiple faces by holding the Ctrl key down and clicking on them. The values set in the dialog box at this time are from the first selected face. If you change a value in the dialog box, that value will be set to all the selected faces.

MIRROR

Set this flag if you want the face to be a mirror. Setting this flag to On for a face not intended to be a mirror will cause noncritical errors and hurt the performance of the level. If you select a face to be a mirror, you must also turn on the Transparent flag and make adjustments to the transparency of the face. For samples of the mirror face in action, see Figures 18.7–18.9. You can see that the settings must be experimented with, if you use them at all.

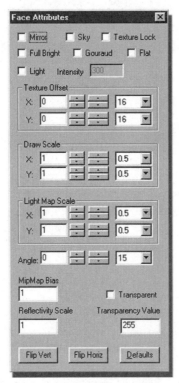

FIGURE *The Face Attribute dialog box.*
18.6

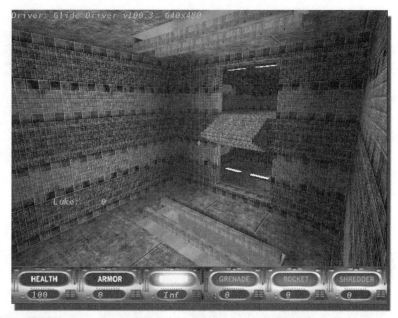

FIGURE *The floor has the transparency value set to 0. This setting causes the floor to mirror*
18.7 *everything and the floor texture is lost.*

FIGURE *This floor has the transparency value set to 125. This setting causes the floor to look highly*
18.8 *polished. Some of the texture is there, but we see a great degree of what is above. This setting*
is not right for our dirty subway.

FIGURE *This floor has the transparency value set to 200. This setting causes the floor texture to show*
18.9 *through stronger and diminishes the high polish of the floor.*

SKY

The Sky flag will make the face bluish in the level editor but be invisible in the game. It allows the Sky box to be seen outside the level. See Figures 18.10 and 18.11.

TEXTURE LOCK

The texture lock allows you to line up a texture on a brush and lock it in place. If you do not lock it, the texture will shift if you move the brush.

If you are going to use this function, engage it first before adjusting the texture. In addition, it often appears that this function does not work (textures shift or distort when the brush is moved), so be sure and use the Quick Compile feature to refresh the window.

FULL BRIGHT

The full bright will make the selected face impervious to darkness during the game. This is great for brushes made to look like lights. We will use this option later. You can see in Figure 18.12 that one cube has the full bright option turned on.

FIGURE *This is the sky as it appears in the level editor.*
18.10

FIGURE *This is the sky as it appears in the running game.*
18.11

FIGURE *One cube has the full bright option on. This option makes the face fully lit under all*
18.12 *circumstances.*

LIGHT

Set the light flag if you want the face to emit light. If you set this flag, be sure to set
the light's intensity value as well.

TEXTURE OFFSET

The texture offset controls where your texture is drawn on the face. The texture can
be moved left to right and up and down in large increments or small from the two
windows. Remember to engage texture lock if you are going to spend any time ad-
justing a texture to a face. When you move the brush, the texture will shift.

DRAW SCALE

The draw scale is the scale or size at which you want the texture drawn. Figure 18.13
shows one block with the draw scale taken down to 0.5, meaning that the texture is
drawn half as big and looks smaller.

LIGHT MAP SCALE

The light map scale is the size of the light map that you want to use for this face. A
larger light map size produces a more efficient level but with softer lighting and

FIGURE *The blocks have the same texture but two different draw scales.*
18.13

shadows. You can see in Figure 18.14 how the shadows, cast from the same light and from the same brush, are different due to the setting of the Light Map Scale parameter on the face on which the shadow is cast.

ANGLE
The angle option refers to the angle at which you want to rotate the texture on the face.

FLIP VERTICAL
Flip the texture vertically on the face.

FLIP HORIZONTAL
Flip the texture horizontally on the face.

FIGURE *The light and the brush casting the shadow are the same, but the face on which the shadows*
18.14 *are cast have different Light Map Scale settings.*

TRANSPARENT AND TRANSPARENCY VALUE

By turning this switch on and adjusting the value, the face will range in transparency
from completely invisible to solid. If you use this option in conjunction with the
mirror flag, you can get various effects. By setting the transparency value to a very
low number, you get more reflection and less of the texture showing through. Ad-
justing this value can make dirty- or clean-looking mirrors and windows. See Figure
18.15.

TESTING THE MAP

If you have been looking at the Face Edit dialog box, close it now by clicking the X
in the upper-right corner of the window. Save the level file, too. Before we test the
map, we must do one last thing.

FIGURE *By assigning transparency to a face and adjusting the values, you can make effects ranging*
18.15 *from chains to dirty glass.*

Press the T key and go onto Template mode. Select the Template tab on the Control Panel and scroll down the list. Choose the DeathMatchStart entity from the drop-down list. Click the Yellow Light Bulb to place the entity in the level (a blue X in your window). It is not there until you press Enter and hear the "Whoosh."

You can move the entity before you press Enter.

Once you hear the "Whoosh," you are still in Template mode and have to change to Select mode before you can select and move the entity. Make sure entities are not inside a wall or out of the level, and make sure the DeathMatchStart entity has some room around it for the player to spawn.

From the menu, select Tools | Compile or click the Compile button on the Toolbar. Accept the defaults, and let the map compile. Make sure the Preview option is checked, and choose Yes when you are prompted to preview the map.

TROUBLESHOOTING

If you have problems with your compile, ask yourself:

Did you put the DeathMatchStart entity in? Is it in a wall or off in space? Check all your views.

Run GTest. Even before you load a level from the editor try and run GTest. If this does not work then you may have a system or configuration problem.

If you created more than one room, you might have made a hole in your level. Your level has to be sealed. Make sure you don't have a cut brush cutting a hole in your level by accident.

CONCLUSION

In the next chapter, we add to our map and use even more of the features of Genesis.

CHAPTER
19
Finishing Up
the Map

Now we will create a second room in the station. We will link the two rooms with a Cut brush, add a sky, and discuss a few tips for making your maps run at their best. We will also explore how these basic techniques of brush placement and manipulation will allow you to add a great deal of varying detail to your maps easily.

ADDING THE SECOND ROOM

Our next step in the subway is to create another room. Let's start by making the room we have a little bit longer, about twice as long as it is now. Select the brush in the Side view and then press L to resize the brush. While in the Side view, drag the brush edge out.

Now press the L key again and you will be back in Select mode.

CLONING BRUSHES

Since most construction is very similar in our building, we could redo every step of building our first room to create the second—or we could simply *clone* it. To clone the first room, click the Top view and press Shift, and then click your left mouse button and drag. You will see the newly cloned brush moving. Keep dragging until the brush is roughly next to the original brush. We will make fine adjustments later.

NOTE

Keep in mind that when we used the Top view to make the clone, we were able to move the clone side to side but not up or down in relation to the original room. This keeps the floor at exactly the same level as the original room. This feature should be remembered because it can make editing easier. If you need to keep any surface aligned with an-other—floors or walls across parts of a level, for instance—you might as well create them perfectly aligned.

ALIGNING THE BRUSH
In the Top view, hold Shift and the left mouse button, and center the place where both brushes meet at their ends. Then hold Shift and the right mouse button to zoom up to the one texel level. See Figure 19.1.

Turn the Grid Snap off and place the two brushes together, as shown in Figure 19.2. Hold down Shift and the right mouse button, and zoom back out.

PLACING A CUT BRUSH
Now go to Template mode (hot key T) and select the Cube brush. Change the parameters to Solid and Cut Brush, and press OK. The template is there, but the cut brush is not, so press Enter.

FIGURE *The two brushes side by side.*
19.1

FIGURE *The two brushes placed precisely.*
19.2

Now go into Select mode and select the newly created Cut brush. Press L to resize.

Zoom in from the Side view and match the Cut brush with the floor of the two hollow cubes. Bring the top of the Cut out a bit lower and the sides in to form a roughly door-size hole. Make sure that the Cut brush does not cut through the Hollow brushes to the outside of the rooms anywhere and cause a leak in the level.

MORE FACE EDITING

You might notice that the faces of the Cut brush contain the wrong textures. Go into Face Editing mode (PgDn key; the brush must be selected in the Texture view first) and assign the proper textures to each face (Wall1 for the top of the brush as well as the sides, Tile1 for the floor).

Next we will give our room a view.

SKY BOXES

The way you create a sky in Genesis is by rendering a huge six-sided cube on the outside of your level. If you go to the Sky tab on the Control Panel, you will see six check boxes, as shown in Figure 19.3.

Each of the check boxes allows you to activate a face and then assign to that face a bitmap image from the texture library. Right now, you can assign to each face the image Stars from the pull-down list.

Here you can also assign a rate of rotation and axis. The current setting is great for storm clouds, but for the stars, set the rate to 0.

That's it for setting up a sky. Keep in mind that the Sky box is not visible from the level editor.

MAKING A SKYLIGHT

Now to use our sky. We could simply face edit the room, click the ceiling, and set the face to Sky, and we would see the stars in the game. But we will use another approach and take a few minutes to make our level look good.

First, go to the Texture tab and select the Ceiling texture.

Go to the Templates tab and create a solid cube and make it a Cut brush.

Now place the Cut brush into your ceiling (not cutting through it) and center it in the room, but give your skylight a nice thick edge to it, as shown in Figure 19.4.

This approach helps give the composition of the room a feeling of a solid structure. Try the simpler approach by making the entire ceiling face a sky face, and you will see how this ruins the illusion of solidity and makes the walls seem paper thin.

FIGURE *The Sky tab from the Control Panel.*
19.3

FIGURE *The alignment of the Cut brush for the skylight.*
19.4

While we are here at the skylight, create a Solid brush with the Woodold texture. Clone a few across the opening in the sky. Make sure that you line them up one texel from each edge.

PUTTING UP FENCES

Next we will put up a raunchy iron fence across the skylight to give things a really oppressive feeling. Simply select the Walk texture and create a Sheet brush. Place it along the top of the skylight. Face edit the brush, and turn on Transparency. Compile and run your map to see the effect.

You might want to take the Draw scale down to 0.5 in the Face editor so that the gate texture will be drawn smaller and look better. You can even set the transparency down a little so that the gate is not so hard edged but so you still cannot see through to the background. See Figure 19.5.

FIGURE *The iron fence in the editor and in the game.*
19.5

A FLUORESCENT LIGHT

Move over into the room with no skylight and create a Solid brush with the Stone_pale texture. Place this brush one texel from the ceiling, and make it about 32 texels wide, 100 long, and 10 or 15 high. See Figure 19.6.

Now use the PgDn key to enter Face Editing mode. Select the bottom face, where the light comes out.

Go to the Texture tab and assign the Light texture to this face.

Select the Full Bright option and close the Face Editing dialog box.

Clone a few more lights on your ceiling. Remember that as you do the cloning from the Top view, the lights will stay exactly one texel from the ceiling. For effect, face edit one and turn the Full Bright option off so it will appear burnt out.

Save your file. In the next chapter, we will add a light entity to the light objects and test the map.

FIGURE *The layout and placement of the fluorescent light fixture.*
19.6

A POSTER

Create another Sheet brush and assign it the texture Poster. Place this one texel from a wall, about midway up. With the poster, you want to turn on Transparency and Texture Lock. Position the poster and size the brush to fit.

Since we are using Transparency, go to Brush Adjustment mode and make this a Detail brush to avoid draw errors.

Sheet brushes often are created facing up and need to be rotated.

Look through the Texture Library. There are a few more signs and things that you can add to this room. The Marble texture makes great dirty glass. Simply create a Sheet brush with Marble as the texture, and turn Transparency on and set it down to about 75.

SPEED TIPS

As you make your maps larger and more complex, you will need to know a few tips for speeding them up and making them more efficient.

THE ONE-TEXEL RULE

Always distance every brush one texel from all others, whenever possible. This prevents the splitting of geometry into more faces.

LIGHT MAP SCALE

Texture scale, how big a texture or image is drawn, and light-map scale are separated. If you have large outdoor areas running slowly, you can make your light-map scale a 5 or an 8. In smaller indoor areas, you can bring them down to 1 or 2 for finer shadows. Texture scale does not affect rendering speed.

DETAIL BRUSHES

Every time you create an object and place a brush in your world, ask yourself if it can be a Detail brush. Detail brushes are key to getting fast compiles. If the object is not going to block visibility, make it a Detail brush. Only the basic shape of your world should be structural (non-detail). Fully vising the level will speed up the radiosity pass as well as the overall speed of the level in the renderer.

AVOID CUT BRUSHES

The editor and engine do not handle Cut brushes very well. Lots of portals get built by the fragments left behind from the current cut method. This makes for *slow* vising times (20 to 30 hours!).

HINT BRUSHES

In tight spaces that should be running fast but are running slow, put a couple of Hint brushes in. Hint brushes should span the entire problem area (like cutting a

hallway totally in half). Hint brushes are a way of letting the engine know that it needs to do a better (tighter) vis job around the Hint brush area.

USE AREA BRUSHES

Area brushes were described earlier and should be used on doors.

CONCLUSION

Next we will start lighting our level using the various lights and effects available in Genesis.

CHAPTER

20

Adding Lights to the Map

Before we add all the lights to this map, we need to make room for them all. You can simply select the Hollow brush that composes the room with the skylight, make the floor a little lower, and make the room a little wider. Be careful not to move the wall that the Cut brush to the other room is in or you will have to go in and make the fine adjustment all over.

You can place some stairs in the opening between the two rooms. Assign the Tile1 texture to the stairs and press Enter; move, rotate, and size the stairs in place. See Figure 20.1.

If you have compiled your level and run it, you will see that default ambient lighting looks harsh and flat. Let's now start placing lights in our level and making it look like an abandoned subway.

There are several lights or light effects we can use. They are:

- **Light.** These lights illuminate in a radius and can have effects assigned them.
- **Dynamic light.** Dynamic light can be assigned behaviors and attached to models.
- **Spotlight.** A spotlight gives a controlled beam or circle of light.
- **Fog light.** A fog light produces a radius of fogged light.
- **Corona.** A corona renders a bitmap in the scene that looks and behaves like the glow or halo around a light at night.

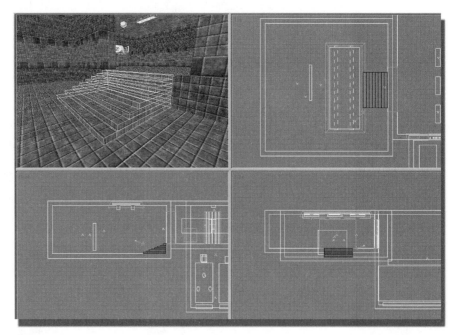

FIGURE *The stairs in the enlarged room.*
20.1

We will assume that there is no or very little light in the level. The next time we compile the map, we will turn the default lighting way down. Now we will place a few regular light entities in our level.

LIGHTS

Go into Template mode and go to the Template tab. From the pull-down list, select the Light entity. See Figure 20.2.

Click the Light Bulb icon to place the Light Entity template on the map.

You can press the Center Brush/Entity in View button on the Toolbar to center the Light entity in the middle of all views.

After you have moved the dark blue X to the corner of the room and the middle of the wall, press Enter to place it in the world. Go into Select mode and select the light you just placed. Open the Properties box for this entity using the Toolbar icon. Figure 20.3 shows the Light Properties dialog box. Let's look at the options in this box.

COLOR

The Color option is the RGB color of the light. You can bring up a color picker to visually choose the color of the light.

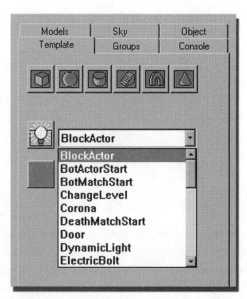

FIGURE *The pull-down entity list on the Template tab of the Control Panel.*
20.2

FIGURE *The Light Properties dialog box.*
20.3

LIGHT

The Light option represents the radius of the light in world units. The default is 150. Change this to about 300 or 350.

ORIGIN

The Origin shows the *xyz* coordinates of the light in the world. This option is set by moving the entity, although you can also type in the *xyz* coordinates here if you needed to.

STYLE

Using numbers from 0 to 11, you can assign different effects to the light using the Style option. Many effects are various rates of flicker, but a few stand out:

3 - Flickers slower
4 - Flickers really fast
5 - Fades in and out at medium speed
6 - Flickers like a torch
11 - Is a throbbing, shadowy effect that you really need to see

Go back into Select mode and clone the light the way we cloned the brush. Hold down Shift and the left mouse button and drag. Do this from the Top view, and place three lights: one in the center of each wall from above and toward the floor.

Now we are ready to compile and test the map. When you select the Compile option and are presented with the Compile Manager dialog box (shown in Figure 20.4) go down to the Default Light Level (RGB) and set it to 45,45,45. To change

this setting, click in the window and delete all the digits already there (they should be 128,128,128) and type in 45,45,45.

Make sure the Preview option is checked, and press OK and Yes when prompted.

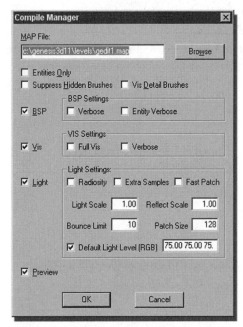

FIGURE *The Compile Manager dialog box.*
20.4

DYNAMIC LIGHTS

Dynamic lights can add some real atmosphere to your level. As an example, place a Dynamic light, as you would a regular light entity, from your Top view and center it.

Move the Dynamic light right in the middle of the Fluorescent light object, the one closest to the poster we laid on the wall earlier. From the Side view, position this light about 16 to 32 texels away from the surface of the light. You can set your grid and turn Grid Snap on and off to help with this.

Once you have placed the Dynamic light, open the Entity dialog box for the light and look at the options.

ALLOW ROTATION

The Allow Rotation option pertains to a function of a model we will talk about later in the book.

COLOR

The Color option is the RGB color of the light. You can bring up a color picker to visually choose the color of the light. For the fluorescent, I chose a whitish-blue, RGB value 128,255,255.

INTERPOLATE VALUES

You can turn the Interpolate Values option off or on to make a smoother transition between the Radius function values, discussed in a moment.

MAX RADIUS

The Max Radius option represents the maximum radius of the light in world coordinates.

MIN RADIUS

The Min Radius option represents the minimum radius of the light in world coordinates.

MODEL

You can attach a Dynamic light to a model. We will look at this feature in the chapter on modeling.

ORIGIN

The *xyz* coordinates of the light in the world are handled in the Origin option. These coordinates are set by moving the entity, although you can also type in the *xyz* coordinates here.

RADIUS FUNCTION

The Radius function allows you to set a pattern for your dynamic light using the alphabet a–z. The letter *a* represents the minimum radius and *z* the maximum radius.

For the Fluorescent light, use all maximum and minimum values. Type in a long string of letters with a varied pattern so that the effect will appear more random. Make a portion of the string where the letter *a* is repeated to make the light look as though it is failing and flickering:

Radius function azaazzaazzaaaaaaaaaazzzaazazazazazazzazaaaaaaaaa

RADIUS SPEED

The Radius Speed is how fast the program cycles through the Radius function values in seconds. Set this down to half a second (0.5) and the light will appear to flicker.

Now compile and run your map. The fluorescent light should now appear to flicker like a failing light.

SPOTLIGHTS

As we said, a spotlight shines in only one direction and at only one angle. You can control the circle (or *arc*) of the light, the distance it shines, and the color.

You must be sure to set the options of a spotlight so that the light is shining where you want it. You will not see your spotlight in the game, no matter how close it is to the surface, if it is pointing the wrong way.

The Spotlight options are Angles, Arc, Color, Light, Origin, and Style.

ANGLES

The Angles option controls the direction your light is facing, in values between 0 and 359 (like a compass, with 0 being north, 90 east, 180 south, and 270 west). If you change these values and close the Entity dialog box, you will notice that the Light icon in the editor will appear, showing the angle.

ARC

The Arc option represents the width of the cone of your light.

COLOR

The Color option can be set as with the other lights.

LIGHT

The Light option controls distance the light is effective, in world coordinates.

ORIGIN

The Origin option is where you change the *xyz* coordinates of the light.

STYLE

Styles can be set in this option as for the Light entity.

FOG LIGHTS

Fog lights are used to simulate fog and are expensive to render, so use them sparingly. Fog, just like fog in the real world, cannot be seen when you are in the center of it. The options for Fog lights are Brightness, Color, Origin, and Radius.

BRIGHTNESS

The Brightness option is set at 0. You must bring it up to about 300 or more to see the fog effect.

COLOR

Use the color picker to set the color of your fog effect.

ORIGIN

The Origin option represents the location of the entity in *xyz* coordinates.

RADIUS

This option controls the radius of the Fog light effect.

CORONA

A corona is the effect you might have seen around a streetlight at night. We use it here to simulate a train light in a tunnel. First, let's make the tunnel.

Start by creating (or cloning) a Hollow brush. Move the Hollow brush next to an empty wall. The one opposite the poster is a good place. Line up the hulls of the brush. See Figure 20.5.

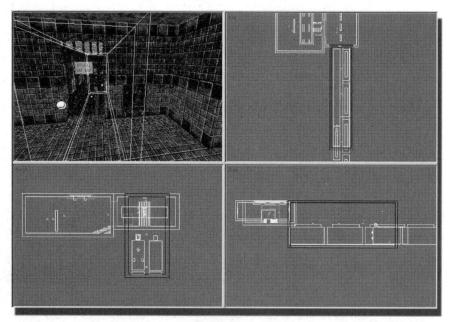

FIGURE *The layout of the new Hollow brush and a close-up of its alignment.*
20.5

With the Hollow brush selected, size it to be a little narrower than the room and roughly four times longer. From the Side view, lower the floor of the brush to make the brush about twice as high. See Figures 20.6 and 20.7 for the layout.

Finally, add three lights down the center of the room and set their radius to about 200. To add more detail to this scene, you can face edit the tunnel and use the Blocks texture for the walls and build tracks if you like. The Track texture can be put on a Sheet brush for this effect.

Clone the Cut brush used between the two rooms. It is already set up with the right textures. Size it to fit between the poster room and the new tunnel. You can create small bars out of some solid brushes to fit over the opening to keep the player from falling in, but spaced wide enough to see between.

Finally, add the Corona entity to the end of the tunnel, opposite the cut door and a little off the floor.

You can compile your map with the default Corona setting to see the "train in the tunnel" effect.

The options for the Corona entity are Allow Rotation, Color, Fade Out, Fade Time, Maximum Radius, Maximum Radius Distance, Maximum Visible Distance, Minimum Radius, Minimum Radius Distance, Model, and Origin.

ALLOW ROTATION

The Allow Rotation option is applicable if the corona is attached to a model.

FIGURE
20.6
The layout of the Hollow brush from the Top view, after sizing.

FIGURE *The layout of the Hollow brush from the Side view.*
20.7

COLOR

Using the color picker, you can select the color of the corona.

FADE OUT

The Fade Out option allows the corona to fade out when it passes out of visible range.

FADE TIME

The Fade Time option controls how long the fade takes to drop to zero viability, expressed in seconds.

MAXIMUM RADIUS

The Maximum Radius option is the maximum size, expressed in texels, the corona will ever get.

MAXIMUM RADIUS DISTANCE

When the maximum radius distance is reached, the corona will not get any larger.

MAXIMUM VISIBLE DISTANCE

The Maximum Visible Distance option controls the maximum distance at which the corona is visible.

MINIMUM RADIUS

The Minimum Radius option controls the smallest the corona will ever get; the radius is expressed in texels.

MINIMUM RADIUS DISTANCE

Below the minimum radius distance, the corona will get no smaller.

MODEL

Through the Model option, you can attach a corona to a model. We will learn to make a model later.

ORIGIN

The Origin option controls the *xyz* location of the corona entity.

CONCLUSION

As you have seen, lighting can be very powerful and make a huge difference in terms of how a level looks and feels. Next, we add a model to our map and animate it.

CHAPTER

21

Adding Models to the Map

Creating models in Genesis is easy and allows for the animation of brushes or groups of brushes in your level. You can make doors, platforms, and even ambient movement, such as that of waterwheels and vehicles. In this chapter, we create a very simple model, but the effect will be pretty dramatic, given the simplicity of the steps.

A SIMPLE TRAIN

The effect we are going for is a train rushing through the dark, below the player as he or she stands on the platform looking down. All we have to do is create a solid brush with the Bolttile texture on it. See Figure 21.1 for the general proportions and layout of the train.

Looking at this train in the editor, we see that it is not so impressive; see Figure 21.2. However, this is a good illustration of how game-level construction is part trickery and illusion.

FIGURE *The general proportions and location of the simple train.*
21.1

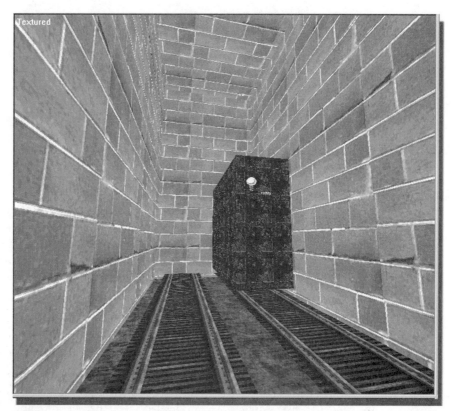

FIGURE *The simple train in the level editor; it's not very impressive—yet.*
21.2

Right now, the train is just a brush. To make it a model in the eyes of the editor, we have to make it a model using the Model tab. Click the Model tab, which is shown in Figure 21.3.

THE MODEL TAB

Notice that everything in Figure 21.3 is grayed out but the Add Model button. To make the train a model, select the Train brush and click the Add Model button. You will be prompted to name the model. Name it Train.

When naming your models, give thought to their names so that you can identify them more easily later on. If your level will have one or two elevators, names such as Elevator 1 and Elevator 2 are okay. If your level will be one with many elevators, those names might become harder to keep track of as you work. You might have to put some thought into your names and come up with your own naming convention.

FIGURE *The Model tab.*
21.3

Now all the buttons of the Model tab are available, because we have a model to work with. Let's look at the options of the Model tab: the pull-down list, Add Model, Delete Model, Select, Deselect, Add Brushes, Remove Brushes, Clone Model, and Set Origin.

THE PULL-DOWN LIST
This list allows you to select any model on your map. Currently, you should have one model, Train, in this list.

ADD MODEL
The Add Model option allows you to make selected brushes a model.

DELETE MODEL
The Delete Model option deletes the model but not the brushes composing the model.

CAUTION

Be careful. If you animate a model and assign it to various entities, then delete it, you will have to redo your work. Even if you add the same brushes to a new model of the same name, you will have to go back and reanimate and reassign the model, even though the model name appears in the Entity dialog boxes.

SELECT

When you choose a model from the list, you can select it from the Select option.

DESELECT

You can also deselect the model from the Deselect option.

ADD BRUSHES

With a brush selected that is not part of a model, you can choose the model from the drop-down list and click Add Brushes to add the selected brushes to the model.

REMOVE BRUSHES

The Remove Brushes option opens the model and allows you to remove brushes.

CLONE MODEL

Click the Clone Model option, and you will get a copy of the model, and animation as well. The model will be assigned to no entities, though.

SET ORIGIN

The Set Origin option sets the pivot point of the model. This option is especially useful for doors. After selecting Set Origin, you can drag a small blue X around until you have the hinge line or pivot point of your model set where you want it.

ANIMATING A MODEL

The bottom half of the Models page allows you to define an animation path for the model. Animation works in Genesis by defining *keyframes*, or points throughout the animation where you want the model to be. You can also assign the time it will take for the model to reach each of those points in the animation. If you animated a door opening, for example, you would start the animation at 0 (seconds) and rotate the door open, and then enter the keyframe value of 2. That means that the door will take 2 seconds to go from closed to open. See Figure 21.4.

To create motion for the model, select the desired model from the drop-down list on the Models tab, and then press the Animate button. The editor will select the model and put the editor into Move mode. You can now move and rotate the model to the next position you want it to be in the animation (the next keyframe). When you have the model at the position you want, press the Stop Animating button and enter the keyframe time.

Now let's animate the train:

Select the train model, then click the Animate button.

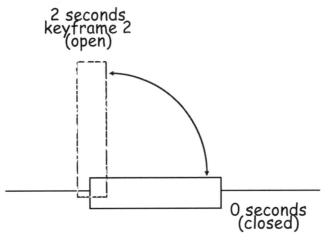

FIGURE *The concept of an opening door and its keyframes.*
21.4

You can use the Restrict x, y, and z buttons in the toolbar to move the train in a straight line.

Now move the train to well under the room—even outside the level is okay.

Press the Stop Animating button. You will be prompted to enter the key time. Enter 3, for 3 seconds. Remember that this is the amount of time in seconds it takes for the model to reach this first keyframe. A speeding train could take 3 seconds and a slower one 5 or 6. See Figure 21.5.

Since Genesis interpolates between keyframes to smooth the animation, we will define an additional keyframe at the same location to help the interpolation.

Click the Animate button once again and do *not* move your model. Press Stop Animating. When prompted to enter a key time, enter the value 3.01.

We want our train to appear as though it is rushing under us, never to return. To do this, we can animate the train moving along the track and then create another keyframe in the animation, where the train simply sits out of sight for a few seconds. The effect in the game will be the train speeding under us and then nothing for several seconds, as though the train has continued on. When the animation starts the next time, the train will not go backward; rather, it will instantly appear at the starting point. The effect will be that another train is coming down the track some time after the first.

Another effect you can try is an endless line of boxcars passing by. Make a simple car and clone it about four times, and place each car exactly the same distance from the other cars. Make them all one model called Cars, and animate them so that the animation starts and stops at the exact same place. Using this technique, you can make it appear that an endless line of cars is moving through the tunnel. See Figure 21.6.

Start: 0

End of Track: 3

Out of Site: 8

(seconds)

K 0 (seconds) K 3

train

tracks

FIGURE *The train animation and its keyframes.*
21.5

Key 0

Key 2

FIGURE *The "endless line of cars" effect.*
21.6

ANIMATING DOORS AND PLATFORMS

You can also animate doors and raising platforms, such as elevators, using the same process you used for animating the train. The major difference here lies in what you have the animation do. For a door or elevator, you usually want the animation to run in three phases; door opens, door pauses, door closes. The pause is so that the player has time to get through the door or off the platform. See Figures 21.7 and 21.8 for animations of a door and a platform.

When animating doors and platforms, keep in mind the setting and the technology or "magic" behind them. Obviously, the setting a door is in is established by the texture and model, but a good animation supports the setting. A space or high-tech door might pop open quickly and close a little more slowly. Heavy doors might be thicker, open painfully slowly, and close even more slowly. Although having large objects floating in space often destroys the illusion that the computer world is real, this illusion can be used, too, if implemented well. A door that floats magically away can look good if done right or ludicrous if done poorly.

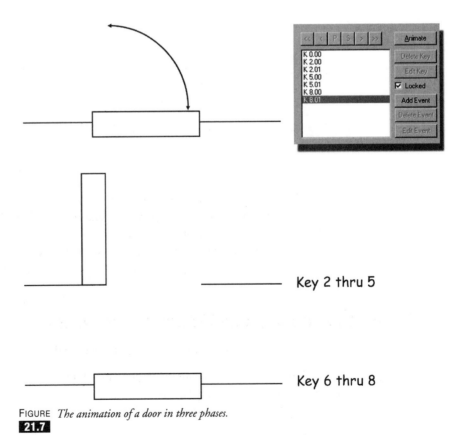

FIGURE *The animation of a door in three phases.*
21.7

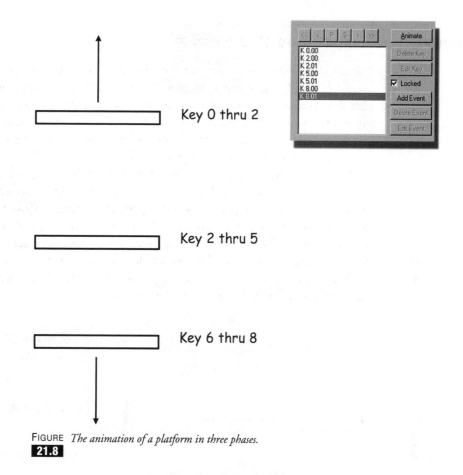

Key 0 thru 2

Key 2 thru 5

Key 6 thru 8

FIGURE *The animation of a platform in three phases.*
21.8

When animating models that are to return to their original position, be sure to use the Grid Snaps and line things up to the one-texel level so that the model doesn't jump or pop at the end of its animation.

Simply animating a model doesn't make the model work in the game. To make the model work, we have to work with three different entities in the Template tab.

THE DOOR, PLATFORM, AND MODEL CONTROLLER

In the Template tab are three entities we need to work with:

Door. This entity makes the model respond as a door.

Model Controller. This entity makes the model's animation run in a loop.

Moving Platform (MovingPlat). This entity makes the model respond as an elevator.

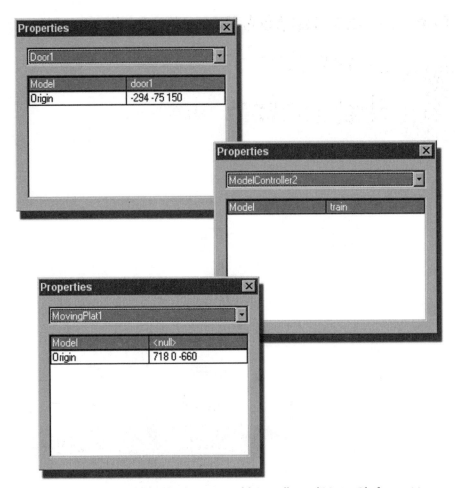

FIGURE *The Properties dialog box for the Door, Model Controller, and Moving Platform entities.*
21.9

To use these entities, simply place them in the level and from their Properties dialog boxes, assign the model. See Figure 21.9.

A LIGHT AT THE END OF THE TUNNEL

Finally, press the Entity Dialog button and choose the Corona entity from the drop-down list. Double-click the Model options, and select the Train model. This choice will attach the corona to the train as it moves. See Figure 21.10.

FIGURE *The Corona Entity dialog box.*
21.10

CONCLUSION

You are now ready to compile and test your level. You should be able to stand in the barred door and look down on the tracks shrouded in darkness. Every so often, the hulk of a train will speed through, the corona light adding a nice touch.

One thing is missing, though: sound—the deafening roar of a train beneath our feet, the whir of hydraulics as a door opens, and even ambient sounds such as wind in the skylight or water gurgling in some unseen subterranean pipe.

Adding sound is where the many advances of the Reality Factory come in. We look at all those possibilities in the next few chapters.

CHAPTER

22

Level Creation Using Reality Factory

Now that we have mastered the basics of map building with Genesis, we can build a more complex game map using Reality Factory and add effects to it as well. Reality Factory, on the outside, looks like Genesis, but there are big differences behind the scenes. Mainly, a large number of entities have been added or enhanced. This portion of the book reviews and explores those entities and the effects we can create with them.

Reality Factory is largely the effort of Rabid Games, but many other individuals have helped improve the core Genesis 3D technology. With Reality Factory, you can use the basics you learned about building a level to create more elaborate and stunning game levels. Particularly of interest to designers are the expanded entities that allow far more control over special effects, atmosphere, audio, and even AI. Best of all, you won't need a couple of programmers just to prototype your game idea.

Obviously, programmers are still very important to game development, but Reality Factory is a rapid-prototyping tool that allows artists and designers the freedom to experiment and create. Reality Factory is set up to be completely driven by entities and configuration files—files that can be edited and changed by designers as opposed to having to open up the source code and then recompile the code, as is done by a programmer.

Rabid Games has also decided (in the spirit of the original Genesis 3D team) to make Reality Factory open source software.

WHAT YOU NEED TO RUN REALITY FACTORY

Let's take a quick look at the things you need to run Reality Factory (RF).

MINIMUM SYSTEM REQUIREMENTS

At minimum, you need a YAMD K6-2/400 or similar performance CPU, 64MB of RAM, 50MB of hard disk space for the game, a SoundBlaster Live or other PCI audio card, and a NVidia TNT-class 3D accelerator (PCI or AGP).

Although Genesis 3D provides software-rendering capabilities, note that Rabid Games doesn't support it. RF needs a 3D hardware accelerator.

RECOMMENDED SYSTEM REQUIREMENTS

For better performance while running RF, you should have an Intel Celeron 433MHz or similar-performing CPU, 64MB of RAM, 100MB of hard disk space (for levels and content, mainly), a SoundBlaster Live or other PCI audio card, and an AGP NVidia TNT2-class 3D accelerator.

PREFERRED SYSTEM REQUIREMENTS

For optimum performance, you need an Intel Celeron 500MHz or better CPU, 128MB of RAM, 100MB of hard disk space on a UDMA/33 hard disk, Sound-Blaster Live, and an AGP Voodoo3-based 3D accelerator.

Voodoo2 3D-only cards are not recommended and not supported by RF. RF might work on a Voodoo2 card with a little tweaking of the initialization file, but it becomes problematic if you manage to crash Reality Factory because you can't see any error messages that pop up. RF will work with a Voodoo2 chained to another 3D card.

TROUBLESHOOTING REALITY FACTORY

When you start running increasingly more complex levels, you will most likely run into some technical problems. Every time Reality Factory runs, it generates a log file, REALITY FACTORY.LOG. This file contains information on the content that was loaded, the graphics driver that was selected, and any run-time error messages that Reality Factory generates. When you start having problems with your level, check the log file first. Other things to check are:

- Do you have a PlayerStart on the level? You *must* have one.
- Is all your content (BMP and WAV files, etc.) in the right directories, as defined in the Reality Factory .INI file?
- Are you trying to use the software renderer? The renderer is *not* supported.
- Are you using the Glide driver on a Direct3D system? Always fall back to Direct3D!
- Are you crashing in full-screen mode? Switch to Windowed mode for debugging.

REALITY FACTORY ENTITY OVERVIEW

With RF, you use two major components to build your game world: world geometry and entities. *World geometry* is all the textured brushes or geometry. *Entities* allow the geometry to move, sounds to play, and effects to operate.

All the entities we discuss here have attributes, some of which are required and others optional. When required, the attribute is marked Required. Entity attributes that are not marked Required are optional and can be left blank.

There are several categories of entity:

- **Environmental setup.** Setting up the game world and player environments.
- **Audio effects.** Control over the various soundtrack and audio effects.
- **World model helpers.** Doors, triggers, platforms, etc.
- **Props.** Nonmoving items to add realism to the world.
- **Paths and AI support.** Path points, path followers, NPC AI.
- **Special effects.** Atmospheric, electrical, lighting, teleport, particle effects, and more.

Most entities have names associated with them. These names need to be unique per level because they will be used in path following and scripting. It's okay to use the same name in different levels.

SETTING UP A LEVEL IN REALITY FACTORY

A small outdoor campsite was built for this section of the book. The Genesis/Reality Factory engine cannot handle massive and complex terrain-based levels, but you will see that we can build some pretty effective scenes with an outdoor feel to them if we use certain techniques and some of the tools in Reality Factory.

If you want to examine the map, open the RF editor and then open the map file CAMP.3DT, located in the Tutorials/Camp folder on the CD-ROM.

You will notice that the entire level is one large hollow cube. The sides and top faces were face edited and set to the Sky attribute. The Stars image was selected, but once we start applying the effects of RF, we will no longer see the sky.

The level was built using the basics learned in the chapters pertaining to Genesis 3D. If you want to build the level yourself, here are the basic steps:

1. Open a new file and set the Options | Level Options | Texture Library to CAMP.TXL.
2. Create a large hollow cube and go into Face Editing mode (PgDn is the hot key). Select the four sides and the top face, and set them to the Sky attribute.
3. Select the bottom face or floor of the cube and assign it the Grass texture. If you increase the tiling of this texture from the default 1 to 1.5 in the Face Editing dialog window, the texture will cover more ground and greatly decrease the chance that any tiling will show.
4. Place a Player Start entity in the level and compile your level. Any problems should be fixed following the suggestions in the previous chapters on Genesis.

In your level, you should see a large grassy plain that ends unnaturally. To cover this unnatural truncation, we use a combination of techniques. Remember to use the speed and optimization tricks here, even in this small level. Making the various objects Detail brushes, keeping them one texel away from each other, and so

on makes a difference in terms of rendering time and frame rate, even in a small level.

Make the cube larger if you need to.

SETTING UP CAMP

THE TENTS

To create the tents in the level, simply create a Sheet brush and assign it the Tent texture. Face edit this brush before moving or slanting it for ease. Remember to apply Texture Lock before face editing. Select the Transparency while you are here.

Go into Move mode (the M key). Hold down the right mouse button and rotate the Sheet brush about halfway.

Clone the Sheet brush and rotate it. Now line up the two sides with each other.

As a final touch, create a thin Solid brush with the Oldwood texture on it and make tent poles.

THE CRATES

Create solid Cube brushes and face edit them. Use the Texture Lock flag, and apply the Crate texture. Line up the textures.

THE TREES

The trees are nothing more than solid cylinders with the Pine texture applied. Pine trees were chosen because they can grow quite tall and their trunks are often no more than bark-covered poles from the Ground view, since the branches grow high off the ground. An oak tree, on the other hand, tends to have twisting roots that grow high up the trunk, with low-hanging and sprawling branches. This effect is very hard to model in RF and slow to render. You will also see why we leave the tops of our trees as they are, with no branches or leaves; it's because we will use fog that will blur the tops of the trees.

You should select all the trees and make a group called Trees so you can hide them for easier editing.

Finally, if you look at the map file on the CD, you will see that there are other items around the camp. With basic shapes and a few good textures, you can make a loading dock, a shack, and a fire. You will also see in the sample map how the various new entities—Fire, Rain, 3D Audio, and so on—are used.

EnvironmentalSetup

We look at the EnvironmentalSetup entities first because they are usually the first to be placed in a level. The EnvironmentalSetup entities are used to define levelwide attributes and behaviors. There is usually only a single instance of each type of entity per level. The only required entity is the PlayerStart entity, which tells Reality Factory where on the level to place the player when the game starts.

THE PLAYERSTART ENTITY

The PlayerStart entity defines where the player starts on the level. See Figure 22.1.

Only one PlayerStart entity should be defined per level. Placing more than one Player-Start in your level will cause problems.

CAUTION

Notice that there are various soundtrack options, but none is required. You can start your level with a soundtrack here, or start a soundtrack later using the SoundtrackAudio entity.

The PlayerStart entity has the following attributes:

- **szMIDIFile.** Name of a MIDI file to play when the player starts the level.
- **szCDTrack.** Number of a CD audio track to play when the player starts the level.
- **szStreamingAudio.** Name of a streaming audio .WAV file to play when the player starts the level.
- **bSoundtrackLoops.** True if the soundtrack loops, False if it plays through only once.

These options are used for one-time soundtracks or introductory narration to the game level. This entity can be used to play the character's voice-over comments or a narrator's explanation of the game situation.

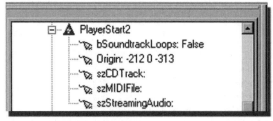

FIGURE *The PlayerStart dialog box.*
22.1

THE ENVIRONMENTALSETUP ENTITY

The EnvironmentalSetup entity, which is not a required entity, defines various levelwide attributes for the current level only. Only one of these entities should be defined per level; defining more than one will cause problems. See Figure 22.2.

One of the most powerful features here is the ability to set distance fogging and the far clip plane. Fog not only adds a lot of ambiance to the environment of your game, but distance fogging and the far clipping plane can significantly improve performance—especially on large, open-space levels.

Make sure that the TotallyFoggedDistance is less than the FarClipPlaneDistance. The reason is to prevent the player from seeing the level get cut off. In addition, with the Fog option on, the Sky box will not be visible.

You will see that the rest of these attributes require some experimentation to find optimum settings for the atmosphere and feel of your level, but careful adjustment of the gravity and jump-speed parameters can provide an outer-space feel to levels in high-tech starship and/or space station environments.

The EnvironmentalSetup entity has the following attributes:

- **Gravity.** Enhances the pull of gravity downward for the player and entities in the level.
- **Speed.** The speed of player motion for walking.
- **JumpSpeed.** The speed of an upward jump for the player.
- **StepHeight.** The maximum height (in world units) the player can automatically "step up" without jumping. Going up stairs should not require the player to jump up each one.
- **EnableDistanceFog.** True if distance fog is enabled for this level. Set this to True for the camp level.

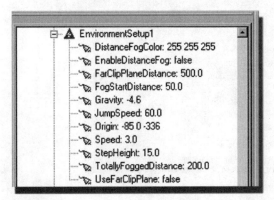

FIGURE *The EnvironmentalSetup dialog box.*
22.2

- **DistanceFogColor.** The color (RGB) of the distance fog, if fog is active. Make this black.
- **FogStartDistance.** The distance from the camera at which fog starts, in world units.
- **TotallyFoggedDistance.** The distance from the camera at which fog totally obscures the view, in world units.
- **UseFarClipPlane.** True if FarClipPlane is to be used.
- **FarClipPlaneDistance.** The distance from the camera (in world units) at which geometry is no longer rendered.

By playing with the FogStart and TotallyFogged settings, you can create the "ball of light" feeling for a user, which can be scary. You can actually set your ambient light in the level up higher and close the darkness fog around players to make them feel as though they are walking by torchlight or flashlight. Tweaking the light color can give the "ball of light" a fiery or electrical feel. See Figures 22.3–22.6.

THE PLAYERSETUP ENTITY

The PlayerSetup entity defines various parameters used to establish how the player appears in the game as well as defining the heads-up display (HUD) and any attributes of the player. See Figure 22.7.

FIGURE *The screens with various fog and clip planes in use.*
22.3

FIGURE *The screens with various fog and clip planes in use.*
22.4

FIGURE *The screens with various fog and clip planes in use.*
22.5

FIGURE *The screens with various fog and clip planes in use.*
22.6

FIGURE *The PlayerSetup dialog box.*
22.7

PlayerScaleFactor and ActorRotation are used to adjust the size and default rotation of the player avatar model. Some 3D programs output their models aligned and rotated along different (xyz) axes than those used by Reality Factory. Careful use of the player scaling can allow you to design levels that appear larger by simply making your actor and props smaller.

Although the player attribute system will persist for all versions of Reality Factory, the HUD system will change. Rabid Games is working on implementing a true 3D HUD.

The PlayerSetup entity has the following attributes:

- **HUDInfoFile.** The name of the text file containing the HUD layout. The default file is HUD.INI and can be edited with a text editor. Make a copy of the default before you change it.
- **AttributeInfoFile.** The name of the text file containing the definition of player attributes.
- **OpeningCutScene.** The name of the AVI file to play as level-start cut scene.
- **PlayerScaleFactor.** The percentage by which to scale the actor (1.00 is no scaling, 0.5 is half-size, and so on).
- **ActorRotation.** The rotation to apply to the actor when the game is loaded; used to adjust default orientation.

THE ENVIRONMENTALAUDIOSETUP ENTITY

The EnvAudioSetup entity defines the various sound effects to be played as "motion sounds" when the player is moving through various zones. A *zone* is an area defined by a Genesis 3D world model that isn't collision-checked.

This entity allows you to define default and generic footsteps and movement sounds such as sloshing in water in other assigned zones. The zones are defines in the Brush Entity dialog box. See figure 22.8.

The sounds used should be short, looping audio effects, such as repeating footsteps or sloshing in water.

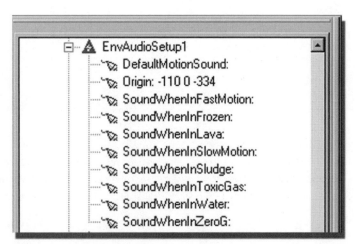

FIGURE *The EnvironmentalAudioSetup dialog box.*
22.8

The EnvAudioSetup entity has the following attributes:

- **DefaultMotionSound.** The sound to play when no other motion sound is defined.
- **SoundWhenInWater.** The sound to play when moving in water.
- **SoundWhenInLava.** The sound to play when moving in lava.
- **SoundWhenInToxicGas.** The sound to play when moving in toxic gas.
- **SoundWhenInZeroG.** The sound to play when moving in zero gravity.
- **SoundWhenInFrozen.** The sound to play when moving on a frozen surface.
- **SoundWhenInSludge.** The sound to play when moving in sludge.
- **SoundWhenInSlowMotion.** The sound to play when moving in a slow-motion zone.
- **SoundWhenInFastMotion.** The sound to play when moving in a fast-motion zone.

As you can see, Reality Factory has made a huge advancement over Genesis. The ability to add fog and a clipping plane alone allows designers to do a lot more with their tools as far as level size, complexity, and atmosphere. The EnvironmentalAudioSetup entity allows us to assign various sound files as the player walks over different types of surfaces, and that alone adds a greater degree of immersion.

CONCLUSION

In the next chapter, we look at additional audio effects and enhancements made to the world models helpers.

23 Audio Effects and World Model Helpers

I n this chapter we'll see how the use of Sound and "Real World" effects can make your games more realistic.

AUDIO EFFECTS

Sound can add a great deal of richness to a level. The choices in RF cover environmental audio, 3D audio point sources, and soundtrack switching. Once you start adding sounds to your game, you will see how much sound enhances the game experience. The ambient noises in games such as *Kingpin* add enormously to the experience. The ambient sounds in *Kingpin* are accessible in the demo as .WAV files. With these entities, the player hears a crackling fire or a babbling brook only when in the vicinity of the fire or water.

There are three kinds of audio files that you can use with Reality Factory:

- MIDI files, which define a musical track to be played;
- CD audio tracks that play a track from an audio CD (use your favorite CD)— Note: Permission for use is probably required.
- Streaming audio files—.WAV files that contain a soundtrack or other sound effects loaded into the computer's memory and played back

THE 3D AUDIO SOURCE ENTITY

The 3D Audio Source entity is used to place a point in your level from which a sound appears to emanate. The entity maintains its position when the player moves around the level. You can, for example, have the purr of an engine come from a generator and, as the player nears the generator, the sound grows louder. Of course, the sound drops off as the player walks away. This technique can be used to create the sound of running water from a sewer opening, music from a bar, or any noise source we hear in real life. The sound you create can also serve as a clue during game play. If all the doors you walk past are quiet, but one emits a low gurgle, what is behind that door for the player to discover?

All Audio Source 3D sounds loop, or play over and over, and have an audible radius beyond which the sound is no longer heard. See Figure 23.1.

The 3D Audio Source entity has the following attributes:

- **szSoundFile.** The name of the .WAV file to use as the audio effect.
- **fRadius.** The maximum distance from the entity at which the sound will be heard, in world units.
- **szEntityName.** The name of this entity (used in scripting and path following).

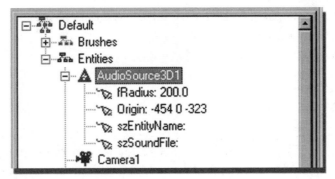

FIGURE *The 3D Audio Source dialog box.*
23.1

THE SOUNDTRACKTOGGLE ENTITY

The SoundtrackToggle entity is used to switch between soundtracks inside a level. The toggle switches back and forth between the two defined soundtracks each time the player comes within the entity's trigger range. You can also set a delay that will prevent the toggle from being switched repeatedly if the player chooses to run back and forth through the entity radius. The trigger range defines how close the player avatar has to get to the trigger before it switches. See Figure 23.2.

This entity can also be used to switch between two different types of soundtrack—from a MIDI file to a streaming audio track, for example. It can also be set to trigger only once if, for example, you wanted a single audio effect to play when the player passes through a certain point.

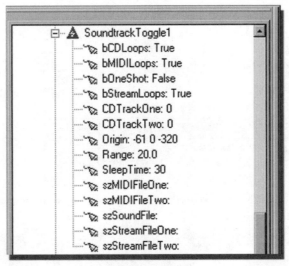

FIGURE *The SoundtrackToggle dialog box.*
23.2

The SoundtrackToggle entity has the following attributes:

- **szMIDIFileOne.** First MIDI file to switch to.
- **szMIDIFileTwo.** Second MIDI file to switch to.
- **CDTrackOne.** First CD track to switch to.
- **CDTrackTwo.** Second CD track to switch to.
- **szStreamFileOne.** First streaming audio file to switch to.
- **szStreamFileTwo.** Second streaming audio file to switch to.
- **szSoundFile.** Audio effect to play when switch activates.
- **bOneShot.** True if the toggle happens only once.
- **bCDLoops.** True if the CD track should loop.
- **bMIDILoops.** True if the MIDI track should loop.
- **bStreamLoops.** True if the streaming audio track should loop.
- **SleepTime.** Delay, in seconds, before toggle is active after being hit.
- **Range.** Range of the trigger, in world units.

THE STREAMINGAUDIOPROXY ENTITY

The StreamingAudioProxy entity defines a trigger that will play a streaming audio effect. The player triggers the playback of the streaming audio effect when it comes within range of the entity. The streaming audio can loop or not loop, as you desire, and a delay is available to prevent the trigger from being hit repeatedly. See Figure 23.3.

The StreamingAudioProxy entity has the following attributes:

- **szStreamFile.** Name of the .WAV file to play when triggered.
- **bOneShot.** True if this trigger happens only once.
- **bLoops.** True if this audio loops.
- **SleepTime.** Delay, in seconds, before toggle is able to be triggered again after being hit.
- **Range.** Range of trigger, in world units.

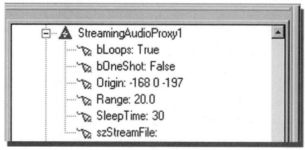

FIGURE *The StreamingAudioProxy dialog box.*
23.3

This effect allows a greater degree of player interaction with the world. You can have a pay phone set to trigger a busy tone every time the player comes right up on it, for example.

WORLD MODEL HELPERS

World model helpers are entities that provide enhancements to Genesis 3D world models. These models, created in the World Editor, are pieces of world geometry that you can animate, such as doors, platforms, and triggers, as we learned earlier.

THE DOOR ENTITY

The Door entity allows you to turn an animated world model into a door. Unlike the Genesis door entity, however, this door can be triggered in many ways. The player can hit it, shoot at it, use a trigger (a separate door trigger), or a combination of these. Doors can also be linked so that when one opens, all the doors in the chain open. This feature is useful for implementing paired swinging doors or the simultaneous opening of multiple exit doors. (The Genesis door did not allow for this possibility.) See Figure 23.4.

The Door entity has the following attributes:

- **Model.** The Genesis3D world model to animate as a door.
- **NextToTrigger.** The next door in the chain to open when this door is triggered.
- **szSoundFile.** The name of the .WAV file to play when the door opens.
- **bOneShot.** True if the door opens *only once*.
- **bNoCollide.** True if door doesn't open when collided with.
- **szEntityName.** The name of this entity (used in scripting).
- **bAudioLoops** True if audio play loops while the door is animating.

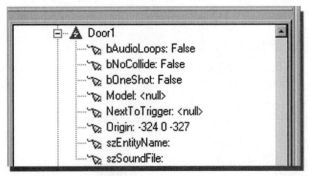

FIGURE *The Door dialog box.*
23.4

THE MOVINGPLATFORM ENTITY

The MovingPlatform entity allows you to turn an animated world model into a moving platform. If the player avatar is on the platform, it will be carried along as it moves. This platform can be triggered in many ways—by the player hitting it, by any projectile hitting it, through a separate platform trigger, or a combination of these. MovingPlatforms can also be linked such that when one opens, all platforms in the chain open. The platform can also be set to start when the level loads and can loop forever.

The MovingPlatform entity has the following attributes:

- **Model.** The model to animate as a platform.
- **NextToTrigger.** The next platform in the chain to start when this platform is triggered.
- **szSoundFile.** The name of the .WAV file to play when the door opens.
- **bOneShot.** True if the platform runs *only once.*
- **bNoCollide.** True if the platform doesn't start when collided with. You might want to prevent the platform from being animated until another part of the chain is reached.
- **szEntityName.** The name of this entity (used in scripting).
- **bAudioLoops.** True if the audio effect loops while the platform is animating. Gears grating or a motor straining would add a lot but would be annoying if they did not stop when the platform did.
- **bAutoStart.** True if this platform starts animating when the level loads.
- **bLooping.** True if this platform animates forever, once started. This can be set up to allow the player to fix, for example, a water wheel. Say that a log was stuck in the water wheel. The player could touch the log to start the animation (played once) of the log falling to the ground. This would trigger the water wheel to animate and keep going.

If you want to recreate the subway from the last part of this book, you can use this method to start playing the animation when the level loads.

THE DOORTRIGGER ENTITY

The DoorTrigger entity allows a Genesis 3D world model to act as a trigger for a door. The door trigger itself can be animated so that you can have moving switches and/or buttons. See Figure 23.5.

The DoorTrigger entity has the following attributes:

- **Model.** The Genesis 3D world model to use as the trigger.
- **Door.** The Genesis 3D world model that is the door to trigger. The door itself still needs to have a door entity attached to it.
- **bOneShot.** True if this trigger operates *only once.*

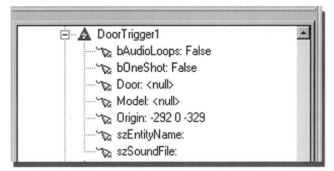

FIGURE *The Door Trigger dialog box.*
23.5

- **szSoundFile.** The name of the .WAV file to play when the door trigger is activated.
- **szEntityName.** The name of this entity (used in scripting).
- **bAudioLoops.** True if the audio effect loops while the model is animating.

THE PLATFORMTRIGGER ENTITY

The PlatformTrigger entity allows a Genesis 3D world model to act as a trigger for a platform. The platform trigger itself can be animated so that you can have moving switches and/or buttons. See Figure 23.6.

The PlatformTrigger entity has the following attributes:

- **Model.** The Genesis 3D world model to use as the trigger.
- **Platform.** The Genesis 3D world model that is the door to the trigger.
- **bOneShot.** True if this trigger operates *only once*.
- **szSoundFile.** The name of the .WAV file to play when the platform trigger is activated.

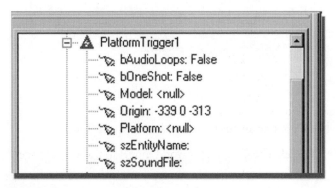

FIGURE *The Platform Trigger dialog box.*
23.6

- **szEntityName.** The name of this entity (used in scripting).
- **bAudioLoops.** True if the audio effect loops while the model is animating.

THE CHANGELEVEL ENTITY

The ChangeLevel entity allows any Genesis 3D world model to be used to change levels. When the player collides with the model associated with the ChangeLevel entity, the current level is shut down and a new level is loaded and started. A bitmap and audio effect can be assigned to display while the new level loads. See Figure 23.7.

The szCutScene attribute provides the ability to play a cut scene between levels. Careful use of this entity allows you to provide additional back-story explanation as the game progresses (especially useful for RPG-style games).

The ChangeLevel entity has the following attributes:

Model. The Genesis 3D world model to use as the change-level trigger.
szSplashFile. The bitmap to display while the new level loads.

szAudioFile. The audio effect to play when the change level is triggered.

szNewLevel. The name of the Genesis 3D file to load as the new level.

szCutScene. The name of an .AVI file to play when the level change is triggered.

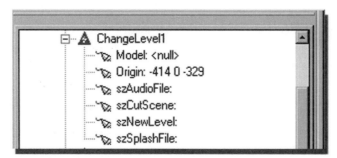

FIGURE *The ChangeLevel entity dialog box.*
23.7

CONCLUSION

As you can see, with the added functionality of the audio effects and the world model helpers, you can begin to build a more interactive and event-driven game. Next we look at props and AI.

Props and AI

In this chapter we will look at **Props** and **AI**. These two entities work together to add a greater level of interaction to the game world. When combined, props and AI allow the game designer to exercise a great degree of control over the look and feel of the game. The Weapon Setup Entity, for example, allows for a very wide array of choices in the way the player's weapon looks, feels, and behaves in the world. You can also combine props and behaviors for random sentries, ghostly entities, and whatever you can imagine. We start by looking at Props, the things we can add to the world, and then we look at AI—or the ability to make props move and react in the world.

PROPS

Props are actors brought into Reality Factory from outside programs such as *3D Studio MAX, Animation:Master,* or *trueSpace.* They are used to add interest to a level. Typical props are desks, chairs, boxes, or anything that would be close to impossible to create with the Genesis 3D World Editor (which means anything that isn't a room). Animation can be associated with a prop, but nothing more complex than a basic motion and an action to play when the prop is collided with. Props can be movable or immovable, so you can have crates you can push around, and moveable props can be pushed up stairs and ramps and off them.

THE STATICENTITYPROXY

The StaticEntityProxy is the main entity used to define a prop in Reality Factory. Static entities can have two basic animations: a default animation and a "collided-with" animation to play when the player collides with the prop. A collision sound effect can be associated with the prop as well, and the prop can be immune or subject to gravity, as needed. (Props immune from gravity can make interesting platforms to jump on.) See Figure 24.1.

The StaticEntityProxy has the following attributes:

- **szSoundFile.** The sound to play when prop is collided with.
- **fRadius.** The audible radius for sound, in world units.
- **szActorFile.** The name of the .ACT Genesis 3D actor file to use as a prop.
- **szEntityName.** The name of this entity (used in scripting).
- **szDefaultAction.** The default animation to play.
- **szImpactAction.** The animation to play when the prop is collided with.
- **bCanPush.** True if this prop can be pushed around the level.
- **InitialAlpha.** The transparency of the actor, with 0 completely invisible.
- **SubjectToGravity.** True if this prop is subject to gravity.
- **ScaleFactor.** The factor by which to scale the prop (1.0 is no scaling, 0.5 is half-size, etc.).

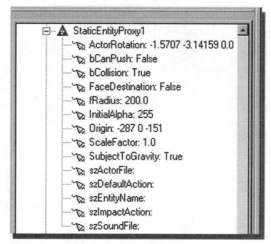

FIGURE *The StaticEntityProxy dialog box.*
24.1

- **FaceDestination.** True if the actor should be rotated to face its direction of motion if this prop is moving on a motion path.
- **ActorRotation.** The rotation used to set the default facing of the prop.

THE WEAPONSETUP ENTITY

The WeaponSetup entity is used to define operational parameters for the weapons used in Reality Factory. You can define various Genesis 3D actors to use as rockets and grenades, sounds to play for associated events, and the damage done by each weapon impact. See Figure 24.2.

The WeaponSetup entity has the following attributes:

- **FBSpeed.** Fireball speed, in world units per second.
- **FBLaunchSoundName.** The name of the .WAV sound to play when the fireball is cast.
- **FBImpactSoundName.** The name of the .WAV sound to play when the fireball impacts.
- **FBDamage.** The amount of damage done by the fireball impact.
- **FBScaleFactor.** The scale factor to apply to the fireball actor (1.0 is no scaling).
- **RSpeed.** Rocket speed, in world units per second.
- **RLaunchSoundName.** The name of the .WAV sound to play when the rocket launches.
- **RFlySoundName.** The name of the .WAV file to play while the rocket is in flight.

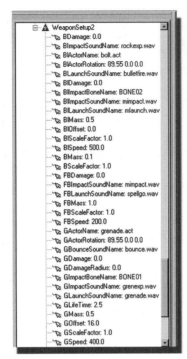
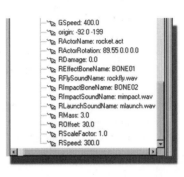

FIGURE *The WeaponSetup dialog box.*

24.2

- **RImpactSoundName.** The name of the .WAV file to play when the rocket impacts.
- **RDamage.** The amount of damage done by the rocket impact.
- **REffectBoneName.** The name of the bone to hook the rocket exhaust effect to.
- **RImpactBoneName.** The name of the bone to hook the rocket impact effect to.
- **RActorName.** The name of the .ACT Genesis 3D actor file to use as the rocket.
- **ROffset.** The point forward of the weapon from which to start the rocket.
- **RActorRotation.** The rotation to apply to the rocket actor to face it correctly in the game.
- **RScaleFactor.** The scale factor to apply to the rocket actor (1.0 is no scaling).
- **GSpeed.** How fast the grenade moves, in world units per second.
- **GLaunchSoundName.** The name of the .WAV file to play when the grenade launches.
- **GImpactSoundName.** The name of the .WAV file to play when the grenade impacts.

- **GDamage.** The amount of damage done by the grenade impact.
- **GImpactBoneName.** The name of the bone to hook the grenade impact effect to.
- **GActorName.** The name of the .ACT Genesis 3D actor file to use as the grenade.
- **GOffset.** The point forward of the weapon from which to start the grenade.
- **GLifeTime.** The number of seconds that the grenade exists before it detonates.
- **GBounceSoundName.** The name of the .WAV file to play when the grenade bounces.
- **GDamageRadius.** The radius, in world units, of the grenade's damage zone.
- **GActorRotation.** The rotation to apply to the grenade to face it correctly in the game.
- **GScaleFactor.** The scale factor to apply to the grenade actor (1.0 is no scaling).
- **BLaunchSoundName.** The name of the .WAV file to play when the bullet launches.
- **BImpactSoundName.** The name of the .WAV file to play when the bullet impacts.
- **BDamage.** The amount of damage done on the bullet's impact.
- **BScaleFactor.** The scaling factor to apply to the bullet actor (1.0 is no scaling).

PATHS AND AI SUPPORT

Reality Factory supports very basic AI functionality and will fully implement the Reactive AI subsystem in Reality Factory soon. Currently, *only* PathPoints and PathFollowers are implemented; the other entities are documented mainly to allow designers to prepare for the nonplayer character AI to be delivered later.

PathPoints work by defining a series of way points for entities to follow.

The PathFollower connects an entity in Reality Factory to the start of a linked series of way points.

The Reactive AI non-player characters (NPCs) will use these PathPoints as well as the PathFollower entities.

Please note that the PathFollower entity is *not* AI. It won't always properly walk your NPCs up stairs and across ramps, because that's not what it was designed to do. If you want an NPC to follow a path as though it were intelligent, you'll have to use an AI to drive it, which means you can't do it right now.

The current PathFollower will work for the most part in driving characters, but the effects will not be as good as true AI.

THE PATHPOINT ENTITY

The PathPoint entity defines a point in a series of way points. PathPoints can operate in two ways: to define a path to be followed (which is the typical use) or to define a zone inside which a bound entity can roam (useful for moving special effects around in a limited area).

To define a path, create a "starting point" named PathPoint of type 0 (start point). As its NextPointName, enter the name of the next point you're going to define. Do this for all the points on the path, but don't assign a NextPointName to the *last point in the path*—this defines the end point of the path. Make *sure* that *only* the *first PathPoint* is of type 0; all other PathPoints should be of type 1.

If you want to have an entity move around within a specific range of a single point (useful for special effects), define a Ranged PathPoint (type 2), and define the Range to be the maximum distance (in world units) that any bound entity will be from the origin of the point. See Figure 24.3.

The PathPoint entity has the following attributes:

- **PointType.** The type of PathPoint this is:

 0 = Start point (beginning of a path)
 1 = Way point (a point along a path)
 2 = Ranging (defines the center of a roaming zone)

- **PointName.** The name of this PathPoint (*must be unique!*).
- **NextPointName.** The name of the next point in the path, if any.
- **Range.** The roaming range, if this point is of Ranging type; it is the maximum distance a bound entity will move from the origin of the PathPoint.

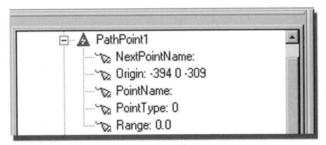

FIGURE *The PathPoint dialog box.*
24.3

THE PATHFOLLOWER ENTITY

The PathFollower entity connects a named entity in Reality Factory to a path or a ranged point. Only certain kinds of entities can be connected to a path or ranged point. Notable exceptions are doors, platforms, and door/platform triggers. Props

and special effects can be bound to a path, allowing for some interesting effects (a MorphingField moving along a motion path, or a 3D audio source, or a particle system—or even a robot actor). See Figure 24.4.

There are a couple of ways to initiate an entity moving along a motion path: You can use a motion-trigger world model (when something impacts the motion trigger, the bound entity starts moving along the path) or a range trigger (triggered when the player gets within a certain range of the PathFollower entity itself).

The PathFollower entity has the following attributes:

- **PathFirstNode.** The name of the start PathPoint to be followed.
- **EntityName.** The name of the entity to be moved along the path.
- **Speed.** The speed at which the entity moves along path, in world units per second.
- **Trigger.** The model to be used as a motion trigger.
- **RangeTrigger.** The trigger distance to start the motion.
- **MotionLoops.** True if the entity will loop back and forth along the motion path.
- **RandomRollTime.** For a Ranged pathbound entity, the number of milliseconds between random direction changes.
- **CollisionTest.** True if collision testing should be used for this entity; this prevents some entities from hitting other actors and pushing them or walking through walls.

The entities that can be bound to a PathFollower are:

- AudioSource3D
- Corona
- DynamicLight

FIGURE *The Path Follower dialog box.*
24.4

- ElectricBolt
- ElectricBoltTerminus
- MorphingField
- ParticleSystemProxy
- StaticEntityProxy
- TeleportTarget

Binding any other type of entity to a PathFollower will be ignored and will generate an error message in your Reality Factory .LOG file.

THE NONPLAYERCHARACTER ENTITY

The NonPlayerCharacter entity defines a nonplayer, AI-driven character in the game. This entity defines the actor to be used and associates a control AI to be used to run the NPC. See Figure 24.5.

This entity is not implemented for alpha1/a. Expected implementation: alpha2 release.

The NonPlayerCharacter entity has the following attributes:

- **szActorFile.** The name of the .ACT Genesis 3D actor file to use for the NPC.
- **szEntityName.** The entity name of this NPC (used for scripting).
- **szAIEntityName.** The name of the control AI entity used to run this NPC.
- **ScaleFactor.** The factor by which to scale the actor (1.0 is no scaling, 0.5 is half-size, etc.).

FIGURE *The NonPlayerCharacter dialog box.*
24.5

THE REACTIVEAI ENTITY

The ReactiveAI entity is the heart of the Reality Factory AI system. This entity allows you to define a broad range of behaviors and situational/stimulus responses for your nonplayer characters, without the need to program or script such behaviors.

FIGURE *The ReactiveAI dialog box.*
24.6

This level of AI is most useful for NPCs—your typical cannon fodder in a shooter game. The reactive AI subsystem is capable of providing motivations and responses for all but the most complex NPCs in your game. See Figure 24.6.

This entity is not implemented for alpha1/a. Expected implementation: alpha2 release.

The various strings for animation sequences might contain multiple, comma-separated names. If more than one animation sequence is defined for a type, Reality Factory will randomly pick from the list of choices. This allows even the least intelligent NPCs to respond in different ways each time, preventing the "seen one, seen 'em all" situation of some AI. For instance, if your NPC has three possible idle animations, the idle animation string would be IdleAndBored, IdleAndAlert, IdleAndTwitching for a bored, alert, and twitching idle animation. Reality Factory will choose randomly from these three when the NPC enters the Idle state.

The possible states for an NPC are:

- **IDLE.** NPC is idle, not at alert.
- **ALERT.** NPC is idle but alert.
- **SEARCH.** NPC is seeking an enemy.
- **PATROL.** NPC is patrolling along a path.
- **ATTACK.** NPC is actively attacking an enemy.
- **RETREAT.** NPC is retreating from an enemy.
- **THREATEN.** NPC is threatening, but not actively attacking, an enemy.

There are also transient states, which are states that an NPC enters for the duration of an event or animation cycle. Transient states are:

- **DEATH.** NPC is dying and is removed from the game at the end of the animation cycle.
- **L_INJURY.** NPC has been lightly injured.
- **M_INJURY.** NPC has been moderately injured.
- **H_INJURY.** NPC has been seriously injured.

An AI can be assigned *reaction codes*, such that an AI will respond differently to other NPCs (and the player) in differing ways. Reaction codes are:

- **R_IGNORE.** NPC will ignore the class.
- **R_NEUTRAL.** NPC is neutral toward this class.
- **R_FRIENDLY.** NPC is friendly toward this class.
- **R_HOSTILE.** NPC is hostile toward this class.
- **R_RANDOM.** NPC reacts randomly toward this class (good for brainless monsters).
- **R_ANTIPATHY.** NPC doesn't like this class but won't attack without provocation.
- **R_AFFINITY.** NPC is nonthreatening but inclined to assist this class, if needed.

The ReactiveAI entity has the following attributes:

- **IdleAnimations.** List of possible IDLE animations.
- **DeathAnimations.** List of possible DEATH animations.
- **AttackAnimations.** List of possible ATTACK animations.
- **RetreatAnimations.** List of possible RETREAT animations.
- **SearchingAnimations.** List of possible SEARCH animations.
- **AlertAnimations.** List of possible ALERT animations.
- **PatrolAnimations.** List of possible PATROL animations.
- **ThreatenAnimations.** List of possible THREATEN animations.
- **LightInjuryAnimations.** List of possible L_INJURY animations.
- **MediumInjuryAnimations.** List of possible M_INJURY animations.
- **HeavyInjuryAnimations.** List of possible H_INJURY animations.
- **PatrolPath.** The name of the starting point for this AI's patrol path.
- **LockedToPatrolPath.** True if the AI won't allow the NPC to leave the path.
- **PatrolRadius.** The maximum allowable distance from the patrol path.
- **PlayerReaction.** The reaction code to use with player entities.
- **OthersReactionCode.** The reaction code to use with other NPC AI entities not of this type.
- **SelfReactionCode.** The reaction code to use with NPC AI entities of the same type.

CONCLUSION

As you can see, with PathPoints and PathFollowers, you can add a lot of excitement to a game. Once the AI subsystems are in place in Reality Factory, things will really take off. As of this writing, the AI is being worked on and tested.

Now let's take a look at special effects.

CHAPTER

25 Special Effects

he special effects in Reality Factory are the best part of the package from an "eye candy" point of view. The special effects are varied and flexible. Once you understand how they each function, you will be able to simulate fire, rain, snow, and virtually anything you can conceive of for your level.

THE TELEPORTER ENTITY

The Teleporter entity, in conjunction with the TeleportTarget entity, provides the typical teleportation effect to move the player from one part of a level to another. Teleporters have adjustable fog and audio effects to add to the variety. There is also a "teleporter effect" that can be run when the player hits the teleport. This effect takes a few seconds to run and can be disabled to provide "instant teleport." See Figure 25.1.

The fog field surrounds the teleporter entity, not *the model used. If you want the fog around the model, put the teleporter entity inside the model.*

The Teleporter entity has the following attributes:

- **Model.** The Genesis3D world model to be used as the teleporter.
- **Target.** The name of the TeleportTarget entity that this teleporter uses.
- **bOneShot.** True if the teleporter works *once only*.
- **szSoundFile.** The name of a .WAV file to play when the teleporter activates.
- **cColor.** The color of the fog field surrounding the teleporter entity (*not the model*).

FIGURE *The Teleporter dialog box.*
25.1

- **fogSpeed.** The speed at which the fog density around the entity changes.
- **fogVariance.** The depth of the variance in fog density.
- **fogRadius.** The radius of the fog effect around the entity.
- **szEntityName.** The name of this entity (used in scripting).
- **bUseFogEffect.** True if the fog effect around the teleporter is to be used.
- **BUseTeleportEffect.** True if the "teleporter effect" is to be run when the teleport activates.

THE TELEPORTTARGET ENTITY

The TeleportTarget entity defines the target for a Teleporter entity. It has the following attribute:

- **Name.** The name of *this* teleport target. The name *must* be unique.

THE MORPHINGFIELD ENTITY

The MorphingField entity defines a morphing field of fog with an associated 3D audio source. This entity is useful for adding to the atmosphere of a level (say, a red/blue morphing fog field with an electrical crackling for a dangerous reactor core). MorphingFields can be assigned to PathFollower entities for even more fun! The morph effect loops continually from start to end, then back to the start state. See Figure 25.2.

The MorphingField entity has the following attributes:

- **szSoundFile.** The name of the .WAV file to play, looped as the 3D audio source.
- **clrStart.** The fog color at the start of the morph.

FIGURE *The MorphingField dialog box.*
25.2

- **clrEnd.** The fog color at the end of the morph.
- **fogSpeed.** The speed at which fog density changes, in milliseconds.
- **fogVariance.** The depth of the fog density variance.
- **fogRadiusStart.** The radius of the fog effect at the start of the morph.
- **fogRadiusEnd.** The radius of the fog effect at the end of the morph.
- **szEntityName.** The name of this entity (used in scripting).

THE PARTICLESYSTEMPROXY

The ParticleSystemProxy allows the placement of various predefined styles of particle effects. The defaults for these styles can also be overridden to vary the look of different instances of the same style of particle effect. See Figure 25.3.

There are 12 different styles of particle system:

1. SHOCKWAVE particle system (rings expanding from center)
2. FOUNTAIN particle system (typical particle fountain)
3. RAIN particle system (particles fall randomly from flat plane)
4. SPHERE particle system (particles emitted in sphere from origin)
5. COLUMN particle system (particles fall in a cylindrical column)
6. EXPLOSION_ARRAY (tribute to *Lina Inverse*; particles rise from floor)
7. SPIRAL ARM particle system (you get the idea)
8. TRAIL particle system (leaves a trail of slow-falling particles)
9. GUARDIAN EFFECT particle system (hard to describe—try it!)
10. Imploding sphere particle system
11. Imploding shock wave
12. Imploding spiral arms

FIGURE *The ParticleSystemProxy dialog box.*
25.3

The ParticleSystemProxy entity has the following attributes:

- **nStyle.** Particle system style number (from the above list).
- **szSoundFile.** The 3D audio source to play, looped for this particle system.
- **fRadius.** The audible radius of the 3D audio source.
- **szTexture.** The name of the .BMP bitmap file to use for particle texture.
- **clrColor.** The RGB color to use for particle color.
- **BirthRate.** The number of new particles generated per second.
- **MaxParticleCount.** The maximum number of particles permitted at once.
- **ParticleLifespan.** The lifespan of each particle, in milliseconds.
- **szEntityName.** The name of this entity (used in scripting).

THE VIDEOTEXTUREREPLACER ENTITY

The VideoTextureReplacer entity allows you to replace a bitmap texture used in your world with an .AVI video loop. This entity is useful for playing back video clips on "monitors" inside your game, in real time, without having to fall back on full-screen cut scenes. See Figure 25.4.

Make sure that the bitmap you're replacing is used only *where you want the video to play. The video will play on every occurrence of the texture throughout your level.*

The VideoTextureReplacer entity has the following attributes:

- **szTextureName.** The name of the texture to replace with video. This is the name displayed when texturing the world within the World Editor.
- **szVideoName.** The name of the .AVI file to use as the replacement texture.
- **Radius.** Start video texture playback when the player gets within this distance of the entity (in world units). This value should be 0.0 if the video plays from level load on.
- **OnlyPlayInRadius.** True if the video plays only while the player is inside the trigger radius.

FIGURE *The VideoTextureReplacer dialog box.*
25.4

THE CORONA ENTITY

The Corona entity provides that wonderful, overused "ring around a light source" effect that you see in almost every first-person shooter made since *Quake2*. Used sparingly, the Corona effect can add a great deal to your level's ambiance. See Figure 25.5.

The Corona entity has the following attributes:

- **szEntityName.** The name of this entity (used in scripting).
- **FadeOut.** 1 if corona fades when passing out of visibility, 0 if not.
- **FadeTime.** Time in seconds that the fade takes to happen.
- **MinRadius.** Minimum size (radius) to which corona will ever drop (in world units).
- **MaxRadius.** Maximum size (radius) to which corona will ever grow (in world units).
- **MaxVisibleDistance.** Maximum distance from which corona is visible (in world units).
- **MaxRadiusDistance.** Above this distance, the corona stays at MaxRadius size.
- **MinRadiusDistance.** Below this distance, the corona stays at MinRadius size.
- **AllowRotation.** Permit rotation around model, if model is used (0 if True).
- **Model.** Genesis 3D world model to which to slave motion of corona.
- **Color.** The RGB color of the corona.

FIGURE *The Corona entity dialog box.*
25.5

THE DYNAMICLIGHT ENTITY

The DynamicLight entity defines a light for which the intensity changes over time, based on a pattern supplied by the level designer. See Figure 25.6.

The DynamicLight varies based on a thing called the RadiusFunction. This is a string of letters, from A to Z (A being the minimum light value and Z being the maximum), that are used to determine how the intensity of the light varies. Reality Factory processes this radius function across time, varying the intensity of the light (and interpolating in-between values, if desired), producing a constantly fluctuating light source.

The DynamicLight entity has the following attributes:

- **szEntityName.** The name of this entity (used for scripting).
- **MinRadius.** The minimum radius of the light, in world units.
- **MaxRadius.** The maximum radius of the light, in world units.
- **InterpolateValues.** 1 if values are to be interpolated between those defined in the RadiusFunction, 0 otherwise.
- **AllowRotation.** 1 if light is to follow the rotation of the model to which it is attached.
- **RadiusFunction.** The string of letters defining the light's radius function.
- **RadiusSpeed.** The speed, in seconds, that the RadiusFunction is run through.
- **Model.** The model to which the light is attached, if any.
- **Color.** The color of the light.

THE ELECTRICBOLT ENTITY

The ElectricBolt entity defines an electrical bolt source in conjunction with an ElectricBoltTerminus entity (the ElectricBoltTerminus defines the target of the

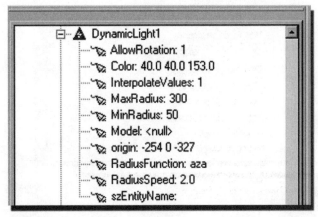

FIGURE *The DynamicLight dialog box.*
25.6

electrical bolt). This effect is useful for simulating arcing electrical faults and atmospheric lightning. See Figure 25.7.

For the bolt color, be careful to ensure that the two values that aren't the dominant color are the same (in other words, if red is dominant, then green and blue); otherwise, problems will occur.

The ElectricBolt entity has the following attributes:

- **szEntityName.** The name of this entity (used in scripting).
- **Width.** Width, in world units, of the bolt.
- **NumPoints.** The number of control points; must be one of 32, 64, or 128.
- **Intermittent.** True if the bolt is random, False if it is continuous.
- **MinFrequency.** If an intermittent bolt, minimum time in milliseconds between pulses.
- **MaxFrequency.** If an intermittent bolt, maximum time in milliseconds between pulses.
- **Wildness.** The degree of wildness of the bolt, between 0 and 1.
- **Terminus.** The ElectricBoltTerminus entity to use as the target.
- **DominantColor.** The dominant color of the bolt: 0 = Red, 1 = Green, 2 = Blue.
- **Color.** The base color of the bolt.

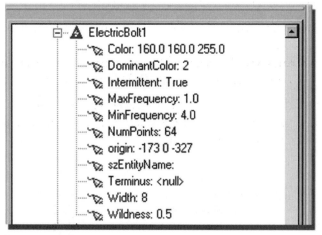

FIGURE *The ElectricBolt dialog box.*
25.7

THE ELECTRICBOLTTERMINUS ENTITY

The ElectricBoltTerminus entity defines the target of an ElectricBolt entity.

Try attaching one to a PathFollower and watch the lightning move around the room!

The ElectricBoltTerminus entity has the following attribute:

- **szEntityName.** The name of this entity (used in scripting).

THE TEXTUREPROC ENTITY

The TextureProc allows you to replace a normal bitmap texture, as applied from the World Editor, with a procedural texture. A procedural texture is one that changes over time and is generated by Reality Factory rather than being a predefined video or bitmap sequence. Procedural textures are extremely useful for various special effects: moving lava, some smoke effects, liquid effects, and the like. See Figure 25.8.

Because of the flexibility of procedural textures, setting them up is a complex process. The Reality Factory procedural textures were ported over from various Genesis 3D sources (mainly GTest and GDemo). The fact that there's no pre-existing documentation from Genesis on procedural textures makes them hard to use.

The TextureProc entity has the following attributes:

- **szTextureName.** The name of the texture to replace, as used in the World Editor.
- **szProcName.** The name of the type of procedural texture to use.
- **Parameter.** Parameters to pass to the procedural texture processor.

These three seemingly simple parameters control a powerhouse of procedural texturing. szTextureName is obvious, it's the name of the texture to replace. Table 25.1 describes each type of procedure.

FIGURE *The TextureProc dialog box.*
25.8

Table 25.1

Procedural Method Name	What It Does
fire	Produces an effect similar to upward-moving flames
water	Produces ripples like drops falling in water
smoke	Produces the effect of smoke drifting upward
electric	Produces electrical spark and moving fractal-type effects
plasma	Produces a shifting plasma effect

Like the Video Texture Replacer, every instance of this texture is replaced, so if you want a unique face texture to be replaced, you need a special texture for that. szProcName defines the method that is to be used to generate the procedural texture.

TYPES OF TEXTURE PROCEDURES

Of course, this isn't all there is to it. Some of the effects don't take any parameters, but the most interesting effects are those with parameter control. The parameters used for control depend on the effect used, so for each procedural method, we'll list the various parameters:

Fire has from one to three parameters, depending on how much control you want over the effect. The first parameter is the number of jets of flame you want:

T One jet
F Two jets
<#> Any other number is the # of jets desired

The second parameter is the format of the color palette you want to use:

- **list.** You list the palette colors manually. Selecting 0 uses the default palette values. If you don't use the defaults, you must specify two or more colors in the following format: R, G, B, A, where R = red, G = green, B = blue, and A = alpha (each of which ranges from 0 to 255). Repeat this process for each color in your list.
- **pow.** You list a color, then floating-point values to be used to influence the color shifting (using the pow() function). The format is R, G, B, A, RPow, GPow, BPow, APow, where R = red, G = green, B = blue, RPow = floating-point red power, GPow = floating-point green power, BPow = floating-point blue power, APow = floating-point alpha power.
- **trig.** You list a color, then floating-point values to be used to influence the color shifting (using trig functions). The format is R, G, B, A, RFreq, GFreq, BFreq, AFreq, RBase, GBase, BBase, Abase, where R = red, G = green, B =

blue, Rfreq = floating-point red frequency, GFreq = floating-point green frequency, BFreq = floating-point blue frequency, AFreq = floating-point alpha frequency, RBase = floating-point red base value, GBase = floating-point green base value, BBase = floating-point blue base value, ABase = floating-point alpha base value.

For example, a two-jet, pow-based fire procedural might be:

F, pow, 400,280,200,530, 0.3,0.6,1.0,0.8

And a four-jet list procedural might be:

4, list, 3, 0,0,0,0, 200,50,0,100, 255,100,50,255

Smoke has eight parameters:

- **Palette type.** Choose one of Smoke_PalSlime, Smoke_PalFire, Smoke_PalOrange, Smoke_PalBlue.
- **Number of smoke particles.** From 1 to 1024.
- **Base X position.** Floating-point X base position in the texture.
- **Base Y position.** Floating-point Y base position in the texture.
- **Base Z position.** Floating-point Z base position in the texture.
- **Base X Velocity.** Floating-point base velocity in X.
- **Base Y Velocity.** Floating-point base velocity in Y.
- **Base Z Velocity.** Floating-point base velocity in Z.

As an example, here's a smoke effect using the fire palette:

Smoke_PalFire, 128, 6.0, 64.0, 25.0, 4.0, 5.0, 1.0

Plasma works only with textures of size 128 × 128 pixels. The parameters are extremely similar to the fire procedural:

- **Circle scale.** A floating-point circular scaling value.
- **Roll step.** A floating-point value.
- **Alpha flag.** T (True, do alpha) or F (False, don't do alpha).
- **Displacement flag.** T (True, do displacement) or F (False, don't do displacement).

From this point on, it's all about palette, and if you don't define one, then (as in fire) you get a default. Otherwise, use the list, pow, and trig functions as detailed previously.

Here's an example plasma parameter line:

0.005, 0, f, f, trig, 128,128,128,255, 5.0,1.0,5.0,0.0, 0.0,0.5,0.0,0.0,0.0,0.01,1,f,t

Flow is the easiest of the parameterized procedurals. It has only two parameters:

- **X Offset.** Floating-point X motion value.
- **Y Offset.** Floating-point Y motion value.

Be careful when applying procedural textures to walls that have "empty space" outside the world on the other side. Some procedurals that have transparent sections will show interesting but undesirable results if applied to "outside walls."

THE FLOATINGPARTICLES ENTITY

The FloatingParticles entity produces a system of upwardly moving particles defined by a texture and alpha bitmap. This entity can be connected to the bones of a StaticEntityProxy actor so as to follow those bones' motion in the game. See Figure 25.9.

The FloatingParticles entity has the following attributes:

- **Color.** The base color of the particle.
- **Scale.** The scale to use for the particle bitmap.
- **ParticleCount.** How many particles to use.
- **Radius.** The radius of particle cylinder.
- **Height.** The maximum height each particle will travel from the base.
- **XSlant.** Upward slant of particle area on X axis.
- **ZSlant.** Upward slant of particle area on Z axis.

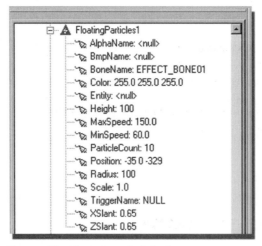

FIGURE *The FloatingParticle dialog box.*
25.9

- **MinSpeed.** Minimum upward speed of each particle.
- **MaxSpeed.** Maximum upward speed of each particle.
- **BmpName.** The name of the bitmap file to use for the particle texture.
- **AlphaName.** The name of the bitmap file to use for the particle alpha texture.
- **TriggerName.** The name of the trigger to use.
- **Entity.** The StaticEntityProxy to which the effect is bound, if any.
- **BoneName.** The bone in StaticEntityProxy actor to which the effect is bound.

THE ECHAOS PROCEDURAL TEXTURE ENTITY

The EChaos procedural texture entity produces a chaotic moving texture effect, replacing a texture bitmap used in the World Editor. See Figure 25.10.

The EChaos entity has the following attributes:

- **MaxXSway.** Total texture horizontal pixel sway.
- **MaxYSway.** Total texture vertical pixel sway.
- **XStep.** Horizontal texture scroll speed.
- **YStep.** Vertical texture scroll speed.
- **AttachBmp.** The name of the texture defined in the World Editor to which to attach this effect.

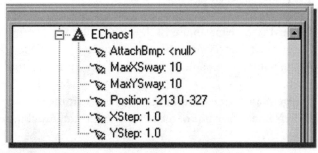

FIGURE *The EChaos procedural texture dialog box.*
25.10

THE RAIN PARTICLE SYSTEM ENTITY

The Rain particle system entity produces a "rain of particles" effect that can be attached to a bone of a StaticEntityProxy actor. See Figure 25.11.

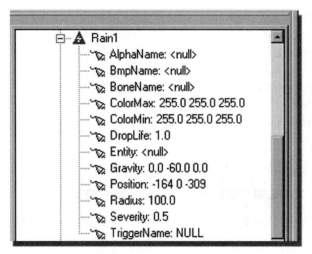

The Rain dialog box.
25.11

The Rain entity has the following attributes:

- **Entity.** StaticEntityProxy to which the effect is attached.
- **Gravity.** Velocity applied to each particle per second (in world units).
- **Radius.** Radius of the rain coverage area (in world units).
- **Severity.** How severe the rain is; 0.0 is tame, 1.0 is insanity.
- **DropLife.** Lifespan of a single drop, in seconds.
- **ColorMin.** The minimum RGB color for drops.
- **ColorMax.** The maximum RGB color for drops.
- **BmpName.** The name of the .BMP bitmap file to use for raindrops.
- **AlphaName.** The name of the .BMP bitmap file to use as the drop alpha mask.
- **TriggerName.** The name of the trigger to start the rain effect.
- **BoneName.** The name of the bone in the StaticEntityProxy actor to which to attach effect.

THE SPOUT PARTICLE EMITTER ENTITY

The Spout entity implements a fountain of particles. The fountain varies over time and is useful for many smoke and fire/plasma effects. See Figure 25.12.

The Spout entity has the following attributes:

- **Angles.** The direction in which particles will shoot from the spout.
- **ParticleCreateRate.** The number of seconds after which to add a new particle.

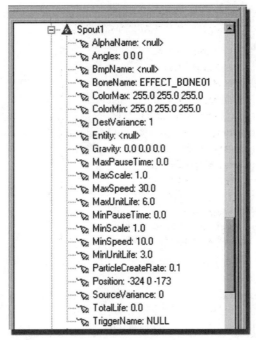

FIGURE *The Spout particle emitter dialog box.*
25.12

- **MinScale.** The minimum scale of the particles.
- **MaxScale.** The maximum scale of the particles.
- **MinSpeed.** The minimum speed of the particles.
- **MaxSpeed.** The maximum speed of the particles.
- **MinUnitLife.** The minimum life of each particle.
- **MaxUnitLife.** The maximum life of each particle in seconds.
- **SourceVariance.** The amount to vary the source spray point.
- **DestVariance.** The amount to vary the destination spray point.
- **ColorMin.** The minimum RGB color value for each particle.
- **ColorMax.** The maximum RGB color value for each particle.
- **Gravity.** The gravity vector to apply to each particle.
- **BmpName.** The name of the .BMP bitmap to use as the particle texture.
- **AlphaName.** The name of the .BMP bitmap to use as particle alpha mask.
- **TriggerName.** The name of the trigger for effect.
- **MinPauseTime.** The minimum number of seconds for randomly chosen pause time.
- **MaxPauseTime.** The maximum number of seconds for randomly chosen pause time.
- **TotalLife.** The total life for this effect; 0.0 means eternal.

- **Entity.** The name of the StaticEntityProxy to which to attach this spout .
- **BoneName.** The name of the bone in StaticEntityProxy actor to which to attach the spout.

THE FLAME ENTITY

The Flame entity is used to produce flame and plasma effects. This entity is useful for torches, fireplaces—even steam effects. See Figure 25.13.

The Flame entity has the following attributes:

- **Angles.** The direction in which the flame will shoot.
- **Scale.** The overall scale of the flame effect.
- **Model.** The model to which the flame is attached.
- **Entity.** The StaticEntityProxy to which the flame is attached .
- **BoneName.** The name of the bone in the StaticEntityProxy actor to which the flame is attached.
- **ParticleCreateRate.** The number of seconds in which to create a new flame particle.
- **MinScale.** The minimum scale of the flame particles.
- **MaxScale.** The maximum scale of the flame particles.
- **MinSpeed.** The minimum speed of the flame particles.
- **MaxSpeed.** The maximum speed of the flame particles.
- **MinUnitLife.** The minimum life of each flame particle.

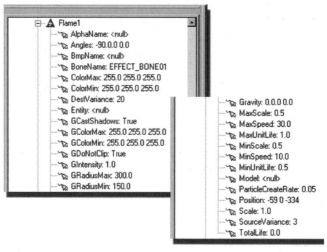

FIGURE *The Flame dialog box.*
25.13

- **MaxUnitLife.** The maximum life of each flame particle.
- **SourceVariance.** The amount to vary the flame source point.
- **DestVariance.** The amount to vary the flame destination point.
- **ColorMin.** The minimum RGB color for each flame particle.
- **ColorMax.** The maximum RGB color for each flame particle.
- **Gravity.** The gravity vector to apply to each flame particle.
- **BmpName.** The name of the .BMP bitmap to use as the flame texture.
- **AlphaName.** The name of the .BMP bitmap to use as the flame alpha mask.
- **TotalLife.** The total life for this spout; 0.0 means eternal.
- **GRadiusMin.** The minimum flame light radius (in world units).
- **GRadiusMax.** The maximum flame light radius (in world units).
- **GColorMin.** The minimum flame light RGB color.
- **GColorMax.** The maximum flame light RGB color.
- **GIntensity.** The maximum flame light intensity.
- **GDoNotClip.** True if the light should not be displayed if the flame isn't visible.
- **GCastShadows.** True if the light can cast shadows.

AREA EFFECTS (BRUSH CONTENTS OR ZONES)

'Area Effects' in Reality Factory is not its own entity as are the other special effects, rather it is the ability to create a brush and define that brush as a **zone**. A zone, when entered by the player in the game, will exhibit behaviors as if the player entered a different environment.

For example; You can create a Genesis3D brush and set it to **empty** (no collision detection or the player can pass through it) and you can define the zone type of the brush to **water**. Further you can texture the brush in a water texture, make the brush **translucent**, set it to **wavy**, and in the game you will have really nice looking water. When the player enters the zone they will be able to move as if they are swimming.

*While many Zones are defined, currently the only working zones are **Water** and **ZeroG**.*

Brush Contents

You access these zone choices through the **Brush Attributes Window**. As noted the only working zones are **Water** and **ZeroG**, but the other zones are in the window as the developers of RF are working to implement them. The other zones you can look forward to are:

- Lava
- ToxicGas
- Frozen

- Sludge
- SlowMotion
- FastMotion

As you can see the Special Effects in Reality Factory are quite varied and flexible. Experimentation will continuously turn up new ways to utilize these entities. With careful planning and resource management you can even combine effects; orange floating particles and a flame look like a real outdoor fire. The flame entity with some colors and parameters changed can look like natural steam or if green colored, toxic steam. A Rain entity above a surface with the Water Procedural Texture applied to it looks like real rain falling on water.

THE CONCLUSION OF DESIGNING 3D GAMES THAT SELL!

Over the course of this book we have been able to look at some of the most often overlooked aspects of game development that are critical to success as a developer. Among the most important are:

- Looking at game development from the perspective of the product designer, publisher, and business person. Looking at your project from the same business perspective as the publisher to ensure that the publisher will view it favorably when it is submitted.
- Realizing that the challenge is not *how to make a game* but how to make a game that *will sell*, and then *selling* it. Selling a game doesn't just involve selling it to the consumer. First you have to sell it to your team, the publisher, the reviewers, the retail buyers and managers, the end users and always to yourself. You need to be the *champion* for your idea and never lose the love you feel at the initial stages of design, all the way through development.
- To become aware of the legitimate economic needs of the publisher. If you understand the core business principles of intended audience, project management, scheduling, budgeting, (and most important) publicity and marketing, you'll be better prepared to deal with the game publishers.
- Developing the business and presentational skills to make the proper presentation to the appropriate groups. Realizing that there's no "magic" about submitting to a publisher. It involves routine processes that most developers have not been exposed to. These processes are similar to those a writer is intimately familiar with: cover letters, a synopsis, and knowledge of the intended audience and the publisher submitted to, and so on.
- Finally to provide the proper tools for developing a game and some guidance for starting the implementation of your game idea.

A

Low-Poly Tricks, Tips, and Techniques

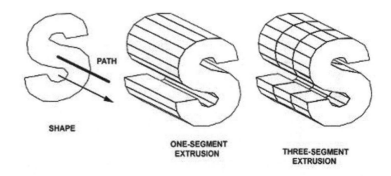

SHAPE

PATH

ONE-SEGMENT
EXTRUSION

THREE-SEGMENT
EXTRUSION

by Paul Steed of id software

This article originally appeared as an article on Loonygames (www.loonygames.com) and, with a few tweaks, in the June 1998 issue of Game Developer *magazine. Paul Steed has a few tutorials and "must read" opinion columns on Loonygames. For this book, the article's content has been updated, and comments referring to the modeling utility MilkShape 3D have been added.*

What I've tried to do in this article is to assign terms and definitions to the way I model and optimize low-polygonal models. Optimizing is not easy. There is definitely a learning curve, not only to all art tools, but to training your mind to be able to sort out a mesh from any angle and identify areas that can be pared down. Although I use 3D Studio 4 or 3D Studio Max,[1] most of these techniques are applicable across the board in other modeling packages as well.

ACCOMMODATION

What I call *model accommodation* is nothing more than making sure that the model's geometry supports its animation. Low-poly limbs (arms, legs, tentacles, etc.) need to bend and flex yet still hold their shape in their optimized state. I always see these stock models you can buy with their typical outstretched arms and legs frozen halfway-through-a-jumping-jack-looking pose. This is no problem with a thousands of faces to work with, but with low-poly, it's actually better to model limbs slightly or fully bent so that the proper detail can be given to the elbow or knee. See Figure A.1.

At the very least, manually bend these limbs at their intended joints and see if their shape can be held, then straighten them back up if necessary.[2]

ATTITUDE

Attitude gives characters life and identity. Don't be afraid to make your creations have personality. I exercise my imagination quite freely when imbuing my characters with virtual life.

TESSELLATION

Tessellation is simply adding faces and vertices to an object for more detail. This is most useful with curved surfaces yet can be used with anything. Of course, with low-poly objects, the last thing you're likely to do is tessellate an object, since

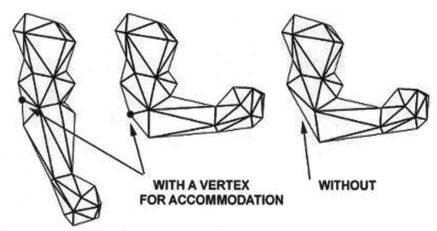

FIGURE *A vertex added for accommodation in a model.*
A.1

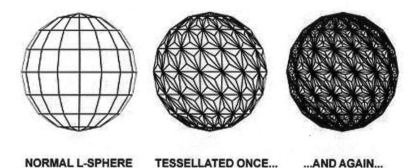

NORMAL L-SPHERE TESSELLATED ONCE... ...AND AGAIN...

FIGURE *This is how tessellation adds faces to a model.*
A.2

tessellation adds even more face that you're trying to find a way to get rid of.[3] See Figure A.2.

OPTIMIZATION

The act of reducing the number of faces making up your model is *optimization*. Almost every modeling tool out there has some sort of Optimize command; some are good, some aren't so good. I'm a neat freak with my models, so I try to keep a sort of order or symmetry to the design of the mesh whenever possible. See Figure A.3.

A lot of optimization programs aren't so aesthetically inclined, to say the least. I always prefer to optimize by hand when I do low-poly meshes (unless the mesh needs to go from 10,000 faces to 500) because ultimately I have more control.[4]

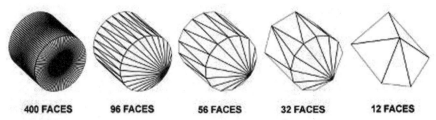

| 400 FACES | 96 FACES | 56 FACES | 32 FACES | 12 FACES |

FIGURE *The steps of optimization applied to a cylinder.*
A.3

VERTEX MERGE

To me, *vertex merging* is the best friend I have when it comes to creating low-poly models. It is key to ridding yourself of unwanted faces and vertices that allow you to hit that magic number given to you by your programming staff or art director. Merging a vertex simply takes one vertex and merges it with another vertex, effectively reducing the number of vertices by one and the number of faces by two in the immediate area of the merge.[5] See Figure A.4.

This technique or command combined with the Edge Division and Edge Turn form the "Trinity" of most useful low-poly modeling techniques. I consider them very highly, so don't dis the Trinity.

Edge Division

Edge division isn't some metaphysical math technique—it's the antonym of the vertex merge. Basically, edge division divides the length of an edge exactly in the middle, inserting a vertex and creating the appropriate faces resulting from the new vertex addition. See Figure A.5.

FIGURE *Vertex merging.*
A.4

FIGURE *Edge division.*
A.5

Edge Turn

In Alias, *edge turn* is called the Quad Split or something, but basically, this technique takes the bisecting line of a quad made up of four vertices and "turns" that edge so that it goes to the other two vertices. It's a very useful tool, and I wouldn't touch a modeler that doesn't have it.[6] See Figure A.6.

FIGURE *Edge division.*
A.6

LOFT/EXTRUDE

When lofting or extruding something, you're basically just taking the outline of a shape and lofting it along a path (i.e., an extrusion of that shape). This technique is very useful when a primitive won't fit the bill. Lofts can have as many segments or layers as you require.[7] See Figure A.7.

Primitives

Primitives is a term used for a group of polygons that can be created quickly by most modeling packages via a single command such as Create/box or Create/sphere.

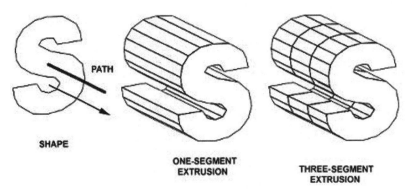

PATH

SHAPE

ONE-SEGMENT
EXTRUSION

THREE-SEGMENT
EXTRUSION

FIGURE *Loft, or extrusion.*
A.7

Primitives are excellent for starting a model and can be likened to a lump of clay or putty. If primitives can't fit the need of a shape, of course a loft or Boolean would be the next choice. See Figure A.8.

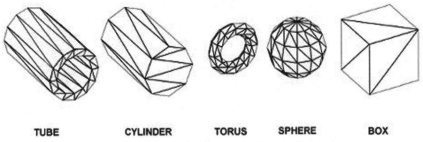

TUBE CYLINDER TORUS SPHERE BOX

FIGURE *A few of the basic modeling primitives.*
A.8

BOOLEAN

Boolean is one of the more useful tools for creating models, because it alters the shape of an object using the intersection, subtraction, or union of another overlapping shape to subtract or add to the original object's geometry. See Figure A.9.

In reality, this tool can be a pain, since (at least in 3D Studio 4) it creates extraneous faces that are sometimes hard to find, thus adding to your face count unnecessarily. Still, it is very, very useful when it works the way you want it to.[8]

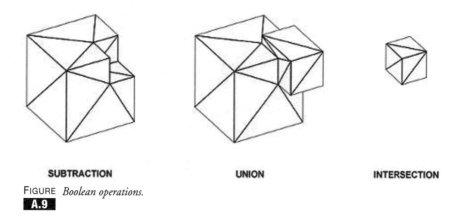

SUBTRACTION UNION INTERSECTION

FIGURE *Boolean operations.*
A.9

LEVEL OF DETAIL

Level of detail (LOD) is when only several triangles represent the object if it's no more than a few pixels on the screen, and the closer you get to the object, the more detailed the model that pops into view. This technique can be done manually, but if you went up to, say, 10 levels of detail, you'd take a memory hit because 10 separate objects would still have to be stored and tracked instead of one. A technique called *displacement mapping* or *real-time deformation and tessellation,* based on displacement map information, can overcome these LOD limitations but has yet to be implemented on a large scale.

We will be using LOD in *Quake 3: Arena,* but each LOD will be done manually by yours truly, with the distance of their respective appearances dialed in appropriately.

High to Low vs. Low to Higher

High to low and *low to higher* are two methods by which I model based on how I'll be using the mesh. The former method is usually reserved for meshes that will be in high-rez cinematics as well as in the game. Initially, I take an unlimited face-count approach, and the model ends up being very detailed. This high-rez version can be used for advertisements, cinematics, or whatever. It also serves as the template to model a low-rez version of the same model to go into the game.

The latter technique involves creating a mesh without considering a high-rez version, keeping the face count relatively low from the beginning and optimizing on the fly. Sometimes, though, I'll make a high-rez version of a character or object just to have a starting point to texture. Usually, Adrian is our texture guy, so I don't overly worry about the texturing process.

Figure A.10 shows a comparison of a hi-rez gunner I built from *Quake 2* to the actual in-game gunner.

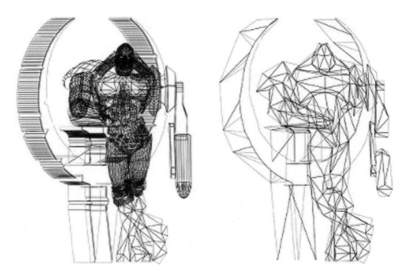

FIGURE **A.10** *A wireframe comparison of the low- and high-resolution versions of the Gunner from Quake 2.*

As you can see, the low-rez version wouldn't hold up very well on the cover of a magazine, despite his charming demeanor. Figure A.11 shows a better comparison of their relative difference in complexity.[9]

ROUNDNESS

The most face-consuming geometry you can make is curved, tubular objects such as hoses, bars, or tentacles. Normally, I limit the maximum cross-section to a pentagon. Sometimes, based on the visibility and proximity of the object, you can mix up the cross-sections accordingly (see the "Mixed Cross-Sections" section). See Figure A.12.

Diamonds Over Squares

When you need to make a tube-like shape such as an engine nozzle or cable, a pentagon is the optimal shape for low-poly objects. However, sometimes we need to use less, and a square cross-section is all we can afford. If the shape is supposed to be rounded, make it a diamond shape instead of a square. The reasoning for this could be debatable, but it's been my experience that, if the top edge of a supposedly round object is blatantly flat, as in the case of a square, it seems just that much closer to being round if it has an edge at the top. See Figure A.13.

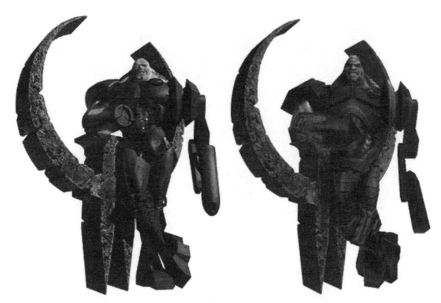

FIGURE
A.11 *A textured comparison of the low- and high-resolution versions of the Gunner from* Quake 2.

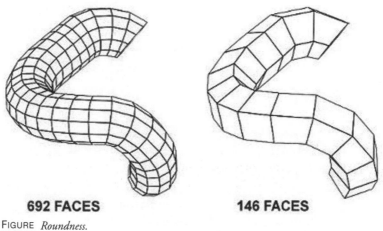

692 FACES **146 FACES**

FIGURE *Roundness.*
A.12

MIXED CROSS-SECTIONS

Mixed cross-sections is a technique whereby a shape is not constrained by the same cross-section or lofting shape in its length. This works especially well with darker or smaller objects or when a cross-section is very noticeable in the design and needs to look rounded. See Figure A.14.

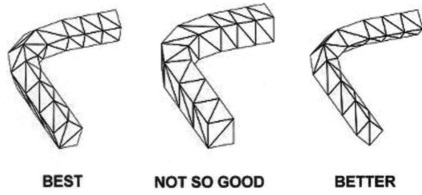

BEST NOT SO GOOD BETTER

FIGURE *A comparison of rounding techniques.*
A.13

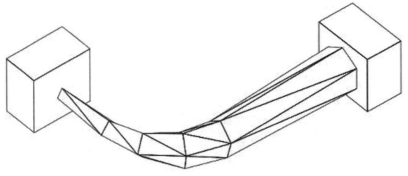

FIGURE *A mixed cross-section.*
A.14

SPLITTING THE DIFFERENCE

Sometimes you'll get an edge that needs to be represented by a more triangular shape than a rectangular shape. A quick and easy way to accomplish this with accuracy is to *split the difference*. Basically, you simply take an edge, divide it, and merge the end vertices to that point. You could just merge the vertices and move them, but then that'd be more work now, wouldn't it? See Figure A.15.

A corollary to STD I use in 3D Studio Max is to simply select the two vertices making up the line being divided and uniformly scale them to a point, then click Select under the Vertex Merge command.

FIGURE *The creation of a triangular shape.*
A.15

CURVE ANGLE

Curve angle is what I call the angle made by the edge of a low-poly curve. If the curve angle is low enough, I'll make it higher to the point of acceptability by reducing the segments or facets that make up the curve of the shape. Therefore, the lower the curve angle, the more likely the chance a shape can be optimized. See Figure A.16.

FIGURE *The curve angle.*
A.16

HAVING THE RIGHT SET OF BALLS

When creating spheres or a partially spherical geometry, consider using a geodesic sphere instead of a latitudinal/longitudinal sphere. L-spheres are nice and tidy, but they're not very frugal when it comes to low-poly. Check out Figure A.17.

The G-sphere on the left might not look as pretty as the L-sphere, but it is more efficient *and* more effective. Figure A.18 shows you why.

G-SPHERE **L-SPHERE**

FIGURE *A comparison between G-spheres and L-spheres.*
A.17

15 SEGMENTS **14 SEGMENTS**
144 FACES **168 FACES**

FIGURE *The segment and face count comparison between spheres.*
A.18

CONCLUSION

Paul Steed's work can, of course, be seen in Quake3 *and on Loonygames. He has several great tutorials as well as some really great opinion pieces posted on Loonygames.*

NOTES

[1] Notes were added pertaining to MilkShape 3D, since MS3D is included on the CD-ROM that accompanies this book. Aside from that, little else was changed from Paul Steed's original text.

[2] MS3D can deform meshes with the skeletal animation system. It is important to have a bit more detail in the critical parts of the models like knees and ankles, because they tend to bend a lot. It takes a bit of experience to assign the mesh to the skeleton correctly to reduce mesh distortion.

[3] MS3D has a feature called Subdivide. Tessellation is better because it doesn't create triangles of the same size. Tessellation optimizes better than Subdivide.

[4] With MS3D, you will need to optimize by hand, but you will be modeling simple models and starting from the lowest poly count possible. Learning to snap, weld, and jerk those vertices around now will make you a better modeler in the long run.

[5] The command Vertex Weld in MS3D is the same as Vertex Merge.

[6] Fortunately, MilkShape 3D does have this tool.

[7] MS3D calls this Extrude.

[8] Sadly, MS3D does not support Boolean operations, but Boolean operations are tentatively planned for future versions.

[9] Due to the lack of optimization features and control that a package like MAX gives you, you should model low to higher in MS3D to avoid frustration. You can use the snap/weld feature to reduce polygon size manually.

APPENDIX
B

The Goldtree
3D Tools

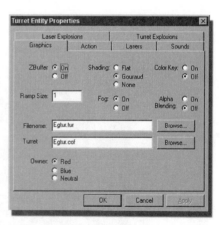

335

The Goldtree 3D Engine and associated tools are copyright © Goldtree 1998–2000 and are not free to use. If you use the engine in a game, you must sign a license agreement and display the Goldtree logo in the game credits.

INTRODUCTION

The Goldtree 3D Level Editor is a graphical level editor initially used for the 3D game *Dead Reckoning*, although it has had several improvements made to it since then. The editor was developed in-house by Goldtree.

The editor was designed to be as simple as possible for an artist new to game development. An artist can work in his or her favorite 3D application and then import the resulting textured objects into the game editor. All that is left is the placement of those objects and the assigning of properties used by the game. A 3D artist will already know most of what they need to build a level for *Dead Reckoning*. Probably the biggest challenge will be to understand the game, game-play issues, and elements of the arena. But even these factors can be easy if you invite an avid gamer to be your level tester (if you are not one yourself). See Figure B.1 for the level editor screen.

FIGURE *The main screen of the level editor.*
B.1

It is assumed that you have at least a rudimentary knowledge of a graphical user interface (Windows 95) and 3D terminology. This primer is designed as a quick guide to the level editor and design issues.

INSTALLATION

The CD-ROM contains a folder called Goldtree Tools that has all the resources you need to create levels. You can simply copy this folder to your hard drive and use it from there. There is no specific installation program. To uninstall, simply delete the directory into which you installed the tools.

NOTE

Starting the level editor for the first time opens the Browse for Folder dialog box (see Figure B.2). You will be prompted to select the folder in which you would like your new level to be stored, along with all its assets.

CAUTION

If you select an empty folder, the editor is supposed to create the necessary folders (subdirectories) needed to store all the level assets (see the "Files and Parameters" section). However, it usually crashes. Please make sure that you copy the file structure from the CD-ROM to your level folder.

TECHNICAL SUPPORT

This level editor and the 3D Engine are *not* supported or guaranteed by Goldtree in any way.

FIGURE *The Browse for Folder dialog box.*
B.2

SYSTEM REQUIREMENTS

Pentium 200MHz or better
32MB RAM
Quad-speed CD-ROM drive
640 × 480 display (minimum)
Windows 95 or 98

GETTING STARTED

You will need the following things to adequately produce a game level:

- The level editor installed and this documentation.
- The minimal app. to study the game play of the game and test run your levels. In order for you to produce the best possible level, you must understand the game. Read the user's manual and play the game as much as possible. A programmer must compile the code for you.
- A 2D paint program or a way to produce and manipulate textures for the 3D objects in your level. We have provided Paint Shop Pro 6 on the CD-ROM, but be advised, it is a time-limited demo.

Optional: *You should get your hands on an audio package or way of producing .WAV files for sounds in the game. This item is optional because we have the default sounds in the game. We did provide you with Goldwave, the sound editor.*

Once you are very familiar with the game *Dead Reckoning* and the level editor, you should lay out your level on paper. Sketch the various elements of the level. The section "Creating Your First Arena" should help with the process of planning and building a level. The most effective way to prepare to build a level is to play *Dead Reckoning* and understand it.

Next, you will probably spend most of your level-building time in your 3D program building the objects. Actual level editing involves placing objects and assigning properties (behaviors). Then you will play your level and tweak it so that it runs well and plays well.

It is advisable to frequently load and test your objects, even building your arena as you go, to be sure every object works, the textures are correct, and any bad design elements can be caught and fixed sooner rather than later.

MENU SELECTIONS

The game interface is based on the standard Windows 95 interface. The following section explains in detail all the options available to you in the level editor. For further details on each of the options, read on.

When you first start the *Dead Reckoning* level editor, it will open the Browse for Folder dialog box. You will be prompted to select the folder in which you would like your new level to be stored, along with all of its assets. As stated previously, if you select an empty folder, it will create the necessary folders (see the "Files and Parameters" section). You will then see the Cylinder Properties Dialog box. You can accept the default parameters and change them later. See Figure B.3.

Your new arena will look like a black screen, but the world is not empty. Even before you say "Let there be light," there are two lights in the world.

There is also an invisible boundary called the *guide cylinder*. This guide cylinder defines the length and radius of your game world. To help in laying out your arena, you can turn on a visible guide cylinder from the menu bar as well. Go to the View option, pull down the menu, and select Guide Cylinder to show the boundaries of your world. See Figure B.4.

The arenas are all limited to a cylindrical shape.

BROWSING FOR ASSETS

Browse buttons exist throughout the editor's dialog boxes. Everywhere a filename is required, a button pops up the standard Win95 Open File dialog box. When you

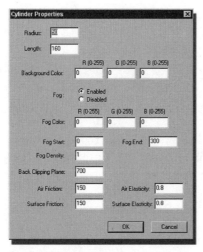

FIGURE *The Cylinder Properties dialog box.*
B.3

FIGURE *The Guide Cylinder in the level editor window.*
B.4

pick a file that way, its name is automatically entered into the appropriate text field.
If you cancel, the text field is unchanged.

*These Open File dialog boxes are customized for each use. For example, when a mesh file
is required, the dialog box is titled Browse for Mesh File and offers a filter to show either
just .COF (mesh) files or all files.*

The Browse buttons automatically import asset files into the level's own subdi-
rectories. That is, you can browse to a .COF file anywhere in the file system, and
when you click OK, you'll get a message box saying that the file must be copied into
your level's assets. You can OK this and let the copy happen, or you can cancel to
skip the copy and leave the filename text field unchanged. If you OK the copy and
there is already an asset file by that name in your level, a message box will ask you to
confirm whether you want to overwrite the existing file.

You can still type into filename text fields directly, but of course there is no auto-
matic import into your level's directories.

The editor does not check to see whether manually entered files actually exist.

MENU OPTIONS

The following sections discuss the menu options in the Goldtree editor. See Figure B.5.

File

New CYL. Create a new world file. This option opens the Browse for Folder dialog box. You are prompted to select the folder in which you would like your new level to be stored with all its assets. You should create a folder for your project before you start the editor. If you select an empty folder, it will create the necessary folders (see the "Files and Parameters" section).

You can create a new file while working on an existing world and have multiple files open at once.

Open CYL. Open an existing file.

Save CYL. Save the currently open file.

Level Summary. This window summarizes all the objects and entities in the arena. It also has a window into which to type level descriptions and notes. See Figure B.6.

FIGURE *The menu bar of the editor.*
B.5

FIGURE *The Level Summary dialog box.*
B.6

Last Used List. Keeps a list of the last few world files used.
Exit.

Edit

Undo provides undo capability for positional changes only. You can also undo changes to an object's position and orientation by menu commands Set Orientation, Snap to World Axes, and Snap to Cylinder. The Undo menu item changes to reflect what operation will be undone. As expected, the menu item changes to Can't Undo when an indelible action is performed.

You cannot undo scaling, move/rotate camera, move/rotate entity, and move/rotate light.

NOTE

Only a single level of Undo is provided, and there is no Redo.

CAUTION

Cut. Cut or delete a selected object.
Copy. Copy the selected object.
Paste. Paste the cut or copied objets.
Find Object. This is a very convenient tool for finding objects and getting information about them. It lists all the objects in your cylinder, their types, and their positions. You can also view these objects from this dialog box. This is useful if you want to quickly find an object you want to edit. See Figure B.7.

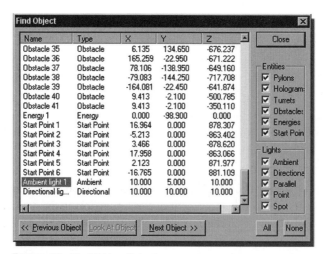

FIGURE *The Find Object dialog box.*
B.7

View

Toolbar. Check and uncheck this option to view the toolbar. Toolbars can be dragged and resized around the work area. Most of the toolbar icons represent commands or functions found in the pull-down menu. Holding the cursor over the icons will pop up a little text bar telling you what the icon does.

Status Bar. Check and uncheck to view the status bar. The status bar at the bottom of the editor identifies the currently selected object by name. Objects get default names such as Turret 1 and can be assigned names in the Find Object dialog box.

Guide Cylinder. Shows the wireframe of the world.

Wireframe Shading (F12). Draws the entire world in wireframe.

Hide Object (F10). Hides selected objects.

Unhide All Objects (F11). Reveals all hidden objects.

Window

New Window. When you create a window in a world, you are in effect creating a new camera. Multiple windows in the same arena can be used for navigating the large arenas and for better placement of objects. For quick navigation of a world, you can locate views in various parts of the world. You can maximize one view to work in, and when you are ready to pop over to the other end of the cylinder, you can simply open the appropriate window view. When trying to place a tricky object, you can locate several views around the object and watch the object from all angles as you place it.

Cascade. This arranges open windows, one on top of another, to help you find information.

Tile. Similar to Cascade but puts windows side by side.

Active Window List. Lists open files.

Mode

Mode indicates what will happen when you click the mouse and drag your cursor along the screen. Will an object move, rotate, or change size? Will the camera move? Your present mode is indicated in the toolbar by a depressed icon and in the pull-down menu by a check mark.

Move Camera (F2). Holding the left mouse button down allows back-and-forth and side-to-side movement of the camera (along the X and Z axes). Holding down the right mouse button allows the camera to move up and down on the Y axis.

Rotate Camera (F3). Holding either mouse button allows the camera to point up or down.

Select Object (F4). Highlights the vertices of an object when it is selected. You can now exercise any number of options on the object (rotate, scale, assign properties, etc.)

Move Object (F6). You can move a selected object back and forth and side to side (along the X and Z axes) by holding down the left mouse button. Holding down the right mouse button allows the movement of the object up and down on the Y axis.

Rotate Object (F7). You can rotate a selected object along the X and Z axes with the left mouse button and along the Y axis with the right mouse button.

Scale Object (F8). Holding either mouse button, you can size a selected object smaller or larger.

Select Light (F5). Select a light in the world.

Entity

An *entity* is named for the function it performs in the game. An *object* is simply the 3D representation of an entity.

New Entity. This is the function whereby you place entities in the world, such as pylons, turrets, or energy squares. This function inserts a representative placeholder object in front of the main camera and, using the following commands, you will replace the default object with your own custom object.

Pylon. Inserts a greenish pyramid placeholder object.

Hologram. Inserts a cloud-covered cube.

Turret. Inserts a gun object.

Obstacle. Inserts a smiley face covered cube.

Energy Square. Inserts a gray cube.

Start Point. Inserts a red ship. This entity is not scalable.

Properties "P." Shows the properties dialog box of the selected entity. For the specific properties of each entity, see the "Entities and Lights" section.

Set Orientation. A manual way of setting an object's exact position in 3D space. This is an important function if you are going to use one large textured cylinder as the surface of your world. When you have a large textured cylinder that you have to size exactly to the guide cylinder, it is impossible to do if the textured cylinder is not dead center. This feature is also useful if you want to place objects in perfect rows. You can create and position an entity. Then you can clone and place entities in exact increments away from each other. This feature is useful for pylon rows, turret placement, and even getting one object to appear to float exactly above another by moving it on only one axis.

To set an object in the dead center of the world, type in these parameters:

```
Position: 0,0,0
Front: 0,0,1
Up: 0,1,0
```

Position. X, Y, Z; sets the object's position in 3D space. 0,0,0 is dead center.

Front. X, Y, Z; aligns the object along the X, Y, or Z axis.

Up. X, Y, Z; positions the object.

Snap to World Axis. Lines up the selected object to face the world axis. This axis runs down the center of the cylinder.

Snap to Cylinder. Lines up the selected object to the surface of the cylinder. The guide cylinder is composed of large flat faces.

Remove Entity. Removes the entity and all settings.

Clone Entity "C." Creates a copy of the selected object.

Light

Add Light. This is how you add lights to the world.

Properties. This is where you adjust the properties of the light.

Navigation

Object Coordinates "N." Toggle between world and object coordinates.

X Axis "X." See below.

Y Axis "Y." Keep going.

Z Axis "Z." Okay. These three options can be checked and unchecked. You can also see them in the toolbar as buttons and keystrokes. If you check all the XYZ options, you will have freedom of movement on all axes. If you uncheck any one of the X, Y, or Z options, you will not be able to move along that axis. If you have all the options unchecked, you won't be able to move an object at all.

Coarse Navigation (F9). This toggle option adjusts how far an object or camera moves when you drag it. Coarse Navigation will fling an object into oblivion if you are too close to it and choose this option.

Cylinder

This menu is where you enter the various properties of the cylinder itself. When you create a new cylinder, this dialog box pops up first. See Figure B.8.

Properties. This option opens up a dialog box that allows you to set various properties of the enclosed environment we call a world.

Radius #. This number defines the extents of the world during game play; for example, ships can not fly outside this area. It is purely numerical and is

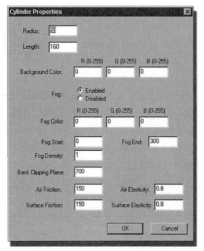

invisible during the game. You can use this option in many ways, as discussed later. There are a few rules about entities that need to be followed so as not to ruin game play.

The average radius of a game cylinder is 150.

Length. The average length of a game cylinder is 2000.
Background color. RGB values 0–255 set the color of the clipping plane or open space in the game.
Fog. Enabled/Disabled buttons.
Fog Color. RGB values 0–255 to set the color of the fog.

Background color and fog color should be the same if fog is enabled.

Fog Start. Fog start and end points for linear fog mode. These settings determine the distance from the camera at which fog effects first become visible and the distance at which fog reaches its maximum density.
Fog End. The value in the Fog End edit control defines the end point of the fog in the scene.

Fog usually starts between 0 and 3; where it ends is up to you. A close fog is 150, and a far fog is 300 to 500.

Fog Density. Fog density for the exponential fog modes. This value should be in the range 0 through 1.

Back Clipping Plain #. Objects behind the clipping plane are still "seen" by the computer AI, even though they are not rendered. The back clipping plane should be set about 50 units greater than the fog end.

Air Friction #. This option is not implemented at this time.

Air Elasticity #. How springy or resilient the air is. Most are set at 0.8.

Surface Friction #. This option is not implemented at this time.

Surface Elasticity #. The higher the value on this option, the more bounce the surface has. Careful, or it can bounce too much and bounce right out of the arena. Most are set at 0.8.

Sound Properties. The game supports standard Windows .WAV files.

Laser Obstacle Collision. Sound played when a laser hits anything.

Missile Obstacle Collision. Sound played when a missile hits anything.

Vehicle Obstacle Collision. Sound played when a ship hits an obstacle.

Vehicle Pylon Collision. Sound played when a ship hits a pylon.

Red Pylon Charge. Sound played when a red ship tags a pylon.

Blue Pylon Charge. Sound played when a blue ship tags a pylon.

Energy Recharge. Entering the energy bounding area charges shields and plays this sound in a loop.

Help

Help gives version and copyright information for the editor.

THE TOOLBAR

Figure B.9 shows the toolbar and its corresponding functions in the menu.

FIGURE *The toolbar.*
B.9

ENTITIES AND LIGHTS

Everything in *Dead Reckoning* is an entity. An entity is named for the function it performs in the game. An object is simply the 3D representation of an entity.

To create and place entities, see the description of those functions in the "Menu Options" section. Understanding Navigation Modes and Entity Creation is important. This section explains the specifics of each entity and goes into detail about the properties of each entity.

When you create an entity in the level editor, you are creating a thing that will behave in a certain way, according to its assigned properties. A default object is always assigned by the level editor, but it will be replaced with the custom objects that you are creating. It is actually possible to create an entire game level with the editor by inserting the entities and using the default objects.

The entities are:

Pylons. For every pylon you create, you must create a green, red, and blue version of that same pylon. These objects usually start out neutral (green) and are swapped as ships hit them.

Holograms. These are objects that you can pass through. Great for energy areas to recharge shields and hiding stuff. Example: The energy square in the city cylinder is a hologram with an energy square entity around it.

Turrets. Versions for each team. The red and blue color scheme helps a player know what side of the cylinder he or she is on. Keep in mind the balance of power when assigning fire rate and damage done.

Obstacles. Cool-looking things that don't do anything but look good. These are great for decoration and obstruction as well as for building an energy square. Example: The brain in the fleshy cylinder is an obstacle.

Energy Square. This entity is invisible in the game. It is used in the editor so you can visually see the area that will charge shields when flown into during the game. Using holograms and obstacles, you can build any energy square you can conceive of.

Putting an energy square entity around turrets and pylons might seem cool, but this really messes up the game AI. Make the entity yellow or obvious in color and nature. The entity's area shouldn't be too big or small.

Start Points. You do not create any objects for start points. They are simply where the ships are placed when a game level is started. This entity is purposely not scalable or resizable.

Lights. Add lights to your scene.

The following is a list of entities and their properties.

PYLON

The default pylon object is the greenish pyramid (see Figure B.10). This is the entity in the game that gives your weapons more strength as you tag them. The dialog options are:

Weight. Numerical range. This is a relative number. If you have 20 pylons in a level and they are all set at 1 or all set at 4, they will all have the same weight. But if they are all set at 1 except one, which is set at 4, that pylon will charge your weapons 4 times as much.

Z Buffer. On/Off radio buttons. These are really here for the sky; they should always be on.

Ramp Size. This option controls aspects of render quality. Generally set to 1.

Neutral COF. The object displayed when the pylon is in a neutral state.

Red COF. The object displayed when the pylon has been tagged by the Red Team.

Blue COF. The object displayed when the pylon has been tagged by the Blue Team.

Collision COF. Invisible collision object used to make collision detection more efficient.

Example: You could create a 20-sided pylon, but the object is basically square, so you can then use a square bounding box that allows the game to collision detect on 6 faces rather than 20. The game will then display the several 20-sided objects but only collision detect on 6.

Visibility. Normal, Red, Blue, Collision radio buttons. What object do you want to see displayed as you work in the editor—the red, the blue . . . ?

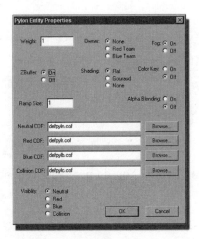

FIGURE *The Default Pylon object and its dialog box.*
B.10

Owner. None, Red Team, Blue Team radio buttons. The state of the pylon when the game begins.

Shading. Flat, Gouraud, None radio buttons. See glossary for definitions of shading types.

Fog. On/Off radio buttons. This option allows an object to be affected by fog or not. In other words, an entity with fog turned off will stick out because it will be bright and not subject to fog.

Color Key. On/Off radio buttons. This controls single-color transparencies.

Alpha Blending. On/Off radio buttons. Texture that ends in .ALP (a renamed .BMP file) is considered alpha channel. This must be the same size as the original image. Black is clear and white is solid.

HOLOGRAM

The hologram is the cloud-covered cube. This is an entity that allows no collision detection; you can pass right through it. See Figure B.11.

Layer #. Multiple sky layers. Numbers 1, 2, 3 . . .

Z Buffer. Off and On radio buttons. See glossary for definitions.

Ramp Size #. This controls aspects of render quality. Generally set to 1.

File name. The file that will be displayed as the hologram in your level.

Parallax. On/Off.

Shading. Flat, Gouraud, None radio buttons.

Fog. On/Off radio buttons.

Color Key. On/Off radio buttons. This controls single color transparencies.

Alpha Blending. On/Off radio buttons.

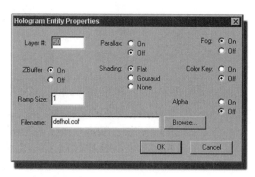

FIGURE *The Default Hologram object and its dialog box.*
B.11

TURRET

The turret is your radar with a gun built in to protect it. You can have multiple turrets in an arena. The turret has a bit more information attached to it, as you will see, and requires a bit more effort to get working well in the game. See Figure B.12 for the default turret object.

The Turret Entity Properties dialog box has six tabs on it, which are:

Graphics. Sets the parameters for how the turret object is displayed in the game.
Action. Controls the movement of the turret in the game.
Lasers. Assigns the laser objects the turret shoots and their number.
Sounds. The sounds that are played for the lasers, explosions, etc.
Laser Explosions. The explosions assigned to the laser.
Turret Explosions. The explosions assigned to the turret.

Explosions are explained in the section "Files and Parameters."

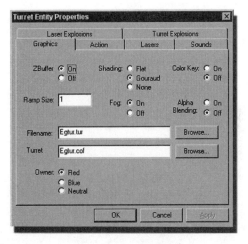

FIGURE *The default turret object.*
B.12

Figure B.13 shows the options available on the Graphics tab.

Z Buffer. On/Off radio buttons.
Ramp Size. This option controls aspects of render quality. Generally set to 1.
Filename: FILENAME.TUR. A .TUR file is simply a text file containing all the
 information about a turret. All the parameters are defined in this dialog box.
 By altering the information in this dialog box, you alter the TUR file. By
 typing a nonexistent file name, you create a new .TUR file.

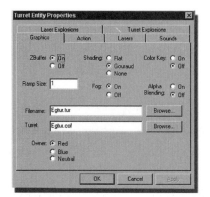

FIGURE *The Graphics tab of the Turret dialog box.*
B.13

If you read in an existing .TUR file, make changes to properties, and click OK, then a standard Save As dialog box will appear to remind you that you're about to change an existing .TUR file. You can say OK, or you can decide to save the settings under another filename. This happens only when you change the turret's associated .TUR filename; as long as you leave that filename alone, all your other turret property changes will be written to the file transparently, without the need to deal with a Save As dialog box.

As a special case, if you change some settings while the filename is DEFAULT.TUR and say OK, you will get a Save As dialog box with an empty name field (instead of having the current name pre-entered for you). This prevents you from accidentally accepting changes to the special default turret file. However, you can manually type DEFAULT.TUR and change the default file, if you want.

Turret. The .COF file or object used for the turret in the game.

Owner. Neutral, Red Team, Blue Team radio buttons.

Shading. Flat, Gouraud, None radio buttons. See glossary for definitions.

Fog. On/Off radio buttons.

Color Key. On/Off radio buttons. This controls single color transparencies.

Alpha Blending. On/Off radio buttons. See *alpha blending* in the glossary.

Figure B.14 shows the options available on the Action tab.

Swivel Rate. The rate of turning in angles per second. The speed at which it tracks the enemy.

Hit Points. Maximum number of hit points of this turret before it is destroyed.

Range. Enemy vehicles outside this range are ignored. This option also determines when its radar starts to lock.

Figure B.15 shows the options available on the Lasers tab.

FIGURE
B.14 *The Action tab of the Turret dialog box.*

FIGURE
B.15 *The Lasers tab of the Turret dialog box.*

Laser COF. The object used for this turret's lasers.

Alpha Laser. The .COF file used if alpha blending is enabled.

Laser 1–5. You can have up to five lasers on a turret. Any unused rows are ignored, but you must make sure that your laser data is entered into the first few contiguous rows. Data entered after a blank row will be ignored. The fields for lasers 1 through 5 are as follows:

Start. The start point for this laser in model coordinates (UV). Where on the model the turrets come out.

Damage. The amount of damage this laser does.

Rechg. The recharge rate; the time until this laser can fire again.

Speed. The speed this laser travels in world space.

TTL. Time to live; the life span of this laser after it has been fired.

Figure B.16 shows the options available on the Sounds tab.

Laser Fire. The .WAV file played when this turret fires.

Projectile. The .WAV file played when this turret gets hit.

Turret. The .WAV file played when this turret explodes.

Figure B.17 shows the options available on the Laser Explosions tab.

Laser. The .EXP file used when a laser hits an obstacle.

Alpha Laser. The .EXP file used when or if alpha blending is on.

Red Hit. The .EXP file used when a laser hits a vehicle.

Alpha Red Hit. The .EXP file used when or if alpha blending is on.

Blue Hit. The .EXP file used when a laser hits a vehicle.

Alpha Blue Hit. The .EXP file used when or if alpha blending is on.

FIGURE
B.16 *The Sounds tab of the Turret dialog box.*

FIGURE *The Laser Explosions tab of the Turret*
B.17 *dialog box.*

Figure B.18 shows the options available on the Turret Explosions tab.

Red. The .EXP file used when this turret explodes.
Alpha Red. The .EXP file used when or if alpha blending is on.
Blue. The .EXP file used when this turret explodes.
Alpha Blue. The .EXP file used when or if alpha blending is on.
Red Color. Color of the red explosion light.
Red. Length of time the light shines.
Blue Color. Color of the blue explosion light.
Blue. Length of time the light shines.

Explosions are explained in the section "Files and Parameters."

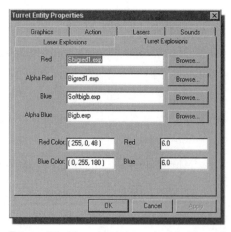

FIGURE *The Turret Explosions tab of the Turret dialog box.*
B.18

SAMPLE EXPLOSIONS

An .EXP file is a text file containing information about explosions in the game. It calls up .COF files and, in turn, the .COF files call up .BMP files and .WAV files. An .EXP file defines the behavior of the combined elements to create an explosion.

The behavior of an explosion is complex. For that reason, several basic explosions have been given to you. If you want, however, you may decipher the .EXP text file and customize the explosions yourself.

The sample explosions included are all used in the turret object, as shown in Table B.1.

Table B.1 Sample Explosions

Event	EXP File
Laser Explosion	SORED.EXP
Alpha Laser Explosion	LASER15.EXP
Red Laser Hit Explosion	SOFTXXX.EXP
Alpha Red Laser Hit Explosion	XXX.EXP
Blue Laser Hit Explosion	SOFTXXX.EXP
Alpha Blue Laser Hit Explosion	XXX.EXP
Red Turret Explosion	SBIGRED1.EXP
Alpha Red Turret Explosion	BIGRED1.EXP
Blue Turret Explosion	SOFTBIGB.EXP
Alpha Blue Turret Explosion	BIGB.EXP

OBSTACLE

The obstacle is the smiley face covered cube. The obstacle is just that, an obstacle. It does nothing but get in the way and look nice. It has no behavior other than being an obstacle. See Figure B.19.

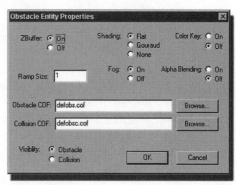

FIGURE *The default obstacle object and its dialog box.*
B.19

Z Buffer. Off and on radio buttons.

Ramp Size. This controls aspects of render quality. Generally set to 1.

Obstacle COF. Filename of the object to be displayed in the game.

Collision COF. Bounding box object. Invisible collision object used to make collision detection more efficient. Example: You can create a 20-sided obstacle, but the object is basically square, so you can then use a square bounding box that allows the game to collision detect on 6 faces rather than 20. The game will then display the several 20-sided objects but collision detect on only 6.

Shading. Flat, Gouraud, None radio buttons.

Fog. On/Off radio buttons.

Color Key. On/Off radio buttons. This controls single color transparencies.

Alpha Blending. On/Off radio buttons. See the glossary.

ENERGY SQUARE

The energy square is a gray cube. Keep in mind that this entity is always invisible during the game. It is an area that the ships fly into to charge their shields. You can define an area around a solid obstacle or have a hologram that fits the area. See Figure B.20.

Energy Rate. How fast does it recharge shields? Seventeen is the midrange number.

File Name. The bounding shape used to define the recharge area.

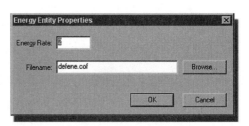

FIGURE *The default energy square object and its dialog box.*
B.20

START POINT

The red ship object is the start point—the place where players start the game. You should insert an even number of ships per side, either two or four. See Figure B.21.

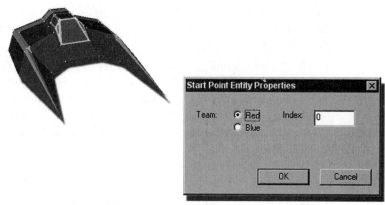

FIGURE *The start point object and its dialog box.*
B.21

Team. The team that starts at this point, Red or Blue.
Index. The number of start points consecutively, from 0 up. For example, two
teams of three will be numbered 0–2 for one side and 3–5 for the other.

LIGHTS

Lights slow down the frame rate quite a bit. Each new cylinder comes with a basic
set of lights; you should try to work with them as is. See Figure B.22.

Color. Red, Green, Blue color entries.
Attenuation. Constant, Linear, Quadratic.
Range. Sets the range for spotlights and point lights.

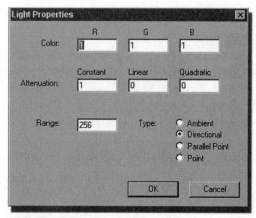

FIGURE *The Light Properties dialog box.*
B.22

Type. We support Ambient, Directional, Parallel Point, Point, and Spotlight.

Ambient. An *ambient* light source illuminates everything in the scene, regardless of the orientation, position, and surface characteristics of the objects in the scene. Because ambient light illuminates a scene with equal strength everywhere, the position and orientation of the frame it is attached to are inconsequential. Multiple ambient light sources are combined within a scene.

Directional. A *directional* light source has orientation but no position. The light is attached to a frame but appears to illuminate all objects with equal intensity, as though it were at an infinite distance from the objects. The directional source is commonly used to simulate distant light sources, such as the sun. It is the best choice of light to use for maximum rendering speed.

Parallel Point. A *parallel point* light source illuminates objects with parallel light, but the orientation of the light is taken from the position of the parallel point light source. That is, like a directional light source, a parallel point light source has orientation, but it also has position. For example, two meshes on either side of a parallel point light source are lit on the side that faces the position of the source. The parallel point light source offers similar rendering-speed performance to the directional light source.

Point. A *point* light source radiates light equally in all directions from its origin. It requires the calculation of a new lighting vector for every facet or normal it illuminates, and for this reason it is computationally more expensive than a parallel point light source. It does, however, produce a more faithful lighting effect and should be chosen where visual fidelity is the deciding concern.

Spotlight. A *spotlight* emits a cone of light. Only objects within the cone are illuminated. The cone produces light of two degrees of intensity, with a central brightly lit section (the *umbra*) that acts as a point source, and a surrounding dimly lit section (the *penumbra*) that merges with the surrounding deep shadow.

USING THE KEYBOARD

Mode Changes. All the important mode changes can be done with single keystrokes. These keys are in the same left-to-right order as the little icon buttons which appear at the bottom of the editor window. Table B.2 summarizes the functions of select keys.

Arrow Keys. The arrow keys act like mouse input for moving and rotating things. Only the equivalent of left-button mousing is currently supported. Like the mouse, the arrow keys respect the mode setting; for example, if you are in Rotate Camera mode, the four arrow keys rotate the camera just as you would by moving the mouse in those four directions with the left button held down. You can nudge with the arrow keys by holding down the Shift

Table B.2 Function of Select Keys

Key	Function
F2	Move Camera
F3	Rotate Camera
F4	Select Object
F5	Select Light
F6	Move Object
F7	Rotate Object
F8	Scale Object
P	Object Properties
C	Clone Entity
N	Object Coordinates ("Nav")
X	X-Axis Toggle
Y	Y-Axis Toggle
Z	Z-Axis Toggle
F9	Fine/Coarse Toggle
F10	Hide Object
F11	Unhide All Objects
F12	Wireframe/Solid Toggle

key at the same time as you press the arrow key. In this case, the arrow keys do the same thing, but one pixel at a time.

FILES AND PARAMETERS

When you create a new level, you are creating a .CYL file and, if they're not already present, a set of subdirectories that are listed below. Careful—when moving a .CYL file, you must move or copy all the associated subdirectories with it so that the editor can find the assigned assets.

The following are directories created by the *Dead Reckoning* level editor:

Explode. Stores .EXP files.
Mesh. Stores all .COF files.
Sound. Stores all the .WAV files used by the game.
Texture. Stores all the .BMP and .ALP files.

STexture. Stores 256 color versions of textures here for use with software renderers. They should have the same filenames as files in Texture.

Turret. Stores all the TUR files.

The following are the various files in *Dead Reckoning* and their relation to one another.

EXPLODE SUBDIRECTORY

.EXP. An .EXP file is a text file containing information about explosions. It calls up .COF files and, in turn, the .COF files call up .BMP files and .WAV files. An .EXP file defines the behavior of the combined elements to create an explosion.

The behavior of an explosion is complex. For that reason, several basic explosions have been given to you.

MESH SUBDIRECTORY

.COF, or Cylinder Object Format. A proprietary 3D model format (mesh). It is a binary file, but if you open it in a word processor, you will see the name of the texture (.BMP) used by this file.

Sound Subdirectory

.WAV. *Dead Reckoning* uses .WAV files. PCM, 22,050Hz, 16-bit, mono.

TEXTURE SUBDIRECTORY

.BMP. All graphic files used by *Dead Reckoning* need to be .BMP, sized in orders of 2: 64 × 64, 128 × 128, 256 × 256, 512 × 512. Generally, you will store 16-bit textures in this directory, then duplicate them in the STexture directory as 256-color textures. These will be used by software renderers for greater speed.

.ALP. A texture file that ends in .ALP (a renamed .BMP file) is considered alpha channel. It must be the same size as the original image. Black is clear and white is solid.

TURRET SUBDIRECTORY

.TUR. A file that contains information about a turret. All parameters are accessible and explained through the Turret Properties dialog box. You will see that a .TUR file calls up .WAV files, .EXP files, and .COF files, which in turn summon the lowest level file in DR a .BMP or .WAV file.

World Subdirectory
Empty and unused.

STORING YOUR LEVEL ASSETS

Each level (i.e., each .CYL file) needs to have its own set of directories for meshes, sounds, and the like. When you create a new level in the editor, you are immediately asked to choose a folder for the .CYL file and assets; it's not possible to wait until you save the level to choose a folder. When you open an existing level, the editor uses the level's proper directory automatically.

BROWSING FOR ASSETS
Browse buttons exist throughout the editor's dialog boxes. Everywhere a filename is required, a button pops up the standard Win95 Open File dialog box. When you pick a file that way, its name is automatically entered into the appropriate text field. If you cancel, the text field is unchanged. These Open File dialog boxes are customized for each use; for example, when a mesh file is required, the dialog box is titled Browse for Mesh File and offers a filter to show either just .COF files or all files.

The Browse buttons automatically import asset files into the level's own subdirectories. That is, you can browse to a .COF file anywhere in the file system, and when you click OK, you'll get a message box saying that the file must be copied into your level's assets. You can OK this and let the copy happen, or you can cancel to skip the copy and leave the filename text field unchanged. If you OK the copy and there is already an asset file by that name in your level, a message box will ask you to confirm whether you want to overwrite the existing file.

You can still type into filename text fields directly, but of course there is no automatic import into your level's directories. Currently, the editor does not check to see whether such manually entered files actually exist.

CONVERTING YOUR 3D MODELS

Whatever your initial 3D file format, you need to convert it into a TrueSpace .COB file. After you have it as a .COB file, you can take it through the converters and finish with a .COF file.

NOTES ON THE CONVERTERS
You should create your game objects in TrueSpace 2 (on the CD-ROM) or import them and then save them as ASCII .COB files. Then run them through the converters.

CylConv

This is the main tool for converting ASCII Caligari TrueSpace .COB models into the Cylindrix object format .COF files. It is a DOS utility that uses the source code from ConvCOB and X2COF, which follow. Basically, it takes a .COB file, converts it to an .X file, then converts that into a .COF file. This should be the only tool you need to use.

Usage: cylconv filename.cob filename.cof texturedir.

The following two tools are components of CylConv. You shouldn't need to use them, but we included them in case you want to examine the conversion process if you are having problems.

ConvCOB

Converts ASCII and binary Caligari TrueSpace 2.COB files into the Microsoft .X file format.

Usage: Convcob filename.cob filename.cof.

X2COF

Converts Microsoft .X files into the Cylindrix object format .COF files.

Usage : x2cof filename.x filename.cof.

PLACEMENT OF OBJECTS IN THE WORLD

This radius number in the Cylinder Properties dialog box defines the extents of the world during game play; ships cannot fly outside this area. It is purely numerical and is invisible during the game. You can use that in many ways, as discussed later. A few rules about entities need to be followed so as not to ruin game play:

Pylons and Energy Squares. You can't have these objects desired by the AI outside the defined area. They need to be all the way in the area. No part can stick out of the area, or the AI gets silly.

Turrets. They can be part of the way out, but they need to be at least half the way in so they can be killed.

Holograms and Obstacles. These can be placed outside the area.

Start Points. Need to be in the defined area as well.

CREATING YOUR FIRST ARENA

Even with the limits of any game, if you are resourceful and creative, you can make almost any type of world or environment. To aid you in your beginnings, we will create a hypothetical arena that will be pretty basic, utilizing just a few of the features or creative things you can do.

FIRST, PLAN

Have a good understanding of the game *Dead Reckoning* and the game play. Play the game for a good while.

Kick around several ideas and decide what you want to create. As an example, we chose the Camelot cylinder. We can make this arena a castle environment, Stonehenge-like, a dark forest. Since we want to stay away from organic environments, we choose the castle motif. There are many aspects of Camelot we can fit into an arena.

We usually start the cylinders with an idea for the surface. This one will be enclosed, a dark and spooky place. First we create a tiled stone surface that will cover the floor.

The entities: In Camelot, we have many cool elements: Excalibur, Merlin, knights, the Round Table, the notion of the Red Dragon, Celtic and fantasy elements, and almost anything medieval.

ENERGY SQUARE

We can make a wizard's tower, like the small temple in the Egyptian cylinder. We can make a black and ominous structure with one or two entrances. Inside, the walls are tinted red. This would be an obstacle entity. Inside the tower a large black cauldron sits. The inside of the cauldron is gold colored, another obstacle entity. Then we can lay a small yellow swirled hologram right at the top of the cauldron so you can see into the cauldron through the murky golden brew (alpha blended). Maybe we can make the cauldron big enough for a ship to go into it, like the Maze cylinder—a place to ambush people. For the finishing touch, we can make a transparent golden Excalibur hologram floating over the cauldron. What an energy square! Of course, as artists you can make your textures sport gargoyles, glyphs, and really cool details.

PYLONS

We can make some really cool obelisks that are stone encased and have glowing Celtic runes on them. They can be free standing or placed halfway into castle-type walls.

OBSTACLES

The remainder, before we place start points, turrets, and other details, is laying out the fighting arena, which is largely a combination of pylons and obstacles. We have the castle idea rolling, so we create a few basic obstacles that can be reused and sized differently to be efficient with texture memory and so on.

TURRETS

Using a basic obstacle, we can place four towers on the end caps of the cylinder. Each one points to the others, like spokes on a wheel. We can create one large

textured mist-like surface and make it transparent, like the mist in the Maze cylinder, and place that right where the end cap boundary is. Beyond where the ships are stopped is inky blackness. In the center of the end cap, above the tops of all four towers, is the turret, a special red or blue object. This is a nonmoving turret, an obstacle that lets off projectiles, like the pyramid end caps in the Egyptian cylinder, as opposed to the mounted guns of the City cylinder—maybe a standard Celtic glyph, the Holy Grail, or a shield.

OVERALL LAYOUT

The real challenge is to lay out a cylinder that looks cool, runs well on the target machine, and plays well. This is where you experiment with obstacle size and placement, pylons, and all the other variables.

Playability is an issue. Best advice: Get several game-playing friends to load up your level and play it. Keep in mind aspects of difficulty, and balance them.

FINISHING THINGS UP

Once you have your level completed, you need to do a couple last-minute things to make sure your level plays well on a wide variety of systems. You need to make sure that the textures are set up for software mode, and you need to generate final AI information for the game.

TEXTURES

In your level directory, there are two subdirectories called TEXTURE and STEXTURE. The textures directory should hold all the textures you use for your level. These should be 16-bit textures because they will be used by hardware accelerators to give your level the best look. You should also have a duplicate set of textures in the STEXTURE directory. These are the textures that will be used in software mode. To make software run faster, these textures should be reduced to 256 colors.

GENERATING AI GRIDS

When you change your level, the AI section of the program needs to generate two AI grids to help control the ships. Since the program needs to know where everything is for the AI to work properly, you will need to generate new AI grids whenever you change the geometry of your level. To do this, simply delete the *cylinder name*.G2D and *cylinder name*.G3D files from the directory with the level's .CYL file, and then run the game. The program will generate new AI grids for you automatically, once it sees that the files are missing. Be prepared, though—this process can take quite a long time (upward of 30 minutes). For that reason, we suggest that you do this as one of your last steps before you complete the cylinder.

INSTALLING YOUR LEVEL

Once you have a level done, you need to install it into the game. The files need to be located in a Levels directory located in the installed directory of the game. This is typically C:\Program Files\Dead Reckoning. Copy your entire directory with all its assets into this folder. Be sure that the name of the directory is the same name as the .CYL file. At that point, the game will be able to detect and play your level.

GLOSSARY OF GOLDTREE TOOLS

Alpha blending. Texture that ends in .ALP (a renamed .BMP file) is considered alpha channel. Must be same size as original image. Black is clear and white is solid.

Attenuation. In real life, light gets scattered as it travels, diminishing its ability to illuminate objects the farther it gets from its source.

Flat shading. The flat-shading method is also called *constant shading*. For rendering, it assigns a uniform color throughout an entire polygon. This shading results in the lowest quality: an object surface with a faceted appearance and a visible underlying geometry that looks "blocky."

Gouraud shading. Gouraud shading, one of the most popular smooth-shading algorithms, is named after its French originator, Henri Gouraud. Gouraud shading, or color interpolation, is a process by which color information is interpolated across the face of the polygon to determine the colors at each pixel. It assigns color to every pixel within each polygon based on linear interpolation from the polygon's vertices. This method improves the "blocky" look (see *flat shading*) and provides an appearance of plastic or metallic surfaces.

new pixel = (alpha)(pixel A color) + (1 - alpha)(pixel B color)

Back clipping plane. The far boundary of a viewing frustum beyond which objects are not rendered.

DEAD RECKONING LEVEL EDITOR FAQ

This lists some of the questions people have asked about using the editor and creating levels. Remember, this level editor is not supported.

Q: Once you have a level, how do you install it in the game?

A: All the files need to be located in a Levels directory located in the installed directory of the game. This is typically C:\Program Files\Dead Reckoning. Copy your directory with all its assets into this folder. Be sure that the name of the directory is the same name as the .CYL file. At that point, the game will be able to detect and play your level.

Q: How do I start making a new level?

A: You can either choose New from the File menu or you can copy the template level from the level editor directory. If you use the template, you will want to rename the level, so change both the directory name and the name of the .CYL file to the same name.

Q: The computer-controlled ships are bumping into things. What's wrong?

A: When you change your level, the AI section of the program needs to generate two AI grids to help control the ships. Since the program needs to know where everything is for the AI to work properly, you need to generate new AI grids whenever you change the geometry of your level. To do this, simply delete the Cylinder name.G2D and Cylinder name.G3D files from the directory with the level's .CYL file, and then run the game. The program will generate new AI grids for you automatically once it sees that the files are missing. Be prepared, though—this process can take quite a long time (upward of 30 minutes). For that reason, we suggest that you do this as one of your last steps before you complete the cylinder.

Q: Is *Dead Reckoning* compatible with DirectX 6 or NT?

A: *Dead Reckoning* was designed to work with DirectX 5. You might be able to get it to work with DirectX 6, but driver compatibility and other factors could keep the game from functioning properly. We might release a maintenance version that will work with DirectX 6 once it has matured. As for NT, since both the game and the editor rely heavily on DirectX 5 and DirectX 5 won't work on NT, neither program will work under NT.

Q: How do I convert files for the game?

A: There is a section on converting files in the documentation. Many 3D modeling programs use their own proprietary formats for storing their files. The tools for *Dead Reckoning* need the files to be stored in the .COB file format used by Caligari TrueSpace. These files need to be ASCII .COB files. You need to convert your models into this format before they can be used with the game. Some programs come with translation options available as export features. Once you have it in .COB format, use the CYLCONV utility to create the game files.

Q: What is a .COF file?

A: A .COF file is a Cylindrix Object File. This is the main object file for *Dead Reckoning*. .COF files are not to be confused with .COB files, which are 3D files generated by TrueSpace.

Q: How do I design a level for the best performance?

A: *Dead Reckoning* is a 3D-intensive program. The amount of 3D geometry used in a level directly impacts the performance of the game. The more complex the level in terms of geometry, the slower it plays; the less complex, the faster. There is definitely a trade-off here in terms of performance and having a really good-looking level. Generally, you should keep things as simple

as possible while still letting it look good. Keep in mind both geometry and textures. Sometimes you can add depth to simpler objects by using good textures, but don't let your textures get out of control, either.

Q: Can I check the frame rate for my level?

A: Yes. You will need to start the game from the Run prompt under the Start menu. Find the main program, then on the command line, add -framerate to the end. You should have something like C:\Dead Reckoning.exe-framerate. This will display the frame rate in the upper-left corner of your screen. You can use this information to gauge how fast your level is playing.

Q: How many polygons go into a good level?

A: This is really a performance issue. The number of polygons depends on the level's characteristics and how fast your target machine is going to be. Please see "How do I design a level for the best performance?"

Q: What special effects are available in the game?

A: The most apparent special effects are fog, transparency, and lighting effects. You can create many different environments by using these alone or in combination.

Q: Do special effects slow the game down?

A: Generally, the special effects are handled by 3D accelerators if you have them installed. As such, they don't really slow the game down. This will depend, however, on the degree to which the card actually supports the particular graphic function.

Q: What can you do to speed up the editor?

A: The best thing you can do to speed up the editor is to get a good 3D accelerator card. The editor uses the accelerator through DirectX, so the faster the card you get, the faster the editor will run.

Q: Can I do anything to make software only play faster?

A: In your level directory, there are two subdirectories, called Texture and STexture. The Textures directory should hold all the textures you use for your level. These should be 16-bit textures because they will be used by hardware accelerators to give your level the best look. You should also have a duplicate set of textures in the STexture directory. These are the textures that will be used in software mode. To make software run faster, these textures should be reduced to 256 colors.

Q: Can I create ships or other characters with the editor?

A: No. The level editor is strictly for creating cylinder levels.

Q: Can I test my level in the level editor?

A: No. It is an entirely separate application from the game. The editor is for placing objects and assigning parameters.

Q: I verify all filenames and still my level crashes. What's happening?

A: Try to observe what incident is taking place when it crashes. Crashes can occur because objects are too small, and the game will crash when a ship hits

it. If a certain sound event seems to crash the game, it might be that your files have incorrect parameters. Formats need to be correct, not just the extensions. A .WAV file that is stereo or of too high a quality will crash a level.

Q: When I take a .COF file from another directory, the editor tells me I need to copy the file, but there are no textures on the object. What's happening?

A: The editor copies only the mesh file. Verify the files to get a list of missing files, then close the editor and copy or create the textures into their proper directories.

Q: What format do the sound files need to be in?

A: The format for sound files should be 22.050kHz, 16-bit, mono, no compression.

C

Sample Design Document: *Ghost Hunter*

The sample document contained in this appendix was written for a very low-budget game proposed to a company interested in interactive content for its Web site. Although the company's needs were minimal in the areas of technology and game play, that did not mean it wanted an inferior game. The game play, as simple as it was, had to be scripted so that it was logical and consistent. The content had to appeal to the audience and not offend them. In other words, this game—as simple as it might appear to a hard-core gamer—still had to meet the requirements of a real product and all the criteria discussed in Part I of this book.

In fact, be aware that this appendix is only supplemental to the material covered in Part I of this book. The complete game proposal contains other elements and more detail. This example was meant to convey a tone of the material and provide guidance in generating your own documentation and not be a fill-in-the-blank form.

Ghost Hunter uses technology that is inexpensive and easy use. The click-and-drag application *The Games Factory* by Clickteam was used in this example. This sample was chosen because it is representative of the kind of content most very small developers and individuals who are making money developing interactive content are generating for their prospective clients. As we have seen in Part I of this book, the market for low-end, simple games is growing as the number of PC owners continues to grow and the number of businesses are getting on the Internet and trying to come up with ways to stand out. Often, unique content such as screen savers, novelty games, and the like are attractions to many Web sites.

This appendix provides you with a peek into the actual correspondence (with names changed to protect the innocent) between our developers and the client.

The parts of the proposal included here are:

The cover letter. A response to an initial inquiry and meeting with the prospective clients.

The treatment. This document orients the clients to the game we are developing for them based on their needs.

The design document. This document details the game for the clients.

THE COVER LETTER

The cover letter on the following page provides a brief description of the project, audience, genre, and what materials you have enclosed:

October 1, 2000

Nancy Client
VP Marketing
Seasonal Gifts
1234 Main Street
City, State, Zip

Dear Ms. Client,

Thank you for considering our proposal to develop the interactive game *Ghost Hunter* for download on your company Web site. Given your customer base, the fact that your site promotes seasonal novelty items, and the fact that the completion date is six weeks before Halloween, *Ghost Hunter* seems to be just what you need.

Ghost Hunter is a simple action shooter that allows the player to shoot the ghosts that appear and disappear in the windows. When all the ghosts are gone, the next level loads. I have enclosed a one-level functioning demo; we have designs on paper for three more levels and the complete game flow.

The team we have assembled contains a mix of experience in professional game development and programming. We anticipate the full version of *Ghost Hunter* to take two months to complete.

Please find enclosed the following:

 The game treatment
 The *Ghost Hunter* design document
 A running demo of *Ghost Hunter*

We look forward to your response.

 Regards,
 Joe Developer

THE TREATMENT

Ghost Hunter is a 2D shooter from the first-person perspective. The design is based on the end-user specs provided: theme, look and feel, and other aspects noted from our phone conversations. *Ghost Hunter* will run on a minimal system—in fact, any system that can run Windows can run *Ghost Hunter*. *Ghost Hunter* is also small in terms of file size for faster downloading from your Web site.

The game will include custom artwork and sound design. The level of production will include a full installation routine, animated sequences between levels, and credit and splash screens. The sound designer and artist have done some preliminary work, and the results are remarkable. The creepy organ music and ghost sounds are top notch and add depth to the Haunted House level demo included.

The backdrop of each level will be rendered in 3D and depict a traditional haunted house, graveyard, and spooky castle, respectively. Each location will have its own cast of ghosts and other creatures. For example, in the Haunted House level, a bat will occasionally fly across the level, and if the player can hit the bat, he or she will receive extra bonus points. Points are important because in the last level the player will receive weapon power according to the number of points scored during the game. The stronger the weapon, the better chance the player has of defeating the final Big Boss in the Dungeon level.

THE DESIGN DOCUMENT

Ghost Hunter (GH) will require the full-time efforts of three team members: an artist, a sound designer, and a game builder. *GH* will be developed using The Game Factory (TGF), which allows the rapid building of games such as this and drastically reduces the development costs.

GH includes a full installation routine that is customizable to your needs. We can place the advertising and promotional information required in the installation routine.

The following are the areas considered during our design of *GH*.

INTENDED AUDIENCE

Based on the information provided pertaining to your customer base, we designed *GH* to support the minimum requirements of a PC running the Windows operating system. In fact, your customer survey has indicated that the computers your audience uses can actually support a fairly high-resolution version of the game, which will in turn raise the file size of the game. In our design, we opted to create the higher-resolution images and compromise in the area of number of levels. We used

fewer levels due to size restrictions, but we designed each level to have a longer play time in the following ways:

- Each level must be beaten three times in order to progress.
- There is a timer on each level to increase the play tension. The player must zap all the ghosts in the time allowed or lose the level.
- Small animated scenes take place before, between, and after each level using the level's assets (again, keeping file size down)
- Finally, a great deal of effort has been put into the graphics of the game, so your customers will want to replay the game to see it again and show others.

MINIMUM/RECOMMENDED HARDWARE SPECS

The customer must have an Internet connection to your site to download the file. The game can also be distributed on one 3.5-inch floppy disk.

The customer's machine must be running Windows 95 or 2000.

A mouse is required.

If the customer can hear sounds in Windows, he or she will hear sounds in the game.

GHOST HUNTER GAME FLOW

The game style of *GH* is a standard point-and-click shooter interface, much like the older arcade games before *true* 3D environments were rendered in real time. This is very intuitive and does not require players to be familiar with advanced game play or complex moves.

Players will progress through levels until they fail at some point or win the final level. They will be rewarded with victory screens along the way and introduced to each level with a screen pointing out what they will be zapping and what they are worth in terms of points.

Finally, all games, whether players have won or lost, return them to the main menu where they can play the game again, view credits and information, or quit.

Installation

After the file is downloaded, the customer must simply click on the downloaded file and the installation routine will start automatically. Several areas of the installation program that can be customized for you:

- A welcome screen that displays your company logo and message
- A sidebar image during installation for your company logo and the *Ghost Hunter* logo
- A license agreement for the copyright information of the game, assets, and any associated properties
- A README file that can be displayed at the end of the installation and that can include technical, legal, and marketing information

- The installation will also provide the option to create a shortcut to *GH* on the Windows desktop and in the Start menu of Windows. The following options will be installed in the Start menu:
- An icon to run *Ghost Hunter*
- A link to your home page or URL of choice
- A link to the README file
- An icon to completely remove *Ghost Hunter* from the user's system; no files are installed other than those copied into the directory specified during installation, and there will be no files left on the user's system after removing *GH*

We will discuss the file formats and particulars of incorporating the above materials at a later date. The installation program will be generated later in development.

Credit Screen 1

Fade up from black.

This is the first screen the end user will see on starting *GH*. This screen will display your company's logo for 5 seconds or until the user presses a key.

Fade to black.

Credit Screen 2

Fade up from black.

The *GH* splash page will display for 5 seconds until the user presses a key. This screen is a unique 3D artwork depicting a ghost-infested haunted house. The *GH* logo and your company logo will be placed on the bottom of this screen.

Fade to black.

We can include as many credit screens as you want and even incorporate a presentation type of feel to this area, with slide shows, music, and animation. Such changes will, of course, increase the size of the game and resources needed to complete it.

Main Menu

Fade up from black.

The main menu has a custom bitmap backdrop and the following options:

Play. Allows the user to play *GH*.

Information. Displays product and contact information on the company.

Quit. Exits *GH* to the Windows desktop.

Level 1: Haunted House Level

After a very brief load time, Level 1 will start.

Animated introduction. This screen uses assets from Level 1 and shows the various ghosts of Level 1 circling the play area while the sound file MIDI 2 plays in the background. As the music fades, the ghosts fly into the house.

Opening screen. A bitmap image introducing the level. The images of the ghosts are displayed with their point values. The bat is displayed with the "500 Points" label next to it.

Description. The rendered background of this level is that of the typical haunted house: an old ramshackle house with hanging shutters, wrought-iron fence, and dead tree in the yard. The windows provide the places for the ghosts to appear.

Music. MIDI 2 is the basic haunted house music—loud and creepy organ. There are also sound effects of howling wind, creaking branches, and rattling chains in the background.

Enemies. Ghost One, Bat.

Game play. The level starts with the ghosts hiding. As the music begins, the timer starts and the ghosts begin to appear and disappear, fly about, and taunt the player, who must zap them with the Ghost Gun and disperse them before the timer runs out.

Level end, failure. If the player fails at two of the three tries, the player will be met with the bitmap Failure that shows the laughing ghosts. Every game failure brings the player back to the main menu.

Level end, success: If the player beats this level, the next level is loaded.

Level 2: Graveyard Level

After a very brief load time, Level 2 will start.

Animated introduction. As before, this screen uses assets from the level that is about to be played. The scene this time is a spooky graveyard with a few open graves and a crypt. The ghosts of this level are a bit meaner looking than the ghosts of Level 1. They are greenish ghoul types that moan and groan as they walk slowly toward their hiding places. The sound file MIDI 2 plays in the background.

Opening screen A bitmap image introducing the level. The images of the ghosts are displayed with their point values. This time a vulture is displayed next to the "500 Points" label.

Secret monster. If the player can kill all the ghouls in the minimal possible time, a tiny, quick-running ghoul will run across the screen. He will be difficult to hit, but if the player hits him, the player gets 1,000 points.

Description. The rendered background of this level is that of the haunted grave-
yard: several open graves, a spooky crypt with windows, and a dead tree.

Music. MIDI 2 is a more frantic and nightmarish tune than MIDI 1: loud and
howling wind and wolves, creaking branches in the background.

Enemies. Ghouls, Vulture, Tiny Ghoul.

Game play. The ghouls are much harder to hit. Fewer of them are exposed, and
they appear and disappear more quickly and more sporadically.

Level end, failure. If the player fails at two of the three tries, he or she will be
met with the bitmap Failure that shows the laughing ghouls. Every game
failure brings the player back to the main menu.

Level end, success. If the player beats this level, the next level is loaded.

Level 3: Creepy Castle Level

After a very brief load time, Level 3 will start.

Animated introduction. As before, this screen uses assets from the level that is
about to be played. The scene this time is a creepy castle on a cliff. The cas-
tle is further from our view than previous scenes, so the windows are smaller.
There are many ledges and windows in the castle as well. The monsters here
are gargoyles. They are smaller, quicker, and a color similar to the stones of
the castle around them and are harder to hit. The sound file MIDI 3 plays in
the background.

Opening screen. A bitmap image introducing the level. The images of the gar-
goyles are displayed with their point values. This time the bonus creature is a
Ghost Bat and is worth 1,000 points.

Secret monster. If the player can kill all the monsters in the minimal possible
time, a stone moves aside to reveal a gargoyle face for a very brief time. Hit-
ting it is worth 2,000 points.

Description. The rendered background of this level is that of a giant castle on a
cliff. There are numerous windows, balconies, arches, and a dead tree.

Music. MIDI 3 is a more discordant tune with loud screeches, howling wind,
and creaking branches in the background.

Enemies. Gargoyles, Ghost Bat, Hidden Gargoyle.

Game play. The gargoyles are quicker moving, are more numerous, and will stay
hidden longer, so they are far harder to hit than the previous creatures. They
are also similar in color to the stone around them.

Level end, failure. If the player fails at two of the three tries, he or she will be
met with the bitmap Failure that shows the leering gargoyles. Every game
failure brings the player back to the main menu.

Level end, success. If the player beats this level, the next level is loaded.

Level 4: Dark Dungeon of Doom Level

This is the final game level. In this level, the game play is altered to bring out the significance of the level and to add to the odd feel we were going for in the mummy's dungeon. It is a bit harder than the other levels but might not seem so at first.

After a very brief load time, Level 4 will start.

Animated introduction. This time, this screen does not use assets from the level that is about to be played. This scene shows a dark stone arch with steps leading down into the darkness. The sound file MIDI 4 plays in the background.

Opening screen. A bitmap image with the dungeon door background displays the image of only one monster: a rotting mummy. There are no point values this time; rather, the player uses previously earned points as power for the weapon. The points scroll up to the amount earned by the player, and then the level loads.

Description. The rendered background of this level is that of a very dark dungeon with many items in the background associated with a dungeon: a sarcophagus, cobwebs, rats, and an iron maiden hanging from chains.

Music. MIDI 4 is a more subtle and scary tune than the others, almost a throbbing heartbeat put to music.

Enemy. The mummy.

Game play. The mummy actually sits still and moves very little, but that is because he is impervious to the player's weapon. The player must soon realize that the very small jars on the shelf behind the mummy are the jars that contain his powers. As soon as the first jar is shot and explodes, the mummy begins waving his arms and chanting. The jars begin to circle his body and every so often his eyes glow and the jars speed up. The timer begins to count down after the first jar is shot as well. Finally, after each jar is shot, the remaining jars speed up, so the player must shoot all the jars in order to destroy the mummy before the timer ends and the player's weapon energy runs out.

Level end, failure. If the player fails at this level, he or she will be met with the bitmap Failure that shows the mummy. Every game failure brings the player back to the main menu.

Level end, success. If the player beats this level, the Victory Animated Sequence is played.

Victory Animated Sequence

This sequence is a special treat for the winner of *Ghost Hunter*.

- A special bitmap for this sequence loads; the bitmap is a conglomeration of the scenes of the game. The haunted house, graveyard, castle, and dungeon are all incorporated into this image.

- From the left side of the screen, the various monsters vanquished by the player flee across the screen and off the right side of the screen, screeching and howling.
- A new bitmap loads and shows the silhouette of a person (the player) with the title Master Ghost Hunter on the screen. A ghostly howl erupts, and the screen fades to black.
- The player is taken back to the main menu.

DELIVERABLES

Once this design is approved, we can have *GH* developed in under six months. After three months of development, we will have a running demo equal to half the complete game in terms of content and functionality.

D

Game Development Resources

This list of resources is biased toward Web sites and companies that have active Web pages because the Internet is probably the best and most up-to-date source of information for game development and related topics. Keep in mind that these resources are far from the only available resources, however. In fact, there is a mountain of information out there, and I encourage you to always be on the lookout for new information.

Usually, I chose a link or resource because it contained a large list of other resources such as *3D Links*, *The Game Development Search Engine*, and the various game news sites. The sum of online resources is vast and extensive—far too vast for one book. In addition, the fact that the Web is fluid and changing would make any extensive cataloging effort a waste. It is suggested that you browse these links and bookmark those that are the most useful to you, then check them at least once a week. You will find that the online communities are very supportive and knowledgeable. Most have various forums for communicating.

THE WEB SITE

Web sites for a company can range from a few pages containing an online brochure to a huge and constantly changing source of information. The more vibrant Web sites offer mailing lists, forums, and chat rooms. Take advantage of all this wealth of information!

THE MAILING LIST

A mailing list works just as you'd think: You get on a list and are e-mailed updates and announcements. Mailing lists function in many ways. You can get e-mail from every individual who mails to the list address. Because this method can amount to a huge number of e-mails for an active list, you can usually also get moderated lists, in which only e-mails approved by the list master are sent out to the entire list. You can also get the e-mail list digest. This is one big e-mail that contains all the e-mails from the list.

THE MESSAGE FORUM

A message forum is a place online where you can post messages under topics and discussion threads. The typical forum has many topic headings under which you can start a message thread with a post that has to do with the topic. Then people will usually respond to your post. It is advised that you search the forums and get to know them before posting. There is nothing more aggravating than to have the

same questions asked 10 times a day because people don't bother looking at the messages to see if their question has already been answered. Most message boards also have search utilities and other tools to help you navigate them.

NEWSGROUPS

Newsgroups are similar to message forums in that you find a newsgroup dedicated to your topic of interest and then you can post questions and answers. There are thousands of newsgroups, with topics ranging from certain products, subject areas, or people.

ICQ

ICQ, from the term "I seek you," shows you when others using ICQ are online if they are in your list. With ICQ, you can chat; send messages, files, and URLs; or play games.

GENESIS 3D-RELATED RESOURCES

The Genesis 3D Home Page
www.genesis3d.com
Contains links and all the updated information you will need.

MilkShape3D
www.swissquake.ch/chumbalum-soft/
A low-polygon-count 3D package that can import and export many game model formats, including the Genesis format.

WOG: World of Genesis
www.gameznet.com/genesis
The best source for Genesis-related information for newbie and professional alike.

Rabid Games: The Reality Factory
www.rabidgames.com
The Reality Factory is covered in Part II of this book.

vxEdit
http://members.xoom.com/edgarapoe321/quixotic.htm
vxEdit (rfEdit) is covered in Part II of this book.

3D Sector

www.gen3d.de
Tutorials and more.

GENESIS GAMES

AI Wars

www.aiwars.com

Below Zero

Developer: PcFire Interactive
Contact: Matthew Butlar

Henchman

http://henchman.homestead.com/
Features an outdoor area in the beginning of the game. The goal of *Henchman* wasn't to develop a commercial game, but to build a programming tutorial out of it.

The Heir

www.ourfun.com

Heroes for Hire

www.peanutco.com

TrilobiteShell

www.trilobiteworks.com
Trilobite is a game shell based on the Genesis 3D rendering engine. A game shell is the code that organizes the capabilities of the rendering engine into a cohesive application—a game.

Cheese Frenzy

www.gametitan.com
In this action game, the player gets the incredible perspective of a mouse that is on the hunt for his captured friend while collecting cheese bits. Avoiding enemies such as mouse traps, cats, and household dangers, the player has to scurry like a boy or girl mouse through everyday household obstacles, collect cheese for points, and power-up for more chances and speed boosts to exit before the timer goes off. The game play is simplistic, with the player having the option to concentrate on the score or to finish the plot. There are numerous animated sequences explaining the story before the beginning of each stage and at the end of game play. Each stage has its own levels, or rooms of the house. Current stages are Suburban House, Country House, City House, Laboratory House, and, the grand finale, Moon Base House, with Boss Monster Ratto. The game features a bright and stylized look that is ap-

pealing to children as well as adults. The content is mainly slapstick, nongory, and child safe.

PAN: Ground Zero

www.gekido.bc.ca/index.htm.

The Prison Arena Network (PAN) is multiplayer online combat, fast and furious. Combining all the classic death-match and traditional online variations, PAN throws the player into a life-or-death existence as an inmate in the most sadistic prison network ever conceived. Inmates of PAN are subjected to brutal hand-to-hand combat, forced to fight other inmates to survive.

PIG: Politically Incorrect Game

www.cybertag.com

Due to the rising of unhealthy ideologies in the developers' country (France), they decided to use Genesis 3D to contribute to the struggle against all fascism by investing all their time and financial power in the development of PIG.

SpaceBlast!

by Nitroheads

www.gfxspace.com/spaceblast/

SpaceBlast is a fast and furious arcade-style multiplayer space combat game that will bring you and your friends many sleepless nights.

G-Sector

G-Sector is the boldest step in freeware: a full 3D game using the Genesis 3D engine. It supports Glide and Direct3D for 3D acceleration. G-Sector is developed "in-house" by Freeform Interactive LLC, the owners of Ingava.com, FreeGamesWeb.com, GamesHEAD.com, and the FvF franchise.

G-Sector is a 3D action game based around hoverboard combat—a hybrid between an "extreme game" and a third-person shooter. Players control the heroine Cyra as she hoverboards through futuristic cities and arenas. Game play is based on using ramps and tricks to build velocity and avoid opponents' shots. Using a chase-cam and customizable mouse/keyboard interface, *G-Sector* should be familiar to players of the 3D shooter genre. Its features include 3D graphics, a third-person view, and extreme hoverboard combat action.

Gangsters

www.crosswinds.net/~nightwood/index2.html

Gangsters is a first-person shooter, developed by Nightwood using the Genesis 3D engine. It sports a huge arsenal of weapons and some of the best levels made with Genesis.

Pack Rat

www.roguestudios.com

Crystal Interactive picked up the limited license to *Pack Rat* in August 2000. The game is getting enhancements to the engine and the levels. Look for *Pack Rat* at a computer software store near you after October 31, 2000.

SOTA: Survivor of the Ages

www.alien-logic.com

Survivor of the Ages is a third-person RPG with some fighter game elements. It features a fully 3D world populated by creatures of all virtues and kinds. SOTA also features rich textures and scenes along with original soundtracks. SOTA has some of the most advanced collision detection seen in games today. Each character has multiple damage areas distributed at key points. These points allow for precise control of the kind of damage the player wants to inflict on an enemy. There are many more fun and startling features in SOTA. The recommended system is a PII-class processor or better, 64MB or more of RAM, and a 3DFX card such as the VooDoo2 and VooDoo3 or better.

MISCELLANEOUS RESOURCES

Fonts 'n' Things

www.fontsnthings.com

Fonts are very useful for texture creation. You can find many free fonts and links to more sources of fonts at this site.

3D RAPH

www.raph.com/3dartists

Lots of interviews with artists and tutorials.

Free Textures

www.freetextures.com

Loads of free textures of all kinds.

The 3D Studio

www.the3dstudio.com

Free pretextured MAX models, free seamless textures, and free MAX tutorials.

DESIGN RESOURCES

Game Developer Search Engine

www.game-developer.com

A very full site containing much of the information you will need on game development.

Gamasutra

www.gamasutra.com

The mother of all game development sites! You can find articles and resources on all aspects of game development and design here.

GIG News

www.gignews.com

Game Dev Net

www.gamedev.net

Another great source of development resources, with an online glossary of terms as well.

Game Center

www.gamecenter.com/Features/Exclusives/Design/ss01.html

This is a great article on game design.

Lupine Games

www.lupinegames.com

A must-visit link for wannabe developers.

The Inspiracy

www.theinspiracy.com

Noah Falstein maintains this site and has some great articles and information here.

International Game Developer Network (IGDN)

www.igdn.com

IGDN is an unincorporated membership association for the game developer community.

G.O.D. Games

www.godgames.com

Very cool guys. Especially read the Commandments and the Oracle.

GAME NEWS RESOURCES

The following sites have up-to-the-minute news on many areas of game development and the industry.

Game Spy
www.gamespy.com

3D Action Planet
www.3dactionplanet.com

Looney Games
www.loonygames.com

Blues News
www.bluesnews.com

Game Spot
www.gamespot.com

Game Center
www.gamecenter.com

Adrenaline Vault
www.avault.com

Classic Gaming
www.classicgaming.com

Game-Jobs.com
www.game-jobs.com
A European job recruiter for the game and entertainment industry.

Happy Puppy
www.happypuppy.com

SOFTWARE AND DEVELOPMENT ENGINE RESOURCES

Rabid Games
www.rabidgames.com
Improvement on Genesis 3D.

Genesis 3D
www.genesis3d.com
Open source 3D engine.

The Gimp
www.gimp.org
Free GNU Photoshop-like application.

MilkShape 3D
www.swissquake.ch/chumbalum-soft

Paint Shop Pro
www.jasc.com

Photoshop
www.adobe.com

BOOK AND MAGAZINE RESOURCES

Charles River Media
www.charlesriver.com

Game Architecture and Design
Andrew Rollings and Dave Morris

Game Developer's Marketplace
Ben Sawyer, Tor Berg, Alex Dunne

Game Design: Secrets of the Sages
Marc Saltzman

Awesome Game Creation
Luke Ahearn

Game Developer Magazine
www.gdmag.com
A must-visit site.

3D Design Magazine
www.3d-design.com
Great magazine and Web site.

Computer Graphics World
www.cgw.com
A great magazine and Web site. Check out their bookstore.

CONFERENCES AND CONVENTIONS

The Computer Game Developers Conference
www.cgdc.com

E3
www.e3expo.com

SIGGRAPH
www.siggraph.org

MODELING RESOURCES

3D Cafe
www.3dcafe.com

3D Palette
www.3dpalette.com

3D Links
www.3dlinks.com

Turbo Squid
www.turbosquid.com

GAME DEVELOPMENT TOOLS AND ENGINES

The Crystal Space Engine
http://crystal.linuxgames.com

The 3D Engines List
http://cg.cs.tu-berlin.de/~ki/engines.html

Rabid Games
www.rabidgames.com

Genesis 3D
www.genesis3d.com

GAME DEVELOPMENT ASSOCIATIONS

Academy of Interactive Arts & Sciences
www.vectorg.com

Computer Game Artists
www.vectorg.com

Computer Game Developers Association
www.cgda.org

Interactive Digital Software Association
www.idsa.com

International Game Developers Network
www.igdn.com

About the CD

CONTENTS OF THE CD-ROM

This section details the useful tools you'll find on the CD-ROM that accompanies this book.

GENESIS 3D (*WWW.GENESIS3D.COM*)

Folder: Genesis3d
You can use Genesis for free as long as you leave the Genesis logo display at the beginning of your game and follow the license agreement. The Genesis Level editor can be run on any machine running Windows 95 or above; the game engine's minimum requirements are a P-200 processor, 32RAM, and a monitor that can display at 640×480.

REALITY FACTORY (*WWW.RABIDGAMES.COM*)

Folder: RealityFactory
A significant enhancement to the original Genesis 3D, Reality Factory is a no programming game prototype tool. This software is open source as well. The minimum system for a fairly complex level is a P-400 processor, 64MB RAM, 50MB of hard disk space (including generated assets), a PCI audio card, and a 3D accelerator card (PCI or AGP).

CAUTION

Genesis3D provides software rendering, but Reality Factory requires a 3D hardware accelerator.

GOLDTREE TOOLS (*WWW.GOLDTREE.COM*)

Folder: GoldtreeTools
All the source and assets for the Goldtree Tools used to make *Dead Reckoning*. You must give Goldtree credit if you use these tools. The system requirements for the level editor are a P-200 processor, 32 MB RAM, 4X CD, 640 x 480 display (minimum), and Windows 95 or 98.

TUTORIAL FOLDER

Folder: tutorial

All the map files, images, and assets used in the tutorials in this book are in this folder.

PROFESSIONAL-QUALITY GAME TEXTURES BY WAYNE ST. PIERRE

Folder: CGMachine

These textures were created by Wayne St. Pierre (*www.cgmachine.com*).

TRUESPACE2

Folder: trueSpace2

This full retail version of *TrueSpace 2* requires at least a 486 DX2. *TrueSpace 2* is Pentium optimized. At least 8MB of RAM is suggested. A Windows graphics accelerator board (preferably local bus or PCI) is also recommended.

Be sure to check out the special upgrade offer only for readers of this book at *https://forms.caligari.com/store/gte*.

INSTALL MAKER BY CLICKTEAM (*WWW.CLICKTEAM.COM*)

Folder: install maker

If you can run Windows or Windows NT, you can run Install Maker.

PROFESSIONAL-QUALITY GAME TEXTURES BY NICK MARKS (*WWW.FREETEXTURES.COM*)

Folder: NickMarks

These textures were created by Nicholas Marks; lots more textures can be found at the Free Textures site. If you use these textures, you need to give Nicholas Marks credit in your production.

MILKSHAPE 3D BY METE CIRAGAN (*WWW.SWISSQUAKE.CH/CHUMBALUM-SOFT*)

Folder: Ms3d

MilkShape 3D is a shareware product. For a registration fee of $20 (U.S.), you can't beat this product. You have 30 days to see just how awesome this product is! The

minimum system is a P-200, 32MB RAM, software OpenGL drivers and about 2MB HD space on a Win95 or higher machine.

GOLDWAVE SOUND EDITING BY CHRIS CRAIG (*WWW.GOLDWAVE.COM*)

Folder: GoldWave

This is a shareware demo version of the GoldWave sound editor. It requires you to register it if you keep it (about $40 U.S.). GoldWave requires a 486 or better CPU, a mouse, 16MB of RAM, 3MB of disk space, and a sound card. A coprocessor is recommended (but not required). For best performance, use a Pentium 200MHz or faster processor with at least 64MB of RAM.

PAINT SHOP PRO BY JASC, INC. (*WWW.JASC.COM*)

Folder: PSP6-2

A 30-day demo version of Paint Shop Pro.6. The minimum system requirements are a mouse, a Pentium-class computer, 32MB of RAM, 30MB hard drive space, and at least a 256-color display.

Index